DRAWING: MASTERS AND METHODS
Raphael to Redon

DRAWING: MASTERS AND METHODS
Raphael to Redon

Papers presented to the Ian Woodner Master Drawings
Symposium at The Royal Academy of Arts, London

Edited by DIANA DETHLOFF
Foreword by MARYANNE STEVENS

Harry N. Abrams, Inc., Publishers, New York
in association with
The Royal Academy of Arts, London

ISBN 0–8109–3208–3

Library of Congress Catalog Card Number: 91–58231

Copyright © Royal Academy of Arts, London 1992

Copyright of all reproductions rests with the owners of the works reproduced

First published 1992 in Great Britain by Philip Wilson Publishers Limited

Published in 1992 by Harry N. Abrams, Incorporated, New York
A Times Mirror Company
Designed and printed in Great Britain by W. S. Maney and Son Ltd

CONTENTS

LIST OF FIGURES

ZOOLOGICAL ANIMAL DRAWINGS AND THE ROLE OF HANS VERHAGEN THE MUTE FROM ANTWERP

A NEW DRAWING BY GUIDO RENI FOR THE *CROCEFISSIONE DEI CAPPUCCINI*

THE CHARCOAL DRAWINGS OF ODILON REDON

10. PARMIGIANINO *Daniel in the Lion's Den*. Städelsches Kunstinstituit, Frankfurt.

11. Ventura SALIMBENI *Last Judgement with St Michael*. Staatliche Graphische Sammlung, Munich.

12. Marco da Faenza MARCHETTI *Madonna and Child*, Private Collection.

13. Ciro FERRI *Baptism scene (The Baptism of St Ambrose?)*. Private Collection, U.S.A.(?).

14. Anonymous Venetian, sixteenth century *Five children playing in a landscape*. Musée des Beaux-Arts, Dijon.

15. Taddeo ZUCCARO (or studio) *Allegorical Figure: Seated woman with staff*. Musée des Beaux-Arts, Dijon.

16. Anonymous Italian, seventeenth century *Latona transforms the Lycian peasants into frogs(?)*. Stiftung Ratjen, Vaduz.

17. Isack van OSTADE *View of a Cottage*. Courtauld Institute Galleries, London.

18. François VERDIER *Diana and Actaeon*. Kunstmuseum, Basle.

PATTERNS OF DRAWING COLLECTING IN LATE SEVENTEENTH- AND EARLY EIGHTEENTH-CENTURY ENGLAND

1. Sir Peter LELY *Diana Kirke, Countess of Oxford*, Paul Mellon Collection, Yale Center for British Art, New Haven.

2. Sir Peter LELY *Jane Bickerton, Countess of Norfolk, 1677*. His Grace the Duke of Norfolk.

3. PARMIGIANINO *A draped figure turned to the right*. British Museum, London.

4. PARMIGIANINO *Study of the drapery of a female figure*. British Museum, London.

5. PERUZZI *Pan with nymphs and satyrs*. Devonshire Collection, Chatsworth.

6. Sir Peter LELY *Richard Gibson and his Wife*. Private Collection.

7. REMBRANDT *The Parable of the Publican and the Pharisee*. Ian Woodner Collection, New York.

8. School of RAPHAEL (Giovanini Francesco Penni?) *Constantine addressing his troops, startled by the Vision of the Cross in the sky*. Devonshire Collection, Chatsworth.

IN MEMORIAM —
IAN WOODNER

Success of a symposium depends in large measure upon a peculiar chemistry of speakers, discussants and the logical coherence of its central academic theme. In the case of the international symposium held in conjunction with the London exhibition showing important master drawings from the Ian Woodner Family Collection, there was no question that such a distillation had not been achieved. In November 1987 at the Royal Academy of Arts, London, a gathering of distinguished international scholars was presented with papers from leading specialists which addressed four specific issues central to the making, status and subsequent fortunes of drawings: their various media, from chalk and charcoal to pastel; their place within the pedagogic tradition; their diverse applications, and their subsequent fortunes within collections in Britain, in the United States and on the Continent of Europe. The starting point of all four sessions and, within these, of each paper, was the quality and range of drawings presented in the Woodner Collection itself.

I received generous advice and support in the planning of the symposium from Christopher Lloyd, Surveyor of the Queen's Pictures, Frances Carey, Assistant Keeper of Prints and Drawings at the British Museum, and the late Walter Strauss, connoisseur and editor of the *Illustrated Bartsch*. The resulting volume has been ably edited by one of its contributors, Diana Dethloff, who wishes to thank Linda Hind and Graham Maney at W. S. Maney & Son Ltd for their invaluable advice. It is hoped that it will stand as a fitting tribute to a man whose heart and eye dictated his passionate commitment to the art of drawing and whose belief in the primacy of this art brought both exhibition and symposium to London for the appreciation of the public, the delectation of the connoisseur and the enlightenment of the scholar.

MARYANNE STEVENS
Librarian and Head of Education
Royal Academy of Arts
December 1990

The Renaissance draughtsman and his models

by FRANCIS AMES-LEWIS

During the last third of the fifteenth century and into the early sixteenth, the accurate representation of the human form, fully articulate in both anatomical structure and movement, became a more and more critical issue in the central Italian artist's worshop. Study from the model was essential, both in training the draughtsman's eye and hand, and in the preparation of designs for finished works. The important group of Italian Renaissance drawings which has been assembled by Mr Woodner provides an opportunity for further speculation about the range of workshop models used by the Renaissance draughtsman and the criteria which in particular instances guided his selection of a model for study. The questions to be reviewed in this paper revolve around whether draughtsmen worked from the live model or from as it were 'inorganic' types of model such as 'prefabricated' patterns of human form in either two or three dimensions, drawings or prints, sculptural models, or jointed wooden mannequins.

Live models were normally workshop assistants or *garzoni* posed by the draughtsman for study, although in the early sixteenth century the use of other figures including the nude female model became less unusual. The practice of drawing from the studio model can be recognized in various ways, sometimes by the figure's characteristic workshop clothing (as in numerous late quattrocento drawings such as the Signorelli drawing acquired a few years ago by the Walker Art Gallery, Liverpool),[1] or sometimes by the repetition of the same model or models in different poses within a single composition. A remarkable example of this practice is the pair of fragments in the Woodner Collection of Raphael's first design for *Christ's Charge to Peter* (Fig. 1), drawn in preparation for the Sistine Chapel tapestry and its cartoon.[2]

The Royal Academy and Metropolitan Museum Woodner exhibition catalogues suggests that Raphael 'made his original study from life by drawing a *garzone* or studio model in contemporary dress in a series of different poses'.[3] In fact he used no less than three studio models, as is shown by the repetition of the features of three different facial types in these fragments. The Apostles, of course, varied considerably in age; so, appropriately enough, Raphael used for his models a boy with long hair, a youth with a short beard, and an older man with a longer beard and perhaps with white hair. Comparison of the fragments with the next stage of design, the *modello* in Paris,[4] shows that he did not keep these facial characteristics for each Apostle. This comparison also shows that by using three *garzoni* Raphael created a compositional difficulty for himself, since this procedure naturally tends to generate an uneven triple-figured rhythm which militates against compositional unification. In the Paris *modello* he achieved a smoother rhythm through the group by spacing the heads of the Apostles fractionally more regularly, and allowing more air between them; this breaks down the sense produced in the Woodner fragments, seen more

[1] *Study of a Youth*, Walker Art Gallery, Liverpool; see M. Evans, 'A Signorelli Drawing for Liverpool', *Burlington Magazine* CXXIII (1981), p. 440, and F. Ames-Lewis and J. Wright, *Drawing in the Italian Renaissance Workshop* (London, 1983), no. 13 pp. 90–91.
[2] See *Master Drawings: The Woodner Collection*, exhibition catalogues (Royal Academy of Arts, London, 1987), no. 12 pp. 42–44 and (Metropolitan Museum, New York, 1990), no. 15 pp. 48–50. This became standard in Raphael's drawing practice, as for example in a nude study for the *Disputa* (Frankfurt, Städel 379; see P. Joannides, *The Drawings of Raphael* (Oxford, 1983), no. 205) and in drawings for the *School of Athens* (Vienna, Albertina V, 4883 (Joannides, 1983, no. 227)) and for the *Sacrifice at Lystra* tapestry (Paris, Louvre RF 38813; see J.-P. Cuzin, *Raphael, vie et oeuvre* (Fribourg, 1983), p. 174 fig. 184). The practice is noted by F. Ames-Lewis, *The Draftsman Raphael* (New Haven and London, 1986), pp. 24–25, 81, and 134.
[3] *Woodner Collection*, exhibition catalogues, (1987), p. 44 and (1990), p. 50.
[4] Paris, Louvre 3863; see Joannides, 1983, no. 360 and pp. 102–03 pl. 35.

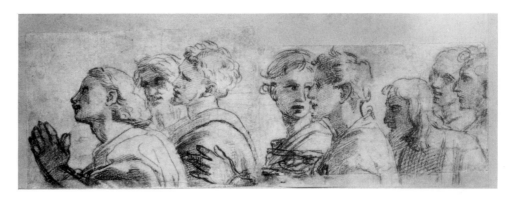

[5] Windsor, Royal Library 12751; see Joannides, 1983, no. 359, and A. E. Popham and J. Wilde, *The Italian Drawings of the XV and XVI Centuries in the Collection of H.M. the King at Windsor Castle* (London, 1949), no. 802.

[6] The hypothesis that Raphael himself dismembered the sheet from which Windsor 12751 was offset was first advanced by J. Shearman, *Raphael's Cartoons in the Collection of H.M. the Queen and the Tapestries for the Sistine Chapel* (London, 1972), p. 97. The suggestion in the catalogue (*Woodner Collection*, exhibition catalogue (1987), p. 44) that after accidental damage only parts of the sheet could be salvaged fails to explain why our undamaged fragment should have been neatly bisected. Other cases exist of Raphael drawings which were cut or otherwise altered during the evolution of a design; see Ames-Lewis (1986), pp 9–10.

[7] In discussion at the Symposium, Konrad Oberhuber suggested to me that throughout the argument that follows I have overestimated the live model's difficulties in holding an active pose for any length of time. It may indeed be that I have; and this aspect of my subject would, I think, merit further investigation.

[8] An early example is the sheet in Stockholm, Nationalmuseum 11, which shows eleven nude male figures disposed on a dodecagonal stage (see B. Degenhart and A. Schmitt, *Corpus der Italienischen Zeichnungen 1300–1450* (Berlin, 1968), 1/2 no. 515, p. 527, and 1/4 pl. 360c).

[9] *Woodner Collection*, exhibition catalogue (1987), no. 72 pp. 201–03 (as 'Italian or French School (Jean Fouquet?)') and (1990), no. 89 pp. 234–35.

[10] For this, see in particular L. S. Fusco's entry in *Early Italian Engravings from the National Gallery of Art*, ed. J. A. Levenson, K. Oberhuber, and J. L. Sheehan (Washington D.C., 1973), no. 13 pp. 66–80, and also L. Ettlinger, *Antonio and Piero Pollaiuolo* (Oxford, 1978), no. 15 pp. 146–47 and pls 72–73.

clearly in the Windsor offset,[5] of clumps of three figures. In the process of reaching this improvement in the original study from his group of *garzone* models, Raphael might well have felt the need to cut his sheet into small pieces to facilitate the trial-and-error manipulation of his figures; and since he had retained the offset as a record of his design, dismemberment of this sheet would not cause a major loss in the continuity of the design process. It seems more sound to argue that the draughtsman himself cut and tore up his drawing for good reason within his working procedure than that these fragments were salvaged from a hypothetical later accident, as the catalogue proposes.[6]

The Woodner fragments are characteristic both of Raphael's preparatory procedure and in general of the Renaissance draughtsman's use of studio models in life-drawing. Seldom, however, is the use of live models quite so clear cut. Before some less unambiguous cases are considered, definitions must be attempted of what were earlier called the 'inorganic' types of model available in the Renaissance painter's workshop. One of the major difficulties in using the live model came in the study of active poses which a *garzone* could not hold steady long enough for a sufficiently detailed study to be completed.[7] This difficulty is clearer still in naturestudy, since animals and birds cannot even be asked to hold a pose, whether balanced or not. In the fifteenth century the representation of natural forms was therefore frequently based on two-dimensional, modelbook patterns; and two-dimensional patterns for the human form also existed.[8] The Woodner sheet from the so-called Cockerell Chronicle records, perhaps at second hand, a number of figures from Masolino's celebrated *Uomini famosi* cycle in the Palazzo Orsini in Rome.[9] The figures in Masolino's fresco cycle were of course recorded here for their iconographical value and served as models for specific figures rather than as general 'patterns' of human form. But some two-dimensional patterns for human anatomy were made especially for other painters to copy, such as outstandingly Pollaiuolo's *Battle of the Nude Men* engraving.[10] Although this print was widely and easily disseminated, its usefulness to draughtsmen was limited. It could provide valuable information, not available from other types of model, about surface musculature under tension, and this is probably why Pollaiuolo stressed these aspects of his forms to the point of exaggeration; but it could not provide much helpful information about the projection and movement of forms into and through space. In their growing preoccupation with these issues, draughtsmen came more and more often to use three-dimensional 'inorganic' models, both pre-existent, such as classical sculpture, and as frequently (one may hazard) purpose-made.

Although often copied, large-scale sculpture, whether in relief or in the round, whether classical or contemporary, was also of limited usefulness for the purpose of figure-study because of the specific style, iconography and function of each figure or relief, and because the range of

angles of view of each form was frequently restricted. But the demonstrable potentialities for study purposes of small-scale, free-standing antique figurines in bronze, terracotta or other media may have stimulated Renaissance sculptors to produce small figures in wax or plaster to serve specifically as models for painters.[11] This seems to be the implication of Ghiberti's rather ambiguous statement, characteristically difficult to translate, that 'I have also brought the greatest honour to the works of many painters, sculptors, and masons, in that I made a great number of sketches in wax and clay and very many drawings for painters...';[12] and the inventory of Fra Bartolommeo's workshop effects includes '22 wax models of children and other things' and '63 plaster pieces including heads, feet and torsos'.[13] It has recently been convincingly demonstrated that Pollaiuolo used some such sculptural model for the exemplary drawing of *A Nude Man seen from Front, Side and Back*, for not only the drawing but the model itself were later used by other draughtsmen as study materials.[14] Verrocchio's workshop, amongst others, is known to have produced wax figures and votive images, so that by the 1470s the pattern set by Ghiberti was probably standard practice at least in Florentine workshops. Particularly useful or celebrated sculptural models might be cast in bronze for greater permanence: figures like the so-called *Pugilist*, perhaps made in Donatello's studio,[15] could originally have functioned in this way and, almost incidentally, might also have fuelled the incipient enthusiasm amongst humanistically-inclined patrons for small, table-top bronzes.

The major advantage of models like these is that the form, accurately modelled in musculature and proportions, could be pivoted about any axis and viewed from an almost infinite range of different angles. A recent exercise in tracing responses to a Renaissance sculptural model based on an antique *Marsyas* associates derivations with several of a range of angles of view.[16] By rotating his model and restudying it from different angles, the draughtsman could investigate at length the projection of forms in space, and could make precise records of the foreshortening of limbs so that his realization of the figure would be both anatomically accurate and convincing in its spatial movement and rhythmic life. But these sculptural models, too, have one crucial inbuilt limitation in that they are essentially inflexible. Plaster or bronze figures are fixed and unalterable: once cast, as in the case of the *Marsyas*, or the 'gnudo della paura' as it was called in the Medici inventory of 1492, there was minimal scope for adaptation for other dynamic or expressive purposes. Similarly, the flexibility even of a wax figurine is limited to slight manipulations to produce merely minor alterations of pose or of the disposition of limbs.

Besides wax and plaster models, Fra Bartolommeo's workshop inventory lists a 'modello grande quanto un uomo'. This was probably the mannequin which later on Vasari preserved in memory of Fra Bartolommeo and of which he wrote: 'in order to draw draperies, arms and such things, he had a large wooden model of life size, with moveable joints, (which) he dressed in natural clothes'.[17] Already in the early 1460s the Florentine architect Filarete had described such a 'manichino' as an aid to artists' study;[18] and in some later fifteenth-century drawings its use is very evident. Fra Bartolommeo was trained in Domenico Ghirlandaio's workshop, and it was perhaps there that he first recognized the potential of a mannequin, such as that used in Ghirlandaio's drapery study for the Louvre *Visitation*, as the posed 'skeleton' as it were, over which fabric dipped in plaster was allowed to set.[19] This technique, first described by Vasari as used by Piero della Francesca,[20] was frequently used in Verrocchio's workshop for the detailed study of cast drapery, and it was perhaps during his apprenticeship there in the early 1470s that Ghirlandaio adopted the practice.

[11] On this subject in general, see most recently L. S. Fusco, 'The Use of Sculptural Models by Painters in Fifteenth-Century Italy', *Art Bulletin* LXIV (1982), pp. 175–94; and see also J. Pope-Hennessy, 'The interaction of painting and sculpture in Florence in the Fifteenth Century', *Journal of the Royal Society of Arts* CXVII (1968–69), pp. 406–24, especially pp. 420–21.

[12] This is the version given in an unpublished translation of extracts from Ghiberti's *Commentari* made many years ago by members of the staff of the Courtauld Institute of Art, University of London. Variations of word-order or punctuation in other translations produce different interpretations: 'Also for many painters, sculptors and stonecarvers I provided the greatest honours in their works (for) I have made very many models in wax and clay and for the painters I have designed very many things.' (R. Krautheimer and T. Krautheimer-Hess, *Lorenzo Ghiberti* (Princeton, 1956), I, p. 15); 'In addition, I have done very great favours to many painters and sculptors and carvers in their works, I have made many preparatory models of wax and clay, and drawn a great many things for painters.' (C. Gilbert, *Italian Art 1400–1500* (Sources and Documents) (Englewood Cliffs, N.J., 1980), p. 88). The text given by J. Schlosser, *Lorenzo Ghibertis Denkwurdigkeiten (I Commentarii)* (Berlin, 1912), pp. 50–51 reads: 'Ancora a molti pictori et scultori et statuarij o fatto grandissimi honori ne'loro lavorij, fatto moltissimi prouedimenti di cera et di creta et a'pittori disegnato moltissime cose.'

[13] See recently, W. Prinz 'Dal vero o dal modello? appunti e testimonianze sull'uso dei manichini nella pittura del quattrocento', *Scritti di storia dell'arte in onore di Ugo Procacci* (Milan, 1977), I, pp. 200–08; and also F. Knapp, *Fra Bartolomeo della Porta und die Schule von San Marco* (Halle, 1903), pp. 275–76.

[14] See Fusco, *Art Bulletin* (1982), pp. 186 and 192–94. The drawing is Paris, Louvre 1486, reproduced in art cit., pl. 32, and in Ettlinger (1978), pl. 70.

[15] See J. Pope-Hennessy, 'Donatello and the Bronze Statuette', *Apollo* CV (1977), pp. 30–33, reprinted in ibid., *The Study and Criticism of Italian Renaissance Sculpture* (New York, 1980), pp. 129–34.

[16] See Fusco, *Art Bulletin* (1982), p. 189, pl. 38.

[17] Giorgio Vasari, *Le Vite...*, ed. G. Milanesi, IV (Florence, 1889), p. 195; the translation quoted here is by W. Gaunt, II (London, 1927), p. 198. In general on the use of mannequins, see Prinz, *Procacci Scritti* (1977), pp. 200–08.

[18] A. Averlino, il Filarete, *Treatise on Architecture*, trans. and ed. J. R. Spencer (New Haven and London, 1956), I, p. 314; see also Fusco, *Art Bulletin* (1982), p. 185.

[19] This drawing is Florence, Uffizi 315E; see B. Berenson, *The Drawings of the Florentine Painters* (Chicago, 1938), II no. 876 p. 91 and III Fig. 313.

[20] Vasari/Gaunt, 1927, I, p. 335.

Filippo Lippi Pitt: Fior:-

FIG. 2. Filippino LIPPI, Ian Woodner Collection, New York, *Various Figure Studies*. Silverpoint with white heightening, on ochre prepared paper, 22 × 32.8 cm. Exhibited, Royal Academy of Arts, London, 1987, no. 22D and Metropolitan Museum, New York, 1990, no. 29D.

These examples of Raphael's use of the live model, Pollaiuolo's of the sculptural model, and Ghirlandaio's of the mannequin have been chosen for their clarity. Sometimes the models converge, as when for a drawing, now at Windsor, Signorelli had his *garzone* adopt the pose of the 'gnudo della paura';[21] but this too is an unusually distinct case. The type of model on which many Renaissance figure-drawings were based is at best uncertain and sometimes is completely indefinable, and in many cases the draughtsman probably worked entirely from his imagination. Studies of children who, like animals and birds, tend not to stay still for long are rather unlikely to have been drawn from life; and this is probably why Fra Bartolommeo had a particularly large group of wax models of children in his workshop. But in the case of a pen-and-ink drawing of the excited freedom of Filippino Lippi's *Dancing putto* it is impossible to say with confidence that there was a model at all.[22]

Against this background, two particularly interesting examples in the Woodner Collection of drawings from the model may now be examined. It can be stated with some confidence that Filippino Lippi studied from the live model in the major sheet of figure-studies on the Woodner page from Vasari's *Libro de' disegni* (Fig. 2). A significantly high percentage of the numerous figure-drawings made in Filippino's workshop in his characteristic silverpoint technique are demonstrably studies from the *garzone* model.[23] This is paradoxical, since his technique required two processes, drawing with the silverpoint and heightening with the brush and white pigment; and thus the model had to hold his pose longer than was required by the pen draughtsman sketching at the same speed. Perhaps for this reason, in a high proportion of these Filippino workshop studies the model holds a balanced pose. This is the case here in the figure at the right-hand side which could possibly, it is suggested in the catalogue, have been copied from a Botticelli workshop painting of the *Judgement of Paris*, but was more probably drawn from a suitably posed *garzone*.[24] Also seated in a

21 Windsor, Royal Library 070; see Popham and Wilde, 1949, no. 30 p. 177 and pl. 11.
22 *Woodner Collection*, exhibition catalogues (1987), no. 22E pp. 74–75 and (1990), no. 29E pp. 88–89. Mr Woodner pointed out to me in a discussion at the Symposium that in this drawing Filippino handled his pen in two distinct ways: the putto's torso, head and arms are freely sketched, apparently from the imagination, whereas below the waist the forms are much more closely studied (perhaps from a model such as the terracotta attributed to Verrocchio in the National Gallery of Art, Washington, as is suggested in the exhibition catalogue), with hatching and cross-hatching of widely varying tonality and character.
23 See inter alia C. Ragghianti and G. Dalli Regoli, *Firenze 1470–1480: disegni dal modello* (Pisa, 1975).
24 *Woodner Collection*, exhibition catalogues (1987), no. 22D pp. 72–73 and (1990), no. 29D pp. 86–87.

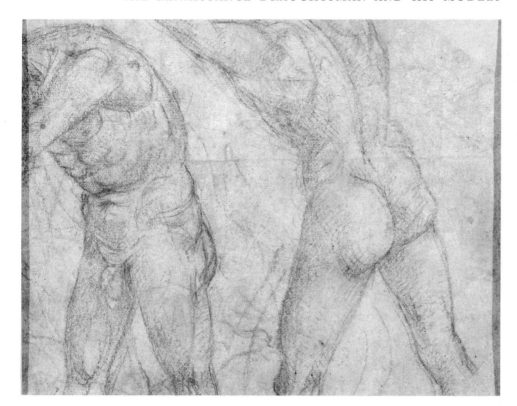

FIG. 3. Luca SIGNORELLI, Ian Wood-
ner Collection, New York, *Two Nude
Figures*. Black chalk on brown paper,
17.3 × 21.7 cm. Exhibited, Royal
Academy of Arts, London, 1987, no. 4
verso, and Metropolitan Museum, New
York, 1990, no. 5 *verso*.

hunched but stable position was the model whose legs were studied and
restudied in the centre of the sheet. Perhaps significantly, however, the
more vigorous, unstable pose at the left was studied much more swiftly
with free, brisk movements of the silverpoint and with spontaneous
touches and fluently rapid strokes of the highlighting brush. The contrasts
in handling, included on a single sheet, encourage the deduction that the
speed of Filippino's drawing was in some degree proportional to the length
of time that he could expect his model to hold the pose. The constraints
under which the draughtsman using a live model worked may have had as
much influence on Filippino Lippi's handling as did any preparatory
functions that can be hypothesized for the sketches on this sheet. The
parallel drawn in the catalogue between this swift sketch and drawings for
the litter-bearers in the Strozzi Chapel *Raising of Drusiana* may therefore
be as much due to the speed of execution demanded in both cases by the
model's difficult pose as to any similarity in date or function. Even when
studying unstable poses which had to be recorded as rapidly as possible,
Filippino tended to work from the *garzone* model, and he adapted his
graphic handling to this precondition. This working practice may help to
explain the apparent contradiction that this sheet should incude sketches
which, on the catalogue compiler's criteria, are datable both early and late
in his career.

One of the most exciting drawings in the exhibition at the Royal
Academy, the sketch of two nude figures recently revealed on the *verso* of
the Signorelli sheet (Fig. 3), poses the problem of the nature of the model
used perhaps more acutely than any other Woodner drawing.[25] While
Filippino's figure-drawing practice was remarkably uniform, Signorelli's
varied: a drawing may clearly be from the studio *garzone* model (as in the
two cases mentioned above) or, alternatively, from the mannequin which
was used for a drawing now at Bayonne, to judge by the figure's stiff pose
and thickened, distorted joints.[26] Now, the hunched figure at the left of the
Woodner sheet reflects, albeit distantly, the 'gnudo della paura' pose: it
could therefore be an adapted study from the *Marsyas* sculptural model
which Signorelli often used, or it could have been drawn from a posed
studio model. It seems most likely, however, that Signorelli used a pair of

[25] *Woodner Collection*, exhibition catalogues
(1987), no. 4 p. 26 and (1990), no. 5 p. 28.
[26] This drawing is Bayonne, Musée Bonnat
1298; see Berenson (1938), no. 2509A–2
p. 329.

mannequins in this case. The *motif* of two figures linked together like this, in apparently violent confrontation, recurs frequently in Signorelli's work. This may suggest that he systematically used a method of figure-study by which posed and reposed mannequins provided the information essential to his understanding of the projection and movement of foreshortened forms through space. On this basis he could subsequently build up the finer details of form and structure. The simplified quality of the shapes and surfaces of anatomical forms inevitable in a mannequin is frequently reflected in Signorelli's nude figures, both drawn and painted, and here too this simplification may explain the roundness of the buttock and the exaggerated clarity and size of the shoulderblade of the right-hand figure. In particular, the use of a mannequin seems to explain best the strident straightness of the line along the underside of the left-hand figure's arm, which looks especially artificial at the awkward juncture with the shoulder. Finally, the degree of thoroughness of his black chalk hatching which builds the forms in full three-dimensionality, and the major *pentimento* in the pose of the hunched figure's left leg, suggest that SIgnorelli worked on this confronted group study at some length and with conscientious attention. It may be doubted that a live model or models could have been expected to hold the poses long enough for such a detailed study to be executed: and it probably follows that in this case, as in many others, Signorelli chose to work from a mannequin.

By scrutinizing a varied group of Renaissance drawings such as those in the Woodner Collection from this particular point of view, it may be possible to deduce more about the Renaissance draughtsman's workshop practices, and in particular about how he used study models as he developed his perceptions of, and his ability to represent, human form and anatomy. Although speculations like these must of course remain open to modification, they may serve to increase awareness of the nature and limitations of the Renaissance draughtsman's models. Finally, these sorts of explorations may be of value in establishing further criteria to be borne in mind when assessments are made of the dating of Renaissance figure-studies and of their relationship with finished paintings.

Concepts and consequences in eighteenth-century French life-drawing[1]

by JAMES H. RUBIN

This paper will have two main parts: first a factual and historical account of life-drawing in eighteenth-century France based on work I did some years ago, then a more general and speculative discussion of the consequences of academic life-study for eighteenth- and early nineteenth-century painting. From the founding of the French Royal Academy of Painting and Sculpture in the mid-seventeenth century, life-drawing had a central role that was both political and artistic. For the founders, an Academy under Royal charter was a way to break the conservative grip of the guild of painters and sculptors which since the Middle Ages had ruled their profession. The group of painters including Poussin, Vouet, Le Sueur, Le Brun and others, were inspired by the example of Italian humanism. They resented the guild's arduous system of apprenticeship, its resistance to the progressive influences of foreign styles, and its preoccupation with matters of mere craft. The academicians viewed painting as a 'liberal art', a concept supported through yearly lectures on theory which they initiated in 1667. In fact, most technical instruction itself continued to take place in the studio of the master, each professor being allowed six students.

The main exception to this practice was drawing instruction, especially life-drawing, since it was considered the central experience of any art teaching. It was the only course offered without interruption from the Academy's inception until the French Revolution. By the mid-eighteenth century it was the Academy's defining function: Diderot's *Encyclopédie* described an *académie* as 'a public school where painters go to draw or paint, and sculptors to model, after a nude man called the model'.[2]

The right to hold life-drawing classes was at the centre of the power struggle between the guild and the new Academy. Classes were theoretically open to all, which meant to all who could show a letter of protection from an affiliated master. Members of the guild were thus excluded until 1651, when there was an attempt to fuse the rival groups, an unhappy experiment that soon led to renewed quarrelling and four years later ended in a complete rupture. The Academy's ultimate victory consisted in being granted a monopoly over life-drawing instruction. Even private life-classes were forbidden, and since no artist could claim status in educated society without the direct experience of the live model to his credit, any rivalry was effectively quashed. During the eighteenth century, when the weakness of the Academy allowed the guild to regain some favour, the monopoly over life-drawing had to be re-established by Turgot's edict of 1776, which dissolved the guild once again.

The Academy's monopoly meant that most eighteenth-century French life-drawings were indeed made at the Academy as part of the process of

[1] This article is a slightly abridged version of the paper given at the Woodner Drawings Symposium at the Royal Academy in October 1987. Since it draws on work already published, particularly in my *Eighteenth-Century French Life-Drawing* (Princeton, 1977) for the first half of the paper, I have not greatly modified its informal tone, and I have restricted footnotes primarily to direct citations. I wish to thank The Art Museum of Princeton University for permission to use passages from that book.
[2] Denis Diderot, Jean le Rond d'Alembert, *et al., Encylopédie, ou dictionnaire raisonné des sciences* (Paris, 1751–65; second edition, Paris, 1782–88), second edition, s.v. 'académie de peinture'. All translations from the French are my own.

instruction — from which comes the term *académie* often used to designate them. They were executed either by a student or by a professor, whose task it was to set an example. While there are major exceptions — for instance, the drawing after the life made by an established master for his own edification, as is frequent in the cases of Boucher and Bouchardon, or more obviously, the drawing meant to be reused for a painted figure — the term 'académie' generally implies the academic exercise. Moreover, painted *académies* also exist, especially those sent to Paris by *pensionnaires* from Rome as evidence of their progress. I will discuss some of these in the second part of the paper.

Before being allowed access to the live model, the student had to show his proficiency in preliminary phases of drawing instruction. His work was judged by professors at every stage. It was unthinkable that an inexperienced pupil confront *la nature* right away; for drawing was regarded as a science, and as one of the most important eighteenth-century treatises on drawing declared: 'The science of drawing can be acquired only after long practice and much concentration.'[3] The first stage in drawing instruction was to copy two-dimensional works either done by the instructor or engraved after the old masters (called *dessiner d'après l'exemple*). This meant copying not entire pictures, but profiles, heads, hands, feet, and other details of the body, beginning with eyes, noses, lips, ears, and so on. Some instruction manuals carried as many engravings of these details as they did images of entire figures, and there was always a series of such elements grouped on a plate to give the student an experience of their diversity. Later he progressed to copying whole figures.

The reasoning behind this system is relevant to our general understanding of life-drawing. First, the human form was considered the most important object of the painter's study, so he ought to approach it right away. Restricting his attention at first to individual features would, of course, give him a greater intimacy with its details and anatomy before he began to study the entire figure. Studying flat works, rather than three-dimensional forms, offered a more simplified beginning. It might be added that it certainly encouraged the acquisition of conventions and techniques of draftsmanship used to transcribe the three-dimensional form. As the student advanced, he was allowed to copy engraved or drawn *académies*; albums of engraved nude figures intended for this use or for similar uses (such as drawing instruction without a master) abound.

After spending what Roger de Piles estimated to be about a year with these first exercises, the student in the next stage of his training, which may have lasted several years all together, began to study three-dimensional objects. Drawing after sculpture, usually plaster casts, was called *dessiner d'après la bosse* and was regarded as a necessary transition between flatworks and the live model. Its purpose was to familiarize the student with effects of light and shadow; he again began with heads and parts of the body, moving eventually to the figure as a whole.

The purposes of drawing instruction following this programme were summarized by Roger de Piles: 'What ought to be the first aims of the beginner in drawing?' he asked. '(1) To accustom his eye to correctness; (2) to acquire ease of execution and to break in his hand to working; (3) to form his taste in good things.'[4] In order to achieve the last goal, certain drawing manuals preferred the use of engravings after the great works of the past in the first stage of instruction; and it should be observed, with reference to the second stage, that in any case most plaster casts were made from recognized masterpieces of antiquity. By the time he reached the live model, then, the student could hardly have avoided assimilating certain ideas of how drawn forms should look; that is, he acquired conventions that would remain with him thereafter. According to Wâtelet and

[3] Charles A. Jombert, *Méthode pour apprendre le dessin* (Paris, 1740; reprint edition 1755), p. 35.

[4] Roger de Piles, *Eléments de la peinture pratique* (Paris, 1776), p. 51.

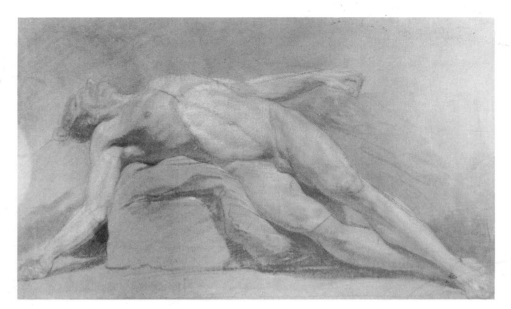

FIG. 1. Jean-Bernard RESTOUT, Private Collection, Paris, *Lying Man*, *c.* 1758. Black chalk and charcoal on grey-green paper 33.2 × 56 cm.

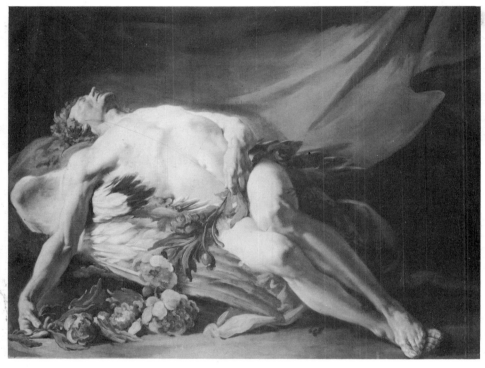

FIG. 2. Attributed to Jean-Bernard RESTOUT, The Cleveland Museum of Art, Purchase, Leonard C. Hanna Jr. Fund, 63.502. *Morpheus*, *c.* 1758–60. Oil on canvas.

Levesque's *Encyclopédie méthodique ou Dictionnaire des Beaux-Arts*, 'the student draftsman must through his académies give a glimpse of the system he will follow as a painter'.[5]

Twelve professors, one each month, were responsible for posing the model in a class lasting two hours each normal working day. Life-class was held from six to eight o'clock in the morning in the summer and from three to five in the afternoon in winter. Order of access and seating arrangements were carefully regimented. The posing of the model was done before any student was allowed to enter. It is reported that in 1764 there were about four hundred students enrolled, while the room in which the life-class took place could actually hold only about one hundred and twenty. Though classes were to last two hours, in 1756 there were complaints by professors that it was becoming customary to go on much longer; as a result, the two-hour limit was officially reinstated.

Jean Locquin has pointed out that, unlike in many art schools of today, the model himself was a person of some status: a royal functionary, he was allowed to wear livery and to carry a sword, he had the right to a

[5] *Encyclopédie méthodique ou par ordre des matières, dictionnaire des beaux-arts* (Paris, 1789–90), s.v. 'académie'.

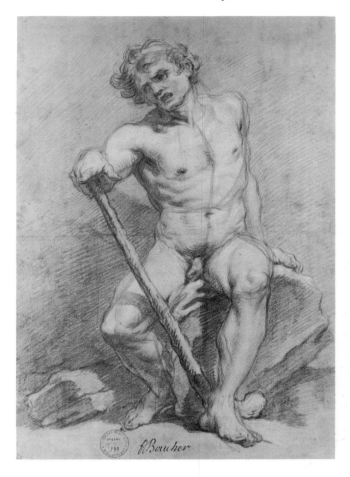

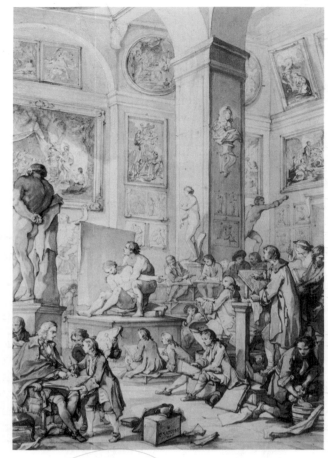

FIG. 3. François BOUCHER, Ecole des Beaux-Arts, Paris, *Seated Man*, 1730s. Red chalk on paper.

FIG. 4. Charles NATOIRE, Witt Collection, The Courtauld Institute of Art, London, *Life Class at the Academy*, signed and dated 1746. Watercolour over black chalk on paper.

FIG. 5. Charles-Nicolas COCHIN, *School of drawing*. Illustration from Diderot, D'Alembert, *et al.*, *Encyclopédie*, (Paris 1751–65) s.v. 'dessein'.

pension and, like many artists themselves, was lodged at the Louvre. Given the variety of life-drawings, it is amazing to learn that for more than forty years the same model was employed. Named Deschamps or Descamps, he was said by Wâtelet and Levesque to have been studied for 'almost all the figures of painting of the French school', even female ones, since women were forbidden as models at the Academy; and elsewhere, such as in professors' studios, they were extremely expensive. An anecdote involving Jean-Bernard Restout's use of Descamps (Fig. 1), combined with Wâtelet's description of his face as 'un peu bachique', leads me to suspect he was the model for the Cleveland *Morpheus* (Fig. 2), which I will refer to again later. And it is no surprise that the same face appears in many drawings by different masters — here is a drawing by Boucher (Fig. 3) — as well as in their paintings. A drawing by Charles Natoire (Fig. 4) shows the life-class in Paris, where Natoire had been a professor since 1737. While it appears to show the disorder and crowding of the class, its description is actually somewhat programmatic. In the centre of the arrangement, two models pose together — a monthly occurrence. The models are observed from different angles by a variety of students. In the foreground, from left to right, we see Natoire himself, who is seated, advising a student on his work, while another student, looking on, waits his turn to show his own work. Near the centre, slightly farther back, possibly waiting his turn too, sits a student who muses over the work he seems just to have completed. At the far right, a student who has probably finished for the day washes his hands. Casts after famous antique marbles are a reminder of the noble enterprise at hand. Finally, the walls are hung with examples of great works by former academicians.

An illustration for the *Encyclopédie* by Cochin (Fig. 5), secretary of the Academy during the mid-eighteenth century, represents a drawing school and is accompanied by a ground plan showing an arrangement in amphitheatre form with wooden stands for seating. We observed something of this sort already in the Natoire drawing; it is not used in the present image, however, since its purpose is not to depict an actual place but to suggest the step-by-step process of instruction. To the left are seated two very young pupils. The smallest, whose feet do not even reach the ground, copies a drawn or engraved head, while the second, who is receiving criticisms from the instructor, has copied an entire figure. Above them hang plaster casts of heads and parts of the body, which will be used in the second stage of instruction, drawing after *la bosse*, shown in the centre. The students here are noticeably older and appear to be copying from the original of a modern master rather than from a cast after the antique, which would be larger and of a different style. To the right, Cochin has next represented the life-class itself: its students may be yet older than the middle group. The brightly lit model stands on a podium, with one knee raised up by a box and cushioned on a pad. The purpose of this kind of position was to contrast the movement of the two legs, while other attitudes served similar purposes, as one easily surmises after a viewing a number of *académies*. With his right arm, the model holds a rope suspended from the ceiling; the left arm is posed with the aid of a wooden staff, another significant contrast. These mechanical aids appear frequently in *académies*, such as the one by Jean-Baptiste Suvée (Fig. 6), and were used because the model had to endure the same pose for at least two hours, a pose that seems usually to have been changed twice weekly. The student to the far right is a sculptor drawing in soft clay after the antique: he uses a different, stylus-like drawing instrument and holds a sponge in his left hand. Note in all the exercises the use of artificial lighting, which was necessary in winter, but, in addition, obviously lent itself to more control. It is even more clearly visible in another drawing by Cochin

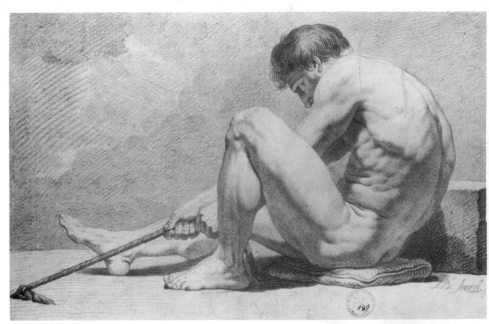

FIG. 6. Joseph-Benoît SUVÉE, Ecole des Beaux-Arts, Paris, *Seated Man Pulling a Rope*, 1760s. Red chalk on paper.

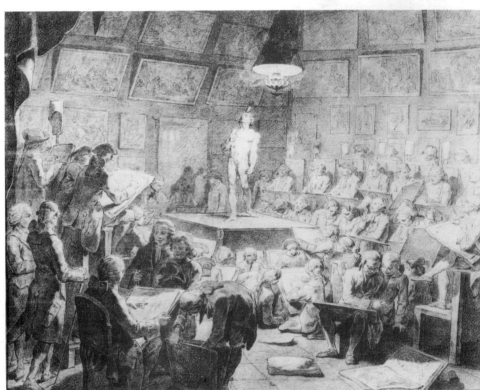

FIG. 7. Charles-Nicolas COCHIN, Collection unknown, *Life-Drawing Class*, 1750s. Chalk on paper.

[6] *Encyclopédie méthodique*, s.v. 'académie'.

(Fig. 7), which more casually than the Natoire shows the students in tiers with a professor in the foreground examining student work.

Wâtelet and Levesque claimed that a well-executed *académie* 'had as much right to become a precious collector's item as a work of any other category. Both one and the other should be beautiful and faithful images of nature, which ought to serve as models and as concrete representations of the precepts of art, while attesting to the degree of perfection to which art has been brought'.[6] The taste for *académies* that had developed among art lovers by the mid-eighteenth century is reflected not just by their appearance in numerous reproductive engravings, but also by their presence — to which sales catalogues bear witness — in many of the foremost collections of the age. By this time, the *académie* had become a genre in itself, much more, at least in spirit if not in fact, than a standardized academic exercise.

The second part of this paper involves aspects of life-drawing that led to its decline. As they acquired aesthetic and concomitant commercial value, life-drawings led to their own demise, for the personal virtuosity and individual expression that gave them such value were in conflict with their original premise as standard exercises. I propose now to explore the consequences of this contradiction, branching out into the realm of painting in addition to drawing for some essential documents.

Life-study was considered so important that painted *académies* were required of students studying at the French Academy in Rome. Joseph-Marie Vien was instrumental in establishing the regularity of this practice, which fits with his effort to bring the French school back to nature. The Cleveland Museum's famous *Morpheus* (Fig. 2), which Pierre Rosenberg and I have attributed to Jean-Bernard Restout, is the best example of this type. It is also an example of the carry-over into such painted studies of the conventions of life-drawing. That the poses of such painted figures are similar to those in drawing is understandable, of course, given that the basic exercise is the same. But that the figure would continue to resemble well-known paid models of the time conflicts with the regular practice of giving the figure attributes of a mythological character, as with Morpheus, the god of sleep. If taken literally, such attributes ought to lead the painter away from copying nature toward the ideal form appropriate for embodying some ancient god. I think the point is, however, that they are not meant to be taken literally; they are part of the structure of artifice that underlies even the painted study after the life. Note that in the *Morpheus*, and in other painted figures that openly display their origins in the live model, certain characteristics of drawing are ostentatiously preserved. I am thinking especially of the hatch marks that can be found on so many painted life-studies like the Morpheus or, for example, on Boucher's figure of Vulcan from the *Venus and Vulcan* of 1732 in the Louvre. Now this figure is obviously taken from the model Descamps, whom we find represented in so many life-drawings by artists of Boucher's generation. So I think we can be sure that for those in the know, his casting as Vulcan may have been something of a joke. Like the hatching marks, it playfully reminds us of the artifice lying at the heart of painting, and it locates our pleasure in perceptions of the skill with which it is deployed. The subject is its vehicle and nothing more.

Thus, it was under the guise of nature-study that in their early training eighteenth-century French artists learned to manipulate what were in fact the anti-naturalist devices of their trade. They fit the pattern of an art that served as sophisticated entertainment for the rich. It might be argued that the eroticism of the figure's carnal presence was seconded by the eroticization of technique — the generous thickness of the chalk line in the undulating rhythms of its contours and the staccato precision of its hatch marks. These are effects which only the Goncourts can adequately describe: 'Is there anything more charming than Boucher's female académies! They amuse, they provoke, they tease the eye. See how the chalk follows the curve of the hip! What wonderful accents of red suggest the blood under shaded skin. What rich, facile drawing playing as flesh!' Note that these remarks followed the observation that Boucher was the first to make drawing into a branch of commerce. And the brothers concluded with the statement: 'There were amateurs galore. Farmers-general filled their portfolios with them.'[7]

The tendency of artists like Boucher to isolate aesthetic properties, for which the observed model became a mere vehicle, seemed mannered to the following generation. So the stylistic evolution of eighteenth-century French life-drawings is marked by a second aspect of the development of individualism. Painters such as Jacques-Louis David, to whom I have

[7] Edmond and Jules de Goncourt, 'Boucher' (1862) in *L'art du dix-huitième siècle et autres textes sur l'art*, ed., J.-P. Bouillon (Paris, 1967), pp. 100–01.

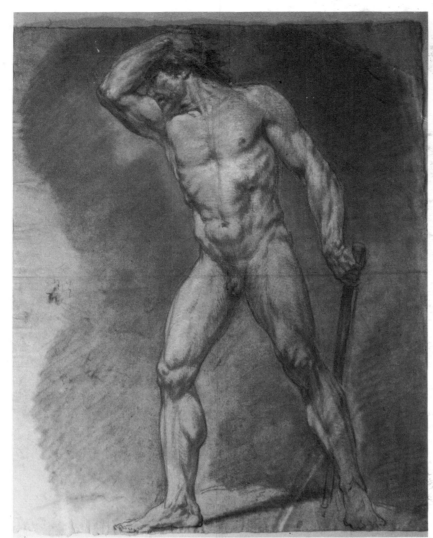

FIG. 9. Jacques-Louis DAVID, Ecole des Beaux-Arts, Paris, *La Douleur*, 1773. Black and coloured chalks on brown paper.

FIG. 8. Attributed to Jacques-Louis DAVID, The Art Museum, Princeton University, Gift of Mathias Polakovits, *Man Stepping to the Right*, 1770s. Black chalk on grey-brown paper, 54.5 × 44.5 cm.

attributed a magnificent drawing at Princeton (Fig. 8), introduced a certain realism of expression as its antidote, while at the same time returning to a less self-conscious, more soberly descriptive technique. This trend was of course supported by the establishment by the Comte de Caylus of the Competition for expressive heads, which David won in 1773 with his superb drawing of *La Douleur* (Fig. 9), which reveals a similar style. The consequence of this development was to re-endow the model with life, to make him a subject as well as an object for study. But the consequences of what could be seen here as a budding romanticism were eventually drastic.

The premise of academic instruction was of course that drawing was a science, through which adequate knowledge of the human form could be acquired by proper effort and exercise. Such an attitude fits perfectly with the Encyclopedic enterprise of promoting progress and harmony through the compilation of knowledge drawn from observation. That drawing was a conventional mode of representation was unproblematically recognized in the eighteenth century. For example, Wâtelet's *Encyclopédie méthodique* defined it as 'the art of imitating with lines', and it recognized that contour did not exist in nature but was 'a sort of convention of art'.[8] One suspects that the academic attitude was that reality was an assemblage of surfaces that could be immediately translated by such conventional signs manipulated by the artist. However, such trust in the powers of human reason and observation gave rise to the confident individualism that soon confronted academic recipes. Calls to curb the overwhelming importance of the life-exercise can already be found in the *Encyclopédie méthodique*'s article on instruction. Its author, one Jean-Baptiste Robin, cited life-class

[8] *Encyclopédie méthodique*, s.v. 'contour'.

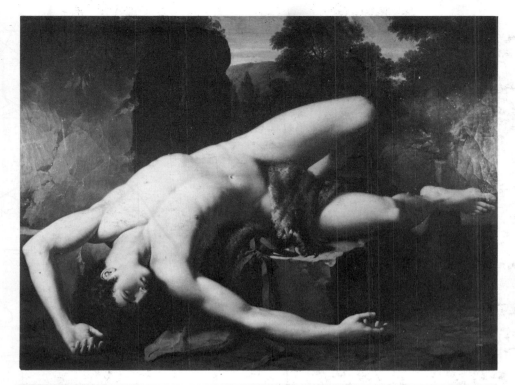

FIG. 10. François-Xavier FABRE, Musée Fabre, Montpellier, *Death of Abel*, 1790. Oil on canvas.

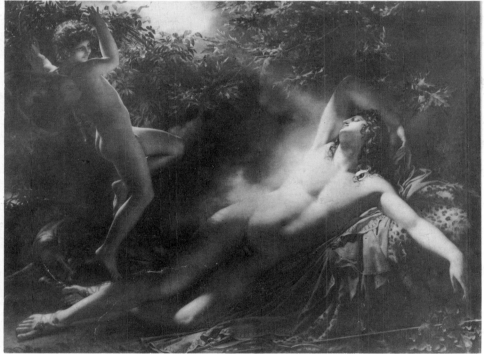

FIG. 11. Anne-Louis Girodet de ROUCYTRIOSON, Musée du Louvre, Paris, *Endymion's Dream*, 1791. Oil on canvas.

as the most stifling aspect of academic training because it required slavish copying. Robin advocated a method that would lead to discovering the principles of beauty in nature rather than impose its formulas upon the student. And he claimed that the truly great artist was the one who differed from the mass of students, the one who 'followed the impulse of his genius far from the well-beaten paths...'.[9] While lip service to genius is a topos of writing on the arts, the specificity and stridency of Robin's remarks force us to take them seriously. Moreover, they appeared during the first years of the French Revolution.

I mentioned how in the Cleveland *Morpheus* the model was represented with the attributes of a god or hero. In the late eighteenth century, similar transformations of the model became something of a tradition, as in David's *Hector*, now at the Musée Fabre in Montpellier. By the 1790s, some painters seem to have tried to transcend the requirement that they

[9] Ibid., s.v. 'instruction'.

paint an académie in oils in order to produce more ostensibly self-sufficient works, such as François-Xavier Fabre's *Death of Abel* (Fig. 10) at Montpellier, which alludes to history painting as well as to the academic exercise. Two artists who especially prized originality used this vehicle as a visual means to express their growing resentment of the life-exercise. Both were students of David: Girodet-Trioson and Ingres. While at the Academy in Rome, Girodet yearned to assert his originality and independence from the routines of the school and the influence of his former teacher. He wrote home bitterly about being herded around like a sheep. Begun as a painted life-study, as still required by the academic programme, his *Endymion's Dream* of 1791 (Fig. 11) harbours these ambitions.[10] The care lavished over each detail, the addition of a companion figure, and its curious lighting suggest much more than a mere academic piece. The legendary Endymion was a shepherd so beautiful that even the goddess Diana wanted to make love to him. Aside from her association with the hunt, she was a moon goddess, hence the moonlight bathing the shepherd while he sleeps embodies her secret visit to him at night. Of course the sensual qualities of Endymion's body allude to physical love, but by representing Diana's visit as moonlight Girodet accents the spiritual and the divine as its source. In antiquity, the theme was used on funerary monuments to portray death as no more than a permanent sleep during which the deceased would experience the ideal. The twisting posture suggests the shepherd is not just sleeping passively but responding to the vision with which he is infused. For Girodet, Endymion's dream was therefore an allusion to the ideal vision all of us inwardly crave. Such experience was especially sought by artists, who were told by recent theories that poetry, philosophy, and art came from inner inspiration. It is worth noting that Fragonard often alluded to this theme in his representations of poets and artists, and there are numerous other examples, as well. Girodet's preoccupation with Edymion, then, is linked to this concept of art as an emanation of inner personal experience. And this preoccupation was such that Girodet actually signed a letter a few years later using the shepherd's name. Just how much he really saw himself as a being with dreams of divine beauty, we cannot exactly know, but in the very least he seems to have coveted Endymion's vision. What originated as a life-exercise thus expresses yearning for a very different sort of art.

Thus, by the early nineteenth century, the conversion of the life-exercise into history painting was a well-known device. But no one used it quite so subversively as did the angry and radical young Jean-Auguste-Dominique Ingres.[11] Wounded by criticisms of the deliberate archaism and anti-naturalism in his early work, he decided as a student in Rome to send to Paris an allegory of his eventual victory. His first idea for such a work, based as always on the painted life-study requirement, was to show a *Hercules Vanquishing the Pygmees*. As he wrote to his father-in-law to be, he would some day, like Hercules, vanquish the mad dogs who were attacking him. Rather than represent the victory of brute force, however, Ingres ultimately opted for a more intellectual confrontation. The life-study he sent to Paris in 1808 was the *Oedipus and the Sphinx* (Fig. 12). In the early 1800s, the theme of Oedipus was an allusion to the mysteries of nature, whose temples were guarded by Sphinxes in ancient Egypt. Only the genius could penetrate to the temple's interior, that is, to nature's inner truth. While Oedipus counts off his answer to the riddle of man on his fingers, he displays a contrast of extended and distended limbs to satisfy his often critical academic judges. More important, Oedipus' self-assurance is expressed by a gaze that looks right through the Sphinx, that is, through the proverbial veil cast by nature's surface over ideal truth. Dominating the painting's psychology, Oedipus' eyes allude to the

[10] The following summarizes my 'Endymion's Dream as a Myth of Romantic Inspiration,' *Art Quarterly*, Spring 1978, pp. 47–84.
[11] The following summarizes my 'Ingres' Vision of Oedipus and the Sphinx: The Riddle Resolved?' *Arts Magazine*, October 1979, pp. 130–33.

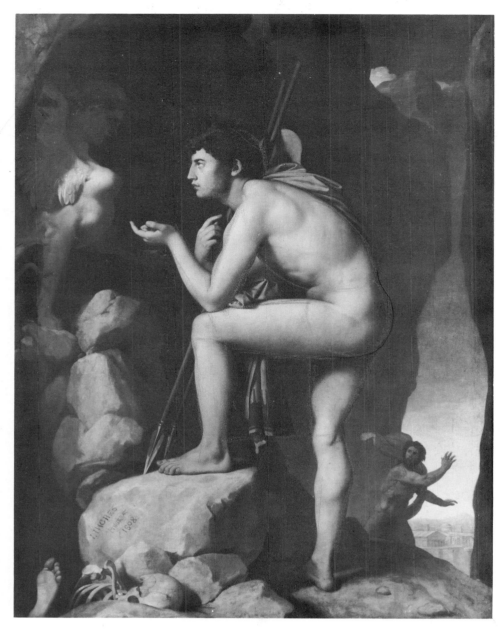

FIG. 12. Jean-Auguste-Dominique INGRES, Musée du Louvre, Paris, *Oedipus and the Sphinx*, 1808 (retouched *c*. 1827). Oil on canvas.

capacity for clairvoyance that animates artistic vision. For some time now, particularly among the radical Primitives, Barbus or Meditators sect within David's atelier, the exercise of life-drawing was denigrated in favour of inner sight.

Having made this excursus into the realm of painted life-studies, I want to return now to the earlier point concerning life-drawing as a vehicle for acquiring stylistic conventions. Girodet and Ingres paint in the style we commonly call Neo-Classicism, with tight drawing, high finish and no sign at all of hatching marks or underpainted contours. They are anxious to avoid the signs of handcraft that would destroy the illusion that they paint from inner vision rather than from mechanistic training. They want their forms to seem present through apparition rather than through paint. They deny their history as artisan, subject to the rules and conventions of academic training, in order to pose as intermediaries between the public and the divine. Of course their paintings make a highly sensuous appeal through polished surfaces, rich colour and exquisite detail. But these beauties are proposed in the name of artistic vision rather than of luxurious craft. Despite their official role as painted life-studies, they suppress the traditional evidence of life-drawing and preparatory study.

It is worth noting in conclusion that such attitudes hardly made life-drawing disappear. But they did lead to a far less central role for

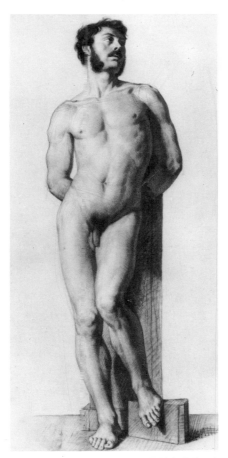

FIG. 13. Pierre-Auguste COT, Private Collection, Paris, *Standing Man*, 1860s. Black chalk on white paper.

life-drawing, the exercise of which was no longer as directly reflected in painted work. Nineteenth-century life-drawing tends to have the quasi-photographic meanness of the naked rather than the nude. Such works (Fig. 13) are almost never the vehicle for artistic exuberance but rather for a dead seriousness that reflects, I believe, the strenuousness of copying rather than the joys of interpretation. Such images seem to do their best to fulfil the criticisms of life-drawing made by the early Romantic visionaries. Perhaps there is a connection between such work and the growing naturalism of the nineteenth century, but for me they are marginal reminders that even in Realist art greatness is tied to personal expression rather than transparent reproduction. What better reminder of the artifices of eighteenth-century life-study than the artlessness (of course I'm being provocative) of nineteenth-century academic drawing.

The creative copy in late nineteenth-century French art

by RICHARD THOMSON

This is a speculative essay, intended to open up lines of enquiry; after all, what *is* a 'creative' copy?[1] A copy is often considered as inferior to an original work of art, second-hand and so second-rate. Perhaps one can look beyond that prejudice, and propose that making copies and, more importantly, the after-effect of copying, the assimilation of past art into an artist's own productions, encapsulated some pivotal issues in late nineteenth-century French art. In order to develop these issues, one must operate within very broad territory, using loose and somewhat experimental definitions of the word 'copy' to suggest how different types of copy might be categorized. The discussion will be directed primarily — but not exclusively — at the drawn copy.

First, one must draft an historical and theoretical framework for this discussion. The conventional academic position in nineteenth-century France was clear enough. As part of a period of intense training, the art student would produce regular copies, intended to emulate as exactly as possible the execution and the forms of an accredited prototype.[2] In such a way, academic theory had it, the great traditions of European art would be sustained and the student would be schooled in the ideals of the Antique and the High Renaissance, a process which would condition his imagination, his way of seeing, thoughout his career. Ingres voiced this view with characteristic force:

> Is there anything new? Everything has been done, everything has been found. Our task is not to invent, but to continue, and we have enough to do ... interpreting ... [nature] ... with genuine sincerity, following the example of the masters. How absurd to believe that one's natural temperament and faculties are compromised by the study or even the imitation of the classical masterpieces![3]

However, such a view was increasingly challenged by the nineteenth-century's commitment to progress rather than continuity, to novelty rather than repetition, to modernity rather than conservatism. Even critics who wished to support the traditions of history painting were aware that too much reliant respect for past art could lead to derivative sterility; as Maxime du Camp grumbled of the history pictures at the Salon of 1866, 'one can only find feebly disguised reminiscences of Guilio Romano's sketches and Marcantonio's engravings.[4]

Some artists were beginning to react against the entrenched academic position, trying to generate a modernity, an individuality, in their work. Often these painters had been through the academic system, and key questions for many artists in the second half of the century were: how can one accommodate a respect for past art with a truly modern art? Must one's training be repudiated? Is any resonance of the past idle, insincere, uncreative?

The academic teaching structure and the ideas it sought to convey have been increasingly analysed over recent years, as art historians have reassessed the role of the Academy and the Salon in nineteenth-century

[1] This paper was written prior to the publication of an important new contribution to the subject: Egbert Havercamp-Begeman, *Creative Copies. Interpretative Drawings from Michelangelo to Picasso* (1988). In my lecture at the Woodner Master Drawings Symposium I briefly discussed the humorous copy or spoof, and mentioned the importance of parody 'copies' in political caricature and other satirical imagery. These are fascinating areas, but cannot be developed here for reasons of space.

[2] For copying practice at this period see, *inter alia*, Theodore Reff, 'Copyists in the Louvre, 1850–1870', *Art Bulletin*, vol. 46, no. 4 December 1964, pp. 552–59; Albert Boime, *The Academy and French Painting in the Nineteenth Century* (1971); Paul Duro, '"Un Livre ouvert à l'Instruction": Study Museums in Paris in the Nineteenth Century', *Oxford Art Journal*, vol. 10, no. 1 (1989), pp. 44–58; Paul Duro, 'Copyists in the Louvre in the Middle Decades of the Nineteenth Century' *Gazette des Beaux-Arts*, pér. VI, LXI, no. 1431, August 1988, pp. 249–54.

[3] Vicomte Henri Delaborde, *Ingres, Sa vie, ses travaux, sa doctrine* (Paris, 1870), p. 112.

[4] Maxime du Camp, 'Le Salon de 1866', *Revue des Deux Mondes*, pér. 2, vol. 63, 1 June 1866, p. 694.

FIG. I. Daniele da VOLTERRA, Santi
Trinità dei Monti (Cappella Orsini),
Rome, *Deposition*, 1541–*c*.1545.
Fresco.

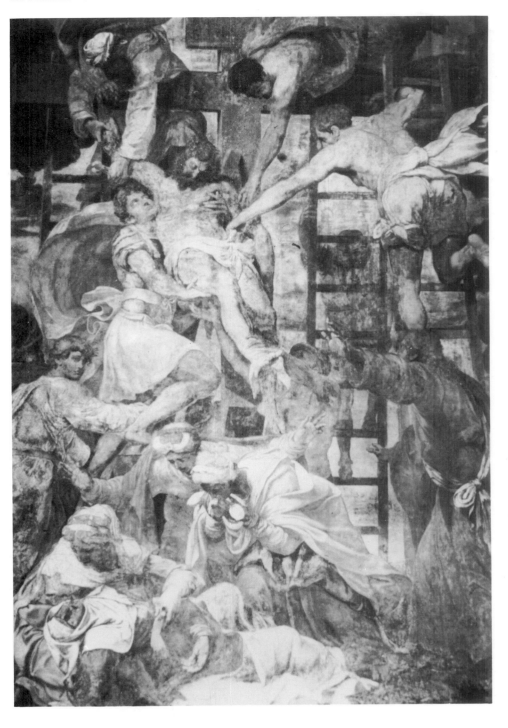

French art.[5] We are learning not to slip into rigid Manicheism, setting the
'insincere' pompier against the innovative independent — a polarization
which this paper will have to negotiate. From such studies we have learnt,
in the matter of copies, to expect surprises, whims, *non sequiturs*:
Bouguereau copying the Ravenna frescoes,[6] Degas Assyrian sculpture,[7]
Pissarro Ingres' *La Belle Zélie*.[8] Yet still we have to face a great imbalance
of material. For until further research evens out our information about the
production of copies in the later nineteenth century we are left with a
tantalizingly unequal picture. There is a plethora of material about the
copies made by non-academic artists, those who — apparently — broke
away from tradition, such as Delacroix, Manet, Degas, Cézanne, Redon or
Seurat. On the other hand, there is little on the copies of the academics who
ostensibly strove to uphold tradition; the recent exhibition catalogues on
Baudry and Bouguereau and the catalogues raisonnés of Lehmann and
Gérôme, for instance, had little or nothing to say about their activities as

[5] For critical discussion of this issue see most
recently Jacques Thuillier, *Peut-on parler d'un
peinture 'pompier'?* (Paris, 1984); Charles
Rosen and Henri Zerner, *Romanticism and
Realism. The Mythology of Nineteenth
Century Art* (New York, 1984).

[6] *Oeuvre italiennes de Bouguereau* (intro-
duction by René Jullian), Lyon, Musée des
Beaux-Arts, April–June 1948, nos 142–43.

[7] Theodore Reff, *The Notebooks of Edgar
Degas*, 2 vols (Oxford, 1979), note 18, p. 129.

[8] Camille Pissarro, *Lettres à son fils Lucien*,
ed. John Rewald (Paris, 1950), p. 377 (letter of
19 April 1895).

FIG. 2. Gustave MOREAU, Musée Gustave Moreau, Paris, Copy after Daniele da Volterra, *Deposition*, 1858. Black chalk, 42.5 × 24.8 cm.

FIG. 3. Edgar DEGAS, Private Collection, Paris, Copy after Daniele da Volterra, *Deposition*, 1857–58. Black chalk on green-grey paper, 22 × 29.8 cm.

copyists.[9] Having posed these questions, mapped out these pitfalls and provisos, one can try to put forward some speculative definitions, some patterns of enquiry.

The copy had its most obvious function during the artist's student years, and here we might talk about the 'practical' copy. Copying formed the foundation of academic training; Ingres' first advice to Amaury-Duval in 1825 or to Degas in 1855 was to copy, copy.[10] The first stages of an art student's training would be dominated by copying, by visits to print-rooms to study engravings, by trips to the Louvre and other galleries to analyse the masterpieces there, by hours toiling in the École's cast gallery. Copying remained central to the advanced curriculum, for one of a Prix de Rome winner's *devoirs* during his second year at the Villa Médici was to paint a large-scale copy of a Renaissance masterpiece. However, it is important to remember that, for all copying's immutable status within the academic system, it was subject to much variation, as individual artists copied different passages of the same picture, sought different stimuli or solutions from the same work of art or from a variety of precedents. For example, Daniele da Volterra's *Deposition* from Santi Trinità dei Monti (Fig. 1) was frequently copied by mid-nineteenth-century artists in Rome. But while one of Gustave Moreau's drawings involved a detailed record of the central focus of the foreshortened Christ, Degas preferred the dramatic but peripheral figure of the fainting Virgin, making a study of facial expression (Figs. 2, 3).[11] When Rodin copied the *Borghese Gladiator* he worked

[9] *William Bouguereau, 1825–1905*, Paris, Petit Palais, February–May 1984 (subsequently Montreal, Musée des Beaux-Arts; Hartford, Wadsworth Atheneum; *Baudry, 1828–1886*, La-Roche-sur-Yon, Musée d'Art et d'Archéologie, January–March 1986; Marie-Madeleine Aubrun, *Henri Lehmann, 1814–1882. Catalogue raisonné de l'oeuvre*, 2 vols (Paris, 1984); Gerald Ackerman, *The Life and Work of Jean-Léon Gérôme* (London and New York, 1986).

[10] Amaury-Duval, *L'Atelier d'Ingres* (Paris, 1878; see 1924 ed., p. 13); Paul Valéry, *Degas, danse, dessin* (Paris, 1934; see 1938 ed., p. 62).

[11] For Moreau's copies after Daniele da Volterra's *Deposition* see Paul Bittler and Pierre-Louis Mathieu, *Musée Gustave Moreau. Catalogue des dessins de Gustave Moreau* (Paris, 1983), nos 1200, 4175, 4203, 4414–15, 4430, 4434–35, 4464, and for Degas' *Degas e l'Italia*, exhibition catalogue by Henri Loyrette, Villa Médici, Rome, December 1984–February 1985, no. 14, and *Vente Atelier Degas*, Vente IV, 2–4 July 1919, no. 103d. Léon Bonnat and Jean-Jacques Henner also copied the altarpiece; see *Ville de Bayonne. Musée Bonnat. Collection Bonnat* (Paris, 1908), nos 47–48, and *Musée J.-J. Henner*, Paris, n.d, nos 31–32.

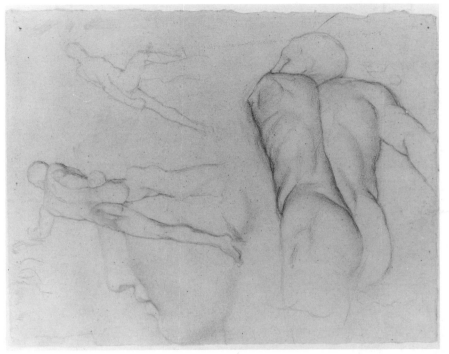

FIG. 4. Auguste RODIN, Musée Rodin, Paris, Copy after the *Borghese Gladiator*, c. 1855–60. Pencil.

FIG. 5. Edgar DEGAS, Sterling and Francine Clark Art Institute, Williamstown, Copy after the *Borghese Gladiator*, c. 1854–56. Black and red chalk on grey paper, 31.1 × 24.1 cm.

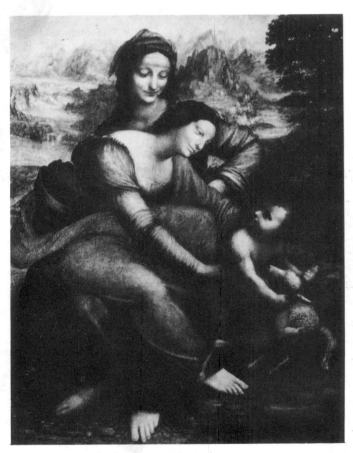

FIG. 6. Leonardo da VINCI, Musée du Louvre, Paris, *The Virgin and Child with St Anne*, c. 1507–12. Oil on panel, 170 × 129 cm.

FIG. 7. Odilon REDON, Cabinet des Dessins, Musée du Louvre, Paris, Copy after Leonardo, *Virgin and Child with St Anne*, c. 1908? Charcoal on buff paper, 23.4 × 26.9 cm.

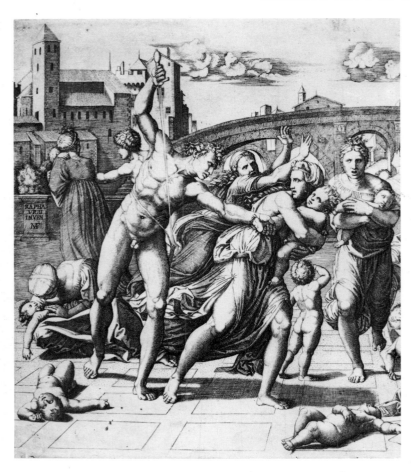

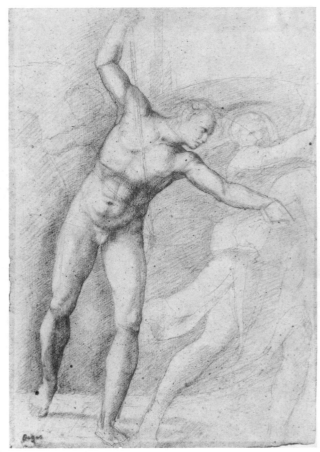

rapidly, producing an informal sketch which caught the momentum of the figure's action (Fig. 4). He drew it from the vantage-point which best emphasized the powerful diagonal of the *Gladiator's* pose and which caught the figure in a shallow, frieze-like space. Degas, on the other hand, was concerned to observe the figure in the round, making three studies on the same sheet of paper, all taken from different angles and distances (Fig. 5). If Degas was here more detailed and comprehensive, Rodin was more immediate and dynamic. Each artist satisfied his own requirements, manipulating the Antique prototype to address his own specific practical purposes.[12]

If copying's general aim was to imbue the student with the academic system's ideology of tradition, this was pursued in the studio by practical means. The copy was used to fulfil certain functions. One of these was to acclimatize the student to the 'ideal forms' of the Antique and the High Renaissance. Life models were often posed in the manner of Antique sculptures. Degas drew several such in Rome in the mid-1850s, when he was allowed to sit in on the life-classes at the Villa Médici; he studied one model, for instance, standing in approximation to the *Apoxyomenos* or *Athlete scraping himself*.[13] The purpose of such drawings would have been to rehearse the formal structure of an acknowledged masterpiece and to bring the deficiencies of the 'natural' model into harmony with the 'ideal' of the pose. Another central concern of the academic copy was to train the student to emulate a chosen master's technique. Degas' copy after a head in the Uffizi print-room, in 1858 attributed to Leonardo but now demoted, strove for an exact rendition not only of the form but also of the medium, his sharp pencil rendition echoing the silverpoint of the original.[14] His identification with Leonardo seems to have gone even further than this, for he surrounded his study of the head with casual, overlapping marginalia as was Leonardo's occasional custom. Similarly, for a copy after Leonardo's *Virgin and Child with St Anne* (Figs 6, 7), Redon chose to use charcoal on a

FIG. 8. Marcantonio RAIMONDI, Whitworth Art Gallery, Manchester, *Massacre of the Innocents*, Copy after Raphael. Engraving, 28.3 × 43.4 cm.

FIG. 9. Edgar DEGAS, Artemis Fine Arts Limited, London, Copy after Marcantonio Raimondi, *Massacre of the Innocents*, c. 1854–56. Black chalk and stump, 40.8 × 28.3 cm.

[12] For these copies see also K. Varnedoe, 'Rodin's Drawings', in *Rodin Rediscovered*, National Gallery of Art, Washington D.C., June 1981–May 1982, p. 159, and *The Private Degas*, exhibition catalogue by Richard Thomson, Whitworth Art Gallery, Manchester (subsequently Fitzwilliam Museum, Cambridge), January–March 1987), p. 82.
[13] Richard Thomson, *Degas: The Nudes* (1988), pp. 24, 28.
[14] *The Private Degas*, op. cit., pp. 15, 17, repr. p. 51. This head from the circle of Leonardo (Uffizi no. 426) was also copied by Gustave Moreau (Bittler/Mathieu, op. cit., no. 4390) and Odilon Redon (Musée du Louvre, Cabinet des Dessins, Paris), RF 40894.

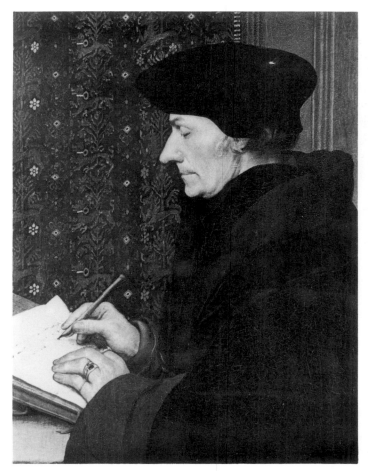

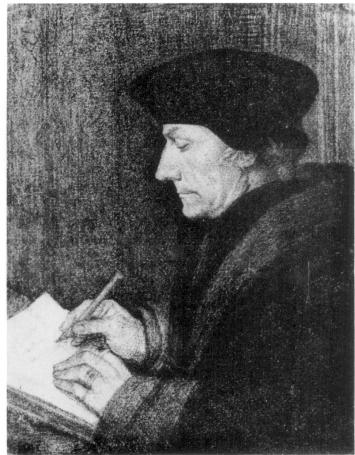

FIG. 10. Hans HOLBEIN, Musée du
Louvre, Paris, *Portrait of Erasmus*, 1523.
Oil on panel, 42 × 32 cm.

FIG. 11. Alphonse LEGROS, location
unknown, Copy after Holbein, *Erasmus*,
c. 1854–56. Charcoal?

FIG. 12. Lucien PISSARRO, Ash-
molean Museum, Oxford, Copy after
Holbein, *John Poyntz*, 1880. Charcoal
and stump, 30.8 × 23.3 cm.

rough paper, the better to evoke the painting's *sfumato*.[15] A third motive for copying was to explore a master's compositional practice: how he manipulated a pose to accord with the rhythm and pattern of a composition. Thus Degas' copy after Marcantonio Raimondi's engraving of Raphael's *Massacre of the Innocents* (Figs 8, 9), while it attends to the muscular structure of the soldier's body, is also concerned to locate this dynamic form within the open space it commands in the composition.[16] Such a copy taught more than mere pose; it taught the coincidence of formal matters — mass, rhythm, space — and the representation of narrative. A copy like this was not just concerned with studio proficiency, with sleight of hand, but with the pictorial and intellectual ordering of an image to render the true character of the subject and the artist's response to it as expressively and legibly as possible for the spectator.

The drawn copy could thus be used in an active sense, going beyond the copyist's imitative skills to bring into play his personal powers of interpretation and imagination. Lecoq de Boisbaudran's teaching, laid down in his *L'Education de la mémoire pittoresque* of 1847, was intended to cultivate the student's memory, setting the copyist first to observe the motif carefully and then draw it 'blind', relying on memory alone,[17] as Legros did with his copy after Holbein's *Erasmus* (Figs 10, 11). Lecoq's teaching was intended to supplement, not replace, the standard academic diet of life drawing and copying, but his training gave the young artist a valuable new resource. A copy such as Legros' was not only a test of draughtsmanly dexterity, but also a test of the ability to retain and reproduce visual information. Ironically, a quarter of a century later Camille Pissarro advised his son Lucien that the best way to avoid Legros' influence, which Pissarro condemned as having succumbed to academism, 'la théorie grecque' as he called it, was to work from memory and to copy. 'Preferably choose simple things', he urged Lucien in 1883, recommending Egyptian reliefs, 'the primitives won't do badly, either; Holbein (Fig. 12), and don't neglect nature.[18] Lecoq intended to provide the student with an extra tool — a powerful visual memory; Pissarro wanted to encourage his son's individuality, his naïveté. Both sought to use the copy not as the passive emulation and absorption of an ideal but as a means to activate and extend the burgeoning artistic personality.

For the imaginative student, copying's influence could be fruitfully extrapolated beyond the immediate business of copying. Even a work which cannot strictly be categorized as a copy might perhaps be reckoned to have something of a copy's character. One of the *académies* Moreau made in 1858 (Fig. 13) is positively Leonardesque in its sinuous pose, stylized curls and subtle shading.[19] In the consciousness of its emulation it becomes almost a 'creative copy'. It was also in 1858 that Degas, studying in Florence in Moreau's company, copied the head of one of the left-hand figures in Ghirlandaio's *Joachim expelled from the Temple* in Santa Maria Novella (Figs 14, 15).[20] Intensely interested in portraiture at this time, Degas was fascinated by a particular face, as he had been with the Virgin in Daniele da Volterra's *Deposition*. It was about this time that he made the self-portrait drawing in the Woodner Collection (Fig. 16), which turns its head to the spectator with a distant hauteur similar to Ghirlandaio's youth. However, the self-portrait is executed in red chalk, in a manner not dissimilar to drawings by, say, Andrea del Sarto. One might suggest that in the self-portrait Degas takes on a Florentine identity, essaying both the persona and the technique of the Renaissance Florentine. Once again we have a work which, if by no means a copy, is moulded by the artist's concurrent experience as a copyist.

Another motive for copying was to record the colour of a chosen master's work. Delacroix's watercolour copy of Veronese's *St Barnabas*

[15] The date of this copy is not given in Roseline Bacou, *Musée du Louvre. La Donation Arï et Suzanne Redon* (Paris, 1984), no. 113, though it may date from c. 1908, when Redon included the head of St Anne in his large pastel *Hommage à Léonard de Vinci* (Stedelijk Museum, Amsterdam).

[16] Thomson (1988), pp. 17–19.

[17] The most convenient introduction to Lecoq remains H. Lecoq de Boisbaudran, *The Training of the Memory in Art and the Education of the Artist*, trans. L. D. Luard and introduction by Selwyn Image (London, 1911). See also Christopher Lloyd, 'The Academic Tradition and the Emergence of Impressionsm', in *Impressionist Drawings from British Public and Private Collections*, Ashmolean Museum, Oxford (subsequently City Art Gallery, Manchester; Burrell Collection, Glasgow), March–April 1986, pp. 12–13.

[18] *Correspondance de Camille Pissarro. I. 1865–1885*, ed. Janine Bailly-Herzberg (Paris, 1980), letter 167, p. 229 (letter of 8 July? 1883).

[19] Bittler/Mathieu, op. cit., no. 857.

[20] D. Rouart, *The Unknown Degas and Renoir in the National Museum of Belgrade* (New York/Toronto/London, 1964), no. 35.

FIG. 13. Gustave MOREAU, Musée Gustave Moreau, Paris, *Two 'académies' of a boy*, 1858. Black chalk, 26.8 × 19.2 cm.

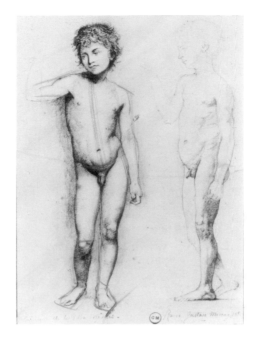

FIG. 14. Domeninco GHIRLANDAIO, Santa Maria Novella, Florence, *Joachim expelled from the Temple*. Fresco.

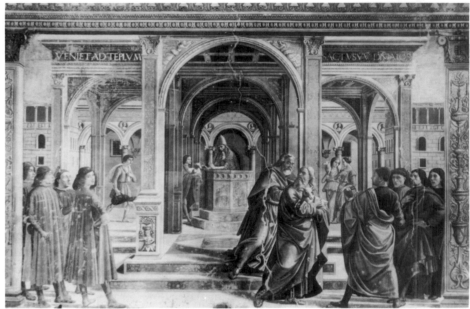

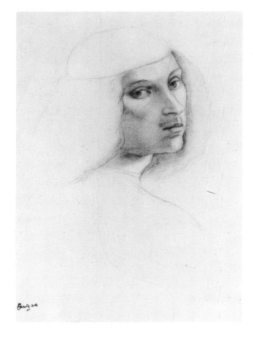

FIG. 15. Edgar DEGAS, National Museum, Belgrade, Copy after Ghirlandaio, *Joachim expelled from the Temple*, 1858–59. Pencil, 33 × 24 cm.

FIG. 16. Edgar DEGAS, Ian Woodner Collection, New York, *Self-portrait*, c. 1858. Red chalk, 29.5 × 21.6 cm.

 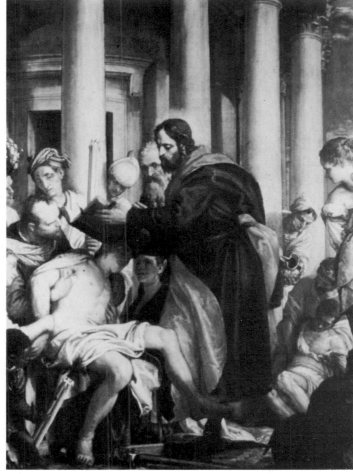

healing the Sick, made on a visit to Rouen in 1834,[21] can stand as an example of this. He intended to fix the composition, of course, but his main interest was the colour, centring on the rich primaries of the saint's cloak. But not all coloured copies involved such passive recording of information. Cézanne's watercolour after Delacroix's *Medea* (Fig. 20), executed in the early 1880s, was made from neither of the two large versions, then in Lille (Fig. 19) and a private collection, to which Cézanne had no access. Cézanne may have borrowed a small oil of the *Medea* from his friend Victor Chocquet to copy, or he may have worked from a lithographic reproduction, grafting on his recollection of the colour of Chocquet's picture.[22] Whichever the case, Cézanne clearly went beyond the original, giving the pyramidal composition more dramatic intensity by pulling it up to the surface, emphasizing Medea's grim head and ready dagger. On another occasion Cézanne's colouristic response to a Delacroix composition was at once more inventive and a step further from the original. A decade earlier, in the early 1870s, Cézanne's fascination with Delacroix found expression in a number of copies or variants on the subject of Hamlet. Dr Gachet, with whom Cézanne was in close contact at this time, owned an impression of Delacroix's 1828 lithograph of *Hamlet and the Gravedigger*, from which Cézanne drew two copies. Apparently Gachet suggested that Cézanne make an etching of the subject, but this does not seem to have materialized. However, Cézanne did paint a small oil of Hamlet and Horatio confronted by the gravediggers and Yorick's skull (Figs 21, 22), basing his composition on Delacroix's later lithograph of 1843.[23] Clearly this is not an exact copy; like Gustave Moreau's Leonardesque *académie* it is an essay 'in the manner of'. Cézanne's painting is an interpretative extrapolation of Delacroix's composition, and he superimposed onto the black-and-white design of the lithograph his

FIG. 17. Eugène DELACROIX, Musée des Beaux-Arts, Rouen, Copy after Veronese, *St Barnabas healing the Sick*, 1834. Watercolour, 25 × 19 cm.

FIG. 18. Paul VERONESE, Musée des Beaux-Arts, Rouen, *St Barnabas healing the Sick*, c. 1566. Oil on canvas, 260 × 193 cm.

[21] *French Master Drawings from the Rouen Museum. From Caron to Delacroix*, exhibition catalogue by Pierre Rosenberg and François Bergot (International Musuems Foundation, Washington D.C., 1981–82), no. 29.
[22] John Rewald, *Paul Cézanne. The Watercolours* (New York and London, 1983), no. 145.
[23] *Cézanne in Philadelphia Collections*, exhibition catalogue by Joseph Rishel (Philadelphia Museum of Art, June–August 1983), no. 1.

FIG. 19. Eugène DELACROIX, Musée des Beaux-Arts, Lille, *Medea*, 1836–38. Oil on canvas, 260 × 165 cm.

FIG. 20. Paul CÉZANNE, Kunsthaus, Zürich, Copy after Delacroix, *Medea*, c. 1880–85. Pencil and watercolour, 39.5 × 26.1 cm.

[24] *Handbook of the Barber Institute of Fine Arts*, second edition (Birmingham, 1983), p. 25. I am grateful to David Ekserdjian for pointing out to me that Redon's is a copy after the Karlsruhe variant of Grünewald's *Crucifixion*.
[25] Philippe Brame and Theodore Reff, *Degas et son oeuvre. A Supplement* (New York and London, 1984), no. 144; *Ingres*, Petit Palais, Paris, October 1967–January 1968), p. xxxi.

own notion of Delacroix's colour and brushwork. By taking on Delacroix's subject, echoing his composition, and approximating to his colour, Cézanne was trying to put himself in Delacroix's mind, to follow as closely as possible the path of his imagination and his hand. Redon did much the same with a painted copy after Grünewald's *Crucifixion* from Karlsruhe.[24] The copy makes no pretence at total accuracy (Figs 23, 24). Redon substituted a scorching background for Grünewald's gloomy landscape and played down the gruesome details of a hideous death. These alterations added a very personal note to the copy. The reduction of the subsidiary figures to mere spectres concentrates attention on the crucified Christ, whose ordeal is emphasized by the flaming hues against which the cross is now set. Putting aside painful tactility and the intermediary role of the standing figures, Redon's rendition gains an almost visionary intensity by colour.

These colouristic copies and variations by Delacroix, Cézanne and Redon were not made by students, but by men in mid-career. It should come as no surprise to find mature artists continuing to copy, to remind themselves of the great examples of tradition, to let their hand follow the lines and forms of a great master, to seek solutions to an intractable pictorial problem in the efforts of an earlier artist. The sixty-three-year-old Degas made a full-scale copy of Mantegna in the Louvre; Ingres' last work, at eighty-seven, was a copy after Giotto.[25] Copying could still serve some of the purposes it had served the artist as a student. It could, for instance, be expressly practical. In 1889 Degas made his first visit to Madrid, where in the Prado he would have seen Titian's *Temptation of Adam and Eve* and

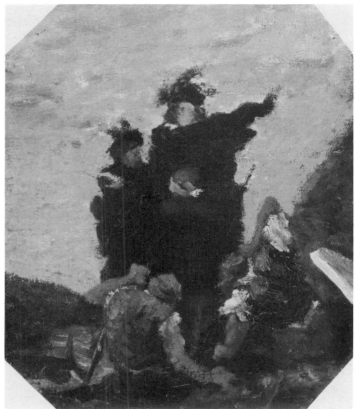

Rubens' full-scale copy of it, a fascinating dialogue between two great masters. Degas' large monotype *Torse de Femme* (Bibliothèque Nationale, Paris) appears to be a memory image of Titian's Eve.[26] It follows the arc of her movement and the careful modelling of her belly and, printed in brown ink on soft Japanese paper, emulates the sensuous surface of Titian's painting. Degas concentrated on Eve's torso, cropping the legs and blurring the head. This particular focus on a bending, twisting body is shared with a sculpture of a woman rubbing her back with a sponge which dates from this period. The monotype acted as some kind of intermediary between Titian's pose and the sculpture, for they are of almost identical height. Either Degas used it to recall the Eve figure prior to reworking an existing sculpture, or it stimulated him to develop a torsion similar to Titian's in three dimensions. Whichever was the case, a response to past art, the process of copying, could have an active function in the studio practice of the middle-aged Degas.

Let us now pass further into hypothetical territory, and deal not so much with the direct copy that a proficient artist might make, but rather with the effect that both his student training and his later copying had on his mature work. As we have seen, it was the very purpose of art-school training in the nineteenth century to imbue the student with a thorough knowledge of ideal forms in order that these would inform his later work. Copying was the prime means to this. What was instilled in the student · might resurface later in a number of ways, which one might try tentatively to identify here. As a student Seurat copied the figure of St Peter from Poussin's *Ordination* (National Gallery of Scotland, Edinburgh), working from an engraving. Copying Poussin, a master highly esteemed in academic circles, was quite unexceptional.[27] But perhaps it is of interest that Seurat chose a figure from this particular composition, which is symmetrical. Seurat used symmetrical compositions to powerful effect in

FIG. 21. Eugène DELACROIX, Kunsthalle, Bremen, *Hamlet and the Gravedigger*, 1843. Lithograph, 28.4 × 21.1 cm.

FIG. 22. Paul CÉZANNE, Sydney Rothberg, Philadelphia, *Hamlet and Horatio*, c. 1870–74. Oil on paper mounted on canvas, 21.9 × 19.4 cm.

26 See Richard Thomson, 'Degas's *Torse de Femme* and Titian', *Gazette des Beaux-Arts*, pér. VI, XCVIII, nos 1350–51, July–August 1981, pp. 45–48; Thomson (1988), op. cit., pp. 194–95.
27 For Seurat's copies see Robert L. Herbert, *Seurat's Drawings* (New York, 1962), pp. 12–18, 166–67; Richard Thomson, *Seurat* (Oxford, 1985), pp. 14–16 (Seurat's copy after Poussin's *Ordination* is repr. Fig. 3; Private Collection, Paris).

FIG. 23. Mathis GRÜNEWALD, Staatliche Kunsthalle, Karlsruhe, *Crucifixion*, 1523–35. Oil on canvas, 193 × 151 cm.

FIG. 24. Odilon REDON, Barber Institute of Fine Arts, Birmingham, Copy after Grünewald, *Crucifixion*, c. 1904. Oil on canvas, 46 × 27 cm.

his mature work, most notably in *La Parade* (Metropolitan Museum, New York), exhibited in 1888. It would be most rash to suggest that Seurat's copying of *Ordination* had any direct effect on *La Parade*, and this is not suggested here. But studying that image did contribute to his temperamental inclination to symmetrical compositions, and would have brought to his attention general rules about manipulating figures at different levels in a frieze-like space. Again, at the outset of his career Degas made a drawing after an engraved illustration of a Raphael drawing for the *School of Athens* (Figs 25, 26).[28] The drawing was made for a purpose, to explore Raphael's solution for the inter-relationship of two figures, emphasizing a narrative connection between them by gesture and the almost mirror-like repetition of their poses, using the device of *contrapposto*. Forty years later this kind of relationship still stimulated Degas. In a group of drawings of Harlequin and Colombine made in the mid-1890s he placed the 'male' figure (actually posed by a female dancer *en travestie*) in a supplicatory position (Fig. 27). Colombine responds in an orthodox *contrapposto* pose, head turned towards Harlequin but torso twisted timorously away, perfectly attuned to convey both the rhythm and the narrative of the composition. Of course Degas did not expressly recall that Raphael copy. But the lesson that it had taught had become an instinctive part of his repertoire. These are instances, one would suggest, of training and copying being assimilated in the most subtle fashion.

In 1864 it was proposed that Paul Baudry, one of the Prix de Rome laureates of 1850, should execute the ceiling decorations for the Grand Foyer of the new Paris Opéra being designed by his friend Charles Garnier. Baudry spent the following winter in Rome, copying the Sistine Ceiling,

[28] See *The Private Degas*, op. cit., pp. 56–57, 60.

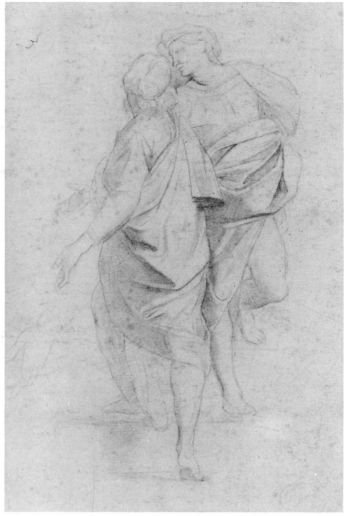

and in 1868 he spent the summer in London, copying the Raphael Cartoons at South Kensingson.[29] Baudry's notion was to instil his imagination with the greatest examples of large-scale decorative work to such an extent that his own project would inevitably take on some of their grandeur. To late twentieth-century eyes Baudry's designs look highly derivative. Take his drawing of the *Judgement of Paris* (Fig. 28). The general configuration is a thinly disguised variant on Marcantonio Raimondi's engraving after Raphael's version of the subject (Fig. 29), and individual figures are lifted from accredited sources; for instance, Mercury comes straight from the Louvre's Antique *Cincinnatus*.[30] At the Salon of 1882 Henner, who won the Prix de Rome eight years after Baudry, showed his *Death of Bara* (Petit Palais, Paris). The figure almost directly follows one from Prud'hon's *Justice and Divine Vengeance pursuing Crime* (Musée du Louvre, Paris), which sketchbooks in the Musée Henner reveal that the artist had been copying as he prepared his *Bara*.[31] But are we entitled to pillory these artists as derivative? Having passed through the full gamut of the academic curriculum, both Baudry and Henner must have come to believe sincerely that it was their duty in their major works to pay homage to past tradition, to echo and extend it. By the establishment standards of the day, this too was successful assimilation. An anonymous monograph on Baudry, published at the turn of the century and perhaps by Henry Roujon, a senior figure in the French art establishment, began with this sentence: 'Paul Baudry, a respectfully faithful disciple of the Renaissance, fervent emulator of Correggio and the great Venetians, remains one of the highest and most pure glories of the French school in the nineteenth century.' The writer could simultaneously admire Baudry's tapping of 'the

FIG. 25. RAPHAEL (after), Ashmolean Museum, Oxford, Figures from *The School of Athens*. Engraving from W. Ottley, *The Italian School of Design . . .*, London, 1823, between pp. 50–51, 27.7 × 25 cm.

FIG. 26. Edgar DEGAS, Ashmolean Museum, Oxford, Copy after Raphael, *The School of Athens*, c. 1853. Pencil, 23 × 15 cm.

[29] *Baudry*, op. cit., p. 113.
[30] For *Cincinnatus* see Francis Haskell and Nicholas Penny, *Taste and the Antique: The Lure of Classical Sculpture, 1500–1900* (New Haven and London, 1981), no. 23.
[31] Prud'hon: '*La Justice et la Vengeance divine poursuivant le Crime*', exhibition catalogue by Sylvain Laveissière (Musée du Louvre, Paris, May–September 1986), p. 109.

FIG. 27. Edgar DEGAS, Boymans-van Beuningen Museum, Rotterdam, *Two Dancers, Harlequin and Colombine*, *c*. 1895. Charcoal, 27.8 × 23 cm.

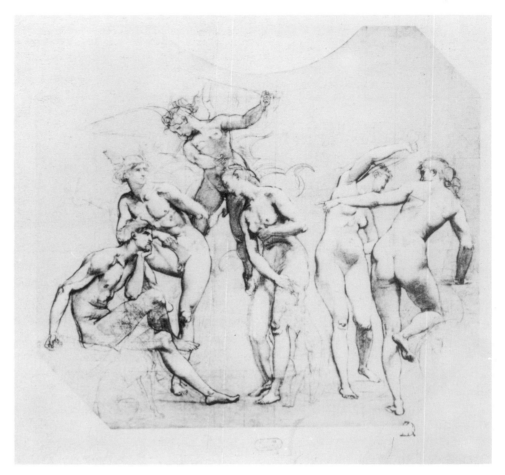

FIG. 28. Paul BAUDRY, Bibliothèque et Musée de l'Opéra, Study for *The Judgement of Paris*, *c*. 1865–69. Black chalk and sanguine, heightened with white, on grey paper, 77 × 86 cm.

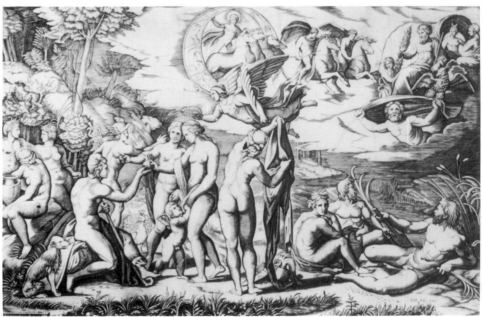

FIG. 29. Marcantonio RAIMONDI, Whitworth Art Gallery, Manchester, *The Judgement of Paris* (after Raphael), *c*. 1514–15. Engraving, 29.3 × 43.9 cm.

32 Anon. [Henry Roujon?], *Paul Baudry* (Paris, n.d), pp. 11–12.

sources of art', of 'the harmonious forms of the antiqué', and claim him as 'un Français très moderne'.[32] It is difficult for us today to understand such a position, to cast aside our twentieth-century preference for invention and innovation. It still seems very hard not to consider such efforts as Baudry's and Henner's — however sincere — as the most barren aspect of the doctrine of continuity we have heard voiced by Ingres. While we should neither doubt their sincerity nor — especially in the case of Henner — their talent, one can perhaps categorize their use of past art as passive, neglecting to pass beyond quotation to assimilation. There is little attempt to adapt the source to their own compositional or narrative requirements;

FIG. 30. Edgar DEGAS, Artemis Fine Arts Limited, London, *Au Théâtre, le Duo*, c. 1877. Pastel over monotype, 11.7 × 16.2 cm.

FIG. 31. Eugène DELACROIX, National Gallery, Prague, Study for *Cicero accusing Verres*, c. 1838–47. Pencil, 22 × 23 cm.

the borrowed motif — the 'copy', if you like — remains inert emulation, not creative transformation.

What one has tried to set up here are two distinct polarities: integrated assimilation in the examples of Seurat and Degas, and establishment quotation on the part of Baudry and Henner. But what about the grey areas between such polarities? Perhaps we can begin to make further distinctions here if we recognize that the copy had a life after the actual process of copying, even many years after. We know that Cézanne's temperamental and practical difficulties in working from the life often led him to build up his bather images as composites from imagined and copied figures. It seems

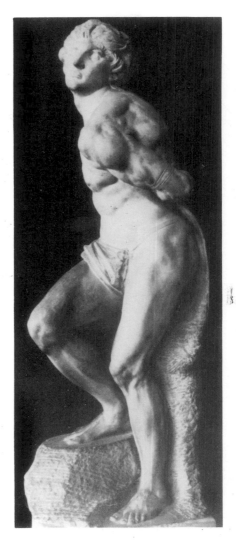

FIG. 32. Paul BAUDRY, Bibliothèque et Musée de l'Opéra, Study for *The Shepherds*, c. 1865–69. Black chalk and sanguine, heightened with white, on grey paper, 77 × 86 cm.

FIG. 33. MICHELANGELO, Musée du Louvre, Paris, *Rebellious Slave*, c. 1513–16. Marble.

highly likely that a copy he made in the late 1860s after a Signorelli drawing for *The Living carrying the Dead* (Private Collection) served as the basis some fifteen years later for a watercolour of a standing bather seen from the rear (Wadsworth Atheneum, Hartford), Cézanne merely adjusting the left arm and casually replacing the corpse with a towel. The pose of this watercolour then recurred in a number of bather canvases.[33] This watercolour, one might argue, is in its way a 'creative' copy. If Cézanne's initial drawing after Signorelli was not precise emulation, departing from the original in its graphic approximation of the musculature, the bather watercolour went far further, discarding Signorelli's apocalyptic motif while adapting its sturdy pose to the requirements of Cézanne's own compositions. A problem that faces us here is this: how far can we trace the influence, the presence, of a copy in an independent work by a mature artist? When does the recollection of something seen, learnt, copied, become so dim as to become an intrinsic part of the artist's imagination? Degas' pastel over monotype *Le Duo* was made about 1877 (Fig. 30). We are set in the wings, as if we were a performer awaiting our cue; we glance through at the two women on stage, one gesturing fulsomely and appealing to the audience, which we make out beyond and beneath her. In its suggestion of both a location and a function for the spectator, its unwillingness to provide us with a central focus, its offhand blocking of our view with a back, this little monotype seems to encapsulate Degas' most sophisticated 'naturalist' devices for conveying the fragmented momentum of everyday life. And yet very much these features — the protagonist's back, the gesturing, the public beyond and below — are to be found in *Cicero accusing Verres*, one of Delacroix's pendentives for

33 See *inter alia* Rewald, op. cit., no. 128 and Lloyd, op. cit., p. 10.

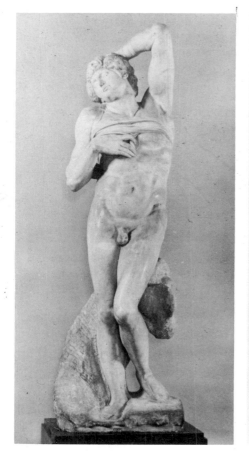

the Palais Bourbon executed some forty years earlier. In fact Delacroix's resolved compositional drawing for this decoration (Fig. 31) belonged at the time *Le Duo* was made to Degas' friend Philippe Burty; later it entered Degas' own possession.[34] This may be coincidence; but perhaps here too one might talk of the 'creative' copy, of the original transformed — who knows how consciously or how distantly? — by the imagination of the 'copyist'.

Perhaps one can speculate further by comparing the responses artists made to what might (rather deviously) be described as a 'single' work of art: Michelangelo's *Slaves* in the Louvre. Another of Baudry's Opéra decorations, *The Shepherds* (Fig. 32), borrowed the figure of the so-called *Rebellious Slave* (Fig. 33) for the standing figure on the right, although calming the pose by decreasing its torsion and aggression. Other figures were derived from the Antique, from the *Barberini Faun* and the Madrid *Castor*,[35] so the composition is essentially a compilation of copies, the kind of work accredited by the academic system and regretted by Maxime du Camp. Cézanne copied the *Dying Slave* on several occasions,[36] and the best of his drawings are powerful sheets in which the artist's efforts to secure the main planes by his hatchings and the outer rhythms by his contours instil Michelangelo's languid forms with a raw energy that is entirely Cézanne's (Figs 34, 35). The pose of the *Dying Slave* haunted Cézanne, and he quoted it in bather paintings, such as the canvas from Basle (Fig. 37), which dates from the mid-1880s. In the rear bather we recognize from the *Dying Slave* the sagging knees and arms raised to protect the chest and steady the tilting head, but the figure has none of the force of Cézanne's drawn copy. Dare one suggest that in this case Cézanne's ability to integrate his source is as inarticulate as Baudry's, that this too is passive quotation rather than active transformation? At times it may be stretching likelihood to see echoes of the copy in the mature work. Degas too had copied the *Dying Slave*, in a superb sheet made about 1859–60 (Fig. 36). But it is hard to accept the suggestion that it somehow

FIG. 34. MICHELANGELO, Musée du Louvre, Paris, *Dying Slave*, c. 1513–16. Marble.

FIG. 35. Paul CÉZANNE, formerly Adrian Chappuis, Tresserve, Copy after Michelangelo, *Dying Slave*. Pencil, 19.4 × 11.8 cm.

FIG. 36. Edgar DEGAS, Private Collection, Zürich, Copy after Michelangelo, *Dying Slave*, c. 1859–60. Pencil, 33 × 23 cm.

[34] *Collection Edgar Degas. Tableaux modernes et anciens* (Galerie Georges Petit, Paris, 26–27 March 1918), no. 138. For the Delacroix see G. Kesnorova and P. Spielmann, *Modern French Drawings in Czechoslovakia* (1969), no. 3 (National Gallery, Prague), K.33.624.
[35] See Haskell and Penny, op. cit., nos 33, 19.
[36] A. Chappuis, *The Drawings of Paul Cézanne. A Catalogue Raisonné*, 2 vols (1973), nos 303, 375, 473, 589–90, 678–79.

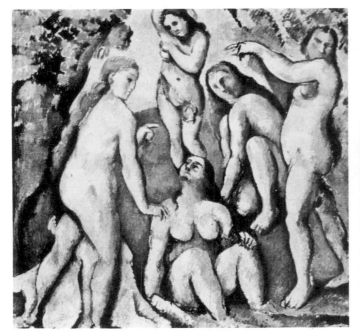

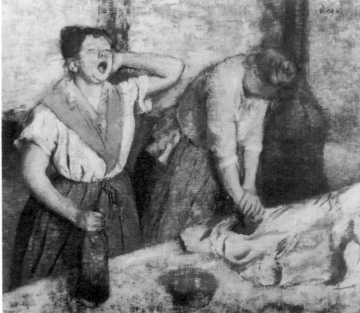

FIG. 37. Paul CÉZANNE, Kunst-
museum, Basle, *Five Bathers, c.* 1885–
87, Oil on canvas, 65.5 × 65.5 cm.

FIG. 38. Edgar DEGAS, Musée d'Or-
say, Paris, *Women Ironing, c.* 1882–85.
Oil on unprimed canvas, 76 × 81 cm.

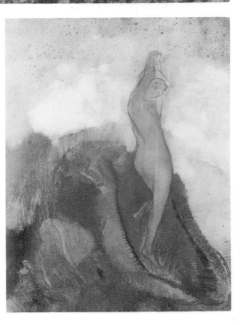

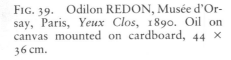

FIG. 39. Odilon REDON, Musée d'Or-
say, Paris, *Yeux Clos,* 1890. Oil on
canvas mounted on cardboard, 44 ×
36 cm.

FIG. 40. Odilon REDON, Petit Palais,
Paris, *The Birth of Venus, c.* 1912. Pastel
on beige paper, laid down, 84.4 × 65 cm.

lies behind the motif of the woman yawning, used in a number of laundress
images traditionally placed in the early 1880s (Fig. 38).[37] Here we seem to
have the product of direct observation, simplified surely, but not glimpsed
through the filter of past art, not, even at the furthest remove, a 'creative'
copy. Perhaps the artist on whom Michelangelo's *Dying Slave* worked the
most enthralling spell in late nineteenth-century France was Odilon
Redon. He wrote of the sculpture in his journal in 1888, lauding the sense
of mystery, dignity and dream behind its 'yeux clos'.[38] Two years later he
painted *Yeux Clos* (Fig. 39), an imaginative variant on the head of the
Dying Slave, similarly sensuous, apathetic and slumbrous.[39] Perhaps, too,
an echo of Michelangelo's sculpture can be found in Redon's gorgeous
pastel *Birth of Venus* (Fig. 40), drawn *c.* 1912. The angled arm above the
head, the flow down elbow, flank and thigh, and the languorously buckled
knee reveal Michelangelo's pose, transformed by the richness of Redon's
imagination.

We do well to acknowledge the copy as a significant aspect of late
nineteenth-century French art. That significance lay not just in its role in
the formation of a young artist but also in its continuing relevance for the
mature painter. For in full career the copy acted as a link with past art,

[37] Norma Broude, 'Degas's "Misogyny"',
Art Bulletin, vol. LIX, no. 1, March 1977,
pp. 105–06.
[38] Odilon Redon, *A Soi-même, 1867–1915.
Notes sur la vie, l'art et les artistes* (Paris,
1961), p. 94 (entry of 14 May 1888).
[39] For this painting see most recently Brooks
Adams, 'The Poetics of Odilon Redon's
Closed Eyes', *Arts Magazine,* vol. 54, no. 5,
January 1980, pp. 130–34.

either in terms of the unconscious assimilation of the craft of picture-making or as an active touchstone of quality. The copy provoked issues which lay at the heart of artists' decisions about the character and direction of their careers, about their balance of imagination and emulation, innovation and conservatism, their capacity to transform or merely quote. These were issues that affected both establishment and independent artists, and as the study of nineteenth-century art moves away from the modernist stress on stylistic progression and we come increasingly to understand the extent to which even 'avant-garde' work was produced in dialogue with tradition, the lasting importance of the copy will be granted the complex, important and, at best, 'creative' position it deserves.

Zoological animal drawings and the role of Hans Verhagen the Mute from Antwerp

by PETER DREYER

Animal drawing has a long history in post antique European art. It started at least in the early thirteenth century with Villard de Honnecourt, is further documented by the pre-bellinian designs of lions in Jacopo Bellini's Louvre *Sketchbook* in the fourteenth century, and first culminated in Pisanello's drawings in the fifteenth. They show the artist's interest in animals whose pictures could mostly be used in different artistic media, such as textile patterns, medals and paintings.

To the same genre belong later examples, such as Ian Woodner's *Dog and Hare* by Benozzo Gozzoli, or Burgkmair's, Baldung's and many of Dürer's drawings, and this type can easily be followed through the centuries to Oudry, Delacroix, Franz Marc and further. I will, however, not illustrate its history, but focus here on what may be called zoological animal drawings. These are not primarily made in preparation for other artistic undertakings; they are mostly works of art in their own right and with the purpose of conveying to the onlooker the exact image of an animal as a species. I therefore exclude from the definition of zoological animal representations portraits of animals, such as those of the Gonzaga horses in Mantua, the horses of Rudolph II, admired and beloved dogs, and even Dürer's watercolour of a hare, all of them concerned more with a private interest in the animal than with a scientific one.

Describing the exact image of an animal requires the extensive use of colour, and therefore the term *drawing* is probably not the appropriate word for our kind of animal depiction, but since the basic materials — water- and bodycolour on paper and vellum — place zoological designs into libraries and collections of drawings, they may be included for discussion at this symposium.

We find the first steps in the direction of scientific animal drawings in the late fourteenth century. Departing from medieval *bestiaria*, the depiction of animals, domestic and exotic, was apparently a Lombard speciality of that time, and *recueils* of animal subjects must have been quite common. Some of the gouaches in Giovannino de Grassi's *taccuino* in Bergamo are astonishingly near to what would be fully developed later — especially the birds and the rat, given in pure profile and seen with rather sharp objectivity — while other folios of the *recueil*, for instance a page with deer, convey little or no zoological interest.

It is in watercolours of the early sixteenth century that we find the most technically precise and naturalistic depictions of animals; but while Jacopo da Barbari's and even Cranach's and Dürer's dead birds belong more to the genre of still life than to science, Dürer's approach can also be different. His depictions of animals, with a most careful and realistic rendering of fur, whiskers, nails and feathers, served as models until late in

A German version of this article, with footnotes and additional illustrations, was published in 1990 in *Jahrbuch der Kunsthistorischen Samlungen in Wien*, vol. 82/83 (1986/87), pp. 115–44.

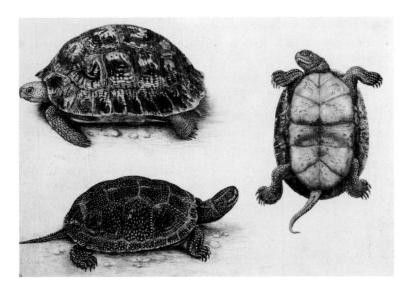 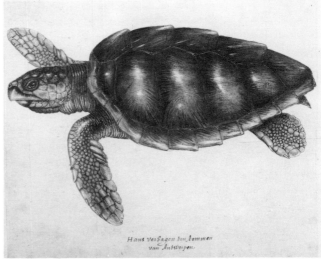

the sixteenth century, as testified by Hofmann's *Hare* or the *Squirrel*, both in the Woodner Collection. There is even a scientific interest in Dürer's drawings as can be seen in the many colourful wings of European rollers by him and his followers.[1] This scientific interest, however, concerns more anatomical questions than zoology, more the single animal than the species.

When, in the middle of the sixteenth century, zoological books that required illustrations as a necessary visual complement for the written information started to be prepared for print, no extensive zoological drawing seems to have existed. Conrad Gesner's volumes began to appear in 1551, demanding a picture for every animal. Their woodcuts are of differing quality, sometimes good, often incredibly bad and not at all reliable. They tend, however, to convey the image of a living specimen, and are — as Dürer's *Rhinoceros* — mainly in profile. Even in Ippolito Salviani's book on fish we meet accurate scientific illustrations in print only occasionally.

The first mere zoological drawings I have come across date roughly from the same period. I will discuss them at some length, because I think they belong to the most important material from the beginning of zoological animal drawing north of the Alps and can be ascribed to an artist whose personality is just emerging from oblivion: Hans Verhagen.

Twenty hitherto anonymous drawings from his hand are kept in the Berlin Printroom and four more are in the Codex Miniatus 42 in the Österreichische Nationalbibliothek, Vienna. The Viennese drawings are inscribed with the name 'Hans Verhagen de Stomme van Antwerpen', written in the handwriting of Joris Hoefnagel to whom they were consequently attributed, the formerly misread name being erroneously interpreted as a nickname for the writer. I will come back to the question of the attribution, but I want first to point out that the sheets in Berlin and Vienna, though belonging to different series, are by the same hand. Consider the nearly abstract zoological interest in the presentation of tortoises (Fig. 1) and turtles (Fig. 2) in Berlin and Vienna. Observe the discrepancy between the naturalism of the buzzard and the schematic drawing of the tree in Vienna (Fig. 3) and the Berlin sheet with squirrels (Fig. 4). Compare the typical rendering of the bark, and the form of branches and twigs in both series or look at the rendering of the fur, whiskers and paws of the Viennese rockmarten (Fig. 5) beside the squirrels, at the eyes, at the dry brushwork, the colour and finally the use of splashes of lead white for corrections. These similarities in the animal drawings in question point to the same master, whose sheets contain a precise

FIG. 1. Hans VERHAGEN, Kupferstichkabinett, Berlin (SMPK, KdZ 26215), *Tortoises*. Watercolour and bodycolour on paper.

FIG. 2. Hans VERHAGEN, Österreichische Nationalbibliothek, Vienna (Cod. min. 42, fol. 121r), *Turtle*. Watercolour and bodycolour on paper.

[1] Illustrated in *Master Drawings: The Woodner Collection*, exhibition catalogues (Royal Academy of Arts, London, 1987), no. 49 and (Metropolitan Museum of Art, New York, 1990), no. 60.

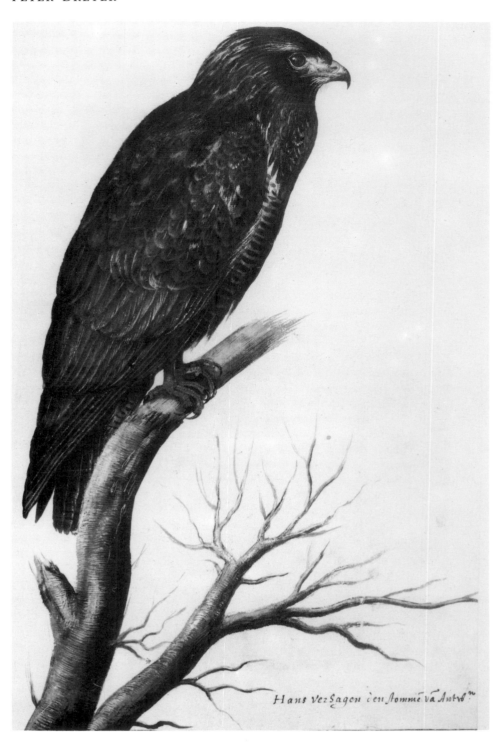

Hans ver§agen den §ommé va Antvol

FIG. 3. Hans VERHAGEN, Öster-
reichische Nationalbibliothek, Vienna
(Cod. min. 42, fol. 26r), *Common
buzzard*. Watercolour and bodycolour
on paper.

observation combined with rather high artistic quality. They are apparently
not copies, as is testified to by a number of *pentimenti*, for instance, the
hunting dog in Berlin (Fig. 6) or the marten in Vienna (Fig. 5), whose legs
were originally in a different position, subsequently covered with white.

The painter is mainly interested in the animals; but while the sparse
indications of their surroundings are mostly carelessly added, they always
convey exactly the natural habitat. The Great white herons are put near
some water (Fig. 7), rats and house mice on a wooden floor (Fig. 8), the
Common dormouse at the margin of a meadow; the cat's function is
underlined through the presence of a dead rat (Fig. 9).

Among the Berlin material figure mammals, birds and one fish, and
besides the most ordinary European specimens like rats, sheep (Fig. 10), a
domestic swine and a goat, we find some rather exotic ones: an elephant
(Fig. 11), two turkeys (Fig. 12) and a swordfish (Fig. 13). All of the animals

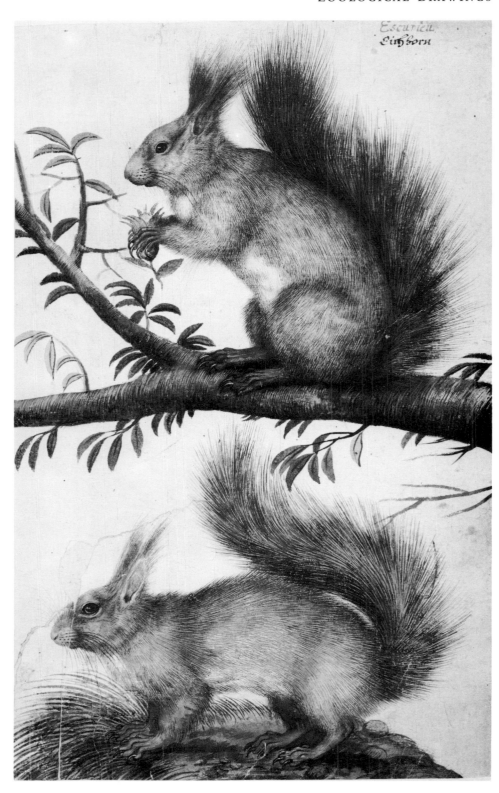

FIG. 4. Hans VERHAGEN, Kup-ferstichkabinett, Berlin (SMPK, KdZ 26218), *Squirrels*. Watercolour and bodycolour on paper.

depicted were once inscribed with their Latin names — most probably by Hoefnagel's hand again — names in other languages being added slightly later, and the sheets are inscribed with numbers, some of which are page numbers, reaching up to more than a hundred and proving that the drawings were part of a much more important series, kept once in one or more volumes.

The originally huge number of drawings, indicated by the old numberings, and the variety of species represented that is still conveyed by the extant sheets, testify to what we could call an encyclopaedic interest in the world of animals in drawing, similar to that of the great *Historiae animalium*, the first scientific catalogues of animals in modern Europe that

Fig. 5. Hans VERHAGEN, Öster-reichische Nationalbibliothek, Vienna (Cod. min. 42, fol. 116r), *Rockmarten*. Watercolour and bodycolour on paper.

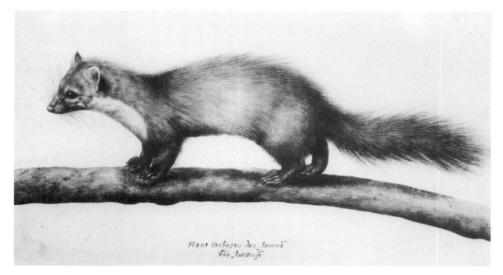

Fig. 6. Hans VERHAGEN, Kup-ferstichkabinett, Berlin (SMPK, KdZ 26223), *Hunting dog*. Watercolour and bodycolour on paper.

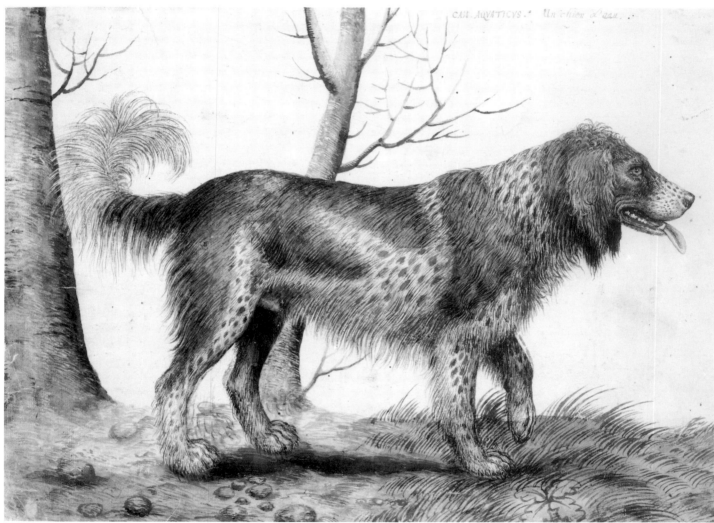

appeared in the second half of the sixteenth century: those by Gesner, Salviani, Belon and Rondolet. The watermarks of the Berlin sheets point to the middle decades of the century, the drawing style to the second half. A more precise date is offered through the representation among the drawings of an Indian elephant, the same animal drawn by Lambert van Noort in Antwerp on 1 October 1563 and published in prints by Jan I. Mollijn and Gerard van Gronningen. The text below the latter's engraving tells us that in September 1563 King Philip II of Spain sent the elephant to Maximilian, later Emperor Maximilian II, and that the animal was first

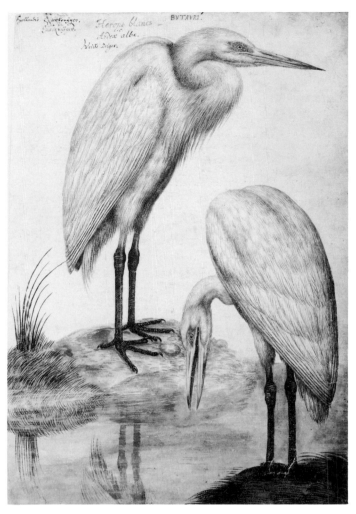

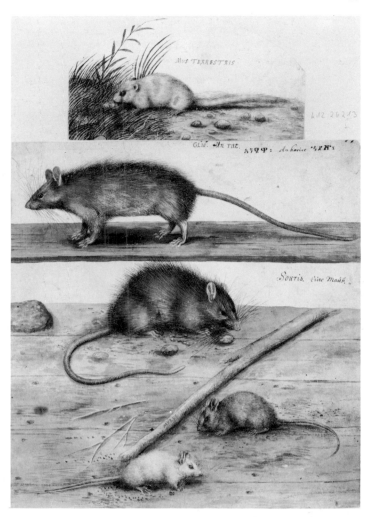

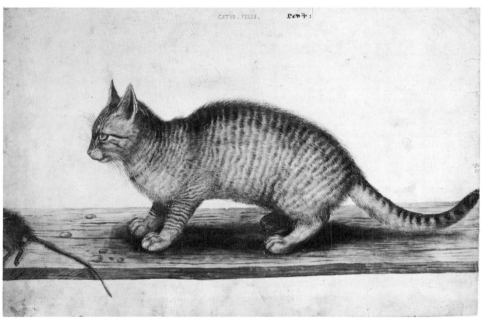

FIG. 7. Hans VERHAGEN, Kupfersti-chkabinett, Berlin (SMPK, KdZ 26231), *Great white herons*. Watercolour and bodycolour on paper.

FIG. 8. Hans VERHAGEN, Kup-ferstichkabinett, Berlin (SMPK, KdZ 26213 and 26214), *Mice and rats*. Watercolour and bodycolour on paper.

FIG. 9. Hans VERHAGEN, Kup-ferstichkabinett, Berlin (SMPK, KdZ 26224), *Cat with dead rat*. Watercolour and bodycolour on paper.

shown to the people of Antwerp, a fact repeated by Emanuel van Meteren's description of the year 1563 in his '*Historie der Nederlandse Oorlogen*'. Lothar Dittrich — director of the zoological garden in Hanover — has followed the curriculum vitae of the elephant, and has told me the following: the bull elephant, whose name remains unknown and who displayed very characteristic dots on his ears, came by ship from Portugal and arrived at Antwerp on 24 September 1563. He was sent to

FIG. 10. Hans VERHAGEN, Kupferstichkabinett, Berlin (SMPK, KdZ 26216), *Sheep*. Watercolour and bodycolour on paper.

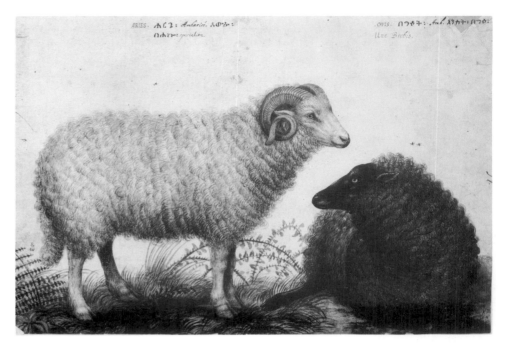

FIG. 11. Hans VERHAGEN, Kupferstichkabinett, Berlin (SMPK, KdZ 26227), *Elephant*. Watercolour and bodycolour on paper.

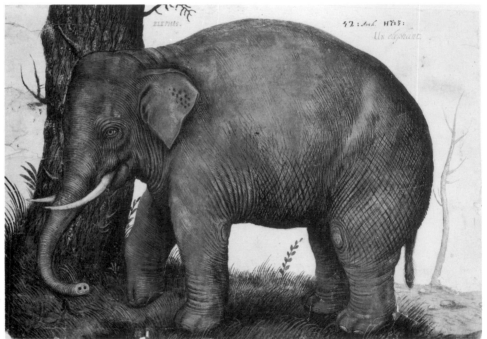

Maxmilian, passing through Cologne on 10 October 1563, and was shown in 1570 in Praque and on the Reichstag at Speyer. He probably died shortly after the year 1574. Accordingly we can date our gouache or its preparatory drawings roughly between 1563 and 1574, but since our elephant is of the same age as in the prints mentioned above and in Noort's drawing, we have reason to date it to autumn, 1563. Another fairly accurate date is provided by the dating '1577' on Hoefnagel's copy in the Louvre after a sea hawk in Berlin.

The Viennese drawings have been regarded as copies by Hoefnagel after his animal miniatures in the four volumes of *Animalia* or *The Four Elements*, said to have been in the collection of Rudolph II. This assumption is incorrect. The drawings in Vienna and Berlin are not copies. I have pointed out their *pentimenti* and now would like to add as evidence their greater realism. They must have been done before the miniatures. The turtles in Berlin are drawn after living animals, the right one laying on its back and labouring to get back on its feet. In Hoefnagel's drawing of turtles (National Gallery of Art, Washington, D.C. Gift of Mrs Lessing J.

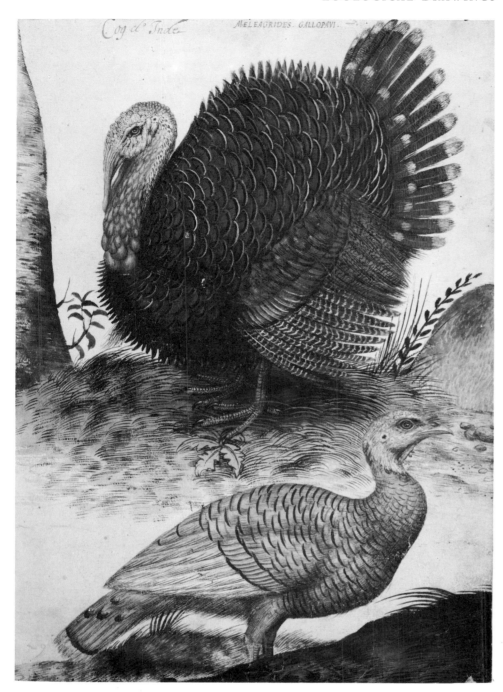

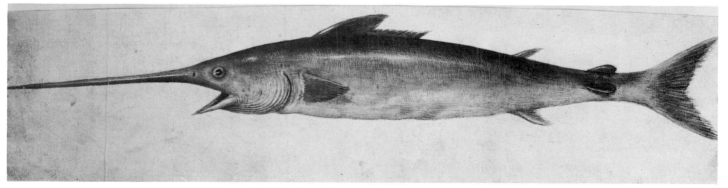

Rosenwald), he leans one turtle vertically against a support, showing that he does not understand the actual situation.

As to the attribution, our drawings differ stylistically from Hoefnagel's, revealing very different artistic temperaments at work. We have therefore to look for a different name, and nothing could be more convincing than accepting Hoefnagel's attribution of our drawings to the

painter Hans Verhagen the Mute from Antwerp, apparently a contemporary and fellow citizen.

I have only a few data about one or more painters of that name. A Hansken Verhagen is mentioned in 1554, and a Hans Verhagen in 1555, both times as apprentice to the painter Antoni Bessemers from Mechlin, then working in Antwerp. In July 1572 a Hans Verhagen married in the Cathedral of Antwerp. Around the year 1600 a painter Hans Verhagen from Mechlin was active at Delft and Rotterdam.

According to Meder, a boy started his apprenticeship as a painter at the age of ten to twelve, and studied for three or more years. If this is correct, our Hansken or Hans would have been born between 1540 and 1545. He would have been of the generation of Hoefnagel who was born in 1542 and married in 1571, one year before the marriage of a Verhagen mentioned above. Both painters, being from the same city and of the same age, would have known each other with all probability. The indication 'Hans Verhagen', written by Hoefnagel's hand on the Viennese drawings, is therefore much more reliable than a normal collector's attribution.

Verhagen's animal drawings had an astonishing impact on other animal series, which I will deal with in order to show his importance as well as to provide additional material for the hypothetical reconstruction of lost parts of his work. Considering the high number of animals in Hoefnagel's *Four Elements* or *Animalia*, it does not astonish us to find out that he did not necessarily draw from life, notwithstanding his motto 'Natura sola magistra'. Indeed he followed patterns by other masters, chief among them, Verhagen, putting them mostly, although not always, into new compositions as for example in his use of Verhagen's Mute swans in two different pages of the volume *AIER*, the first in Berlin and the other in Washington.

Verhagen liked the pure profile or characteristic positions and movements, and was highly objective. We can, therefore, try to find out which of Hoefnagel's animals could actually go back to Verhagen's drawings, discarding first of all imaginary creatures as well as those that are more or less unrealistic or not looked at with a scientist's eye.

In the Hoefnagel miniature which contains a copy after Dürer's hare in the Albertina and an example of a Raurackl (an imaginary combination between hare and deer), I would not dare to attribute any one of the animals' prototypes to Verhagen, with the exception of the crouching hare in the centre. On the other hand, Verhagen's squirrels and hare (Figs 4 and 15) would be easily recognized as his in another of Hoefnagel's miniatures (Fig. 14), even without knowledge of the originals. They not only convey the same scientific approach we know from the Mute, but also differ fundamentally from the hare or rabbit in the lower left, betraying a late gothic inspiration, or the one in the lower right, similar to those depicted by Dürer and Hofmann. We can, consequently, ascribe a number of Hoefnagel's models to Hans Verhagen, without knowing the original drawings. But it is not only the typical stance of the animals that can lead us to Verhagen. Many small details of the habitat, such as the undulating waves around the breast of swimming animals or forms of twigs and bark, can, in addition, point to his drawings. On this basis, we can not only ascribe to his original depictions the birds aside our waterrail in Hoefnagel's copy but even the chameleons on his sheet TERRA LIII. These few examples may be enough to underline Verhagen's importance for Hoefnagel and are, at the same time, instrumental for the reconstruction of an apparently large lost *oeuvre*.

I shall briefly discuss some more series of copies or remnants of such series. A copy of Verhagen's Brown bear was sold at Christie's in 1985. A number of animal drawings from the so-called Lambert Lombard-Album

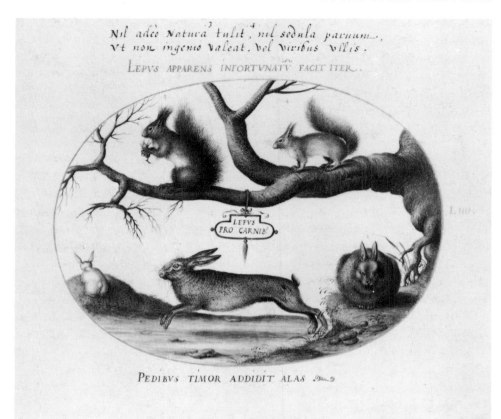

Nil adeo Natura tulit, nil sedula parvum,
Vt non ingenio valeat, vel viribus vllis.

LEPVS APPARENS INFORTVNATV FACIT ITER.

LEPVS PRO CARNIB!

PEDIBVS TIMOR ADDIDIT ALAS.

FIG. 14. Georg HOEFNAGEL, Kupferstichkabinett, Berlin (SMPK, KdZ 4817), *Squirrels and hares*. Watercolour and bodycolour on vellum.

FIG. 15. Hans VERHAGEN, Kupferstichkabinett, Berlin (SMPK, KdZ 26228), *Hare*. Watercolour and bodycolour on paper.

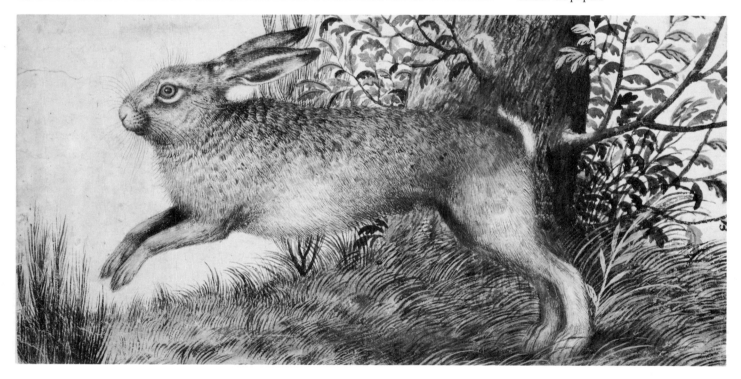

in the Rijksmuseum in Amsterdam can certainly be regarded as copies after the Mute of Antwerp because of the presence among them of a swimming swan, copied from the drawing in Berlin; and there is another swimming swan in the Munich printroom belonging to a series of which only three have come to my attention, one of them dated 1605. This series is of particular interest because it contains a drawing with a salamander and the chameleons we know from Hoefnagel. They are placed on the sheet in an order familiar to us from Verhagen's designs and are inscribed with their names rather similarly to those in the Berlin sequence. I do not know the original drawing, but with the help of Hoefnagel's folio TERRA LIII, we are able to get a rather precise idea of it. The twigs and the bark in the

oval are very near to Verhagen, and in these details the miniature is certainly much closer to the original than the drawing in Munich, which — on the other hand — corresponds in size and composition, amplifying our knowledge and emphasizing at the same time that the methods employed to trace unknown Verhagen material from the copies by Hoefnagel and others are working correctly.

Some new aspects are provided through copies included in Hans Bol's *Icones animalium* in Copenhagen. Like his pupil Hoefnagel, Bol used a variety of sources for his animal miniatures. From Verhagen's extant depictions we find the European roller, the Indian Elephant and — with variations — the goat. There are a number of drawings representing the buzzard known to us from Verhagen's drawing in Vienna, some of them reappearing in Hoefnagel's *Animalia* too, and in addition to the standing elephant we know from a sheet in Berlin, we find a crouching one, the rendering of whose skin and whose general character point unmistakably to a Verhagen drawing as its model. In manuscript 514 of the Biblioteca Universitaria, Pisa, at least 175 drawings are after Verhagen.

Considering the copies taken from him, there remains no doubt that Verhagen must have produced a huge, truly encyclopaedic collection of hundreds of animal drawings, sometimes depicting the animals in many different movements and views, establishing him as one of the earliest and most important draughtsmen in this field. His drawings were apparently regarded as a reliable source of zoological evidence. I would like to add that all the copies mentioned so far were done after the original drawings, that there are many more secondary copies going back to Hoefnagel's *Animalia* or to prints after primary copies, and that copies after Verhagen's depictions were soon not only available in the North but even in Italy. As in the case of Dürer's animals we find that Verhagen's were used by artists who apparently preferred art as a source of inspiration to nature. There might be an explanation for this phenomenon so often found especially in animal drawings. Perhaps there were not enough elephants, chameleons or even hares available that waited patiently to be drawn, or perhaps there were not enough draughtsmen able to catch the image of a breathing, constantly moving animal.

It seems that Verhagen met much more with the demands of zoology in the sixteenth century and later than did Dürer. At least what followed, remained much in his pre-established pattern. The characteristic stance of an animal in profile or in a typical movement, the sparse indications of the habitat, the great importance of colour and therefore the technique, water- and bodycolour on paper or parchment, used in animal depictions, remained essentially the same for a long period to come; and as in the late gothic example of Giovannino de Grassi, the appropriate place for large series continued to be mostly the album or the illustrated book, uniting zoological pictorial representations to the older ones of botanical drawings.

Jacopo Ligozzi was one of the outstanding masters in both fields in Italian sixteenth/seventeenth-century art, working not only for the Medicean court but also for an authentic scientist, the Bolognese Ulisse Aldrovandi. One of the most beautiful examples from seventeenth-century France is possibly the *Velins du Muséum* painted for Gaston de France, duc d'Orleans, probably by Daniel Rabel before 1660. Comparing the turkey of the *Velins* with Verhagen's, one can see how little has changed, and the same is true with Claude Aubriet's *Recueil de Poissons de l'Océan et de la Loire* from the second decade of the eighteenth century when compared with Verhagen's swordfish.

Later, printing made the precious depictions of animals a little more widely available. In the beginning prints still derived from huge series of

artists' or artists/scientists' drawings. Among them are the outstanding hand-coloured etchings of the *Histoire naturelle des oiseaux* by Buffon, printed in Paris 1771–86, or John James Audubon's *Birds of America*, published 1827–38, an incredibly ambitious printed and hand-coloured edition of the artist's drawings now in New York (N.Y. Historical Society). Finally photography with all its advantages and disadvantages was rivalling drawing as scientific illustration. But even here, unless the lens is directed at a casually moving animal, the principles found in the sixteenth century are still valid.

The early drawings of Sir Anthony Van Dyck and the Antwerp Sketchbook

by CHRISTOPHER BROWN

In this paper I wish to consider Anthony Van Dyck's early drawings — by which I mean drawings made before his departure for Italy in 1621 — and, in particular, the so-called Antwerp Sketchbook, the book discovered at Chatsworth thirty years ago by Michael Jaffé and published by him in a two-volume scholarly edition in 1966.[1] If it is by Van Dyck, this Sketchbook is a vitally important document for the artist's early development. Its proposed authorship has, however, been seriously doubted and yet there has been little sustained discussion, apart from that in Jaffé's edition, of the style and contents of the book in so far as it relates to the question of attribution. Here I shall discuss the context of the Sketchbook — that is, our knowledge of Van Dyck's early drawings — and the principal internal features of the Sketchbook which affect the question of attribution. That I had the opportunity to discuss this subject at the symposium, was the consequence of Mr Woodner's having purchased, at the second Chatsworth drawings sale, a sheet by Van Dyck, the *Mystic Marriage of Saint Catherine*, one of the very finest of the compositional sketches made by the artist during his first Antwerp period.[2]

It may be useful to begin by tracing the recent critical history of the so-called Antwerp Sketchbook. Jaffé's discovery was made in 1955 and announced in an article in the *Burlington Magazine* in 1959.[3] The attribution to Van Dyck was rejected by Roger d'Hulst and Horst Vey in the catalogue of their 1960 Van Dyck Drawings and Sketches exhibition in Rotterdam and Antwerp;[4] this rejection was repeated by Vey in his Drawings catalogue published in 1962.[5] Subsequently, Christopher White,[6] Oliver Millar[7] and Julius Held[8] have upheld the attribution, while Justus Müller Hofstede has denied it.[9] I sat on the fence in my 1982 book,[10] while more recently Egbert Haverkamp-Begemann[11] and Arnout Balis (who is currently working on Rubens' Pocket-Book for a volume in the *Corpus Rubenianum*)[12] have supported its attribution to Van Dyck. I shall return to the various arguments, *pro* and *contra*, later.

Let us now look at the book in the context of Van Dyck's early drawings. Van Dyck's early drawing style is not difficult to identify because so many of the drawings are preparatory to paintings which can be more or less dated. They fall into three distinct types which correspond to three stages of work on particular paintings: a bold compositional drawing in which the positions of the principal figures are established and the lighting indicated by dark washes; figure studies of models posed in the studio for particular figures in the composition; and a very detailed drawing using delicate washes and precise areas of hatching which apparently served the same function as a Rubens' *modello*. These last drawings are sometimes marked up with a grid drawn in black chalk.

[1] M. Jaffé, *Van Dyck's Antwerp Sketchbook*, 2 vols (London, 1966). (Referred to hereafter as Jaffé.) The other Sketchbook by Van Dyck which is today in the British Museum was published by G. Adriani, *Anton van Dyck, Italienisches Skizzenbuch* (Vienna, 1940).

[2] Horst Vey, *Die Zeichnungen Anton van Dycks*, 2 vols (Brussels, 1962), cat. no. 55.

[3] M. Jaffé, The Second Sketch Book by Van Dyck, The *Burlington Magazine*, CI (1959), pp. 317–21.

[4] Roger d'Hulst and Horst Vey, *Antoon van Dyck: Tekeningen en Olieverfschetsen* (Antwerp, Rubenshuis and Rotterdam, Museum Boymans-van Beuningen, 1960), p. 26.

[5] Vey, op. cit., p. 30.

[6] In a review of the 1960 Antwerp/Rotterdam exhibition in the *Burlington Magazine*, CII (1960), p. 513.

[7] In the introduction to *Paintings and Drawings by Van Dyck*, exhibition catalogue (Nottingham University Art Gallery, Nottingham, 1960).

[8] In a letter to the present writer.

[9] J. Müller Hofstede, Neue Beiträge zum Oeuvre Anton van Dycks, *Wallraf-Richartz-Jahrbuch*, Band XLVIII/XLIX (1987/8), pp. 125–31.

[10] C. Brown, *Van Dyck* (Oxford, 1982), p. 231 (note for p. 27).

[11] After a visit to Chatsworth with the present writer in 1987.

[12] In a lecture delivered at the Institute of Fine Arts, New York University, in 1987. I am very grateful to Dr Balis for letting me read the text of this unpublished lecture.

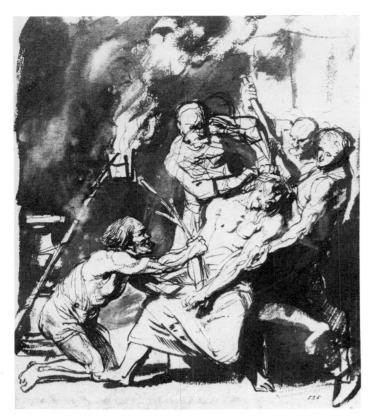 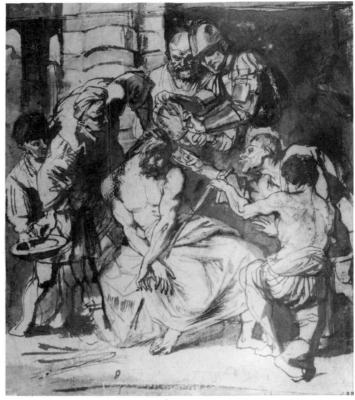

These three types can be observed, for example, in the evolution of the compositions of *The Crowning with Thorns*,[13] the *Taking of Christ*,[14] and the *Mystic Marriage of Saint Catherine*.[15] In *The Crowning with Thorns* Van Dyck's starting-point was Rubens' altarpiece of 1602 for S. Croce in Gerusalemme, now in Grasse. In the first drawing (Vey 72: Fig. 1) Van Dyck closely follows this composition including the kneeling figure on the left; in the second drawing (Vey 73) he incorporates the bearded Roman soldier from Rubens' painting on the right; in the third (Vey 74: Fig. 2) he moves the kneeling figure to the right, adds a second and gives Christ's body a vigorous swerving movement away from the two mockers; there are then three figure studies — for the kneeling mocker (Vey 75), for Christ (Vey 77: Fig. 3) and — on the *verso* of the latter — for the arm and hand of the bearded man holding a lance. Finally there is a detailed drawing with washes and areas of careful hatching which is very close to the finished painting — which was in the Kaiser Friedrich Museum in Berlin but was destroyed during the war. (A second autograph version, omitting the Roman soldier on the left and substituting a dog, is in the Prado.)

For the *Taking of Christ*, of which there are three extant painted versions, there are even more preparatory drawings — the first compositional drawings with pen and wash (Vey 80, 81); more detailed drawings in which the grouping of the figures and the distribution of light and shade is worked out (Vey 82 and 83 [Fig. 4]); studies of groups within the composition, notably that of Peter and Malchus (Vey 85 and 98 *verso*); chalk studies from the model (Vey 87); and finally the large, squared-up study (Vey 86: Fig. 5) for the painting in the Minneapolis Institute of Arts.

For the *Mystic Marriage of Saint Catherine*, in the sequence of which Mr Woodner's drawing takes such a distinguished place, the same pattern is repeated — the first vigorously sketched, extensively corrected sheets (Vey 53 [Fig. 6] and 54), the more worked-up compositional drawing (Vey 55) and the final *modello* drawing (Vey 56). In this case there are also pen drawings for the Child and the head of Saint Catherine[16] cut from a single sheet and remounted.

FIG. 1. Anthony Van DYCK, Victoria and Albert Museum, London (Inv. no. Dyce 525), *The Crowning with Thorns*, *c.* 1618/20. Pen and wash, 24 × 20.9 cm.

FIG. 2. Anthony Van DYCK, Dutuit Collection, Petit Palais, Paris (Inv. no. 1033), *The Crowning with Thorns*, *c.* 1618/20. Pen and wash, 22.3 × 19.4 cm.

[13] Vey, op. cit., cat. nos 72–78.
[14] Vey, op. cit., cat. nos 79–87.
[15] Vey, op. cit., cat. nos 53–56.
[16] These drawings were published by Justus Müller Hofstede in *Master Drawings*, XI (1973), p. 156, cat. no. 5.

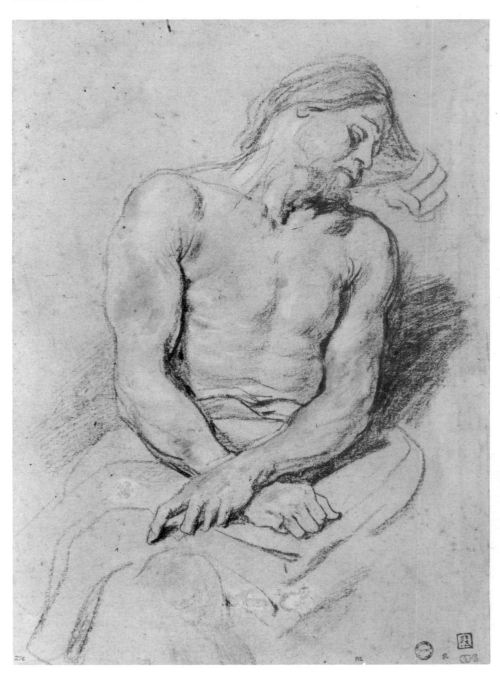

FIG. 3. Anthony Van DYCK, Ash-
molean Museum, Oxford, *A seated, half-
naked man*, *c.*1618/20. Black chalk,
37 × 27 cm.

All the paintings for which these drawings are preparatory can be
dated to 1618–20. They are all highly accomplished drawings, vigorous,
even messy, but immensely assured for an artist in his late teens. They are
all very decidedly *working* drawings, not drawings to be preserved as
teaching aids, records of compositions, or to be valued and sold as works
of art in their own right. This confirms the well-known account given of
Van Dyck's attitude towards drawing by Edward Norgate in *Miniatura*
(1648–50). Norgate had first met Van Dyck in Italy and later knew him
well in England and can certainly be relied upon as a source.

> . . . the excellend Vandike, at our [Norgate's] being in Italie was neat, exact, and
> curious, in all his drawings, but since his coming here, in all his later drawings
> was ever juditious, never exact. My meaning is the long time spent in curious
> designe he reserved for better purpose, to be spent in curious painting, which in
> drawing hee esteemed as lost, for when all is done, it is but a drawing, which
> conduces to make profitable things, but is none it selfe.[17]

There are remarkably few early drawings which cannot be considered
preparatory to paintings. One is the sheet of studies in the Rijksmuseum of
a rider with a lance (which is surely *not* — as has been claimed —

[17] *Miniatura or The Art of Limning by
Edward Norgate*, ed. M. Hardie (Oxford,
1919), pp. 83–84.

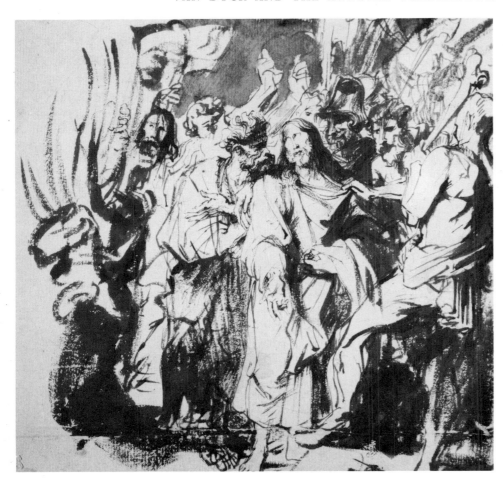

FIG. 4. Anthony Van DYCK, Albertina, Vienna (Inv. no. 17537), *The Taking of Christ*, c. 1618/20. Pen and wash, 21.8 × 23 cm.

preparatory to the *Saint Martin dividing his cloak* at Saventhem) and horses' heads in pen and wash, with colour notes in Van Dyck's own hand (Vey 93: Fig. 7). This sheet has the character of a page from a Sketchbook. The second drawing not related to a known painting that I would like to draw your attention to is the *Ecce Homo* at Besançon (Vey 89: Fig. 8), although this presumably *was* a first idea for a painting which was not executed; the *verso* (Fig. 12) has an early idea for the Louvre *Saint Sebastian* which must date the sheet to *c.* 1620. It is a drawing of quite remarkable freedom in which the subsidiary figures and the architectural setting is indicated with the briskest of pen lines — look, for example, at the head of the man standing behind Christ on his right. And yet with this remarkable economy — together with the blotches of ink and the corrections — there is absolutely assured mastery of form. Christ's legs, for example, are perfunctorily drawn yet not in any sense clumsy or deformed. (As Julius Held has pointed out,[18] it is a characteristic of Van Dyck's drawing style that feet and hands are never treated in detail.)

Let us now turn to the Sketchbook which is still at Chatsworth.

The first six pages contain recipes for painting materials and medicines in Flemish. There are then thirty pages of sketched copies of figures from Italian and German engravings grouped by subject, religious, secular, classical, for example, the Lamentation, judicial punishments, Silenus and Bacchus, Jupiter, satyrs, Hercules. The subject groups have one-word Latin titles. Then follow four pages of simple arithmetic: the conversion of Flemish currency into sterling; twenty more pages of copies grouped by subject: Hercules, scenes of rape and abduction, female nudes, copies after paintings (or copies of paintings) by Titian, again with subject titles in Latin; then five pages of physiognomic comparisons in which the features of women are compared to those of horses and those of men to bulls; finally, there are fifteen pages concerned with illustrated works on

[18] J. S. Held, *Rubens: Selected Drawings*, second edition (Oxford, 1986), p. 13.

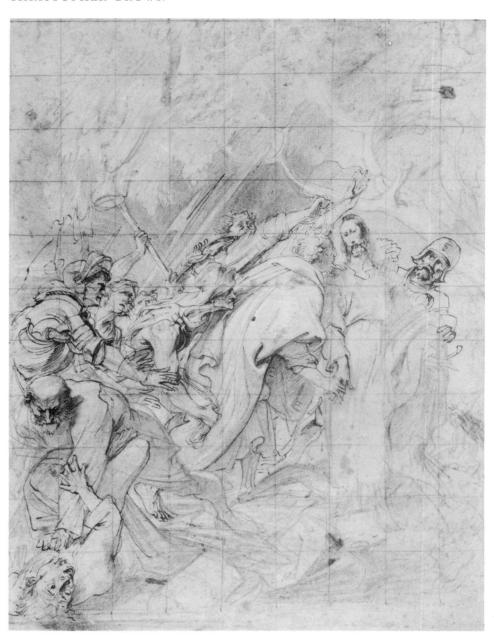

FIG. 5. Anthony Van DYCK, Kunsthalle, Hamburg (Inv. no. 21882), *The Taking of Christ*, *c*.1618/20. Black chalk, 53.3 × 40.3 cm.

architecture, including extensive quotations in Latin from Serlio. The degree to which the Sketchbook follows Rubens' Pocket-Book is not entirely clear. Jaffé considers that many of the copies were collected independently by Van Dyck, but Balis[19] believes that, as page 40 onwards of the Sketchbook can be closely connected with the de Ganay and Johnson manuscript, it is likely that the earlier pages too were copied from the Pocket-Book and that the entire Sketchbook is effectively a copy after Rubens. This is not, however, the issue which principally concerns me here. I wish to concentrate on the matter of the Sketchbook's attribution.

Many of the arguments *pro* and *contra* will be familiar. The matter is a complex one and I will have to simplify the arguments. The key points to be borne in mind are these:

1. At the top of page 2 *recto* of the Sketchbook is a small monogram which Jaffé reads as AVD. It is not used by Van Dyck anywhere else and is very different from the 'Antonio Van Dyck' signature in the Italian Sketchbook both in its calligraphy and its position on the page.

2. The Sketchbook contains substantial passages from Rubens' lost Pocket-Book and so must be the work of an artist very close to Rubens who had access to the Book over a significant period of time.

[19] In the unpublished lecture mentioned in note 12.

FIG. 6. Anthony Van DYCK, Formerly Kunsthalle Bremen (Inv. no. 1189), *The Mystic Marriage of St Catherine*, c. 1618/ 20. Pen and wash, 19.1 × 28.9 cm.

FIG. 7. Anthony Van DYCK, Rijksprentenkabinet, Amsterdam *A rider and three horses' heads*, c. 1620. Pen and wash, 26.4 × 16.5 cm.

FIG. 8. Anthony Van DYCK, Musee des Beaux-Arts et d'Archeologie, Besançon (Inv. no. D. 28), *Ecce Homo*, c. 1620. Pen and wash, 23.8 × 16 cm.

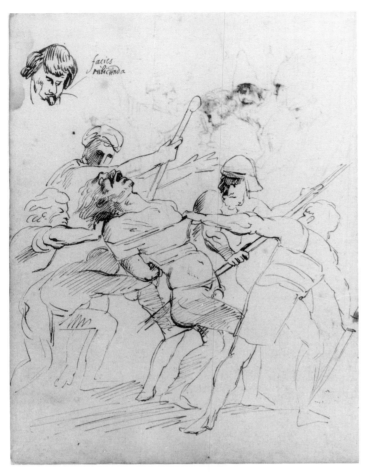

FIG. 9. Anthony Van DYCK, Devonshire Collection, Chatsworth, reproduced by permission of the Chatsworth Settlement Trustees, *Antwerp Sketchbook*, page 17 *verso*.

FIG. 10a + 10b. Anthony Van DYCK, British Museum, London, *Italian Sketchbook*, page 19 *verso* and page 20 *recto*.

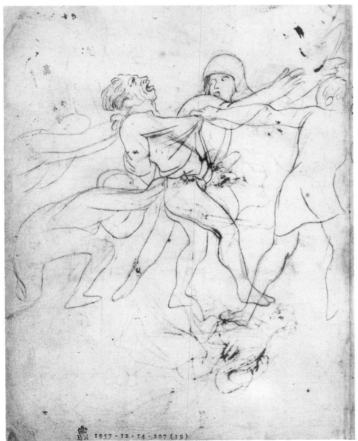

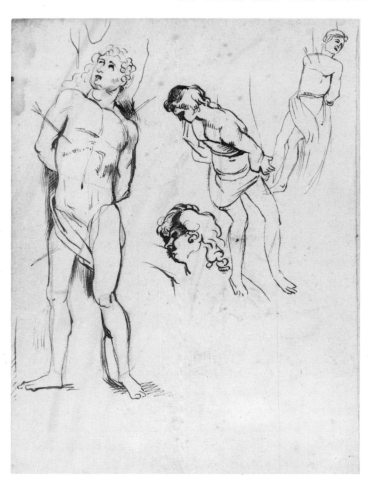
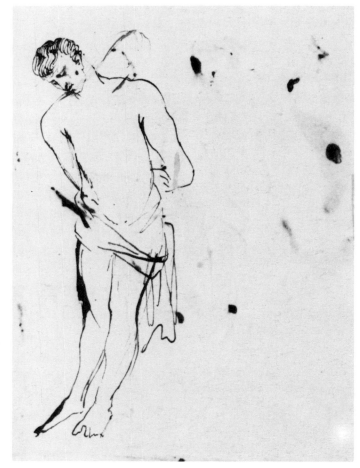

3. It contains a number of copies after Titian, the artist whom above all others Van Dyck admired.

4. It contains on page 17 *verso* a remarkable drawing of a man being dragged to execution (Fig. 9) which is clearly related to a drawing on page 19 *verso* and page 20 *recto* of the Italian Sketchbook (Fig. 10a and 10b). These are our only records of this powerful composition — do they point to a common (painted) prototype or is the latter a reworking, six or seven years later, in Italy, of an idea first recorded in the Antwerp Sketchbook?

In his dismissal of the attribution Vey wrote:

> Der Zeichenstil ist nicht derjenige Van Dycks; dokumentarische Beweise von Gewicht für seine Autorschaft bestehen nicht; die innere Wahrscheinlichkeit für sie ist angesichts des Inhaltes und der mangelnden Resonanz in seinem frühen Werk ebenfalls gering. Das Buch bleibt aber ein seltenes, fesselndes Dokument für den Bildungsgang eines Meisters aus der Nachfolge Rubens' und Van Dycks im frühen 17. Jahrhundert.

(The drawing style is not that of Van Dyck; documentary evidence of any substance for the attribution does not exist; in view of its content and lack of resonance in Van Dyck's early work, it is unlikely to be by him. However, the book remains a rare, captivating document for the development of a master from among the followers of Rubens and Van Dyck in the early seventeenth century.)

Let us take these three points in turn. The drawing style is, it is true, significantly different from any other drawing or group of drawings we know by Van Dyck. If one compares page 19 *verso* of the Sketchbook (Fig. 11) with Vey 89 *verso* (Fig. 12), there is a clumsiness, a lack of anatomical exactitude in the Sketchbook drawing which is difficult to

FIG. 11. Anthony Van DYCK, *Antwerp Sketchbook*, page 19 *verso*.

FIG. 12. Anthony Van DYCK, Musée des Beaux-Arts et d'Archeologie, Besançon (Inv. no. D. 28), *Verso* of drawing illustrated as Fig. 8, *c.* 1620. Pen, 23.8 × 16 cm.

FIG. 13. Anthony Van DYCK, *Antwerp Sketchbook*, page 11 *verso* and 12 *recto*.

reconcile with the Besançon drawing. The latter, while rough, almost scribbled, presupposes a firm grasp of anatomy. Another valuable comparison is 11 *verso*/12 of the Sketchbook showing the *Carrying of the Cross* (Fig. 13)[20] and the series of drawings for the 1617 commission of a painting of this subject for the Dominican church in Antwerp (Vey 7–14). Jaffé connects the two, but the Sketchbook drawings are far cruder. Also, the script is very different from that on the Rijksmuseum sheet. This page of the Sketchbook also has marked graphic mannerisms, notably the abbreviated faces which can to some extent be paralleled in later, firmly attributed drawings (for example, Vey 45). The extent to which these are personal mannerisms rather than mannerisms learnt by those who came under Rubens' influence is hard to judge.

Comparison with the Italian Sketchbook is equally tantalizing. For example, groups of apostles appear on page 22 *recto* of the Antwerp Sketchbook (Fig. 14) and page 97 *recto* of the Italian Sketchbook (Fig. 15). The latter shows such absolute assurance that the comparison emphasizes the former's crudeness. The Italian Sketchbook dates from 1623/24 and later: could this change have come over Van Dyck's drawing style in seven or eight years? It *is* possible: these years — from 1617 until 1624 or 1625 — are the crucial years in the development of any artist, the formation of the mature individual. Another such comparison would be page 21 *verso* of the Antwerp Sketchbook and page 90 *recto* of the Italian Sketchbook.

Vey's second point is that there is no firm documentary evidence for the authorship of the book and this is undeniably true. The monogram is disputable; the evidence for the existence of two Sketchbooks by Van Dyck does not apparently pre-date 1830; and the fact that the Italian Sketchbook was stamped PL by Roger North[21] on every *recto* page but there are

[20] Egbert Haverkamp-Begemann pointed out to me that the inscription on page 20ᵛ in the Chatsworth Sketchbook is mistranslated in Jaffé (p. 219). The Dutch is *vant schaeden te observeren* which is translated by Jaffé as 'to make observations while looking'. This makes no real sense in the context and in fact, it should be translated 'how to observe [that is, observe on paper, and so, represent] maltreatment'.

[21] In *The Autobiography of Roger North*, ed. Augustus Jessop (London, 1987), North says that when going through Lely's collection after his death, he stamped 'every individual paper'.

no such stamps in the Antwerp Sketchbook, points to the latter not having been in Lely's collection.

Thirdly, Vey says that the content of the Sketchbook is not what we would expect of the young Van Dyck. This is a powerful argument. The Sketchbook contains many drawings after the Antique as well as many pages of transcriptions of notes on architecture — illustrated by drawings of architraves and columns — from Rubens' Pocket-Book. There are also the pages of medical recipes. Van Dyck does not display any significant interest in these matters later in his career. Indeed it is a striking aspect of the Italian Sketchbook that there are almost no drawings at all after the Antique; nor are there any of architecture. In this, of course, Van Dyck was most unlike Rubens: Van Dyck was *not* a learned painter on the Renaissance model. When he went to Italy he did not expose himself to the enormous range of artistic experience available to him: he knew what he wanted to see and he sought it out. And what he wanted to see was, for the most part, the work of Titian and his Venetian contemporaries. Ancient art, and for that matter much Renaissance art, did not interest him. Vey found — and indeed continues to find, as I recently discussed this matter with him — the artistic personality of the mature Van Dyck impossible to reconcile with that of the artist of the Antwerp Sketchbook.

Vey's arguments do not seem to me to absolutely disprove Van Dyck's authorship of the Sketchbook. However the drawing style *is* different and the interests revealed are unexpected, so that if the book is by Van Dyck it has to date from early enough in his career to permit these changes to take place. It must therefore be dated *c.* 1616 and considered as juvenilia by a precocious and rapidly maturing artist. The problem with this dating is that, as far as we know with any certainty, it is unlikely that Van Dyck had close enough access to Rubens before 1618/20 to copy extensive passages from the Pocket-Book. The Sketchbook would therefore have to have been

FIG. 14. Anthony Van DYCK, *Antwerp Sketchbook*, page 22 *recto*.

FIG. 15. Anthony Van DYCK, *Italian Sketchbook*, page 97 *recto*.

FIG. 16. Anthony Van DYCK, *Antwerp Sketchbook*, page 46 *recto*.

22 L. Burchard and R. d'Hulst, *Rubens Drawings*, 2 vols (Brussels, 1963), p. 11, cat. no. 140 as from the 1630s. Jaffé, op. cit., p. 235 dates the oil sketch *c.* 1618 and does not discuss the Turin painting.

23 It is first recorded in the Palazzo Pietro Gentile in Genoa in 1768 (*Description des Beautés de Gênes* (Gênes, 1768), p. 33).

24 *Rubens e Genova*, exhibition catalogue (Genova, Palazzo Ducale, 1977–78), cat. nos 3 and 4, pp. 214–21.

used by the young Van Dyck over a period of four or five years and it does not show the kind of stylistic development that would be consistent with use over such an extended period. The alternative attribution — implied by Vey though not explicitly argued by him — must be to a pupil of Rubens who was also familiar with the work of Van Dyck, probably active in the early 1630s. This brings us to what I would consider to be the crux of this whole question. On pages 46 *recto* and 47 *recto* of the Antwerp Sketchbook are two drawings of Hercules (Fig. 16). The pose is that of Rubens' *Hercules in the Garden of the Hesperides*. There can be no doubt of the source — the details of the pose are exactly the same. There is a sketch in Paris (in oil on paper) for this composition: its attribution to Rubens is, however, disputed.[22] We are therefore on firmer ground if we discuss the drawing in the Antwerp Sketchbook in relation to Rubens' painting which has been recently acquired by the Galleria Sabauda in Turin and was formerly in the Palazzo Madama (Fig. 17).[23] It has a pendant which is said to show Dejanira tempted by a fury. Both paintings were included in the exhibition *Rubens e Genova* in 1977/78 and dated in the catalogue to *c.* 1606.[24] This must be incorrect: judging by the very

FIG. 17. Peter Paul RUBENS, Galleria Sabauda, Turin, *Hercules in the Garden of the Hesperides*, Oil on canvas, 246 × 168.5 cm.

loose handling of both figures and landscape, I believe it is indisputable that the *Hercules* and its pendant belong to the last decade of Rubens' activity.[25] So that if the drawing in the Antwerp Sketchbook is a copy of the painting it must date from post-1630 — unless, of course, there was an earlier study which Rubens used as the basis for his large-scale painting.

The attribution of the Sketchbook remains, therefore, problematic. It has some of the graphic mannerisms of the mature Van Dyck and it does seem to be the work of a vigorous, young artist at the very beginning of his career. If we look for candidates amongst later generations of Rubens'

[25] Held also thought the dating in the Genoa exhibition catalogue unlikely (J. S. Held, *The Oil Sketches of Peter Paul Rubens*, 2 vols (Princeton, 1980), p. 647).

FIG. 18. Anthony Van DYCK, *Italian Sketchbook*, page 29 *recto*.

pupils and collaborators they are not easy to find — the drawing styles of Abraham van Diepenbeeck (whose monogram would, of course, be AVD) and Gaspar de Crayer are well-established and quite different; and I have looked in vain through the several hands of the Cantoor Drawings in Copenhagen for the artist of the Antwerp Sketchbook.

I must now climb down from the fence. I have made six trips in recent years to Chatsworth for the sole purpose of studying the Sketchbook and, having been for a long time a doubter, have come to think that it must be by Van Dyck. It must be a very early work of *c.* 1616/17 and I think that rather than its having been used by him over a lengthy period, it in fact supports the idea that Van Dyck entered the intimate circle of Rubens significantly before the Jesuit Church commission. In his famous letter of 28 April 1618, to Carleton, Rubens calls Van Dyck 'the best of my pupils' (*discepolo*) and the Sketchbook should, in my view, be placed significantly earlier. Such a dating has, of course, important consequences for the dating of the Pocket-Book. Rubens must have overwhelmed the young Van Dyck and we must imagine that Van Dyck passionately embraced the older man's enthusiasms for antique art and for architecture, only to abandon them later. If the Sketchbook is — almost in its entirety — a transcription

of the Pocket-Book, this becomes even more comprehensible. It represents Van Dyck's total immersion in Rubens' artistic and intellectual world, which Van Dyck was later, and not so very much later, to reject.

The 'Hercules problem' remains: we can only imagine that an earlier drawing or *modello* was used for the painting in Genoa. If we compare the two compositions this seems to me perfectly acceptable: the profile of Hercules and his excessively mannered pose point to its being the product of an earlier phase of Rubens' career.

In the end, the issue is one of connoisseurship. I believe that the Antwerp Sketchbook simply contains too many of the graphic mannerisms of the mature Van Dyck *in ovo* to be by any other artist. This can be seen when we compare page 29 *recto* of the Italian Sketchbook (Fig. 18) and page 22 *recto* of the Antwerp Sketchbook, particularly the profile of Christ and Saint John; or, again, page 18 *recto* of the Italian Sketchbook and page 53 *recto* of the Antwerp Sketchbook.

Claude Lorrain as a figure draughtsman

by MICHAEL KITSON

[1] *Master Drawings: The Woodner Collection*, exhibition catalogue (Royal Academy of Arts, 1987), No. 74; Marcel Roethlisberger, *Claude Lorrain: The Drawings* (University of California Press, 1968), (henceforth MRD), no. 711.

[2] *Liber Veritatis* (LV), no. 125, discussed below.

[3] The album then contained sixty drawings, all by Claude, a further twenty-one having previously been cut out and removed. It was acquired from Wildenstein by Norton Simon in 1968 and published by Roethlisberger twice, first as *Claude Lorrain: The Wildenstein Album* (Paris, 1962), and secondly in more comprehensive, fully revised version as *The Claude Lorrain Album in the Norton Simon Museum of Art* (Los Angeles, 1971). In 1980, the album was broken up and the sheets sold separately, a good many being bought by Agnew's. Despite further intensive study by Roethlisberger of the Odescalchi Collection ('The Drawing Collection of Prince Livio Odescalchi', *Master Drawings*, XXIII–XXIV (1985–86), pp. 5–30), it is still tantalizingly uncertain whether the Claude drawings in this collection had previously belonged to Queen Christina of Sweden (died 1689), although Roethlisberger makes a good case for saying that they did.

[4] On the other hand, there have been some articles on Claude's figures in his paintings. See in particular, P. du Colombier, 'Essai sur les personnages dans l'oeuvre de Claude Lorrain', *Bulletin de la Société Poussin*, III (1950), pp. 41 ff; H. Bauereisen, 'Claude Lorrain als Figurenmaler', in *Intuition und Darstellung. Erich Hubala zum 25 Marz 1985*, ed. F. Buttner and C. Lenz (Munich, 1985), pp. 159 ff; and, the most important, Marcel Roethlisberger, 'Das Enigma überlängter Figuren in Claude Lorrains Spätwerk', in *Nicolas Poussin/Claude Lorrain: Zu den Bildern im Städel*, catalogue of an exhibition in the Städelsches Kunstinstitut, Frankfurt am Main, 11 February–10 April 1988, pp. 92–100. Roethlisberger gave a brief preview of the substance of this article in the concluding section of his contribution, 'Claude Lorrain: Some New Perspectives', to the proceedings of the Claude Lorrain Symposium at the National Gallery of Art, Washington, in 1982 (*Studies in the History of Art*, XIV (Washington D.C., 1984), pp. 47–65).

[5] From the *Life* of Claude in F. Baldinucci, *Notizie de' Professori del Disegno*, IV (Florence, 1728 (but written shortly after Claude's death in 1682)); English translation in M. Roethlisberger, *Claude Lorrain: The Paintings* (New Haven, 1961), pp. 53–62. Joachim von Sandrart, who was in Rome from 1629 to 1635 and knew Claude there, wrote in *Der Teutschen Akademie*, Part II, Nuremberg, 1675: 'At this point I cannot omit to say that however happy this beautiful spirit is in representing well the naturalness of landscapes, so unhappy is he in figures and animals, be they only half a finger long, that they remain unpleasant in spite of the fact that he takes great pains and works hard on them, and drew for many years in the academies in Rome from the life and from statues, and even applied himself more to the figures than to the landscapes' (English translation, op. cit., pp. 47–50).

My first reason for choosing Claude Lorrain as a figure draughtsman as the subject of this paper — a topic that might seem rather eccentric in relation to one of the greatest *landscape* painters of all time — is that the single drawing by Claude included in the exhibition of the Woodner Collection at the Royal Academy in 1987 was, in fact, a figure-drawing (Fig. 31, p. 82).[1] It represents *Christ and the Two Disciples on the Road to Emmaus* and is the artist's final preparatory study for the figures in a now lost landscape painting of the same title executed in 1652.[2] It is among the most magnificent drawings by Claude of its kind and also among the best preserved. The sheet, measuring 17 × 22.5 cm, was first covered with a clear pink wash, a practice fairly common with Claude at this stage of his career. The white heightening is unusually rich and dense and is used not just to create highlights but also to model the forms. The white is counterbalanced by dark brown wash, a wash that retains its strength and luminosity because the sheet had lain unexposed to light in an album in the Odescalchi Collection in Rome from shortly after Claude's death until 1960, when the album was bought by Georges Wildenstein.[3]

I shall return to this drawing later to discuss its relationship to the painting (which is recorded in Claude's *Liber Veritatis*) and to two other preparatory drawings for the same group of figures. Here I want only to call attention to its extraordinary boldness. This quality shows itself not only in the power of the figures and the forceful straight lines of the staves but also in the vigorous handling of the tree-trunks and foliage, down to the curving chalk lines used for the trees in the distance on the right. For all the delicacy of their rendering of light, Claude's drawings are often much bolder and more dramatic than is generally supposed.

My other reason for deciding to concentrate on Claude's figure-drawings is that they have never been discussed as such before, although more attention has been given to them recently than used to be the case, just as more attention has been paid to his subject matter.[4] From the very beginning, Claude's figures have given trouble to his admirers. Both his early biographers, Sandrart and Baldinucci, remarked on their awkwardness and singled them out as poorly handled by comparison with the beauty of his landscapes, despite the fact that he was known to take a good deal of care over them. (Both critics were, of course, referring to the figures in Claude's paintings, not his drawings, but what applies to the one applies equally to the other. In this paper, I shall inevitably be concerned almost as much with the artist's painted figures as with his drawn ones.) According to Baldinucci: 'He adorned his landscapes with figures made with incomparable care, but since he could never overcome in them his obvious fault of drawing them too slender, he used to say that he sold the landscapes and gave away the figures.' Indeed, continues Baldinucci, his modesty was such that 'he took no displeasure in having the figures in his landscapes and seapieces added by another hand, which was normally done by Filippo Lauri, famous in Rome for this kind of work'.[5]

Now, there is an obvious contradiction here for, if the figures in the paintings were by another hand, it would be that other hand, not Claude's, that would be open to criticism. To put it another way, why should Claude

have hired a figure specialist if the end product was no improvement? Nevertheless, ignoring this difficulty, later commentators have conjured up a whole troupe of artists — among them, Francesco Lauri (Filippo's elder brother), Jan Miel, Swanevelt, Cerquozzi and Jacques Stella — as the supposed painters of Claude's figures. To early twentieth-century critics, such as Roger Fry and A. M. Hind, who judged Claude in the light of French Impressionist aesthetics, his figures were so inept as to be almost unmentionable.

However, there has long been a minor current of opinion which recognized the unity between the figures and the other components of Claude's compositions. This was exemplified in a negative way by Ruskin, who claimed, with perverse logic, that 'his picture, when examined with reference to essential truth, is one mass of error from beginning to end'.[6] In other words, not just the figures but the trees, foliage, mountains, clouds and buildings were incorrect. And indeed, this is strictly speaking the case; any illusion to the contrary is due to the fact that we detect the faults in figures and to some extent buildings more easily that we do those in the more irregular forms of nature.

The same sense of the unity of Claude's treatment of all phenomena was expressed by John Constable, who saw it, however, as a positive virtue. 'Though it is the fashion to find fault with Claude's figures indiscriminately, yet in his best time they are so far from being objectionable, that we cannot easily imagine anything else according so well with the scenes; as objects of colour, they seem indispensable.'[7] And Constable quoted Richard Wilson in support: 'Do not fall into the common mistake of objecting to Claude's figures.'[8]

Today, surely, we would agree with Wilson and Constable; and we may ignore Ruskin who, however correct according to his lights, was simply judging Claude's art by the wrong criteria — or some of his art by the wrong criteria at any rate, for Ruskin recognized the beauty of Claude's treatment of light. What is more, it is now generally agreed that all, or virtually all, the figures in Claude's paintings are by his own hand. The only ones that remain in doubt are those in a few of the early works, though *which* works, if any, is still unresolved.[9] In none of these paintings, be it noted, is there any obvious sign of that disruption of the paint surface which would signal the intervention of a collaborator. An even stronger proof of the authenticity of at least the vast majority of Claude's figures lies in his drawings. There can be no question of the figures in the drawings being by any other artist. And they are in exactly the same style, or styles — for there is more than one, as we shall see — as the figures in the paintings.

It is scarcely necessary to emphasize the role of figures in Claude's compositions. Hardly any of his paintings is without them. They play an essential part both visually and symbolically. As 'objects of colour', to use Constable's phrase, they draw out and exhibit in concentrated form the colours distributed in paler and more muted tones throughout the landscape. The blue of the sky and of water, the soft pinks, violets and yellows blended with neutral hues in the background and in the buildings, the greens of the trees and grasses, all reappear, in whole or in part, much more intensely in the costumes worn by the figures. In addition, the figures are strategically placed so as to provide a focus for the composition and to counteract the pull of the distant horizon (Fig. 1). They animate the foreground and often (not always) enact a biblical or mythological story. Above all, the figures symbolize that ideal harmony between man and nature, which it is the consistent aim of Claude's art to evoke. None of these uses for figures was particularly new or unusual, though the completeness with which Claude's figures fulfil the functions allotted to them perhaps was.

[6] *Modern Painters*, I (1843) (*The Works of John Ruskin*, ed. Cook and Wedderburn (London, 1903), III, p. 167).

[7] Lecture at the Royal Institution, Albermarle Street, London, 2 June 1836; see *John Constable's Discourses*, ed. R. B. Beckett (Suffolk Records Society, 1970), pp. 53 f.

[8] Ibid.

[9] According to Roethlisberger ('Claude Lorrain: Some New Perspectives', article cited in note 4 above, p. 60), 'the collaboration of a figure painter pertains to only a small number of early paintings around 1630'. Presumably one of these is the *Landscape with Part of a Lake*, No. 1 in the exhibition, *Im Licht von Claude Lorrain*, Haus der Kunst, Munich, 1983, catalogue by Marcel Roethlisberger. Diane Russell, in the catalogue of the Washington exhibition, *Claude Lorrain 1600–1682* (1982), pp. 71, 78, cites the artist's earliest dated picture, *Landscape with Cattle and Peasants*, 1629, now in Philadelphia, as an example and also his first two oblong landscapes with anchorite saints (S. Maria de Cervellò and S. Onofrius) in the Prado of c. 1635, the figures in which she seems to suggest are by Swanevelt. I am inclined to agree with Roethlisberger that the figures in these two paintings are by Claude, though the poor condition of the paint surface makes a definite judgement hard to reach. They are, however, close to Swanevelt in style and not, as Roethlisberger claims, like the figures in Claude's *Coast Scene with the Rape of Europa* (Fort Worth) of 1634, which are unquestionably by him.

FIG. 1. Claude LORRAIN, The Earl of Yarborough, *Landscape with a Rustic Dance*, 1637. Oil on canvas, 71 × 100.5 cm. LV, 13.

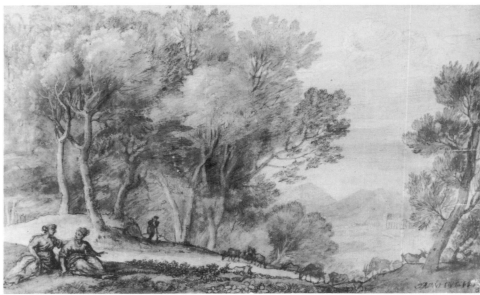

FIG. 2. Claude LORRAIN, Devonshire Collection, Chatsworth, reproduced by permission of the Chatsworth Settlement Trustees, *Landscape with Diana and Callisto*, c. 1665. Pen, brown and grey-brown wash, black chalk and white bodycolour, 23.5 × 39.3 cm. MRD, 950.

They perform a similar role, minus the colour, in Claude's finished composition drawings executed as independent works of art. In these drawings (as distinct from his studies for, or records of, paintings), the rules of composition which govern Claude's paintings are in varying degrees relaxed. In some of them, such as the *Landscape with Diana and Callisto* (Fig. 2) of about 1665, the treatment is only a little simpler and more informal, and the mood somewhat more intimate, than would be the

FIG. 3. Claude LORRAIN, Albertina, Vienna, *Landscape with the Penitent Magdalene*, 1648. Brown wash and white bodycolour, 16.3 × 21.2 cm. MRD, 662.

case in a painting of the same date. However, in the *Penitent Magdalene* (Fig. 3) of 1648, the figure is of equal importance with the landscape, something which never occurs in the paintings.[10] Some fifteen to twenty composition drawings, mostly dating from the middle and late periods of the artist's career, may similarly be described as figure compositions with a landscape setting, rather than as landscapes with figures.

In the drawings from nature, most of which date from before 1645, the deviation from the rules of complexity and order governing the paintings is carried much further. As is well known, Claude's nature drawings are informal, spontaneous and often simple, where his paintings are formal, controlled and complicated. As a draughtsman from nature, he was able to find a graphic equivalent for any *motif* that caught his attention: trees, rocks, hills, buildings, folds in the ground of all shapes and sizes. There is no set pattern — though there is, in another sense, a 'pattern', or quality of instinctive design on the page. And the *motifs* Claude chose to draw are rendered in a wide variety of techniques, reflecting the range afforded by his materials — washes of different strengths and hues, pens cut to different thicknesses, and black chalk, pen and ink and brown ink wash available for use in different combinations.

Many of the nature drawings are without figures altogether, but when figures appear they do so in almost as great a variety as the settings. It is appropriate first to mention representations of the artist sketching — proof if such were needed that Claude's nature drawings really were executed from the *motif* in the open air. The artist shown is not necessarily a self-portrait, though on the sheet inscribed *strada da Tivoli a sobiacha* (i.e. Subiaco; Fig. 4), Claude's signature appears suggestively beneath the figure. The artist is often accompanied by one or two friends, sometimes a sportsman with a gun, as in the dazzling drawing (Fig. 5) of two figures in silhouette perched on a fallen tree.

Shepherds and shepherdesses, predictably, are common. In Figure 6, the solitary herdsman stands, wrapped against the cold, guarding his few cattle in the Forum Romanum, or Campo Vaccino. The gateway to the Farnese Gardens and the church of S. Maria Liberatrice, both no longer there, are in the background.[11] In a more spacious and elaborate drawing,

[10] However, there is one lost figure painting, *The Liberation of St Peter*, LV 51, of 1640–41, the setting of which is an interior. The very late *Parnassus with Minerva visiting the Muses* (LV 195), in Jacksonville, Florida, is the only painting in which the figures can truly be said to dominate the landscape.

[11] Both were taken down earlier this century to make way for excavations in the Roman Forum. The gate has now been re-erected beside Via di S. Gregorio, on the east side of the Palatine Hill.

FIG. 4. Claude LORRAIN, British Museum, London, *On the Road from Tivoli to Subiaco*, 1642. Pen and brown wash, 21.4 × 31.3 cm. MRD, 483r.

FIG. 5. Claude LORRAIN, British Museum, London, *An Artist and another Figure on a Fallen Tree*, 1635–40. Brown wash and black chalk, 21.4 × 32.1 cm. MRD, 290.

Pastoral Landscape (Fig. 7), the shepherds sit or stand beneath the trees, with their herds grazing around them. In *A Town in the Roman Campagna* (Fig. 8), travellers walk along a road outside the walls, while a man in hat and cloak stands gazing at something at his feet, possibly part of a stream.

In Claude's later drawings from nature, which are much fewer in number than those from his early years, the figures are slightly different in style, though still realistic. They are as often women as men, and one or two appear to be simplified portraits. Figure 9, for example, may be the artist's adopted daughter, Agnese, born in 1653 (to whom he bequeathed the *Liber Veritatis*).

It would be easy to find equivalents in Claude's early paintings (Fig. 10) for the figures in his nature drawings of the same period, but after about 1645 there is a parting of the ways. While the few late nature drawings continue to include figures from everyday life, as we have just seen, the figures in the later paintings, even the shepherds and shepherdesses, are idealized pastoral types, suggestive of a mythical past.

Figures taken from daily life in landscape drawings were not, of course, new in art, any more than the use of figures for compositional and symbolic purposes in landscape painting was new. Such figures occur close to Claude's time in drawings by Annibale Carracci and Breenbergh (Fig. 11). Breenbergh, whom Claude must have met and possibly gone sketching with in the Roman Campagna in the 1620s (he returned to Amsterdam in 1629), was the artist who had the greatest influence on Claude's drawings from nature. Yet, compared with Claude's, Breenbergh's figures are stilted and uninventive. Claude makes the personages he encountered on his sketching expeditions vivid and fascinating. More than any other seventeenth-century artist, he reveals in his drawings the routines of daily life in the Roman Campagna: shepherds tending their flocks and herds, men cutting wood, people travelling through the landscape on foot or sitting watchfully, often alone, in the shade of trees. Claude is the silent observer of all this. He does not communicate with the inhabitants or travellers he sketches, nor they with him. Hence the figures in his drawings (less so those in his paintings) appear rapt in their own thoughts or occupations and slightly mysterious.

Yet from a very early date, Claude did not limit himself to a realistic style of figure drawing. The dumpy, rounded *Penitent Magdalene* (Fig. 12) comes from the same small sketchbook dating from about 1630 as the herdsman in the Forum Romanum (Fig. 6).[12] Still clearer evidence that Claude was anxious to develop a more idealistic, classical figure style alongside his naturalistic one is contained in the pair of pictures he painted in 1633, now in the Buccleuch Collection. In the *Harbour Scene* (Fig. 13), the figures are in the realistic style of the Bamboccianti, i.e. the Dutch *genre*

[12] This small sketchbook, from which about 40 sheets can now be traced, is discussed in MRD, p. 57.

FIG. 6. Claude LORRAIN, Royal Library, Windsor Castle, *A Herdsman with Cattle in the Campo Vaccino*, *c*. 1630. Pen and brown wash, 12.8 × 9.4 cm. MRD, 16. *Reproduced by Gracious Permission of Her Majesty the Queen.*

FIG. 7. Claude LORRAIN, Thos. Agnew & Sons Ltd, London, *Pastoral Landscape*, *c*. 1640. Black chalk, brown wash for the lower part, light grey wash for the trees, 22 × 32 cm. MRD, 477.

FIG. 8. Claude LORRAIN, British Museum, London, *A Town in the Roman Campagna*. Pen and brown wash, 19.2 × 26.6 cm. MRD, 428.

painters in Rome with whom Claude associated at this date. The pendant, *Landscape with the Judgement of Paris* (Fig. 14), on the other hand, contains naively drawn but distinctly idealized, classical figures. How do we explain this contrast? It is not a coincidence, of course, that the first painting is a *genre* scene, the other a mythological one — the earliest picture with a mythological subject in Claude's *œuvre* that we know. Underlying his choice of this type of subject must have been a desire to broaden his repertoire and perhaps also to identify himself with a better class of painter — in the year that he executed these two pictures he joined the Roman Academy of St Luke. This is not to say that he abandoned naturalism, though he ceased to include figures in modern dress in his paintings after the early 1640s, as we have seen. The new move represented an extension of his range, not the substitution of one mode for another.

It must have been at about this time, if not earlier, that Claude began, to quote his biographer, Sandrart, 'to draw in the academies in Rome from the life and from statues.'[13] At first sight this statement appears highly implausible, but surviving drawings suggest that it is literally true.

[13] See note 5 above for reference.

FIG. 9. Claude LORRAIN, Teyler Foundation, Haarlem, *Landscape with a Seated Girl*, 1669. Black chalk with pen and light brown wash, 14.5 × 20.6 cm. MRD, 1001r.

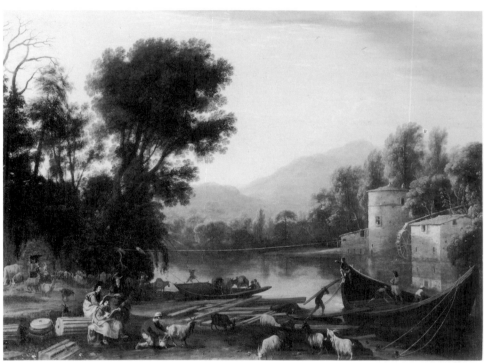

FIG. 10. Claude LORRAIN, Museum of Fine Arts, Boston, *Landscape with a River*, 1631. Oil on canvas, 61 × 85 cm.

[14] Respectively MRD 84, 199 recto and 37.

To take statues first, Figure 15 is a drawing datable to about 1633 after a life-sized classical statue, then as now in the Palazzo dei Conservatori in Rome. Claude also made studies of other statues on the Capitol, including the river god (which he used several times in his paintings, among them the *Harbour Scene*, Fig. 13, where it appears under the portico to the left) and the group representing a lion attacking a horse.[14] As a drawing, Figure 15 is clearly very weak, and Claude may have been motivated more by curiosity and the wish to find a *motif* for his art than by a determination to understand the principles of classical form. It was probably for similar reasons, and specifically for costume details as much as anything, that he made a series of studies, of which Figure 16 is one, of figures in the reliefs on the Arch of Constantine. These studies were executed in a small sketchbook dating from the 1650s. They were made almost certainly by drawing directly from the originals, rather than by the

easier method of using engravings.[15] He probably erected a platform like the one seen in Figure 17, where the artist seems to be sketching, not the statue visible to his right, but another one concealed between the columns in front of him.

Of greater relevance than these to the development of Claude's figure style are the studies he made from the life. Figures 18 and 19 are two examples of academy drawings, one showing the figure in the pose of a *Venus pudica* (it may even be after a statue although, if so, it is very unsculptural in its treatment of form). Both are hesitantly drawn, although more accomplished than the copy of a female statue mentioned above. At first sight, they are untypical of Claude. Yet there is no reason to doubt them, for they appear on the reverse sides of landscape or figure drawings which are unquestionably by him. Seven studies of this type are at present known, all but one in red chalk (the exception is in black chalk), though there must once have been many more.[16] Four of the seven show the figure cut at the waist, indicating that Claude originally used a larger sheet which he afterwards divided into two in order to draw on the two halves of the other side. It follows that the life study on what is now the *verso* is not just earlier, but may be considerably earlier, than the landscape or figure group represented on the *recto*. In fact, I am inclined to think that all Claude's academy life-studies date from the first half of the 1630s, even though on the *recto* of one of them is a fine drawing,[17] done from imagination, not from life, connected with the figures in *The Marriage of Isaac and Rebecca* (LV 113) of 1647–48. The principal stylistic influence on these studies is that of Annibale Carracci, whose drawings were doubtless still given to pupils to imitate in the Roman academies of the 1630s. Compare, for example, the study of legs by Claude illustrated here (Fig. 20) with Annibale's study for the legs of Mercury (Fig. 21)[18] in his fresco of *Perseus and Medusa* in the Camerino Farnese; not only is the treatment of the anatomy similar but so is the drawing of the contour lines and the use of diagonal shading. This is not to say, of course, that the two drawings are equal in power; indeed, Claude's looks almost comically inept beside the Bolognese master's elegant study. But there can be no doubting the source, any more than it is possible to overlook Annibale Carracci's later, wider influence on Claude's drawing style, particularly on his handling of the pen in rough sketches of landscape as well as figures, as will be seen later.

Now, it is abundantly clear from his art as a whole that the time spent by Claude in drawing from the life and from statues did not make him into an academically correct figure draughtsman or figure painter of the class of Sacchi or Poussin. He refrained from attempting to follow that path, partly because he realized that it did not suit him, partly because to try to live up to the standard of those artists was too much trouble, and increasingly no doubt because he became aware that conventionally proportioned and modelled figures would have been out of keeping with his landscapes, as we shall see.

Yet the recollection of the female nude (Fig. 18), may have found its way into the goddesses in *The Judgement of Paris* (Fig. 14), and it is certain that Claude sustained his interest in classical figure style through his borrowing of *motifs* from the work of other artists. Of these artists by far the most important was Raphael, as Marcel Roethlisberger has pointed out.[19] There is, as it happens, only one surviving direct copy by Claude after Raphael — a sheet containing studies, mainly in pen and ink, after figures in *The School of Athens* and *The Battle of Ostia*[20] — but, as a pattern-book supplying models of physical types, if not precisely as a guide to the treatment of ideal human form, Raphael's work proved its value to Claude over and over again. Even the figures in *The Judgement of Paris* of 1633 are Raphaelesque in a non-specific sense, as are the figure groups in

[15] This sketchbook was first published by the present writer in the *Burlington Magazine*, 'A Small Sketchbook by Claude', CXXIV (1982), pp. 698–703. It was bought at Sotheby's on 18 November 1982 by the Nationalmuseum, Stockholm, which afterwards deposited it in the Swedish Embassy in London to evade the ban on its export, after the Export Reviewing Committee had temporarily withheld a licence and even though the British Museum had agreed to match the auction price. The sketchbook is now rumoured to be in Stockholm. It was Dr Jennifer Montagu who pointed out in a letter to the *Burlington Magazine*, CXXV (1983), p. 96 that Claude copied the figures from specific classical sources, probably working from the originals rather than engravings, whereas I had supposed that Claude made the figures up using sources such as the Column of Trajan and the paintings of Raphael only as a guide. The sketchbook was re-published, incorporating corrections to my article and a full set of illustrations but omitting the loose sheets by Claude dating from c. 1630, by Per Bjurström in Stockholm in 1984 (*Claude Lorrain: Sketchbook*). The soldier reproduced here as Fig. 16 is on f.6 *recto* and is the figure of *Roma* on the extreme left of *Trajan's Triumphal Entry from Porta Capena* on the Arch of Constantine. François Perrier's engraving of this relief, dated 1645, illustrated by Bjurström, is in reverse, which tends to confirm that Claude drew from the original.

[16] A list of Claude's surviving academy studies, with illustrations of those that were still pasted down and incapable of being photographed when Roethlisberger's *Claude Lorrain: The Drawings* (MRD) was published in 1968, is given by Roethlisberger in *The Claude Lorrain Album* (Los Angeles, 1971), p. 15 and pl. 61. For further brief particulars of this album, see note 3 above.

[17] MRD 651; formerly Wildenstein/Norton Simon Album; with Agnew's in 1982 and illustrated in colour on the cover of the Claude exhibition at Agnew's in 1982, no. 27. Fig. 20 in the present article is the *verso* of this drawing.

[18] Musée du Louvre, Inv. No. 7405; J. Rupert Martin, *The Farnese Gallery* (Princeton, 1965), p. 247, Cat. no. 33. The one drawing that does not show Annibale's influence is that of a female figure, here Fig. 18, which Roethlisberger (MRD 172v) has said 'bears a resemblance to some of the few early academy studies by Callot'. The legs on the *verso* of MRD 485 recall those of the two *ignudi* above the Eritrean Sibyl on the Sistine Ceiling, but the correspondence is not quite close enough to demonstrate that they are a copy; they were doubtless drawn from a male model seated in the same pose.

[19] MRD, p. 33.

[20] MRD 330 *verso*, c.1640.

FIG. II. Bartholomeus BREEN-
BERGH, The Courtauld Institute of Art,
London, *The Ponte Nomentano, c. 1625.*
Pen and grey-brown wash, 13.8 ×
28.8 cm.

FIG. 12. Claude LORRAIN, Private
Collection, *Penitent Magdalene, c. 1630.*
Black chalk and pen with touches of
brown wash, 10.5 × 7.8 cm. MRD, 40.

several of Claude's drawings of the 1640s[21] and 1650s, including the
Woodner drawing.

To imitate Raphael in figures, like studying in the academies, was
Claude's method of raising his landscapes on to a higher social and
aesthetic plane — and it was a more effective and more durable method
than making life-drawings or studying antique statues. The world of
Raphael — exalted, refined and classicizing — was the sixteenth-century
figural analogue of the type of ideal landscape with figures which Claude
created, albeit by slow degrees rather than all at once, in the seventeenth
century; not for nothing was he known in the period after his death as 'the
Raphael of landscape painting'.[22] More specifically, he looked to Raphael
and his circle for a way of handling pictorial narrative. The model he used
here above all were the frescoes in the Vatican *loggie* — those busy, fluid
yet compactly organized scenes which encapsulate the essence of nearly
fifty Old Testament stories. As a consequence of studying these frescoes,
which he began to do in the 1640s, Claude's figures in his mature and later
paintings and composition drawings are more expressive and purposeful
than those in his drawings from nature; they are more animated and
communicate more freely with each other. The *loggie* may also have given
Claude ideas for the treatment of costume when depicting biblical and
classical subjects; the short tunic worn by men seems in particular to derive
from this source.

The paintings by Claude with figures based on the Raphael (or
Raphael-designed) frescoes in the *loggie*, where the same scenes occur, are,
in chronological order: *Landscape with Samuel anointing David* (LV 69;
c. 1643, Louvre), *The Worship of the Golden Calf* (LV 129; 1653,
Karlsruhe), *Landscape with Jacob and Laban* (LV 134; 1655, Petworth)
and *Landscape with Jacob at the Well* (LV 169; 1667, Hermitage). All
except the first of these paintings were also produced later in second
versions or derivatives. In the first two cases, it is true that figures quoted
directly from the *loggie* frescoes are to be found only in Claude's
preliminary drawings; in the finished paintings, by contrast, they are
changed in position or altered, while other figures were added from the
artist's imagination. We can observe this process of adaptation at work
particularly clearly in *The Worship of the Golden Calf*, for which four

[21] For example, MRD 461, a group of pas-
toral figures beneath a tree, *c.* 1640–45.
[22] See, for example, the inscription beneath
the posthumous portrait drawing of the artist,
c. 1700, in the front of the Wildenstein Album,
reproduced in Roethlisberger's publication of
this album in 1962. For some reason, the
drawing does not appear in the same author's
re-publication of the album in 1971 (for
bibliographical details, see note 3 above).
Claude was also compared to Raphael by
Horace Walpole in the *Aedes Walpolianae*,
1747.

FIG. 13. Claude LORRAIN, The Duke of Buccleuch and Queensberry, *Harbour Scene*, 1633. Oil on canvas, 99 × 124.5 cm.

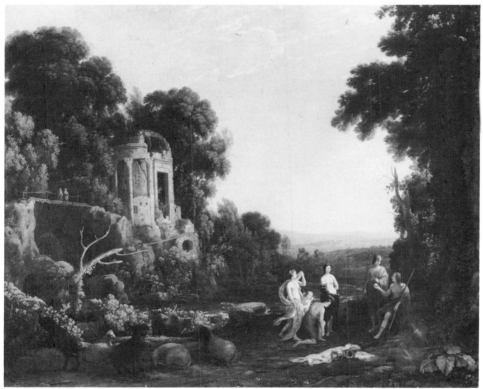

FIG. 14. Claude LORRAIN, The Duke of Buccleuch and Queensberry, *Landscape with the Judgement of Paris*, 1633. Oil on canvas, 99 × 124.5 cm.

preparatory composition drawings are known.[23] Although the first adheres quite closely to the arrangement of the figures in the fresco, the others move progressively away from it and include, as does the painting, a ring of dancing figures derived ultimately from the classical relief known as the *Borghese Dancers*.[24] The designs for the third painting, *Landscape with Jacob and Laban*, may have undergone the same transformation, although there is no means of finding out because only Claude's careful final study for the figures survives,[25] corresponding closely to the figure group in the painting; in this group, only Jacob recalls, in reverse, the corresponding figure in the *loggie*, whereas Laban and his two daughters,

[23] MRD 725–28. In Claude's large and elaborate preliminary study, MRD 522, for the figures in *Samuel anointing David*, the figure of David, among others, is taken directly from the *loggie* but is given a different pose in the painting in order to fit him, together with Samuel and various onlookers, in the space between the columns of the portico.

[24] Poussin's *Worship of the Golden Calf, c.* 1637, in the National Gallery also includes dancers but there is no formal connection with Claude's painting.

[25] MRD 754.

FIG. 15. Claude LORRAIN, British Museum, London, *Study of a Classical Statue*, 1600–35. Pen and brown wash, 20 × 9.4 cm. MRD, 82.

FIG. 16. Claude LORRAIN, National-museum, Stockholm, *The Figure of 'Roma'* (from a relief on the Arch of Constantine), 1650–55. Pen and brown ink, 18.9 × 12.9 cm.

FIG. 17. Claude LORRAIN, Royal Library, Windsor Castle, *An Artist drawing a Statue*, c. 1630. Pen and brown ink, 12.8 × 9.3 cm. MRD, 24. *Reproduced by Gracious Permission of Her Majesty the Queen.*

[26] MRD 959–64.
[27] The engraving is reproduced by Diane Russell, op. cit., in note 9, p. 57. Apollo is shown playing a lyre, as Russell points out, not a sixteenth-century violin, as he does in the fresco.

Rachel and Leah, are completely changed round and are also different in pose. Of the four paintings concerned, only the last, *Landscape with Jacob at the Well*, retains its Raphaelesque derivation to the end, after passing through minor variations in the course of six known preparatory drawings.[26] Figure 22 is Claude's beautiful final study for the figures, replicated in the painting; Figure 23 is the fresco.

It must be remembered that Claude's compositions are much more spacious than are the frescoes in the *loggie* — a spaciousness which enabled Claude to add figures at will and to spread them out over a wider area. Despite this, however, and despite adapting the figures to suit his own purposes, there is no doubt of the importance of the *loggie* for Claude. Like other seventeenth-century artists and unlike certain Neo-Classical painters of the first half of the nineteenth century, he did not aim to make his figures look like Raphael's in any literal sense; rather, the study of Raphael and his school was part of his continuing artistic education and a way of measuring himself by the highest artistic standards.

Besides the engravings after the *loggie*, which he probably used rather than the actual frescoes, Claude turned to other engraved works by members of the Raphael circle. The figures of Apollo, Clio and Calliope in his *Landscape with Parnassus* (LV 193) of 1680, for example, were clearly based on Marcantonio Raimondi's engraving after a not-quite-final project by Raphael for the *Parnassus*, not after the fresco in the Stanza della Segnatura.[27] (Curiously, however, except for the figure of Apollo, Claude does not seem to have used this engraving, or any other specifically Raphaelesque source, for his earlier versions of the theme; these begin with his huge painting (LV 126), of 1652, now in Edinburgh, and continue with

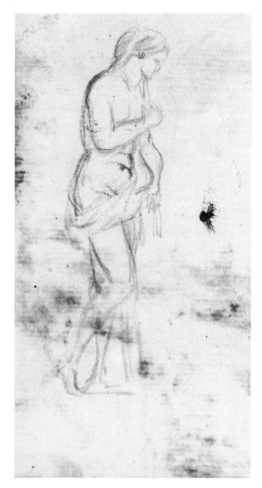

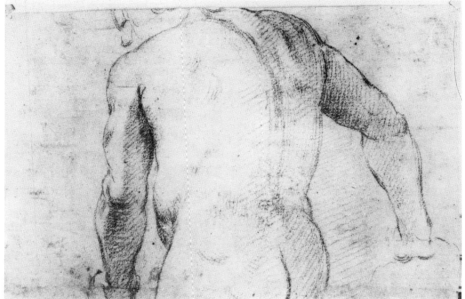

FIG. 18. Claude LORRAIN, Private Collection, *Study of a Female Nude*, 1630–35(?). Red chalk, 19.2 × 27 cm. (part of the sheet only reproduced, the remainder blank). MRD, 172v.

FIG. 19. Claude LORRAIN, Private Collection, Chicago, *Study of a Male Nude seen from the Back*, 1630–35(?). Red chalk, 16.4 × 12.2 cm. MRD, 552v.

a series of drawings dated 1674,[28] when he was already thinking of the 1680 painting.) Another striking borrowing from a Raphael follower is the seated figure of Psyche in *The Enchanted Castle*; this, as Michael Wilson discovered, is directly taken from an engraving by the Master of the Die after one of a series of paintings by Michiel Coxie illustrating *The Story of Cupid and Psyche*.[29]

A third, earlier example relates to Claude's various versions of *The Judgement of Paris*. His first painting of this subject (Fig. 14), dated 1633, is already Raphaelesque in a non-specific sense, as has been said. He next treated the subject about seven years later in one of a group of rough pen and ink sketches illustrating the story of Paris (Fig. 24)[30] — a series presumably intended to be worked up into etchings or small paintings which were never carried out. There is some echo of the 1633 painting in the sketch of *The Judgement of Paris* in this series but the decisive influence is now that of the famous engraving of the subject by Marcantonio Raimondi (Fig. 25) after a lost drawing by Raphael.[31] Not all the figures in Claude's sketch correspond to this engraving, and the women, especially, totally lack Raphaelesque grace. Venus and Juno are made to change places, Minerva is seated rather than represented standing with her back elegantly turned towards the spectator, and Mercury flies off instead of remaining poised for departure on the ground behind Paris. The next example in Claude's *œuvre* was a much finer, larger and more dramatic figure-drawing made in preparation for his painting, *Landscape with the Judgement of Paris* (LV 94; Fig. 26), of 1645–46, now in Washington. In this drawing, he experimented with further changes to the group. Venus is now kneeling, rather improbably; Minerva is standing at the left; and all the figures are almost fully clothed — Claude was by nature a modest artist who had little taste for the erotic in art; he also generally shunned violence.

[28] MRD 1070–74.
[29] *Acquisition in Focus: Claude, The Enchanted Castle* (National Gallery, London, 1982), pp. 11–12, Fig. 8. For an important re-interpretation of the subject, see Michael Levey, 'The Enchanted Castle by Claude: Subject, Significance and Interpretation', *Burlington Magazine*, CXXX (1988), pp. 812 ff. Levey argues convincingly that Psyche is shown in the grassy valley near Cupid's palace, to which she had been wafted by Zephyrus, *before* and not, as is commonly supposed, *after*, her fateful visit to the god by night. She is thus in a state of trance-like anticipation, not of dejection.
[30] MRD 368–75.
[31] The influence of this engraving on Claude's treatment of *The Judgement of Paris* was first discussed in detail by Roethlisberger in 'Claude Lorrain in the National Gallery of Art', *Report and Studies in History of Art 1969* (National Gallery of Art, Washington D.C. 1970), pp. 35–57.

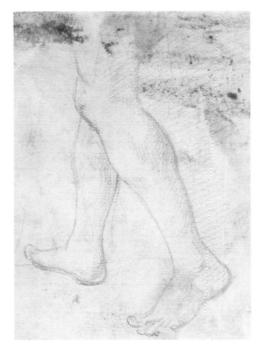 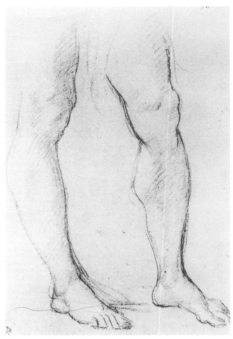

FIG. 20. Claude LORRAIN, Thos. Agnew & Sons Ltd, *Study of the Legs of a Man*, 1630–35(?). Red chalk, 16.4 × 12.2 cm. MRD, 651v.

FIG. 21. Annibale CARRACCI, Cabinet des Dessins, Musée du Louvre, Paris, *Study for the Legs of 'Mercury'*, 1595–97. Black chalk heightened with white on grey-blue paper, 28.9 × 19.4 cm.

[32] See especially pls 16c, 44b, 99b, 114b, 119d, 175b in Donald Posner, *Annibale Carracci* (London, 1971). Mention may be made here of Claude's black-chalk drawing (MRD 664) of about 1648 after Annibale's study, also in black chalk, for his print of *Mary Magdalene in Prayer* (ibid., pl. 63b). So far as is known, this is Claude's only direct copy of a work by Annibale Carracci.

[33] The one exception of any importance is the *Landscape with Nymphs and Satyrs* (LV 108), in Tokyo, dating from only a year or two after *The Judgement of Paris*. Naked nymphs also appear in the background of the *Coast Scene with Acis and Galatea* (LV 141) of 1657 and in a handful of drawings, e.g. MRD 801, 1068. However, even Venus in the finished drawing of *Venus giving Arms to Aeneas* (MRD 1026), dated 1670, in the Courtauld Institute, seems to be wearing some kind of thin dress.

Both this and the previous drawing are, it may be noted in passing, good examples of Annibale Carracci's influence on Claude's figure studies in pen and ink or pen, ink and wash dating from the 1640s; in these studies, in contrast to his academy life-drawings, Claude makes use, not of the sumptuous nude figures in red or black chalk which Annibale executed for the Camerino and Galleria Farnese, but of the latter's much rougher studies for compositions.[32]

In the Washington painting, *Landscape with the Judgement of Paris*, Claude reverts to the figure arrangement of his earlier sketch in the *Story of Paris* series, with Venus on the left (in the pose of a *Venus pudica*), Juno in the centre and Minerva seated on the right and slightly to the rear. Mercury, however, has now disappeared altogether from the scene. By disrobing the figures — except, notably, Juno — and trying his best to draw the nudes according to Raphaelesque principles, Claude here brings his treatment of the theme closer than in any of his other versions to Marcantonio Raimondi's engraving. It was his most ambitious attempt to put into practice the lessons he had learnt in his years in the academies 'drawing from the life and from statues'. It was also, in a sense, his last effort of this kind, and he scarcely ventured to depict the female nude again.[33] At the risk of presuming to read Claude's mind when the evidence is not really there, it would seem that, in drawing and painting figures, he was genuinely pulled in two directions: now following his own instincts, which were for the idiosyncratic, the wayward and the cultivation of a very personal pictorial language; now checking himself and resolving to be conventionally 'correct'. Something of this comes through, I think, in Baldinucci's account, already quoted, of Claude's own attitude to figures: taking endless pains with them yet recognizing that the attempt to conform to establish rules of anatomy and proportion was hopeless. Figure 27, which may be a record of, rather than a study for, the figures in his painting, *Seaport with the Embarkation of St Ursula* (LV 54), of 1641 shows the very great trouble he was prepared to take with figures when the occasion demanded and also that he was not afraid to include large numbers of figures in his compositions. Figure 28, on the other hand, is an example of his ability to combine classical form with a totally individual way of interpreting it; the beauty of this drawing, which was made as a final study for the lost painting, *Landscape with Apollo and Mercury*

FIG. 22. Claude LORRAIN (Formerly Wildenstein/Norton Simon Album), *Jacob, Rachel and Leah at the Well*, 1666. Pen, black chalk, with brown and grey wash, 21 × 32 cm. MRD, 964.

FIG. 23. Workshop of RAPHAEL, Loggie, Vatican, *Jacob, Rachel and Leah at the Well*, 1518–19. Fresco.

(LV 128), of 1654, lies at once in its exquisite use of line and the purity of its colour and light.

Underlying all this, there was a fundamental, if subtle, shift in Claude's approach to both landscape and the human figure in the 1640s. In brief, he became less of a naturalist and more of an idealist as regards both, and the gap widened between his drawings from nature, on the one hand,

FIG. 24. Claude LORRAIN, British Museum, London, *The Judgement of Paris*, *c.* 1640. Pen and brown wash over black chalk, 9 × 13 cm. MRD, 371.

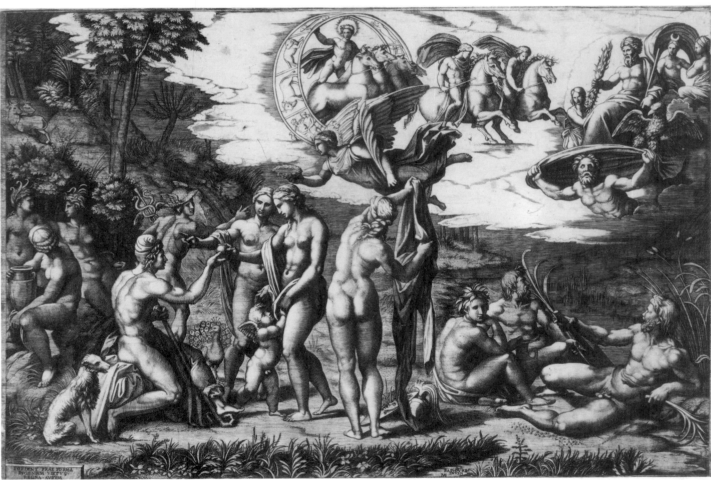

FIG. 25. Marcantonio RAIMONDI (after Raphael), British Museum, London, *The Judgement of Paris*, 1514–18. Engraving, 29.2 × 43.3 cm (sheet).

and his works produced in the studio, on the other. The trees and plants in his paintings and composition drawings began to look less like real trees and plants and the figures to look less like the people he saw and sketched in the countryside or struggled painfully to draw in the life class. As a stimulus to his imagination, it was previous art — and classicizing art at that — rather than nature, which guided his approach. In the drawing of figures, it was the handling of Annibale Carracci and the forms of Raphael and his circle that influenced him, as we have seen. In the treatment of

landscape, he took his cue from the Bolognese, specifically Domenichino; several of Claude's paintings dating from the 1640s have been shown to be based on works by that artist and one of his drawings[34] was freely copied from the latter's fresco, *St John pointing out Christ to Peter and Andrew*, in S. Andrea della Valle.[35] What is striking, however, is how few points of contact there were with the work of his own contemporaries: neither Poussin,[36] Pietro da Cortona, Sacchi, Salvator Rosa nor Gaspard Dughet had any measurable influence on Claude, though their works show a parallel stylistic development to his. While extremely original and forward-looking in his ability to render the beauty of nature and the characteristics of light, for his visual sources Claude looked more and more to the past.

I now want to return to the Woodner drawing (Fig. 31) and consider it as an example of Claude's use of preparatory studies for his paintings.[37] The painting itself, *Landscape with Christ and the Two Disciples on the Road to Emmaus*, executed in 1652 for a Frenchman called Delaborne who had a palace in Rome, is lost. It is, however, recorded in *Liber Veritatis* drawing No. 125 (Fig. 32). No studies for the composition as a whole exist but we may assume that Claude completed, or virtually completed, the design of the landscape first, including deciding on the direction of the light, before turning in detail to the figures. He may even have completed much of the actual painting. He first made a preliminary study for the figures, illustrated here as Figure 29. In this already quite powerful drawing, with the masses blocked in and the light, streaming from the right, indicated by white heightening, Christ is seen leading the two disciples and pointing in the direction they should all go. Claude next turned the sheet over and traced the design through on the *verso* in pen-and-ink (Fig. 30). This enabled him to see what the group would look like in reverse and perhaps to test whether it would fit as well or better in the space allotted to it in the landscape: he also took the opportunity to alter the position of Christ's pointing arm. Either at this stage or later, Claude decided to convert this arrangement of the figures into a separate pictorial drawing[38] with its own landscape quite different from the one in the painting.

The next stage in the evolution of the design was the Woodner drawing (Fig. 31), and in this he followed his normal practice of selecting elements from both the *recto* and *verso* of the preliminary study and combining them. Christ and the central disciple were carried over more or less unchanged from the *recto*, while the other disciple was taken from the *verso* and moved round to the right, so that Christ now occupies the middle, with his staff in his hand instead of pointing. On several counts, this was a more satisfactory solution. Christ and one of the two disciples no longer point, confusingly, in opposite directions. The gestures of all three are less those of movement than of animated conversation, which accords with the account of the incident in St Luke's Gospel. The more frontally arranged, almost symmetrical composition of the group, in place of the earlier sideways movement parallel to the picture plane, was better suited to the landscape as Claude had already conceived it. The principal axis of this landscape recedes at almost a right angle into depth. Imagining this axis as a movement, it starts in the foreground, passes through the space between the trees, crosses the river and ends at the town — Emmaus — on the hillside. The figures, in their final form, both assist and block this movement. What can only be faintly perceived in the *Liber Vertatis* drawing, but must have been very striking in the painting, is the effect of light shining on the figures. They must have seemed irradiated by it as they stood talking while suggesting by the position of their limbs that they were about to continue walking into it.

[34] MRD 499. Among the paintings by Claude derived from Domenichino, or Domenichino in collaboration with Viola, are the *Landscape with St. George* (LV 73; 1643), *Landscape with Hagar and the Angel* (LV 106; 1646) and *Landscape with the Marriage of Isaac and Rebecca* (LV 113; 1648). For general discussions of the classicizing phase in Claude's art, see MRD, pp. 32 f, and Clovis Whitfield, 'Claude and a Bolognese Revival', in *Claude Lorrain 1600–1682: A Symposium, Studies in the History of Art*, XIV (National Gallery of Art, Washington D.C. 1984), pp. 83–91.

[35] Richard Spear, *Domenichino* (New Haven and London, 1982), pl. 285.

[36] Claude's one undisputed borrowing from Poussin is in his etching, *Time, Apollo and the Seasons*, the figure group in which is based on Poussin's famous *Dance to the Music of Time* (or *Dance of Human Life*) in the Wallace Collection. The same patron, Cardinal Giulio Rospigliosi, may have been instrumental in the production of both works. For the fullest discussion of the relationship between the two compositions, see Diane Russell, op. cit., in note 9, pp. 406–11, under no. 50.

[37] The three figure drawings discussed here, including the Woodner drawing, were shown in the exhibition, *Im Licht von Claude Lorrain*, catalogue by Marcel Roethlisberger (Munich, 1983), nos 51–53.

[38] Pen and brown ink, with brown, grey and pink washes, heightened with white, on yellowish paper, 168 × 235 mm; Art Institute of Chicago. Exhibited Munich, 1983 (see the previous note), no. 52, reproduced.

FIG. 26. Claude LORRAIN, Thos. Agnew & Sons Ltd, *The Judgement of Paris*, c. 1645. Pen and brown wash, 18.2 × 26.1 cm. MRD, 597.

FIG. 27. Claude LORRAIN, British Museum, London, *St Ursula and her Companions*, 1641. Pen and brown wash, 26.7 × 41.9 cm. MRD, 459.

To sum up, Claude's figure studies for the *Landscape with Christ and the Two Disciples on the Road to Emmaus*, in their combination of opportunism and purposefulness, are typical of his procedure when preparing his paintings. The initial step, that of tracing the first drawing, with or without variations, on the back of the sheet, automatically gave him two alternative compositional arrangements. From these he would create, by selection or addition, further alternatives, until he obtained the solution he wanted. But other solutions, discarded on the way, were also possible and these might be stored and used for subsequent versions of the

FIG. 28. Claude LORRAIN, Thos. Agnew & Sons Ltd, *Apollo as Herdsman and Mercury*, 1654. Pen, grey and brown wash with white bodycolour on blue paper, 19.4 × 27.1 cm. MRD, 721.

theme. For example, in his later, surviving *Landscape with Christ and the Two disciples on the Road to Emmaus* (LV 151), dated 1660, in The Hermitage (Fig. 33), Claude started with the *verso* of the preliminary study (Fig. 30), and then moved Christ from the front to the rear of the group, so that the two disciples walk ahead but look over their shoulders towards him. Frequently, though not in the present instance, Claude arrived at his eventual solution by means of accretion, that is, he would start with a relatively simple pictorial idea, with few figures, and then, through successive preparatory drawings, add to it. The *Landscape with the Worship of the Golden Calf* is a good example of this.

What Claude lacked in intellectual power he made up for by the intensity of his artistic instincts. Again and again, what was originally conceived of as functional — whether as preparatory study or later record — was transformed into a work of art in its own right. The Woodner figure group was given its own landscape, a landscape which echoes that of the painting yet is of a simpler form appropriate to its more restricted scope. The execution of this drawing is as rich as that of any in Claude's *œuvre*. Strong tone contrasts are employed throughout, and the light, shining from low down outside the picture space on the right, is represented by both spared paper and white bodycolour. The pink wash covering the paper combined with the dark brown wash used for the shadowed forms and the white heightening used for highlights produce an effect of warm, luminous colour. The figure style is noble, Raphaelesque; this Christ and these disciples, allowing for their much smaller scale, would scarcely be out of place in the Raphael *Cartoons*. The drawing marks a high point of Claude's classicizing phase. To emphasize its status as a self-sufficient pictoral image, even though it had been begun as a preparatory study, he framed it with a broad black line on all four sides.

For the last section of this paper I want to return to a question I referred to obliquely at the beginning — the question that everyone asks about Claude's figures. Why, especially in his late works, did he make them so tall and thin? Tallness and thinness are not, after all, characteristics of figures generally in painting of the second-half of the seventeenth century. Nowhere is the elongation of Claude's figures more evident than in the great painting at Anglesey Abbey, *The Landing of Aeneas, or Arrival of Aeneas at Pallanteum* (LV 185; Fig. 34) of 1675. Here, standing on the

FIG. 29. Claude LORRAIN, Pierre Dubaut, Paris, *Christ and the Two Disciples on the Road to Emmaus*, 1652. Brown wash and white bodycolour over black and red chalk, 12.3 × 20.6 cm. MRD, 710r.

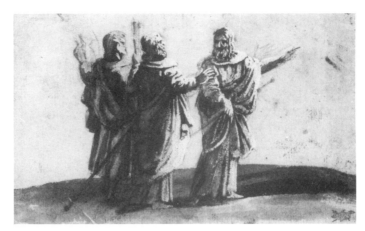

FIG. 30. Claude LORRAIN, *Christ and the Two Disciples on the Road to Emmaus*. Pen and ink. *Verso* of Fig. 29.

FIG. 31. Claude LORRAIN, Ian Woodner Collection, New York, *Christ and the Two Disciples on the Road to Emmaus*, 1652. Black chalk, brown wash and white bodycolour, on paper prepared with pink wash, 17 × 22.5 cm. MRD, 711.

FIG. 32. Claude LORRAIN, British Museum, London, *Landscape with Christ and the Two Disciples on the Road to Emmaus*, 1652. *Liber Veritatis* drawing No. 125, pen, brown and grey-brown wash with white bodycolour, 19.6 × 25.7 cm. MRD, 712.

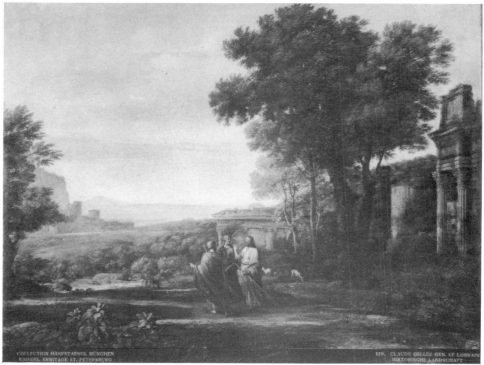

FIG. 33. Claude LORRAIN, Hermitage, Leningrad, *Landscape with Christ and the Two Disciples on the Road to Emmaus*, 1660. Oil on canvas, 101 × 135 cm. LV 151.

prow of his ship, Aeneas reassures his potential enemies, the inhabitants of the city on the site of the future Rome, by holding out an olive branch of peace. His cloak is a vertical pencil of scarlet, marking the exact centre of the painting; it attracts the observer's eye immediately and unites the two halves of the composition.

The factors that might account for the elongation of the figures in this and other late paintings by Claude are of three kinds: external stylistic influence; external cultural influence; and the internal development of Claude's own art. As for the first, there is, in theory, almost an embarrassment of choice. European painting and sculpture from the 1530s to the 1590s were dominated by artists famous for their elongated figures. Parmigianino, Primaticcio, Niccolo dell' Abbate and Giovanni Bologna are just four of the many names from the high tide of the style called

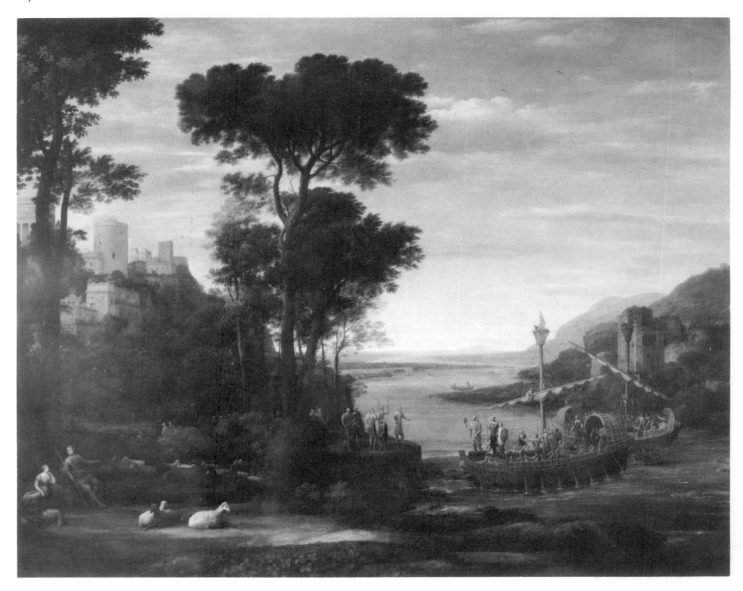

FIG. 34. Claude LORRAIN, Fairhaven Collection, The National Trust, Anglesey Abbey, *The Landing of Aeneas, or The Arrival of Aeneas at Pallanteum*, 1675. Oil on canvas, 175.5 × 225 cm. LV, 185.

[39] Formerly Timothy Clifford Collection; sold Sotheby's, 3 July 1989, lot 11.
[40] See especially the four landscapes by Domenichino, or Domenichino in collaboration with Viola, all dating from the 1620s, in the Louvre: illustrated by Richard Spear, *Domenichino* (New Haven and London, 1982), pls 260–62 and 314.
[41] It was Marcel Roethlisberger who correctly drew attention to the elongated figures in some of Swanevelt's landscapes of the late 1630s and pointed out their potential relevance for Claude; see the article cited in note 4 above, where four telling examples are illustrated, pp. 94 f.
[42] A drawing after Deruet of a woman on horseback with hounds was in the Wildenstein/Norton Simon Album, catalogued as the *verso* of no. 1 in Marcel Roethlisberger, *The Claude Lorrain Album*, Los Angeles, 1971, repr. pl. 64. It is also reproduced in MRD, no. 331. The exact status and date of this drawing remain problematic but, after doubting it in the past, I am now inclined to agree that it is by Claude.

Mannerism that come to mind. Dip into the art of this period almost anywhere and it is possible to come up with an example of a figure or figures that, at least superficially, resembles Claude's; see, for example, the drawing by Biagio Pupini, called *dalle Lame*, illustrated here, Figure 35.[39] Not only is this drawing executed in a technique often used by Claude — brown wash, heightened with white, on pink-washed paper; it also has something of Claude's nervous charm and use of thin classical draperies with fluttering scarves. Moreover, Mannerist elongation lingered on at both the geographical and artistic margins of Europe into the early seventeenth century, for example, at Nancy, where it was practised by Deruet, and in the figures in landscapes of both Domenichino[40] and, rather surprisingly, Swanevelt.[41]

Unlike the Mannerist artists of the sixteenth century, whose importance for Claude was hypothetical and cannot be exactly defined, Deruet, Domenichino and Swanevelt were all well known to him, at any rate through their works. Claude's indebtedness to Domenichino's landscapes in the 1640s has already been mentioned; Deruet was Claude's master in Nancy in 1625–26;[42] and Claude's landscapes in the 1630s are so similar in style to some of Swanevelt's in the same decade that the two artists must surely have been acquainted.

However, it is not easy to translate these connections into sources for Claude's late figure-style. Why, when he began to elongate the figures in his paintings in the 1650s, should he have gone back for inspiration to artists

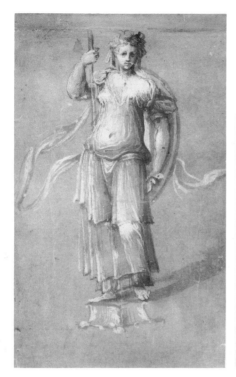

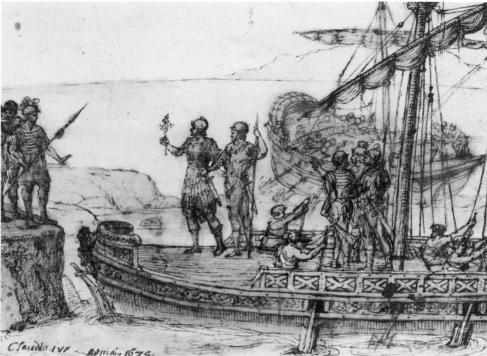

whose work was relevant to him ten or more years earlier and for other reasons? What is more, the similarity between his late figures and theirs of any period is not close or specific enough to give them preference as a source over the work of sixteenth-century artists. Claude *may* have remembered the example of Deruet, Domenichino or Swanevelt, or all three, when he gradually changed his figure style in the second half of his career, but it is more likely, in my opinion, that he cast his mind back to an earlier period. In short, I believe that there is Mannerist influence in Claude's late figure-style, but it is general, not specific, and cannot be pinned down to the work of any one artist.

Recently, Marcel Roethlisberger has produced an ingenious and quite different explanation for Claude's elongation of his figures, one that is independent of — though does not necessarily exclude — the factor of style.[43] This is based on the proposition that, given the exalted social rank of the majority of his patrons in his later years, Claude's work in these years is to be seen as the direct reflection of a courtly society. Roethlisberger stresses the formality of seventeenth-century aristocratic life, the endless round of ceremonies, theatre performances and parades, and the necessity, in order to survive in this milieu, of being able to cut an impressive figure. In other words, in such a society, noble equals tall. He also points to other historical periods in which art was dominated by courts and in which the elongation of figures in painting and sculpture was the rule. The prime example of such a period is, of course, the mid- and later sixteenth century, with its characteristic style, Mannerism. And if, as I agree is the case, there is a neo-Mannerist or at any rate 'neo-sixteenth century' strain in Claude's late work, the argument for associating the tallness and thinness of his figures with the values and attitudes of a courtly culture seems a strong one.

My problem with this is twofold. In the first place, why, if the later seventeenth-century aristocracy was so attached to courtly values and if patrons exerted as great an influence on the work of artists generally as Roethlisberger claims they did on Claude's, do we not find other artists elongating their figures too? Yet on the whole they did not.[44] In the later part of his career, from the 1650s onwards, Claude was artistically almost completely isolated from his contemporaries. He had no pupils or close

FIG. 35: Biagio PUPINI, called dalle Lame (formerly Timothy Clifford Collection), *Minerva, c.* 1560. Brown wash and white bodycolour on paper prepared with pink wash, 18.6 × 11.1 cm.

FIG. 36. Claude LORRAIN, British Museum, London, *Study for The Landing of Aeneas*, 1675. Pen and brown wash over black chalk, 18.5 × 25.5 cm. MRD, 1083.

[43] See the articles cited in note 4 above.
[44] Among the exceptions are Kneller in some of his full-length court portraits (but only after 1690) and Jean Nocret in his *Allegorical Portrait of the Family of Louis XIV*, 1670, at Versailles (illustrated by Roethlisberger in his article, 'Das Enigma überlängter Figuren in Claude Lorrains Spätwerk' cited in note 4 above, p. 99. Another striking, though hardly relevant, exception are the two Bernini *Angels* made for the Ponte Sant' Angelo and now in S. Andrea delle Fratte.

followers, the predominant influence on late seventeenth-century land-scape painting in Rome was that of Gaspard Dughet, and the growing importance of the official academies of art in Italy and France ensured that the figures in history paintings and wall and ceiling decorations in those countries were kept to normal proportions. It is true that a proud aristocracy obsessed with status and ceremonial may have been drawn to Claude's work precisely because he alone elongated his figures and so gave his patrons a flattering image of themselves but, if that is the case, it is strange that they did not force their wishes on other artists as well.

In the second place, I am not convinced that aristocratic society in the second half of the century, even in Rome, *was* more 'courtly' than that of the first half, let alone the century before. The grandest court of the period was, of course, that of Louis XIV. But that, for all its splendour, elaborate rituals and attention to fine distinctions of rank, was a centre of power and the seat of the most active national administration in Europe; it was not a mere show. What is more, the King was physically a tall man and did not need his artists to make him look taller.[45] (Contrast, however, Van Dyck's pictorial treatment of Charles I earlier in the century; Charles I was tiny.) For the great decorative schemes at Versailles, conventional idealization of the human figure was enough. One has the impression, in sum, that the European aristocracy, led by its rulers, was becoming more pragmatic in its attitudes in the second half of the seventeenth century and more concerned with increasing its economic power. It lived less in the metaphysical realm of symbols and allegory, whether religious or pagan, which had earlier produced Mannerism — and elongation. However, it would require the expertise of a qualified historian to investigate this hypothesis and to determine whether or not it is correct. I here put it forward as no more than a suggestion.

The case for associating Claude's elongated figures with the ethos of a courtly culture must then, if I am right, remain in doubt.[46] What of the third argument mentioned above, namely that the phenomenon was a product of the internal development of Claude's own art and that it was of a piece with the other features of his late style — the increasing attenuation of trees and buildings, the softening of surfaces and effects of light, the narrowing of the colour-range, the whole other-worldliness of his late pictures? Before commenting on this it is necessary to recall a few statistics. However close the link between Claude's later work and the social standing of his patrons, there is an even closer correlation between the elongation of his figures and picture-size. In the thirty years from 1652, the date of the *Landscape with the Two Disciples on the Road to Emmaus*, and his death, Claude painted about eighty pictures, out of a total during his life of between two hundred and fifty and three hundred. Of these eighty, three-quarters were of 'royal' size and above, that is, not less than 3×4 Roman *palmi*, or 70×95 cm. Thirty of *them* were 'imperial' or 'large imperial' (respectively 4×6 *palmi* and 5×7 *palmi*, or 95×130 cm and 115×160 cm). A quarter were small (less than 70×95 cm), and ten very large (at least 140×250 cm). In almost all the pictures of royal size and above, of which there are about sixty, the figures are elongated, although it would not be true to say that the larger the painting, the greater the elongation; the curve, so to speak, flattens out, and figures in the largest paintings tend to be only somewhat more elongated than those in paintings of royal or imperial size.

Conversely, with only one partial exception,[47] all the small paintings, that is those less than 70×95 cm, do *not* have elongated figures. Moreover, this characteristic extends to the drawings; because the drawings are small, the figures in them are not elongated, or are elongated only slightly.[48] This means that both figure-studies for paintings and *Liber*

[45] The portrait by Nocret mentioned in the previous note is, so far as I can discover, wholly exceptional.

[46] A better case can, I believe, be made out for the view that the whole of Claude's art, including his treatment of landscape, was imbued with such a culture from the mid-1630s onwards, when he first began working for the King of Spain, the Pope and other princely and noble patrons. This view has been put to me persuasively by David Solkin. It has the advantage of not turning the elongation of fingers into a touchstone and so excluding Rubens (for example) from the equation.

[47] *The Pastoral Landscape* (LV 190), dated 1677, at Fort Worth, which measures 57×82 cm.

[48] Again there is an exception, namely the figure study from the Wildenstein/Norton Simon Album (MRD 1107) for *St Philip baptizing the Eunuch* (LV 191), of 1678. The figures in this study are, uniquely, elongated almost as much as those in the painting.

Veritatis drawings contain figures of more or less normal proportions, even though, in the paintings to which the drawings correspond (provided those paintings are not themselves small), the figures are unnaturally tall. The figure-study (Fig. 36) for the group of Aeneas and his companions in the painting, *The Landing of Aeneas* (Fig. 34), is a very clear illustration of this. The figures (Fig. 22) for *Jacob at the Well* are slightly more elongated but not nearly as much so as those in the corresponding painting. The figures in the Woodner drawing are not elongated at all, nor are those in the *Liber Veritatis* drawing, No. 125. Whether they were elongated in the lost painting is hard to say; perhaps they were to some extent, but this picture was executed just before Claude began to elongate the figures in his larger paintings as a matter of course.

There is thus one consistent formal factor underlying the elongation of the figures in Claude's later work, a factor which embraces both paintings and drawings: the proportions of the figures were a function of the scale on which he was working. The larger the scale (within limits), the more the figures are elongated, and vice versa. There are also other factors with a formal basis. One is that the figures become progressively taller and thinner in keeping with the evolution of Claude's style as a landscapist. The first paintings to contain noticeably elongated figures are the unusually large pair, already referred to, *Landscape with the Worship of the Golden Calf* and *Landscape with Jacob and Laban*, respectively completed in 1653 and 1655 for the Roman nobleman, Carlo Cardelli. Then Claude paused for thought, executing his next important, imperial-sized pair, *Coast Scene with the Rape of Europa* and *Coast Scene with a Fight on a Bridge* (LV 136–37), with normally-proportioned figures; this pair was painted in 1655 for the Chigi Pope, Alexander VII. In 1658, however, with the large *Landscape with David at the Cave of Adullam* (LV 145) painted for the Pope's nephew, Agostino Chigi, the elongation of the figures was boldly resumed and, except in a small group of paintings to be mentioned in a moment, never afterwards abandoned for pictures of royal size and above. In the next picture, *Landscape with Esther approaching the Palace of Ahasuerus* (LV 146) of 1659, the elongation was carried still further; and so on. The process reached its apogee in the very last works, *Parnassus with Minerva visiting the Muses* (LV 195) and *Landscape with Ascanius shooting the Stag of Silvia*. The consistency of this development is underlined by the fact that, whenever a composition is repeated, unless the repetition is very small, the figures in the later version are taller and thinner than those in the original, even though, as is usually the case, the composition of the later version is simpler and less interesting and the patron less important.

The exceptions to the rule, that is, those few large paintings in which the figures are not elongated, are in their own way no less telling. They consist of half a dozen paintings in which the figures are seated or, less often, kneeling, and not standing. Psyche in *The Enchanted Castle* is an example. If she stood up she would, it is true, be a large, even quite massive figure, but she would be of normal proportions, not tall and thin. The same applies to the seated Holy Family in the *Landscape with the Rest on the Flight into Egypt* (LV 154) of 1661. Elongation, therefore, is not only a funtion of scale; it is also related to the shape made by a standing figure or figures in the painted landscape. The conclusion to be drawn from this, I believe, is that the elongated figures of Claude are deliberately designed to supply the picture with additional vertical accents, accents which are all the stronger on account of the fact that the figures are more brightly coloured than the few other, more neutral verticals consisting of tree trunks and buildings. In other words, the late pictures, for example Figure 34, depend a good deal more than the earlier ones on sharply

defined, though not necessarily long, vertical and horizontal lines to articulate the space — a space which is itself often more extensive than before. This applies, however, only to the paintings of royal size and above, not to the small ones or the drawings, including the *Liber Veritatis* drawings, in which the space remains restricted. Hence the figures in these works are not elongated. For all the subtlety and sophistication of their effects of atmosphere, colour and light, the late paintings of Claude above a certain size possess a kind of primitive grandeur, even a starkness, recognizable as hallmarks of a style of old age. In these paintings, the ground is formed of inelegantly shaped masses, which in the foreground are sparsely furnished with plants and, in the background, lie stretched out in low horizontal bands; in the middle-distance, rocks and hillsides pile up awkwardly; and tree trunks and buildings rise stiffly and solitarily against the sky. It is these last-named vertical shapes that the elongated figures are so clearly designed to echo and support, often occupying what would otherwise be an eerily empty space; indeed, precisely because they are figures, which inherently attract the eye more than natural or inanimate objects, they fill the space more than their actual size would lead one to expect.

Of course, where the subject or his own choice dictated that the figures should be seated, Claude lost, as it were, the advantage which standing figures conferred. In his compositions, there are few fixed laws of proportion, contrary to what is often believed. Nevertheless, the contribution which tall, thin figures made to the design was something which he evidently prized. Had he made the figures as thin as they are but of normal proportions, they would have been lost in the landscape. Had he kept them to the same height but filled them out, they would have been too bulky and would have been out of keeping with the attenuated, quasi-ethereal forms of the trees and buildings.

None of this, it is true, quite demolishes the theory that the elongation of Claude's figures is to be explained in terms of cultural influence. The equation of tallness with nobility has to do with 'presence' rather than physique, so it does not matter that seated figures are depicted with normal proportions. Nor is it relevant that the figures in his drawings were not elongated, since drawings were made for private purposes, not public display. Nevertheless, I believe that the explanation I have proposed in this paper fits all the aspects of the case better than any other explanation. It is my contention that the way in which Claude treated the figures in his later works was principally determined by the form of the landscape — a form which changed in accordance with both purpose and date. As we observe the different objectives Claude had in view and as we follow the development of this style, we can watch the figures alter in shape before our eyes. We conclude, like Constable, that 'we cannot easily imagine anything else according so well with the scenes'.

Eighteenth-century French cabinet drawings

by SUZANNE FOLDS McCULLAGH

The topic of 'eighteenth-century cabinet drawings' is one not easily defined, and full of innate contradictions. Even scholars of the period are apt to respond to the topic with the question 'What *is* a cabinet drawing?' Hypothetical definitions range from closeted *erotica* to finished and framed drawings, but in general centre on private, informal collections of drawings representing all stages in the creative process. It is especially difficult for us today to understand this eighteenth-century phenomenon as recently the last contemporary touchstone with the 'cabinet' concept, the Cabinet des Dessins of the Louvre, has changed its name to the more accurate, but certainly less romantic or evocative title, 'Department of Graphic Arts'. The question arises whether the use of the term 'cabinet drawing' in the eighteenth century implied drawings of any degree of finish that were gathered for purely private enjoyment, or — contrarily — distinctly polished works which, like small paintings, were framed and hung in a decorative fashion, to be seen by many. Indeed, why were such private drawing collections assembled, and to what audience were they addressed?[1]

Cognoscenti of the eighteenth century also debated the use of the term '*cabinet*'. As Colin Bailey has recently pointed out, the *Encyclopedia*'s definition of *cabinet*' suggests intimacy:

> used for those rooms devoted to study, for those rooms in which business matters are conducted, and for those rooms which display the most precious paintings, bronzes, books and curiosities.[2]

However, it is clear by accounts from the end of the eighteenth century that these were far from private areas, rather arenas for the dissemination of a connoisseur's taste to his 'public':

> It is singular to observe that, while our collectors fill their homes with an inordinate number of pictures, they are vain enough to employ a term that first implied modesty and restraint.[3]

As such, the role of drawings collectors, then as now, deserves to be evaluated as a seminal force in the shaping of public taste.

The line of major drawing collectors who helped to shape the taste and habits of eighteenth-century connoisseurs can be traced to the historic role of Giorgio Vasari as the first significant drawings collector who put together albums of sheets of drawings — *assemblages* of various artists' works mounted on sheets embellished by Vasari's own hand. Even the first noteworthy collection of seventeenth-century French drawings by Claude Lorrain consisted of independent sheets assembled into an album owned by the Odescalchi family until recently. Gathering drawings in albums has thus a long and venerable tradition and anticipates the development of the 'cabinet'.

Notable in the eighteenth century was the French collector Pierre Crozat who amassed approximately nineteen thousand drawings.

[1] I would like to thank Christopher Lloyd for inviting me to speak on this topic, Mary Anne Stevens for her assistance with its preparation, and Konrad Oberhuber for his invaluable counsel.

[2] Colin B. Bailey, 'Conventions of the Eighteenth-Century *Cabinet de Tableaux*; Blondel d'Azincourt's *La première idée de la curiosité*', *Art Bulletin* LXIX (September 1987), p. 431.

[3] Ibid., loc. cit.

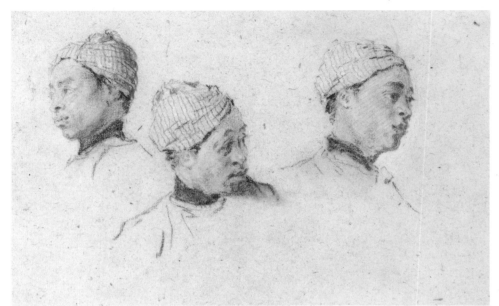

FIG. 1. Nicolas LANCRET, The Art
Institute of Chicago (1987.58), *Three
Studies of the Head of a Turbaned Black
Man*, 1720s. Black, red and white chalks
on oatmeal paper, 17.5 × 27.7 cm.

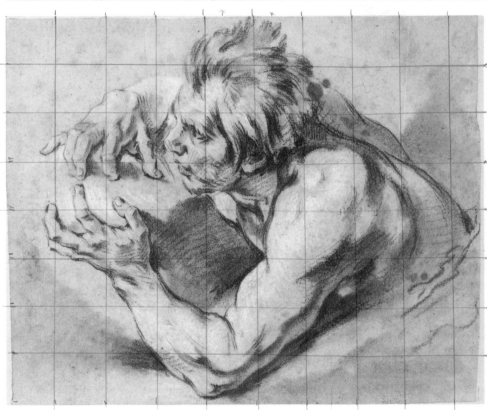

FIG. 2. François BOUCHER, The Art
Institute of Chicago (1965.240), *Study
for a Triton in 'Le Lever du Soleil'*,
c. 1753. Black and white chalks with
traces of red chalk and estompe, on grey
brown paper, 22 × 27 cm.

[4] Alden Rand Gordon, 'Collecting
Eighteenth-Century French Drawings', exhi-
bition catalogue (Colnaghi, New York (in
association with the Galerie Cailleux, Paris),
20 April–26 May, 1983), p. 5.
[5] For documentation one has only to refer to
the exhibition catalogue *Le Cabinet d'un
Grand Amateur: P.-J. Mariette (1694–1774),
Dessins du XVe siècle au XVIIIe siècle* (Musée
du Louvre, Paris, 1967).

Certainly collectors like Crozat, and Everard Jabach before him, did not
dream of framing and hanging their vast drawing collections, yet they did
make them accessible. Crozat is famous for harbouring and nurturing
Antoine Watteau, giving the artist free run of his collection of mostly
Italian drawings. Ironically, Crozat seems to have spurned the collecting of
contemporary drawings at the same time that he and his collection so
influenced his century's pre-eminent draughtsman: it is said that he owned
only nine drawings by Watteau.[4]

Later in the eighteenth century, Pierre-Jean Mariette, curator, cata-
loguer and chief purchaser of Crozat's collection, inherited this bias as
well; while there were some French drawings among his holdings, the few
represent a 'classic' taste based on his Crozat experience.[5] Like so many
collectors in eighteenth-century Paris, Mariette acquired his collection
primarily by buying other collections *en masse*, rather than selectively. The

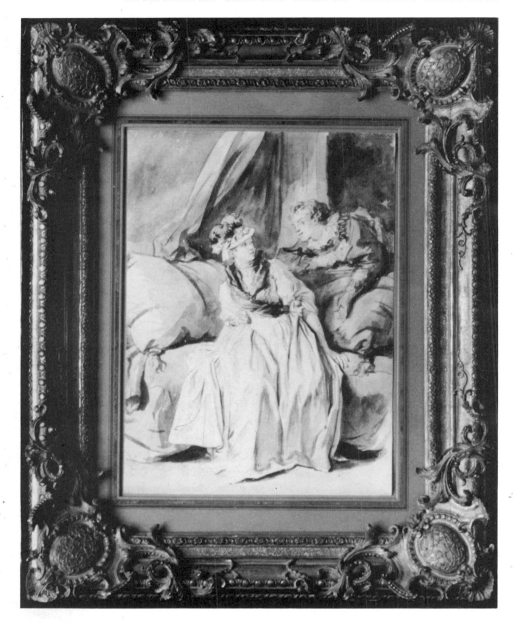

FIG. 3. Jean-Honoré FRAGONARD, The Art Institute of Chicago (1945.32), *The Letter, or The Spanish Conversation*, 1770s. Brush and brown wash, over graphite, on white paper, 39.9 × 29 cm.

taste and habits of these highly visible connoisseurs had a considerable influence on ambitious young collectors. The number of significant art collections in Paris more than tripled by mid-century, and a continuing partiality to the Italian and Flemish schools was only gradually matched by enthusiasm among some daring collectors for French or contemporary art.[6]

Watteau's role in the development of drawings as an independent art form in the eighteenth century should not be underestimated. With commanding, finished character studies, such as his sheets devoted to the Savoyards, he marked a departure from normal seventeenth-century studio practice which utilized drawings as merely preparatory works. On the other hand, the countless sheets of studies on which Watteau created storehouses of images to be used in his paintings were designed in a manner that conveys a sense of spontaneity. However, the sheets betray a careful arrangement that signal them less to be real working drawings than deliberate concoctions designed to titillate the collector with visual splendour and the illusion of entering the artist's imaginative process. Watteau's influence was clear and immediate, most obviously with his close followers such as Lancret. But curiously enough, Lancret's sheets of numerous studies are rare. Even rarer are those works, such as the splendid sheet with quivering line and free *pentimenti* acquired recently by The Art

[6] Note, for example, the collection of Blondel d'Azincourt cited by Bailey, op. cit., p. 435.

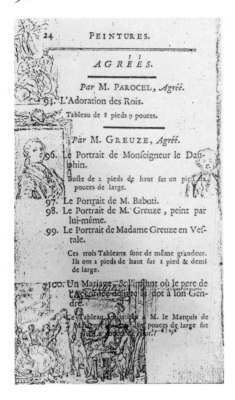

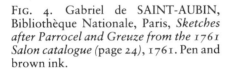

FIG. 4. Gabriel de SAINT-AUBIN, Bibliothèque Nationale, Paris, *Sketches after Parrocel and Greuze from the 1761 Salon catalogue* (page 24), 1761. Pen and brown ink.

FIG. 5. Jean-Baptiste GREUZE, The Art Institute of Chicago (1986.1273), *Study for 'The Father's Curse: The Punished Son'*, 1778. Pen and brown ink with brush and brown and grey wash on white paper, 24.7 × 32.2 cm.

[7] The existence of a second version and the primacy of the Art Institute sheet were first brought to our attention by Margaret Morgan Grasselli. Note also two sheets deriving from the Art Institute drawing sold at Christie's London, 18 April 1989, lot 107.
[8] Beverly Schreiber Jacoby, 'François Boucher's Stylistic Development as a Draftsman: The Evolution of his Autonomous Drawings', in *Drawings Defined*, ed. Walter Strauss and Tracie Felker (New York, 1987), p. 260.
[9] Ibid., p. 270.
[10] One form of drawing — pastel portraiture — was more prevalent in the Salons, in the works of Maurice Quentin de La Tour and Jean-Baptiste Perronneau, but these illustrious works on paper were, like gouaches later in the century, considered by artists and collectors alike to be closer to painting than drawing.
[11] Jacoby, op. cit., p. 273.
[12] Jacoby, op. cit., p. 270.
[13] See the catalogues themselves, for example, 1767, nos 112 and 137; 1769, no. 98; 1771, no. 88; and unnumbered groups in 1775, 1777, and 1779.

Institute of Chicago (Fig. 1), which seem to have been actually drawn from life and later used in preparing a painting. Most study sheets were concocted for a commercial market by Lancret, who later even copied the Art Institute drawing for such a purpose.[7]

The eighteenth-century collector Jean de Julienne played a seminal role in the evolution of the 'potential for drawings to attain aesthetic and commercial recognition as independent works of art', as Beverly Schreiber Jacoby has pointed out.[8] François Boucher's work as an etcher for Julienne clearly influenced his own and others' perceptions of the importance of Watteau's works on paper. Moreover, Boucher's art evolved extraordinary pastels and highly finished drawings, meant to be framed and hung, which elevated the status and visibility of works of art on paper, and enhanced drawings' collectability in the eighteenth century. Boucher 'rethought the concept of preparatory drawings' at mid-century,[9] with individual study sheets deliberately devised to function also as highly desirable, independent, framed works, enhanced by their clear association with important Salon paintings (Fig. 2). It was an idea of revolutionary commercial implications.

The role that drawings played in the public forum of the Salon is complex.[10] Even esteemed Academicians who were avid draughtsmen, such as Jacques-André Portail — who was charged with installing nine salons from 1742 to 1753 — only dared to submit a drawing of his own for exhibition many years later, in 1759. Such little masters often developed specialities in drawing for a private clientele. None the less, the proliferation of finished drawings, and the rise of reproductive engraving in emulation of drawings, speaks to the insatiable demand for drawings in the marketplace with the new 'demi-connoisseurs', to use d'Angiviller's phrase.[11]

Although Boucher can be credited as one of the first Academicians to hang a drawing in the Salon (he added some late to the Salon of 1745),[12] younger artists, such as Hubert Robert and Fragonard, belonged to a generation of *agrées*, or probationary members, that regularly submitted '*plusieurs dessins sous le même numéro*', to the Salon in the 1760s.[13] While it is extremely unlikely that the drawing *The Letter or The Spanish*

FIG. 6. Gabriel de SAINT-AUBIN, Petit Palais, Paris, *Two Views of the Hôtel de La Ferté, rue Richelieu from the Gaignat sale catalogue*, 1769. Black chalk on ivory paper.

Conversation by Fragonard (Fig. 3), was shown in the Salon, it is clearly of a romantic type suited to a private collector, a finished work intended to be displayed. The fact that his drawing resides in a Louis XV period frame — which one may presume has accompanied the drawing since the eighteenth century — is at odds with its superb state of preservation, which would indicate that, although framed, it never was exposed to much light, from the time of its first owner, the famous collector Pierre Lebrun (husband to

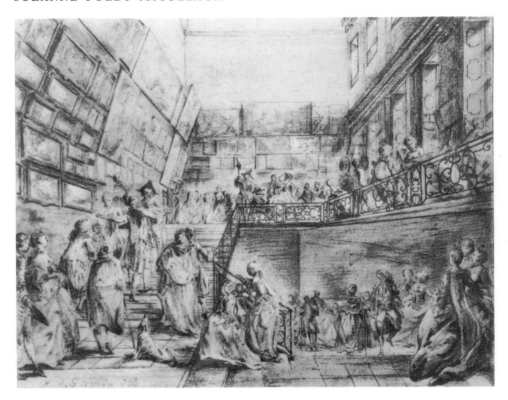

FIG. 7. Gabriel de SAINT-AUBIN, Private Collection, Paris, *View of the Salon du Louvre in 1753*, 1753. Black and coloured chalks with pen and black ink, 13.5 × 17.7 cm.

FIG. 8. Gabriel de SAINT-AUBIN, Cabinet des Dessins, Musée du Louvre, Paris (Inv. 32743), *Salon of 1765*, 1765. Pen with black, brown and grey inks, brush and grey and brown wash and gouache, over graphite, on ivory laid paper, 24 × 46.7 cm.

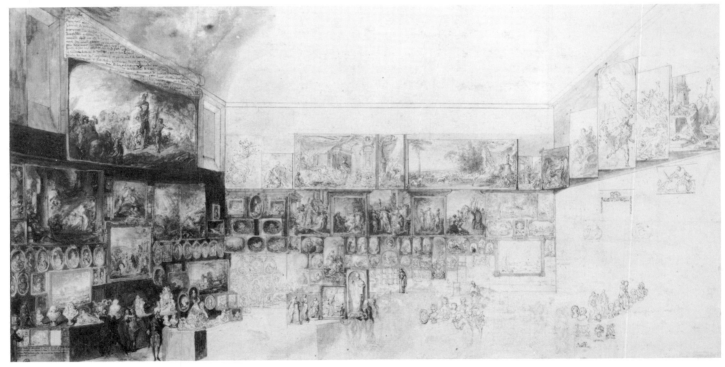

artist Elizabeth Vigée-Lebrun). How were such drawings kept and displayed?

Recent scholarship on the interaction of eighteenth-century architecture and life has elucidated the proliferation of *cabinet* upon *cabinet* in connoisseurs' homes — from what was initially just a small closet, to include, for example, a *grand cabinet* for receiving friends, a *cabinet meridienne* for 'rest and solitude', and the *arrière cabinet* for real retreat.[14] This trend embodies a phenomenon at mid-century noted by Thomas Crow:

> As opportunities for actual state service decreased, it became imperative for the genuine nobleman to distinguish himself from the actual service class — the upstart creatures ... the *honnête homme* now embodied fastidious withdrawal from any mundane interest ... in a life of studied leisure.[15]

[14] Richard Etlin, '"Les Dedans": Jacques-François Blondel and the System of the Home, c. 1740', *Gazette des Beaux-Arts* XCI (1978), p. 143.
[15] Thomas E. Crow, *Painters and Public Life in Eighteenth-Century Paris* (New Haven and London, 1985), p. 67.

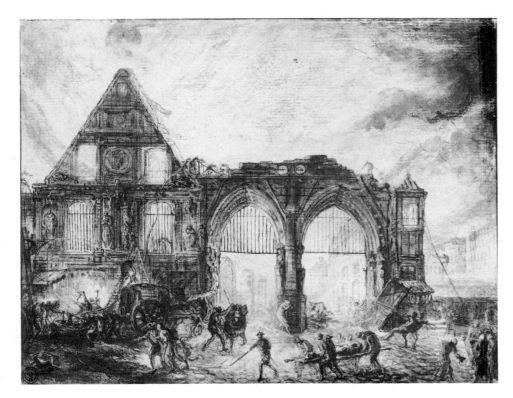

FIG. 9. Gabriel des SAINT-AUBIN, Musée Carnavalet, Paris (IED 5368), *Ruins of the Hôtel-Dieu after the Fire of 1772*, 1772. Pen and brown ink with brush and watercolour over black chalk on ivory paper, 16.3 × 23.6 cm. *Photo: Giraudon.*

Certainly the intimate art of drawing was suited to decorate intimate cabinets for withdrawal, just as painting is suited for — intended for — decoration of socially significant rooms. However, eighteenth-century France also witnessed the perfection and domination of interior decoration and marquetry, formalized to such an extent that in 1747, the famous critic, La Font de Saint-Yenne, despaired:

> The art of the brush has been forced to defer to the brilliance of the looking glass, whose technical perfection has exiled the finest of all the art from our grandest homes. And where painting is allowed, it has but the meanest spaces to fill: over doors, chimney pieces, and those areas which, if not for economy, would otherwise be occupied by pier glasses.[16]

Thomas Crow's characterization of 'Parisian aristocratic ... interiors appropriately intimate in scale, luscious and ornate in their decor, and bright with reflective surfaces of mirrors and gilt'[17] would not seem to have invited the installation or contemplation of the more subtle art of drawing. The over-riding principle applied in collectors' homes, as advocated by Blondel d'Azincourt at mid-century, was a mandate to hang works decorously, in symmetrical pairs, for an overall harmonious effect.[18]

Whatever the dictates of the interior architecture, drawings stashed in portfolios or displayed on easels offered a natural and intimate form of interchange for connoisseurs who gathered to share them.[19] Drawings, as a less costly and less pretentious art form, ought to have been more accessible to connoisseurs of all classes — but which classes were the ones buying them?

Gabriel de Saint-Aubin (1724–1780) offers an apt case-study in terms of cabinet drawings in the eighteenth century, inasmuch as he devoted virtually his entire career to drawing, and, as — ever since the Goncourts extolled his work in the mid-nineteenth century — he has been prized among private drawing collectors and connoisseurs.[20] Indeed, while many of his works are in public collections, many drawings remain inaccessible and virtually unknown, still cherished in private homes.

Although Saint-Aubin made about two dozen oil paintings and around fifty prints, following his failure to win the *Prix de Rome* in history

[16] Bailey, op. cit., p. 432.
[17] Crow, op. cit., p. 32.
[18] Bailey, op. cit., p. 434.
[19] See the frontispiece of the 'Catalogue raissonné de la succession du Vicomte de Fonspernius', 1748 reproduced in Kzyztof Pomian, 'Marchands, connaisseurs, curieux à Paris au XVIIIe siècle', *Revue de l'Art*, no. 43 (1979), p. 27, fig. 2.
[20] Edmond and Jules de Goncourt, 'Petits maîtres français du dix-huitième siècle: Les Saint-Aubin, *L'Artiste* (October 1857), pp. 100–05, 116–22; also subsequent Goncourt publications.

painting for the third time in 1754, his principal occupation — truly an obsession — was drawing everything he saw around Paris. Unkempt and bizarre — he dusted his hair with drawing chalk — Saint-Aubin is said to have died prematurely, of self-neglect. He was a modern bohemian — a misfit despised by some and enjoyed by others for his wit and his memory. Greuze said he had a 'priapism of drawing'.[21]

Saint-Aubin's idiosyncratic kind of drawing placed him outside the hierarchy of the Academy, whose highest standards he failed to meet, and put him in a tradition of little masters traceable to Callot. Indeed, Saint-Aubin's eighteenth-century spiritual heir, even more than the ever-inspirational Watteau, was Watteau's master, Claude Gillot, who bathed in the spectacles of the theatre of everyday life.

FIG. 10. Gabriel de SAINT-AUBIN, Bibliothèque Royale, Stockholm, *Salon of the Maréchal de Noailles from the Stockholm carnet* (folio 114 verso), 1779. Black chalk on ivory paper, 18.4 × 12.5 cm.

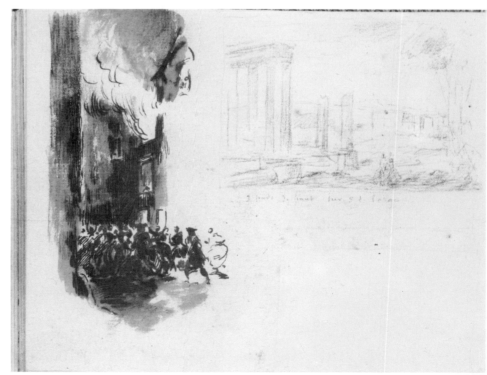

FIG. 11. Gabriel de SAINT-AUBIN, The Art Institute of Chicago (1946.383), *Buildings on Fire with a Crowd Watching from the Chicago Sketchbook* (folio 9 verso), 1760/64. Black chalk, graphite, pen and brown ink with brush and brown wash on ivory paper, c. 17.2 × 13 cm.

[21] Quoted by Charles-Germain de Saint-Aubin in an autograph manuscript, most recently and accurately cited by Suzanne Folds McCullagh, *The Development of Gabriel de Saint-Aubin (1724–1780) as a Draughtsman* (Ph.D. Dissertation, Harvard University, 1981), p. 66.

Saint-Aubin is probably most famous and valued by art historians for the marginal illustrations he put into the Salon *livrets* and sales catalogues of the 1760s and 1770s — an inexaustible resource for tracing works of art and even mapping taste. The number of sales by the late 1780s had grown to almost thirty per year — roughly twenty times that of the 1750s. Meanwhile nearly twenty thousand catalogues were sold at each annual Salon as up to one thousand people flocked daily for the three-week exhibition.[22]

The first major Salon catalogue which Gabriel illustrated was also his most careful, complete and precise — that of 1761 (Fig. 4).[23] Within the 1761 Salon *livret*, Saint-Aubin exercised a range of artistic licence over his subjects, in some important cases, as with Jean-Baptiste Greuze's *Portrait of the Dauphin*, copying the work (even the frame) exactly, in others — as with Greuze's *Portrait of Babuti*, his father-in-law — enjoying a playful but telling caricature. It should be reiterated that 1761 was also the first year that saw a significant increase in the number of drawings exhibited in the Salon, especially by the *Agrées*.[24] Indeed, Greuze submitted three sheets at that time (each acknowledged by individual catalogue numbers), with works of a free and sketchy, expressive nature similar to the *Punished Son* drawing recently acquired by the Art Institute (Fig. 5), or the sheet owned by Mr Woodner. For Greuze, as for many artists who submitted drawings, it was a means of swelling his representation and focusing attention on his major painted compositions and all the work that went into them.

Saint-Aubin was fascinated with art exhibitions and auctions and with the public and private collections which began to attract more and more interest at mid-century, opening their doors to the general public. It was often the very atmosphere of the Salons and collections which the artist sought to capture with his miniscule sketches on the blank pages of his catalogues and sketchbooks, such as the two scenes from the house of M. Gaignat, whose enormous sale took place at home in 1769, attracting much attention (Fig. 6). These drawings are very sketchy, personal overall designs, not nearly as finished as his more 'public' art scenes. They give a sense of the abundance of art, and the decorative hanging — not the content.

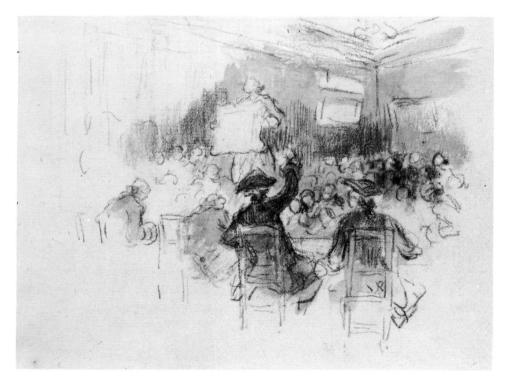

FIG. 12. Gabriel de SAINT-AUBIN, The Art Institute of Chicago (1946.383), *Sketch of a Public Auction from the Chicago Sketchbook* (folio 19 *recto*), 1760/64. Black chalk with brush and brown wash on ivory paper, *c.* 17.2 × 13 cm.

[22] Philip Conisbee, *Painting in Eighteenth-Century France* (New York, 1981), pp. 22 and 29.

[23] By contrast, as time went on, Saint-Aubin became a bit looser, more selective, and whimsical in his marginal drawings, as seen in the painting by Carle van Loo which he sketched in the famous Calvière auction catalogue of 1779.

[24] Lenfant, Demachy and Greuze were the notable contributors of drawings to the 1761 Salon.

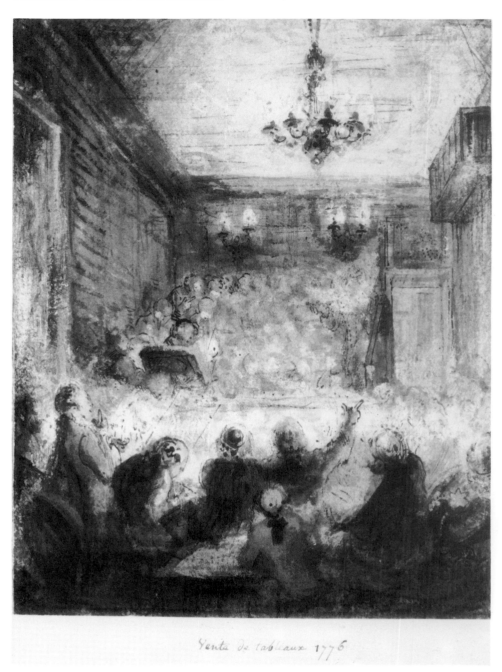

FIG. 13. Gabriel de SAINT-AUBIN,
Cabinet des Dessins, Musée du Louvre,
Paris, *Vente de tableaux, 1776 from the
Louvre carnet* (page 46), 1776. Pen and
brown and black ink, brush and brown
wash and gouache, on ivory paper, 18 ×
12.5 cm.

25 Diderot and Grimm's enthusiasm for the
practice of sketching from works of art in
catalogues and the likelihood of their know-
ledge of Saint-Aubin is discussed in Michael
Cartwright, 'Gabriel de Saint-Aubin: An
Illustrator and Interpreter of Diderot's Art
Criticism', *Gazette des Beaux-Arts*, s. 6, 73
(April, 1969), pp. 207 ff.

Among Gabriel's celebrated independent drawings are his depictions
of the Salons from 1753 to 1769. In these his development runs counter to
the *livrets*: in his earliest work, of 1753 (which he developed into an
etching), Saint-Aubin seems to have been trying to capture the general
atmosphere of the Salon, with all classes of people rubbing elbows on the
narrow staircase of the Louvre, illustrating the growth of a wide art
'public' for the Salons of this period (Fig. 7). Later, perhaps due to popular
response to his meticulously illustrated Salon catalogues, he created far
more exacting documentations of the wall of honour, in which every work
can be identified and the hanging evaluated (Fig. 8). Saint-Aubin's
obsessiveness in these drawings and *livret* illustrations is particularly
poignant in light of the fact that he was a *refusé* of the very hierarchy he
enshrined, a shut-out observer, like most of the new public that he saw
there.

It is not at all clear what sort of market — what collectors, if any —
Saint-Aubin had for his drawings. Although his habit of drawing in the
Salon *livrets* was advocated by the likes of Diderot and the Baron
Grimm,[25] there is no evidence that any of these were commissioned, and

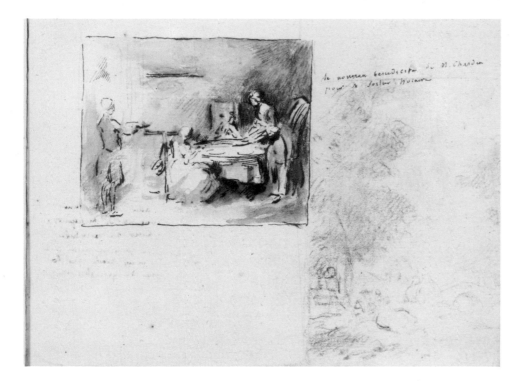

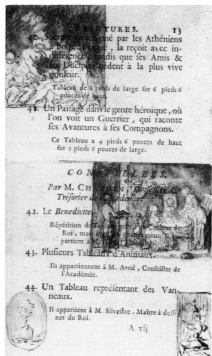

the legend of the disgrace Gabriel brought to his family by his unorthodox artistic behaviour finds little to refute it. Saint-Aubin taught drawing in Blondel's academy for many years, but it is doubtful that he could have supported himself in that way. Most of his approximately one thousand known drawings are unfinished scraps of paper, which would have been difficult — if not impossible — to market. Occasionally there are large or finished sheets which appear to have been hung as independent works of art[26] or made to appeal to a particular segment of the market. Such is the case with a magisterial sheet depicting the fire of late December, 1772 in the Hôtel Dieu (Fig. 9), which probably relates to a number of other Parisian views of architectural and sculptural monuments drawn by Saint-Aubin about that time. This work in particular is very similar to the contemporary watercolours of Hubert Robert, and leads to the speculation that such Parisian views either represent a specific commission or Saint-Aubin's attempt to get in on a lucrative market dominated by Robert and Demachy. However, as handsome and historically significant as these drawings may be, they do not represent Saint-Aubin's most original or characteristic art, and strike a rather commercial chord.[27]

Ironically, for an artist 'who drew at all times and in all places', as Gabriel was characterized by his older brother, only two sketchbooks that survived intact were known and published by his major cataloguer, Emile Dacier.[28] The one in the Louvre was actively used for private notations over most of the artist's career, from 1759 to 1778. It saw little or no use from 1760 to 1764 judging from the many dates and notations which cram the pages in layer after layer.[29]

The other album, in Stockholm, is actually an incomplete manuscript which Saint-Aubin appropriated and decorated more lightly over the last year of his life. Of particular interest in terms of the eighteenth-century *cabinet* is one page (Fig. 10) which depicts the salon of the Hôtel de Noailles with an accompanying inscription that indicates Saint-Aubin's drawings in the book may represent a commission documenting a *'cabinet'*: 'Mgr. le maréchal de Noailles engaged me to go see his paintings and to draw them on December 3, 1779.'[30]

Since 1948, The Art Institute of Chicago has owned a third exquisite sketchbook of twenty-four pages by Saint-Aubin, coming from the

FIG. 14. Gabriel de SAINT-AUBIN, The Art Institute of Chicago (1946.383), *Sketch after Chardin's Painting 'Le Nouveau benedicite' and Study of a Landscape from the Chicago Sketchbook* (folio 17 *recto*), 1760/64. Black chalk, pen and brown ink with brush and grey and brown wash, on ivory paper, c. 17.2 × 13 cm.

FIG. 15. Gabriel de SAINT-AUBIN, Bibliothèque Nationale, Paris, *Sketch after Chardin's Painting 'Le Nouveau benedicite' and other oils from the 1761 Salon catalogue* (page 13), 1761. Pen and brown ink, brush and brown wash over black chalk.

[26] This is particularly evident in a pair of drawings of Porte de Saint-Denis of 1778 (Musée Carnavalet, Paris; repr. in Dacier II (1931), pl. XXII) which were clearly designed as finished pendants, meant to be framed and hung. In inimitable fashion, however, Saint-Aubin scribbled miscellaneous studies on the back of one of these sheets, but not both.

[27] Certainly there was active interest in architectural drawings from the time of Marigny, and there may well have been an eighteenth-century collector obsessed with the iconography of Paris, like Hippolyte Destailleur, who gathered so many of these sheets by Saint-Aubin into albums in the late nineteenth century.

[28] Emile Dacier, *Gabriel de Saint-Aubin, peintre, dessinateur et graveur (1724–1780)*, 2 vols (Editions G. van Oest, Paris and Brussels, 1929–31).

[29] Emile Dacier, *Le 'Livre de Croquis' de Gabriel de Saint-Aubin* (Musées Nationaux, Paris, 1943), p. 6.

[30] Emile Dacier, *Le carnet de dessins de Gabriel de Saint-Aubin conservé à la Bibliothèque Royale de Stockholm* (Paris, 1955), p. 50.

FIG. 16. Gabriel de SAINT-AUBIN, The Art Institute of Chicago (1946.383), *Interior with Watteau's 'Jupiter and Antiope' and Chardin's 'Rattisseuse de Navets' from the Chicago Sketchbook* (folio 22 *recto*), 1760/64. Pen and brown ink with brush and brown wash over black chalk, on ivory paper, *c*. 17.2 × 13 cm.

FIG. 17. Gabriel de SAINT-AUBIN, The Art Institute of Chicago (1946.383), *View of a Wall in the 1761 Salon from the Chicago Sketchbook* (folio 22 *verso*), 1761. Black chalk with brush and watercolour and grey wash on ivory paper, *c*. 17.2 × 13 cm.

31 For a discussion of this sketchbook, see McCullagh, pp. 359–83; for complete reproduction of it in colour see the microfiche publication by Harold Joachim, *French Drawings and Sketchbooks of the Eighteenth Century: The Art Institute of Chicago* (University of Chicago Press, 1977), fiche 4D3–4G12.
32 Indeed, much of the album seems to relate to Gabriel's printmaking in the years 1760–64, such as the rough sketch of the final act, opening night in 1762, of Voltaire's *Tancrède*, an image he caught in pencil at the theatre and worked up later at home, in pen lines that plan the print he made the next day.
33 In their research for the *Chardin* exhibition of 1979, Pierre Rosenberg and Sylvie Savina were unable to find any collection that might have possessed these two works during Gabriel's lifetime.

David-Weill and Léon Fould Collections which, for a variety of reasons, can be dated securely to 1760–64, just those years of little use for the Louvre *carnet*.[31] Of roughly the same small dimensions as that in the Louvre, but horizontal in format, it clearly served its master for on-the-spot-reporting, such as the night in March 1762 when fire broke out in the Foire St Germain (Fig. 11). Saint-Aubin made a large etching of the ruins, probably for sensationalist commercial purposes.[32]

Saint-Aubin's passion for sales and Salons is everywhere present in the lively sketch of an auction room (Fig. 12), similar to a more finished, independent page he pasted into the Louvre *carnet* (Fig. 13). There are many scattered reminiscences of the 1761 salon, such as another version of Chardin's *Benedicite*; having carefully documented the painting in his *livret* (Fig. 15), Gabriel took the liberty of recalling the work from memory, evoking it as an abstract study of light and shade with washes undoubtedly applied to the sketchbook at home, away from the Salon (Fig. 14). Taking even greater liberties, on another page he fabricated what was possibly an entirely imaginary wall of a salon or '*cabinet*' combining famous works of his favourite artists — Chardin's *Ratisseuse* and Watteau's *Jupiter and Antiope* (Fig. 16).[33]

Work of this nature might lead one to believe this sketchbook again represents a private commission — or does it? Did these highly imaginative recollections, and even the Salon drawings and catalogues, give the artist a kind of mastery or authority over official or public art? Was it something private connoisseurs also desired and appreciated? Did they prefer to contemplate the Salons *away* from the crowds? When one compares the page of the intimate and atmospheric Wall of Honour of the 1761 Salon in the Chicago Sketchbook (Fig. 17) with the highly detailed sheet of 1765, now in the Louvre (Fig. 8), it becomes clear that one offers private delectation, the second a public exercise. By 1769, Saint-Aubin had given up such virtuoso Salon documentations in favour of conveying an aura of elegance, a sense of refined atmosphere similar to, but very different from, his earliest work of 1753. As seen in a drawing from a private collection

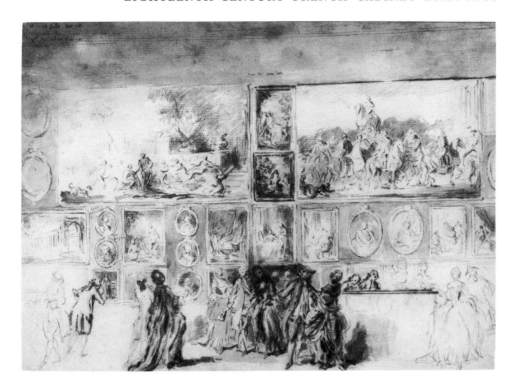

FIG. 18. Gabriel de SAINT-AUBIN, Private Collection, *Le Salon du Louvre en 1769*, 1769. Pen and brown ink with brush and brown wash, 18 × 24 cm.

(Fig. 18), a new romantic concept of the cultivated Salon audience is suggested — is this in response to the demand of the private collectors or Salon officials? Is this more propaganda to legitimize a hierarchical structure in an increasingly liberal age?

Finally, another legendary but unknown and unpublished Saint-Aubin family album, bearing nearly three hundred drawings, represents, within its covers, a virtual microcosm of an eighteenth-century *cabinet*.[34] The album seems to have been started by Gabriel's older brother, Charles-Germain, decorator to the King, whose designs, *papilloneries humaines*, and caustic remarks are sprinkled throughout the first half of the album. It was probably 'finished' by Augustin de Saint-Aubin in the last two decades of the eighteenth century. It contains some of his most beautiful and characteristic sheets, as well as drawings by a large portion of several generations of the Saint-Aubin family, ranging from father, Gabriel-Germain, decorator to the King, and Gabriel's deformed sister, Agathe, to younger brother Louis, decorator at Sevres.

Some of Gabriel's most important and finished works are to be found encapsulated within the pages of this tome, including very personal statements that reveal his sense of humour about himself. A telling sheet is his portrait of the operatic star Sophie Arnould (also a collector) (Fig. 19) which older brother Charles-Germain inscribed with wit: 'on watching Saint-Aubin draw, Mlle Arnould said to me, "your brother has no teeth — he bites off more than he can chew".'

These are the truly inventive, intimate and revealing drawings that constitute the finest of Saint-Aubin's art. For whom were they intended? Why were they drawn?

Indeed, what is significant about this album is that the family may have despised Gabriel's career and deportment, but they *saved* his drawings and cherished them as their own. Indeed, there is a sense that his drawings, and many of theirs as well, were executed for no greater purpose than family enjoyment. This alters appreciably not only our perception of his stature within his family and within his century, but raises the question of artist's drawings made merely for their own private delectation or that of their families. With drawings, one could afford to take risks. In addition to artists who drew commercially, eighteenth-century France spawned

[34] Regarding the *Livre des Saint-Aubin*, see McCullagh, op. cit., pp. 59–89.

FIG. 19. Gabriel de SAINT-AUBIN, Private Collection, *Sophie Arnould aux Grands-Augustins*, 1772. Pen and brown ink over black and white chalks and stumping, on ivory laid paper, 18.5 × 12.5 cm.

individuals who saw drawing as important in itself, whose greatest work might have stayed forever in a private album — toward what end? The Saint-Aubins, like Vasari, must have anticipated that one day their album would leave the family's hands, and serve as a time capsule — a perfect testimony to the world at large of the best of their work — their legacy — even in the album's very *assemblage*.

In this independent behaviour and repudiation of the Academic way of doing things, Gabriel de Saint-Aubin epitomized the 'new art public' of the mid-eighteenth century, the critical but attentive audience feared by the official artists.[35] But at the same time, Saint-Aubin embodied in his drawings a love for the few choice liberties he enjoyed, such as going to sales, Salons, and private collections, or the other spectacles of Paris. His love of these liberties allowed connoisseurs of all ranks to treasure his private art privately ever since.

[35] Crow, op. cit., p. 14.

Raphael: le rouge et le noir

by KONRAD OBERHUBER

In the Albertina, where for convenience drawings are still kept under their old attribution, one can find side by side under the name of Penni, two sheets now nearly universally accepted as Raphael; one is a red chalk study for *St Matthew* in the *Transfiguration*, (Fig. 1) the other is one in black chalk for *David and Goliath* in the Vatican *loggie* (Fig. 2). The former is a sheet of marvellous crispness characterized by sharp outlines and parallel hatchings over some light sketchy indications in red chalk and a squared grid system drawn in stylus. Raphael found the form without much hesitation. The other is much more loosely drawn. The outlines, however sovereign in their command of form, are set more delicately and the sheet abounds in *pentimenti* in the poses. Many light sketches, now rubbed away, and repeated light lines, as in the shield and drapery of Goliath, illustrate characteristic. The hatching lines emerge often into continuous fields or dark blotches, giving the whole a more painterly and atmospheric character. A similar distinction can also be made between this black chalk drawing and another one in red chalk more closely related in function, a study for the horsemen in the *Spasimo di Sicilia* (Fig. 3) where the figures are dressed as in the *loggie* sheet. Yet here too we have the clear crisp quality of the stroke even where Raphael merely sketches in the contours in places where there was no preparation with stylus. In fact only the head of the horse had been incised beforehand.

Clearly the difference between red and black chalk drawings which had sometimes been seen as one between two different artists is just the result of the two different media and Raphael's sensitivity to the hardness or softness of the stones as well as to the light values of their colour. Yet there is also a second factor. Black chalk and charcoal are traditional sketching media, and even before Raphael's time, provided the under-drawing for pen-and-wash drawings. Red chalk is only rarely used for that purpose in the sixteenth century. Raphael seems to prepare most of his red chalk studies with stylus while this is much less often the case when he works in black chalk. Black chalk studies, especially from the late period were therefore doubted more often than the ones in red chalk. They were many times labelled Giovanni Francesco Penni, the assistant whose image was that of a hesitant and feeble draughtsman by contrast with the forceful Giulio Romano. Yet Giulio was also credited with some of these sheets. While the sharp and clear drawing in the Louvre for the two Apostles in the *Transfiguration* was always accepted as Raphael, a black chalk sheet for the drapery of one of them, with its smudgy areas of black shadows and summary treatment of form, remained for a long time unnoticed.

Regteren Altena had a lengthy struggle for the acceptance of a study for the head of the woman in the foreground of the painting, incidentally one of the few black chalk drawings with stylus preparation. Here too shadows are continuous and contours soft. A similar fate was encountered by two studies related to the *Charity* in the Sala di Costantino where extremely fine lines that are hardly visible on the relatively rough paper contrast with deep shadows and thus present to us the full range of the black chalk's possiblities.

FIG. 1. RAPHAEL, Albertina, Vienna,
St Matthew. Red chalk, 12.6 × 14.4 cm.

FIG. 2. RAPHAEL, Albertina, Vienna,
David and Goliath. Black chalk on buff
paper, 24.3 × 32.1 cm.

FIG. 3. RAPHAEL, Albertina, Vienna,
Horsemen in the Spasimo. Red chalk
with metalpoint, 28.6 × 20.3 cm.

These extremes of crisp clarity of line in red chalk and of soft richness of tonal range and gradations in black chalk can be traced back to the time when Raphael systematically began to use red chalk around 1510. The so-called *Cumaean Sibyl* in the Albertina (Fig. 4) differs greatly from the study for a woman in *Heliodorus* in Oxford (Fig. 5) in spite of the fact both must be close in time of execution, since ideas for the *Sibyl* fresco are found on the *verso* of the *Heliodorus* sheet. While black chalk drawing was a heritage Raphael received from the Quattrocento and was used from his beginnings by him for all purposes including crisp lines, red chalk drawings were employed by him only in Florence, where he encountered Leonardo, who may have been one of the first to use this chalk for drawing on paper. In early sketches Raphael actually exploited the softer side of the red medium and even used it for first ideas, something he later did much more rarely. Yet it is only from around 1510–11 onwards when Michelangelo also began to use red chalk consistently for his drawings for the Sistine Ceiling, that Raphael almost began to prefer red chalk to black to judge from what has been preserved of his sheets. Some functions of drawings did remain however, always in the domain of the black chalk such as the cartoon and the auxiliary cartoon, both large drawings the size of the painting. Whether this is a function of the availability of the media, black chalk being more abundant, or of artistic preference, black chalk rendering light and shadows more precisely for the painter, is hard to say.

Black chalk drawings are amongst Raphael's earliest. He uses them with great variety of styles, tones and purposes. One of the first is the

FIG. 4. RAPHAEL, Albertina, Vienna, *Cumaean Sibyl*. Red chalk and pen, 27.9 × 17.2 cm.

FIG. 5. RAPHAEL, Ashmolean Museum, Oxford, Woman in *Heliodorus*. Black chalk, 39.5 × 25.9 cm.

6

7

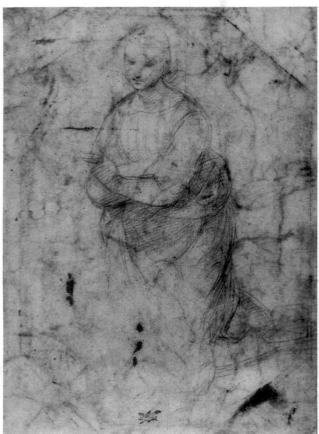

8

9

FIG. 6. RAPHAEL, Ashmolean Museum, Oxford, *Self Portrait*. Black chalk, 38 × 26 cm.

FIG. 7. RAPHAEL, Ashmolean Museum, Oxford, *Study of angel and St Augustine*. Grey chalk, 37.9 × 24.5 cm.

FIG. 8. RAPHAEL, British Museum, London, *Kneeling Madonna*. Red and black chalk, 26.9 × 19.7 cm.

FIG. 9. RAPHAEL, Uffizi, Florence, *Madonna del Granduca*. Black chalk and pen, 21.3 × 18.4 cm.

FIG. 10. RAPHAEL, Albertina, Vienna, *Aeneas and Anchises*. Red chalk, 30 × 17 cm.

delicate self-portrait in the Ashmolean Museum where the medium has the fineness of a silverpoint (Fig. 6). Raphael uses black chalk for most of the drawings for his first documented painting, the now destroyed *St Nicholas da Tolentino* altarpiece and for the Banner, both for Città di Castello. Free and crisp sketches for tiny figures or details of hands as well as broadly rendered studies of garments (Fig. 7) demonstrate the variety of approaches. There are even head studies of the finest and most delicate

FIG. 11. RAPHAEL, Devonshire Collection, Chatsworth, reproduced by permission of the Chatsworth Settlement Trustees, early drawing for the *Transfiguration*. Red chalk. 24.6 × 35 cm.

quality with lines of the greatest sharpness and clarity. The black chalk in Umbria fulfils all functions of chalk. It can be used with painterly richness and freedom as well as with the utmost sharpness and clarity. It can be used openly with lots of paper shining between the strokes or densely so as to render the surface of sun-tanned skin. Raphael exploits a wide range of the medium, even though he does not yet use to the same extent the smudges and soft blurred contours he will seek later. His early style did not demand them.

When Raphael begins with red chalk he experiments with it widely. Reproduced in black, it is not easy to know that the study for a kneeling Madonna in the British Museum of about 1506 (Fig. 8) is drawn in red chalk, so close is it to a black chalk drawing in the Uffizi the *Madonna del Granduca* of nearly the same time (Fig. 9). We already saw that Raphael at that moment also used the red chalk for sketching. He at first employed it like black chalk. There are nude studies like an early one of babies in a New York private collection and the famous one in the Albertina for the *Massacre of the Innocents* where he even smudges the red chalk in deep shadows and heavy and soft contours.

Yet from about 1511 on the medium's quality of clarity and luminosity seems to prevail, even though it will be employed in a great variety of functions and sometimes with the additional use of stumping. Around 1514–15 we find some extraordinary examples like the Albertina's densely handled *Aeneas and Anchises* (Fig. 10), where Raphael studied the surface effect of figures he planned to paint in the nude also in the fresco, or the light and transparent use in the warriors that would

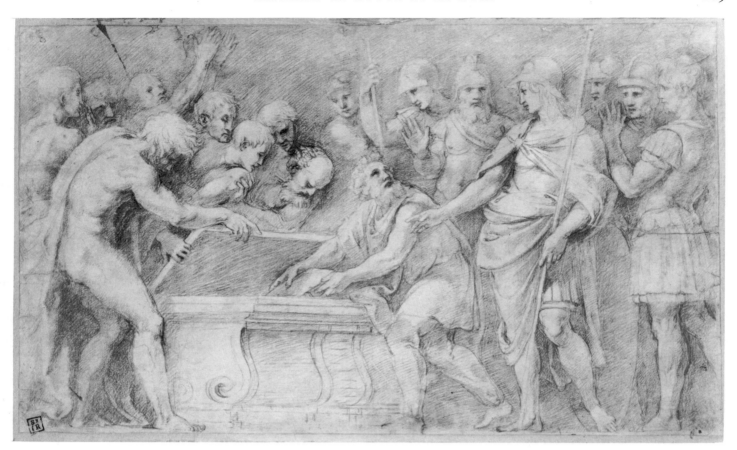

FIG. 12. RAPHAEL, Ashmolean Museum, Oxford, *Alexander and Homer's Books*. Red chalk over indentations with stylus, 24.3 × 41.3 cm.

FIG. 13. RAPHAEL, Royal Library, Windsor Castle, sketch for lower section in the *Disputa*. Grey chalk, 20.4 × 41 cm. *Reproduced by Gracious Permission of Her Majesty the Queen.*

appear in armour in the *Battle of Ostia* which Raphael rightly sent to Dürer to demonstrate his style. There is also the much more free and searching figure-study for the two women and a child, where poses are still sought and were foremost on the mind of the artist.

Till the end Raphael used red chalk both for relatively early ideas in searching for the right arrangement of figures, as in the drawing in Chatsworth for the upper portion of the *Transfiguration* (earlier on he had used pen for a similar drawing for the *Disputa*), as well as for very highly wrought compositional ideas nearly at the end of the preparatory process, such as the *modello* in the nude for *Alexander and Roxane*, in the Albertina. Raphael even drew *modelli* in red chalk as for example the *Alexander laying the books of Homer in the Shrine of Darius* in Oxford (Fig. 12) a drawing used for an engraving by Marcantonio, and similar to a drawing by Giulio Romano for an engraving by Agostino Veneziano of 1516.

FIG. 14. RAPHAEL, Ambrosiana, Milan, *Study for the Virgin*. Charcoal, chalk and bodycolour, 30.8 × 20 cm.

FIG. 15. RAPHAEL, Uffizi, Florence, *Adam*. Charcoal, chalk and bodycolour, 37.5 × 21 cm.

FIG. 16. RAPHAEL, Ashmolean Museum, Oxford, *Drapery Study for the Disputa*. Charcoal, black chalk and bodycolour, 25.5 × 39.2 cm.

I do not want to claim that Raphael in his later period chose black and red chalk always consciously with a clear purpose in mind. Yet there certainly seems to have been a kind of instinctive response to the medium that led him to use one or the other according to his need. Francis Ames-Lewis also seems to think that this was so. It is perhaps no chance that of the three major frescoes in the Stanza della Segnatura the drawings

Fig. 17. RAPHAEL, Ashmolean Museum, Oxford, *Fighting nudes*. Red chalk over indentations with stylus, 37.9 × 28.1 cm.

which have come down to us show the predominance of different media. the *Disputa*, where the painterly ideas of Leonardo are filtered by the strong influence of Fra Bartolomeo, who loved black chalk, seems to be dominated by black chalk drawings and luminous drawings with wash. It shows the range of Raphael's use of black chalk maybe at its widest. There are early compositional sketches with the medium (Fig. 13) showing Raphael's tentative and searching stroke with some deep accents to bring out focal points. There are equally tentative figure-studies where poses are found and details worked out like in the early studies for *St Nicholas of Tolentino*. Yet even the figure-studies for the *Virgin* (Fig. 14) or for *St Paul* which both belong to the early working phase are luminous in the tonal range and atmospheric in their effect and show how Raphael is groping for the monumental style of Rome. As he works, his assurance grows and he creates figures like that of *Adam* (Fig. 15) in which the clarity of corporeal form does not exclude an atmospheric effect. Raphael's search for light is especially reflected in the freely handled drapery studies (Fig. 16) with their floating light that makes one think of Barocci's later experiments in the same vein and one is surprised to see these in conjunction with luminous

FIG. 18. RAPHAEL, Devonshire Col-
lection, Chatsworth, reproduced by per-
mission of the Chatsworth Settlement
Trustees, *Three Soldiers*. Black chalk,
23.4 × 36.5 cm.

and transparent brush studies in which both Leonardo's and Fra Barto-
lomeo's heritage are developed further towards greater luminosity and
clarity, a sunlike quality that Fischel celebrated. The *School of Athens* with
its much greater distinctness of form and colour and its individualized
figures is dominated by studies in silverpoint, the precise medium. Yet
among them are also some studies in red chalk like that for the fighting
nudes in Oxford (Fig. 17). This is a sheet where the clarity and precision of
line, its calligraphic beauty and the luminosity of the paper shining through
the hatching come fully to the fore.

The most rhythmical and calligraphic as well as the most decorative of
the frescoes is *Parnassus*. Here pen drawings dominate. Yet in the *Sibyls* in
Santa Maria della Pace (eg. Fig. 6) red chalk dominated. Pen and red chalk
can hardly be distinguished in these drawings both being carriers of
eurhythmy and grace following above all Leonardo, the great propagator
of the medium.

We have seen that in *Heliodorus*, where a strong chiaroscuro
dominates and grace is suppressed for expression, Raphael returns again to
the painterly effects of black chalk and its richer tonal range. Red chalk
seems to be the medium of formal clarity, black chalk that of expression
and search for chiaroscuro and atmosphere.

Puzzles remain: the soldiers for the never-executed *Resurrection*
(Fig. 18) in the Chigi Chapel reflect Michelangelo's clarity of form and
Raphael here uses the black chalk with great precision of form. Yet in
execution it was going to be a night scene and he may have thought of those
strong chiaroscuro effects when he chose the medium. When he finally
took up the Michelangelesque scene in the well-lit *Fire in the Borgo* he
again used red chalk as we saw (Fig. 12).

Red chalk also dominates the studies for the Tapestry cartoons, a
work of classical clarity of form and structure, and above all the graceful

gods in the Chigi Loggia, which were created during the years 1514–18. Yet I have to admit that Raphael used the medium also for pictures with strong chiaroscuro like the *Madonna of Francis I*, the *Coronation of Charlemagne* and the *Transfiguration*. Yet the expressive frescoes in the Sala di Costantino, to be painted in oil to bring out better their dramatic light effects, were again prepared in black.

Le rouge et le noir. They are next to pen and brush, and silverpoint only a part and not the full gear of Raphael's arsenal of draughtsmanship. They gave him two models of expression which consciously or unconsciously allowed him to widen his means of expression and seek for new ways to approach even better his goals of penetrating ever more deeply into what his subject matter demanded. Yet already here some of the later fate and myth of red chalk seems to appear. It is the fixed medium, the one that cannot easily be corrected and thus the one for the display of academic prowess, the medium of clarity of form and luminous light celebrated above all in eighteenth-century France.

No wonder also that red chalk became in Italy the medium of Florence, of Andrea del Santo, Rosso, and Pontormo as well as Michelangelo while black chalk forever dominated Venice and the work of Titian, Veronese and Tintoretto.

Rembrandt's landscape drawings[1]

by MARTIN ROYALTON-KISCH

When we think of Rembrandt, landscapes, whether painted or drawn, are not the first images to leap to mind. But although most of his work was figurative, his *œuvre* as a landscape artist was not inconsiderable. There is a small group of landscape paintings, twenty-seven landscape etchings and, according to Otto Benesch's *Corpus* of Rembrandt's drawings, well over two hundred landscape drawings, quite apart from the landscapes in the backgrounds of many of his figurative compositions.

The landscape drawings probably account for over twenty per cent of his production as a draughtsman, but have been comparatively neglected. Apart from their inclusion in *catalogues raisonnés* of all Rembrandt's drawings, the only major book devoted to them is that by Frits Lugt, who examined their topography in a volume published in Dutch and German editions in 1915 and 1920.[2] He successfully identified many of the locations that Rembrandt had drawn and found that nearly all of them were made within a few miles of Amsterdam. The drawing now in the Woodner Collection is no exception (Figs 1, 2). It depicts, on both the *recto* and the *verso*, the small hamlet of Houtewael, which lay on the St Anthoniesdijk about a mile east of the city. The walls of the dyke are accented by a horizontal line of wash, running immediately below the houses on the *recto*, while on the *verso* a group of figures is seen standing on the dyke at the entrance to the village.

Lugt's identifications were an enormous step forward in our understanding of the landscape drawings, but from the point of view of style it is fair to say that there has never been a study that has done them full justice. This paper's contribution, given the time available, can only be a modest one, but it attempts, among other things, to make a few inroads into Benesch's *Corpus*, and to reattribute one of his paintings. Prior to this attempt, it is imperative to investigate Rembrandt's work as a landscape draughtsman in some detail, both in terms of style and in terms of the different functions his landscape drawings fulfil. Only then can any tares be separated from the corn, and I shall therefore begin by mapping out Rembrandt's stylistic development as a landscape draughtsman.

His earliest works reveal little interest in landscape. In his painting of the *Rape of Europa* (Fig. 3), a work of 1632, and his etching of 1633 of the *Good Samaritan* (Fig. 4), the landscape elements are treated in a rather rudimentary fashion. The background to the *Europa*, which contains one of the most elaborate passages of landscape from the first decade of the artist's activity, is conventionalized, with somewhat undifferentiated mannerisms describing the scrub and foliage. In the etching, which may be based on a lost painting (the best version of which is in the Wallace Collection),[3] the view to a distant town is rather slackly drawn, without much sense of atmosphere. It reveals little enthusiasm for the details of natural forms. In fact a drawing by Rembrandt related to the composition, survives in Hamburg (Fig. 5), and seems only to confirm his lack of interest in the landscape background. It concentrates entirely on the architecture, on the angle of the stairs and the façade, and on the well which he was to repeat in the final composition.[4]

[1] The text and number of illustrations are somewhat reduced from the lecture given at the Woodner Symposium. I would like to thank Professor J. Bruyn and Peter Schatborn, who have both read the text and offered helpful suggestions.

In the case of illustrated works, abbreviated references to the following books are given in the captions: Adam Bartsch, *Toutes les estampes qui forment l'oeuvre de Rembrandt...* (Vienna, 1797); Otto Benesch, *The Drawings of Rembrandt, Complete Edition*, 6 vols, enlarged and edited by Eva Benesch (London and New York, 1973); Werner Sumowski, *Drawings of the Rembrandt School*, vols 1–9 (New York, 1979–85); J. Bruyn, B. Haak, S. H. Levie, P. J. J. van Thiel, E. v. d. Wetering, *A Corpus of Rembrandt Paintings*, vols 1–2 (The Hague, Boston and London, 1982 and 1986), abbreviated to Bartsch, Benesch, Sumowski and *Corpus* respectively.

[2] F. Lugt, *Wandelingen met Rembrandt in en om Amsterdam* (Amsterdam, 1915); ibid., *Mit Rembrandt in Amsterdam* (Berlin, 1920). Other contributions include Max Eisler, *Rembrandt als Landschafter* (Munich, 1918), G. Wimmer, *Rembrandts Landschaftszeichnungen* (Frankfurt, 1935) and P. Schatborn and E. Ornstein-van Sloten, *Landschaptekeningen van Rembrandt en zijn voorloopers*, exhibition catalogue (Rembrandthuis, Amsterdam, 1983). Dr Cynthia Schneider is preparing an exhibition on the subject of Rembrandt's landscape drawings and prints for the National Gallery of Art in Washington in 1989.

[3] *Corpus* (see note 1), II, no. C48 (advancing an attribution to Govaert Flinck).

[4] The Hamburg drawing is somewhat problematic, because in style and technique (the use of iron-gall ink) it conforms more to the end of the 1630s than to the period of the etching.

FIG. 1. REMBRANDT, Woodner Collection, New York, *View of Houtewael* (Benesch 1261 *recto*). Pen and brown ink with brown and grey wash, touched with white, on paper prepared with light brown wash, 12.6 × 18.3 cm. *Photo: courtesy of Christie's.*

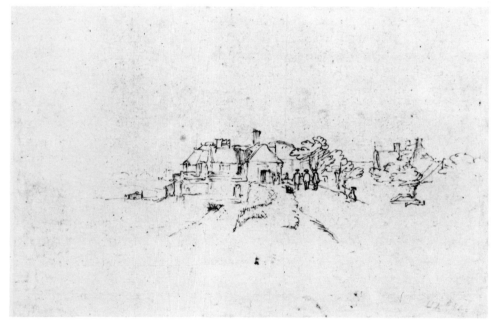

FIG. 2. REMBRANDT (Photo Royal Academy of Arts, London), *The Road on the Dyke entering Houtewael.* Pen and brown ink, *verso* of Fig. 1.

The apparent neglect of nature in these youthful works may reflect the influence, not particularly beneficial in the field of landscape, of Rembrandt's teacher, Pieter Lastman, who was above all a history painter. Although Lastman used landscape as a foil to figurative subjects, he rarely produced a pure landscape painting.[5] His *Ruth and Naomi* of 1614 (Fig. 6), now in Hanover, is a typical example. The background relies heavily on the traditions of northern landscape composition prevalent early in the seventeenth century and responds to the Italianate influence of Adam Elsheimer. The dark screen of hills and trees, silhouetted against an evening sky and relieved by an almost obligatory Roman bridge and tower, are all elements derived from this convention. Although effective, the landscape does not reveal a particularly direct or lively response to nature. Indeed, as in Rembrandt's etching, the individual details are largely unexplored. The trees, for example, are somewhat flaccid and lack substance, and seem more decorative than realistic in their structure.

Rembrandt's neglect of landscape was not to last, but in the absence of dated landscape drawings it is difficult to determine the precise moment in

[5] An exception being formed by a *Pastoral Landscape* in a private collection, see Christopher Brown, *Dutch Landscape, The Early Years*, exhibition catalogue (National Gallery, London, 1986), no. 84, and Peter C. Sutton, *Masters of 17th-Century Dutch Landscape Painting*, exhibition catalogue (Amsterdam, Boston and Philadelphia, 1987–88), no. 55.

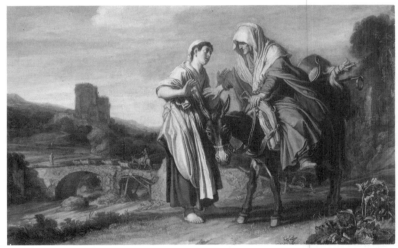

FIG. 3. REMBRANDT, Private Collection, New York, (on loan to the Metropolitan Museum of Art), *The Rape of Europa*, 1632. Oil on panel, 62.2 × 77 cm.

FIG. 4. REMBRANDT, British Museum, London, *The Good Samaritan* (Bartsch 90), 1633. Etching, 25.7 × 20.8 cm.

FIG. 5. REMBRANDT, Kunsthalle, Hamburg, *Entrance to a Cottage with a Draw-Well* (Benesch 462). Pen and iron-gall ink, 18 × 23.3 cm.

FIG. 6. Pieter LASTMAN, Niedersächsisches Landesmuseum, Landesgalerie, Hanover, *Ruth and Naomi*, 1614. Oil on canvas, 65 × 88.5 cm.

his career when he decided to improve his abilities as a landscape artist. Only one landscape drawing survives from his early years in Leiden (Fig. 7), a *View of the Outskirts of a Town* of the late 1620s, now in the Fitzwilliam Museum. This is an astonishingly abstract drawing, revolutionary in its breadth of handling if compared to contemporary landscapes by other artists, but on its own it can hardly be taken to represent a keen interest in the study of nature. Indeed, apart from the outdoor light, most of the elements in the composition are man-made.

A change in Rembrandt's attitude seems to have occurred around the mid-1630s, as can be deduced from a comparison of the backgrounds of the *Good Samaritan* and the *Adam and Eve* (Figs 4, 8), an etching produced five years later in 1638. The difference is obvious. Instead of a somewhat formless mass of foliage, Rembrandt produces in the *Adam and Eve* a masterly portrayal of the trees, whether in the gnarled foreground trunk of the Tree of Life, or in the background row of trees behind the figures. Where he had previously laboured to produce an undistinguished foil to the main action, he now evokes a convincing, airy and light-filled landscape with remarkable economy of line.

That this advance resulted from a direct study of nature is proven by a small group of about a dozen landscape drawings that survive from the mid- to late 1630s. Most of them, like the pair of drawings of a *Farmhouse*

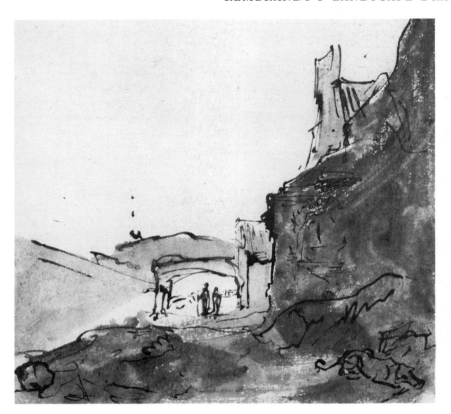

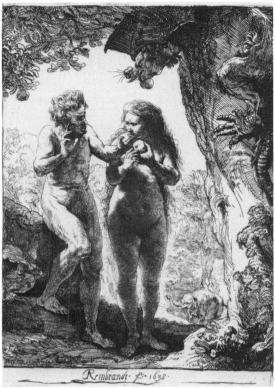

in Sunlight in Budapest (one reproduced, Fig. 9), only just qualify as landscapes. Nevertheless, the Budapest drawings show the artist grappling not only with abstract patterns of light, as in the study at Cambridge, but also with the demanding challenge posed by the twisting forms of a creeper, sprawling uncontrolled over the rigid patterns of the architecture. The concentration in these drawings on an informal motif is remarkable at this period, and they mark a significant moment in the development of Dutch landscape art.

Two other drawings of the 1630s, the *Landscape with a Man standing by a Road*, and the *Landscape with a Herd of Cattle*, both now in Berlin, show Rembrandt undertaking further experiments (Figs. 10, 11). The use of silverpoint in the former is adventurous, being a medium only rarely employed for landscape studies before or since. Together with two further drawings (one on the *recto* of the Berlin sheet, the other in Rotterdam, Benesch 341 *verso*), they may date from as early as 1633, the year of his famous silverpoint study of Saskia. Style as well as the medium appear to confirm the earlier dating. The *Landscape with a Herd of Cattle* (Fig. 11) which must date from around 1638, seems more advanced than the silverpoint drawing. Nevertheless, both drawings show him taking an interest in the breadth and atmosphere of the Dutch terrain. In composition they respond to the patterns set in the previous two decades by Esaias van de Velde and Jan van Goyen, artists that Rembrandt follows in the choice of a low viewpoint and in leading the eye directly into the middle distance. This is especially clear in the silverpoint drawing, where the foreground is totally blank and divided from the rest of the sheet by means of a horizontal line. It was a compositional approach that Rembrandt was later to explore further.

In his finished landscapes, whether painted or etched, Rembrandt is often concerned with more visionary qualities. In the case of the etchings, one of the most obviously poetic is the *Three Trees*, of 1643 (Fig. 12). But even in a print like the *Landscape with a Cottage and a large Tree* (Fig. 13), of 1641, which looks more realistic, the composition is carefully thought out. There is an equal balance between the etched areas and those left

FIG. 7. REMBRANDT, Fitzwilliam Museum, Cambridge, *View on the Outskirts of a Town*. Pen and brown ink with brown wash, 14.3 × 15.2 cm.

FIG. 8. REMBRANDT, British Museum, London, *Adam and Eve* (Bartsch 28), 1638. Etching, 16.2 × 11.6 cm.

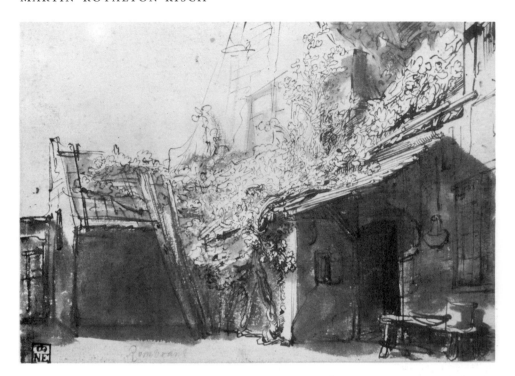

FIG. 9. REMBRANDT, Museum of Fine Arts, Budapest, *Courtyard of a Farm-House* (Benesch 464). Pen and brown ink with brown wash, 16.4 × 22.6 cm.

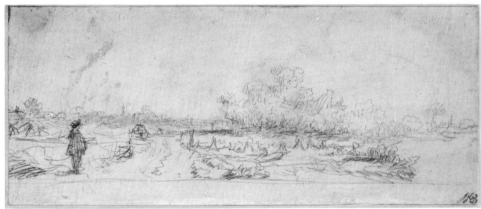

FIG. 10. REMBRANDT, Kupfer-stichkabinett, Staatliche Museen Preussischer Kulturbesitz, Berlin, *Landscape with a Man by a Road* (Benesch 466 verso). Silverpoint on pale grey prepared paper, 10.8 × 19.3 cm. *Photo: Jörg P. Anders; KdZ 2317.*

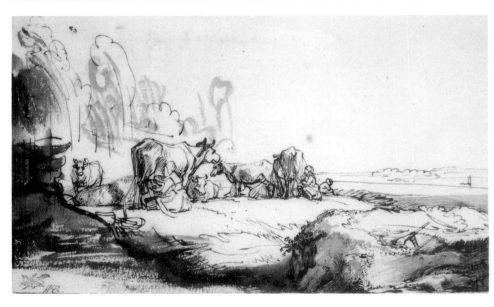

FIG. 11. REMBRANDT, Kupfer-stichkabinett, Staatliche Museen Preussischer Kulturbesitz, Berlin, *Landscape with a Herd of Cattle* (Benesch 465). Pen and brown ink with brown wash, 13.5 × 22.6 cm. *Photo: Jörg P. Anders; KdZ 2314.*

blank, and the more detailed, darker portion on the left acts as a dark repoussoir, contrasting with the lightly-etched landscape in the distance. These qualities are the result of considered choices, and the print should not be mistaken for a work executed entirely from nature.

The etchings of the early 1640s were produced as Rembrandt began again to make landscape drawings, and it was during the next fifteen years

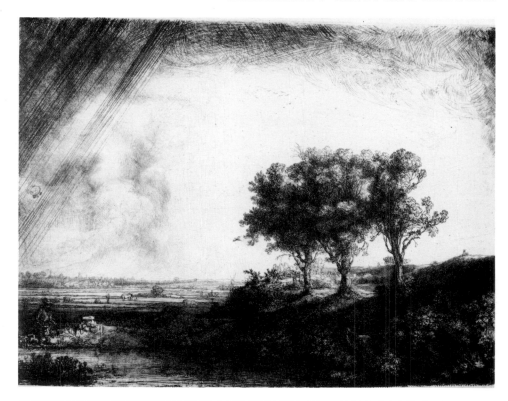

FIG. 12. REMBRANDT, British Museum, London, *The Three Trees* (Bartsch 212), 1643. Etching, 21.3 × 27.9 cm.

FIG. 13. REMBRANDT, British Museum, London, *Landscape with a Cottage and a large Tree* (Bartsch 226), 1641. Etching, 12.7 × 36 cm.

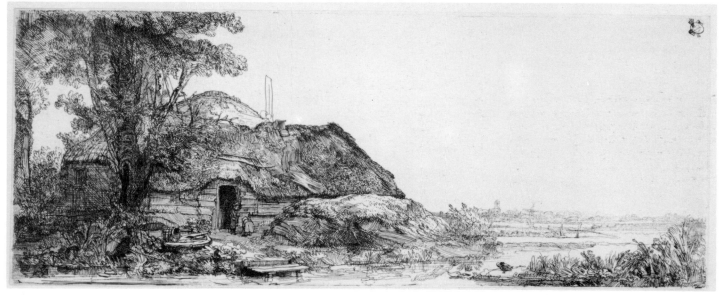

that most of them were drawn. Almost none is dated, but an exception is formed by the drawing of a *Cottage near the Entrance to a Wood*, in the Lehman Collection (Fig. 14). This is signed and dated 1644, but its usefulness as a guide to the chronology of other landscape drawings is limited for two reasons: first, because it is the largest pen and wash landscape he ever made, so that its style is exceptionally broad, and secondly because it is one of the earliest, the majority having been executed between 1645 and 1655. Nevertheless, the Lehman drawing retains some echoes of the two in Budapest of a farm in sunlight (see Fig. 9) but the effect of leaving the sunlit areas white to contrast with the wash is now undermined by the poor condition of the sheet.

Compositionally, the majority of landscape drawings of the 1640s and 1650s exhibit a kind of constructed informality. Two examples are illustrated, the Getty's *Sailing Boat* (Fig. 15), and the *View of Farm Buildings by a Dyke*, now in the British Museum (Fig. 16), a drawing which includes some exceptionally small details: the figure walking near

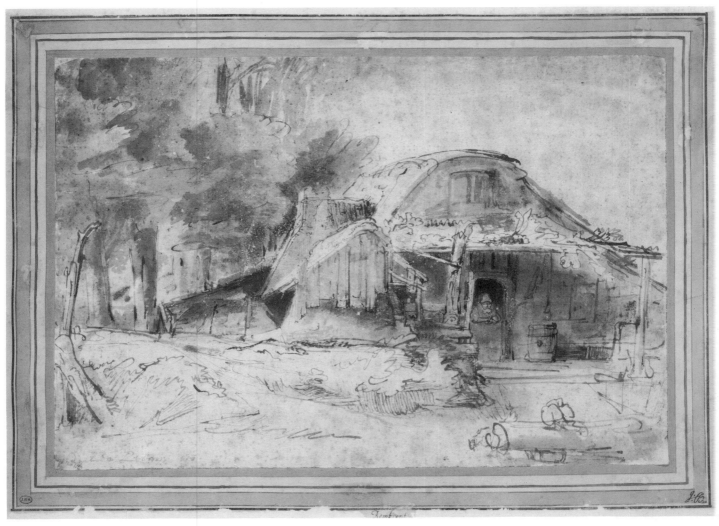

FIG. 14. REMBRANDT, Robert Leh-
man Collection, Metropolitan Museum
of Art, New York, *Cottage near the
Entrance to a Wood* (Benesch 815),
1644. Pen and brown ink with brown
wash, touched with red and black chalk
and white heightening, on paper washed
pale brown, 30 × 45.2 cm.

FIG. 15. REMBRANDT, The J. Paul
Getty Museum, *A Sailing-Boat on a wide
Expanse of Water* (Benesch 847). Pen
and brown ink with brown wash on
paper washed light brown, 8.9 ×
18.2 cm.

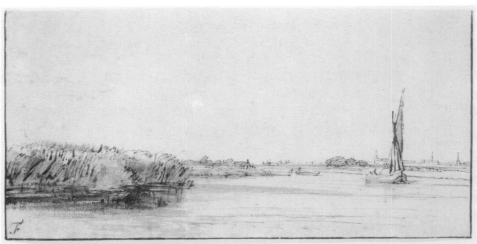

⁶ The drawing includes some grey wash,
apparently not by the artist.

the canal in the centre, the wagon on the left, and the figures and horses up
on the right. In this drawing the trees are shaded in several tones of brown
wash, which has evidently been applied with great care.⁶

In the drawing of a *Sailing Boat* (Fig. 15), Rembrandt is more
suggestive. The composition is pared down to essentials, a wedge-shape for
the terrain interrupted by a single vertical, the mast of the boat. An overall,
unifying atmosphere is provided by the preparatory brown wash. This
example must serve to represent the style of many drawings executed at
this time. In them, the artist concentrates on a simple motif, set down with
an almost oriental regard for the calligraphy of his penwork. This
calligraphic quality increases in Rembrandt's last landscape drawings,

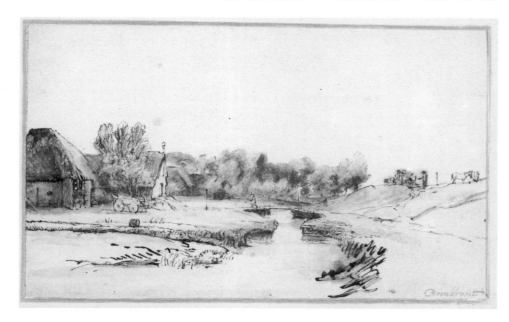

FIG. 16. REMBRANDT, British Museum, London, *Farm Buildings by a Dyke* (Benesch 832). Pen and brown ink with brown and grey wash, touched with white and with red chalk, 14.4 × 24.4 cm.

made in the 1650s, such as the celebrated study, at Chatsworth, of a *Farmhouse amid Trees* (Fig. 17). Here the patterns the lines create assume a lively, almost independent existence from the motif represented. In these later drawings Rembrandt communicates his response to nature with the greatest authority. The pen flicks confidently and boldly. The foreground is only suggestive of forms which in nature would have been out of focus to the eye, and the viewer becomes conscious of the energy inherent in the lines. Such drawings summarize and form a climax to the study of landscape which Rembrandt had begun twenty years before.

The rapid general survey of Rembrandt's development as a landscape draughtsman is now complete, so that we can now proceed to an analysis of the drawings' functions. To try to discover, for example, whether drawings like the Chatsworth *Farm* were executed from nature is in itself a testing problem. But it is only after categorizing the drawings according to their technique and purpose that we can hope to decide which ones do and which do not belong in Rembrandt's *œuvre*.

To begin with there is a sizeable group of studies in black chalk which were clearly executed out of doors. The example in Bayonne reproduced (Fig. 18), dated to around 1641 by Benesch, is one of the most fully realized of Rembrandt's landscapes of this type, although the medium, unusually, includes graphite. The scene is roughly set down, and compared with the pen and ink drawings, the sketch seems markedly less formal. There is nothing to suggest that it is a finished work of art that might be intended for sale. Yet even in this kind of drawing, there is an instinctive sense of balance in the composition, and the artist's concentration on the middle-distance, emphasized by the blank foreground, is typical of the more finished drawings as well.

Black chalk was also used by Rembrandt in other ways. For example, the *Study of Trees* in the British Museum (Fig. 19) is far more precise in detail than the Bayonne drawing, although in composition it seems yet more informal. This informality is taken to an extreme in a sketch, now in Berlin, of *Rooftops seen across a Canal* (Fig. 20). Rembrandt's viewpoint appears to be level with the water, the shape on the left being an abbreviated description of a barge. Although slight, the drawing successfully conveys a menacing atmosphere, with gathering rain-clouds sweeping down on the cottages. Studies of this kind must have fulfilled, in the context of Rembrandt's landscape art, precisely the same function as the rapid chalk drawings he made of figures, as in the well-known sketch in the British Museum of a *Child learning to walk* (Benesch 421).

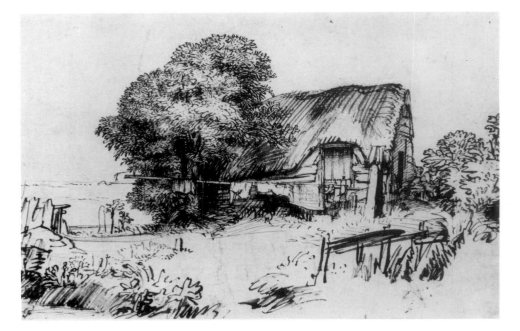

FIG. 17. REMBRANDT, Devonshire Collection, Chatsworth, reproduced by permission of the Chatsworth Settlement Trustees, *A Thatched Cottage by a Tree* (Benesch 1282). Pen and brown ink, touched with brown wash and rubbed with the finger, 17.8 × 26.9 cm. *Photo: Courtauld Institute of Art.*

In the pen and ink landscapes, it is usually less easy to tell whether Rembrandt was drawing from nature. There are a few, like the *Winter Scene* in the Fogg Art Museum (Fig. 21), which share the qualities of brevity and informality encountered in the black chalk studies to such a degree that they may well have been done out of doors, although it is impossible to be certain of this. In this category I would include the Woodner drawing of Houtewael (Figs 1, 2). Such drawings are so briefly stated that it is difficult to imagine that they were preceded by preparatory works. They nonetheless give the impression of being finished and independent works of art. The sketch at Stockholm of *Houses and Trees* (Fig. 22) is rather different. Yet it probably was drawn from nature, a conclusion suggested by several features. It has a rough-hewn quality akin to that of the black chalk studies. The forms are indicated broadly and informally, and it should be noted that Rembrandt has adjusted the horizontal roof-line to the right, without subsequently covering his tracks. This feature would probably have been inadmissible in a drawing considered by the artist to be a finished, independent work. The contact with nature seems immediate, with pulsating rhythms that reach a climax in the cascading foliage of the central tree. Furthermore, there are no less than three other, more finished landscape studies related to it.[7]

FIG. 18. REMBRANDT, Musée Bonnat, Bayonne, *Houses amidst Trees* (Benesch 812). Graphite and black chalk, 17.5 × 29.7 cm. *Photo: Caisse nationale des monuments et des sites; copyright S.P.A.D.E.M.*

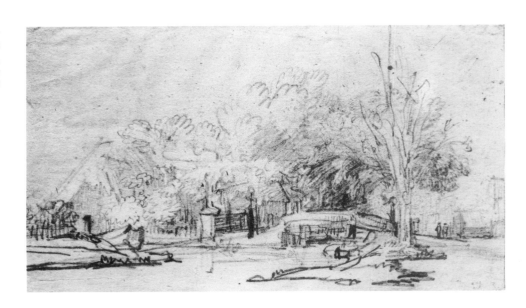

[7] Benesch, nos 1286, 1287 and 1288.

When we turn to drawings in a more detailed style, like the Chatsworth *View of the Amsteldijk near 'Trompenburg'* (Fig. 23), the effect is different again. It is more finished and, although the view is identifiable, it has a compositional poise and balance which suggests that it has been doctored. The upward-curving profile of the tree-tops to the right is carefully mirrored by the downward curve on the left made by the river bank, and these two thrusts of movement are divided into equal parts by the road in the centre. Furthermore, the pen-work seems less spontaneous.

Also at Chatsworth, there is an unfinished version of the same view (Fig. 24). But it is noticeable that this outline version renders numerous details with greater precision. Compare, for example, the cross-bar at the top of the gate on the right. In the outline drawing (Fig. 24) it is fully understood and sits firmly on it support, as do the two small orbs that ornament the top. In the more finished version (Fig. 23) these details are less precise: the orbs are omitted, and the remaining indication of the cross-bar seems insecurely supported. The trees betray similar disparities. Just above the gate, in the outline drawing, they are taller, and the foliage cutting across the trunk is convincingly described. The pen-work here retains something of the freshness, breadth and energy seen in the drawing at Stockholm (Fig. 21). In the more finished drawing (Fig. 23), above the gate again, the clumps of foliage appear more conventionalized. In fact the individual structure of each tree is clearer in the outline drawing, and this is particularly noticeable in the row of trees just next to the road. In the unfinished study, the tree-trunks at this point seem to be attached to particular areas of foliage, while in the highly finished sheet they support a less differentiated mass. This distinction becomes clearer in a third view of the same scene in the Rothschild Collection in the Louvre (Fig. 25), still less precise in its definition of detail. Even allowing for the fact that some of the wash in the Rothschild drawing was added by a later hand, it seems almost certain that landscapes like these, with their carefully balanced compositions and less immediate response to the details of natural form, were executed in the studio, subtly idealizing more matter-of-fact notations made on the spot. In spite of the care evident in their realization, the structures and forms are less firmly grasped than in many sketchier drawings. In some cases preceded by studies of the same motif, they are elaborate and finished works of art in their own right.

This last assumption receives support from the *View of a Farmhouse with a Dovecot*, recently at Christie's and now in a private collection in Amsterdam (Fig. 26). The drawing provides three further possible reasons for regarding it as an item intended for sale, although none is wholly conclusive in isolation. First, the shallow curve at the top, carefully trimmed and complete with a framing line, is matched only rarely in Rembrandt's work as a draughtsman. There are many drawings in which an arched top is roughly indicated, but here the arch is deliberate. The

Fig. 19. REMBRANDT, British Museum, London, *Study of a Clump of Trees* (Benesch 1255). Black chalk, 9.5 × 15 cm.

Fig. 20. REMBRANDT, Kupferstichkabinett, Staatliche Museen Preussischer Kulturbesitz, Berlin, *Landscape with a Canal* (Benesch 818). Black chalk, 8.8 × 17.2 cm. *Photo: Jörg P. Anders; KdZ 1108.*

FIG. 21. REMBRANDT, Charles A. Loeser Bequest, Fogg Art Museum, Cambridge, Mass., *A Winter Landscape* (Benesch 845). Pen and brown ink with brown wash, 6.2 × 16.1 cm.

FIG. 22. REMBRANDT, National-museum, Stockholm, *Farmstead beneath Trees* (Benesch 1289). Pen and brown ink with brown wash, 12.9 × 28.4 cm.

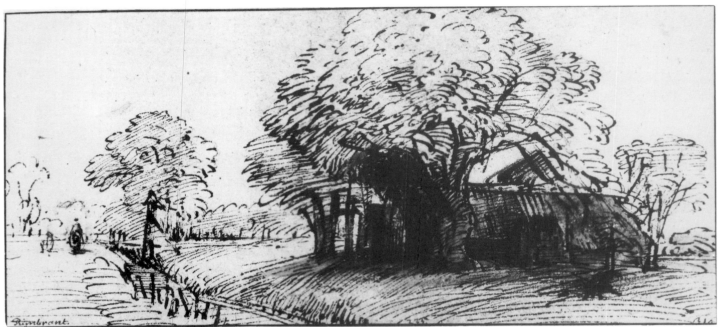

shape does occur in some of Rembrandt's paintings and etchings, which were obviously independent works of art. Furthermore, it can be assumed that Rembrandt himself was responsible for this modification, because of the drawing's framing lines: on the three straight sides, they are in a dark brown ink of the same hue as that used, for the most part, in the drawing. But the drawing was finished in a slightly paler, warmer-coloured ink, again with the pen, in the tree in the centre and some of the scrub at the lower left. This paler brown ink was also used for the wash that completes the drawing and, as can only be seen by inspecting the original, to draw the curved fourth framing line at the top of the drawing. This strongly suggests that the sheet was completed by Rembrandt himself as an independent work of art, even though it may have been largely executed out of doors.

The third reason for believing this is provided by the mark at the top right of the drawing. It is of a type found on about twenty sheets by Rembrandt and members of his circle, as well as on drawings and prints by other masters. Its presence here, and on one other drawing at Chatsworth, shows that at least some of the Rembrandt drawings acquired in 1723 by the second Duke of Devonshire from Nicolaes Flinck, whose mark appears at the lower right, had already been through the open market. The drawing had not simply passed from Rembrandt to his pupil, Govaert Flinck, and then to the latter's son, Nicolaes Flinck, and on to the Duke. The mark at the top right is now thought to be that of an anonymous collector or dealer of the later seventeenth century, the earliest separately identifiable owner of drawings by Rembrandt.[8] The presence of his mark therefore suggests

[8] For the mark, see P. Schatborn, 'Van Rembrandt tot Crozat', *Nederlands Kunsthistorisch Jaarboek*, XXXII (1981), pp. 16 ff. and Jan van der Waals, *De prentschat van Michiel Hinloopen*, exhibition catalogue (Rijksmuseum, Amsterdam, 1988), p. 119.

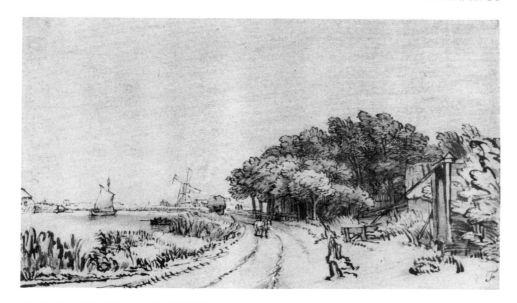

FIG. 23. REMBRANDT, Devonshire Collection, Chatsworth, reproduced by permission of the Chatsworth Settlement Trustees, *The Amsteldijk near Trompenburg* (Benesch 1218). Pen and brown ink with brown wash, touched with white bodycolour, on paper washed brown, 13 × 21.7 cm. *Photo: Courtauld Institute of Art.*

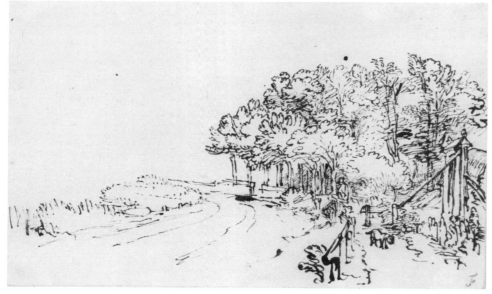

FIG. 24. REMBRANDT, Devonshire Collection, Chatsworth, reproduced by permission of the Chatsworth Settlement Trustees, *The Amsteldijk near Trompenburg* (Benesch 1219). Pen and brown ink, 13.2 × 20.7 cm. *Photo: Courtauld Institute of Art.*

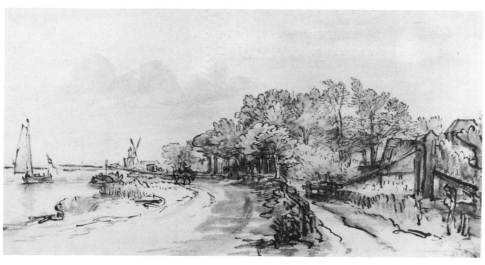

FIG. 25. REMBRANDT, Edmond de Rothschild Bequest, Cabinet des Dessins, Musée du Louvre, Paris, *The Bend in the Amstel River* (Benesch 1220). Pen and brown ink with brown wash, 14.8 × 26.9 cm. *Photo: Musées Nationaux, Paris.*

again that the drawing was meant for sale, although the drawing may have been forced onto the market by the sale of Rembrandt's effects in the later 1650s, or by his death in 1669. But on balance it seems safer to assume that it was always considered by its creator as a finished and independent, saleable work.

Finally, in this survey of Rembrandt's techniques as a landscape draughtsman, the drawing in the Louvre of a *River with Trees* has to be

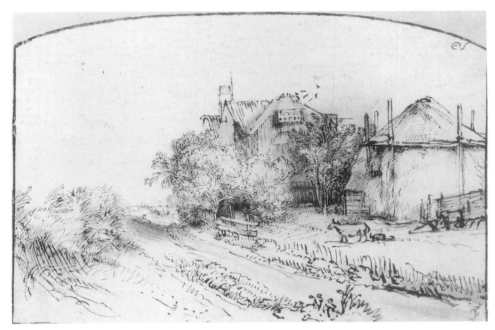

FIG. 26. REMBRANDT, Private Collection, Amsterdam, *Farmstead with a Pigeon-House* (Benesch 1233). Pen and brown ink with brown wash, 13 × 20.1 cm. *Photo: courtesy of Christie's.*

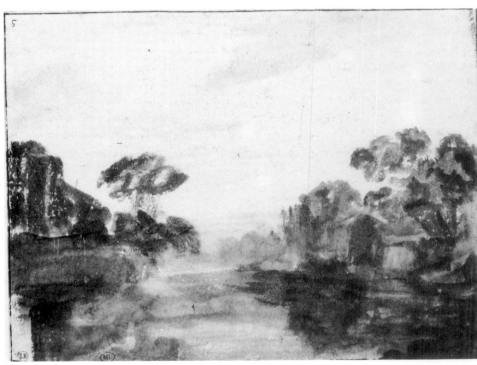

FIG. 27. REMBRANDT, Cabinet des Dessins, Musée du Louvre, Paris, *River with Trees* (Benesch 1351). Brush and brown wash, 13.6 × 18.7 cm. *Photo: Musées Nationaux, Paris.*

⁹ Benesch, no. 1103.
¹⁰ P. Schatborn, *Drawings by Rembrandt, his anonymous pupils and followers* (The Hague, 1985), no. 50, shows that the drawing is based on a *View of the Nieuwzijds Voorburgwal in Amsterdam*, a black chalk sketch in the Rijksmuseum, perhaps also referring to another sketch of this motif, now at Aachen (Benesch, no. 820). Schatborn also believes that the Louvre drawing was executed in the studio. On the *verso* Rembrandt noted a recipe for an etching acid.

included, one of only two landscapes executed entirely with the brush (Fig. 27). As Benesch pointed out, they can only be compared with figure-studies of the same period, the mid-1650s. In particular, he had the celebrated study of *Hendrickje Sleeping* in the British Museum in mind.[9] In drawings in this technique, Rembrandt's use of pure wash is extraordinarily poetic and suggestive. In the case of the landscape, there can be no doubt that we are looking at a largely imaginary creation, executed in the studio on the basis of another kind of study.[10]

Now that Rembrandt's landscape drawings from every period of his career have been studied and separated according to their techniques and purposes, we reach the meat of this paper, because we are now equipped to revise a small part of Benesch's corpus in this field. Stylistically, of course, the Chatsworth drawings provide us richly with material that can be used as a starting-point for attributions. But it should be noted that apart from the signed and dated sheet in the Lehman Collection, which we saw earlier, only one pure landscape drawing can have true claim to be a documentary

starting-point,[11] the drawing in Oxford which is preparatory to Rembrandt's etching of about 1652, the *Landscape with a Fisherman*, here reproduced in reverse sense (Figs 28, 29). Mercifully, the style of the drawing coincides so closely with those from Chatsworth that it only bolsters our belief in them. And in comparing the etching we can observe again that in transfering the design, small changes of detail and a reduction in their clarity have occurred, precisely as noted in the versions of the drawings of Trompenburg.

Like the ex-Chatsworth sheet (Fig. 26), the drawing depicts a straightforward subject based on nature. A strong rhythmic sense underlies the composition, so that it seems almost as if the whole view is bonded to a single elastic force, pulling away from the viewer and along the road. The composition is thereby welded together and given a sense of drama, a drama related to that found in most of Rembrandt's landscape paintings.

Whichever kind or period of drawing we look at, it seems clear that Rembrandt never approached landscape in a style approaching that of the *Tobias frightened by the Fish* (Fig. 30), last seen in Paris at a Hotel Drouot sale in 1925, and it is with this drawing, although it is not a pure landscape, that I would like to begin to weed out a few drawings from Benesch's *Corpus*.[12] The drawing was once doubted and given to Ferdinand Bol by Professor Sumowski, but he has recently recanted. But I think his first instinct was correct on the basis of its analogies with a drawing with which it has not previously been compared, of *St Jerome*, in the Moravska Gallery at Brno (Fig. 31). This drawing has been published as by Ferdinand Bol by Sumowski, who is surely correct in rejecting it, once and for all, from Rembrandt's *œuvre*. The two drawings on the screen appear inseparable. In both, a thick nib of a quill pen has been wielded in the same energetic, but somewhat crude manner. The heavily-outlined figure of Christ on the cross (in Fig. 31), also seems very close to the outlined figure of Tobias in the ex-Drouot drawing.

Sumowski's attribution of the *St Jerome* to Bol is rightly tentative, but it is the most probable hypothesis.[13] At this juncture I want to introduce another drawing that has recently been given to Bol, in my opinion more persuasively. The Rijksmuseum has two drawings of *Christ appearing to the Magdalen after the Resurrection* (Figs 32, 33), which Benesch reproduces side by side in the third volume of his *Corpus*, dating them both to around 1643. But in an article in the *Bulletin of the Rijksmuseum* in 1985, they were separated by Peter Schatborn.[14] He noted that the drawing in Figure 32 is not by Rembrandt, and that it fits very well into Bol's *œuvre*. He demonstrated that a direct comparison of the two sheets shows clearly which was drawn by the master and which was done by the pupil. Bol's composition, he says, is based on Rembrandt's, and it is striking how concentrated the narrative becomes in the master's drawing. The individual elements of the design are combined in a way that reinforces the meaning of the narrative: Rembrandt places the cross between Christ's outstretched hand and the Magdalen, seen wringing her hands (Fig. 33). The main figures and symbols are thereby brought into an active

FIG. 28. REMBRANDT, Ashmolean Museum, Oxford, *Farm-Buildings beside a Road* (Benesch 1227). Pen and brown ink with brown wash, 11.3 × 24.7 cm.

FIG. 29. REMBRANDT, British Museum, London, *Landscape with a Milkman*. Etching, with drypoint, reproduced in reverse, 6.6 × 17.4 cm.

[11] One might also include the *Cottage with Paling among Trees* in the Rijksmuseum (Schatborn, op. cit., no. 30), a study for the etching (B. 232), were it not for the fact that the attribution was rejected by Benesch (his no. C41).

[12] Sold at the Hôtel Drouot, collection of Mme V[iel], 25 March 1925, lot 97, sold for FF 8,500 to M. Seymour de Ricci.

[13] The drawings could be related to those attributed to Carel Fabritius by P. Schatborn op. cit. (note 10), nos 61–66.

[14] 'Tekeningen van Rembrandts leerlingen', *Bulletin van het Rijksmuseum*, XXXIII, no. 2 (1985), pp. 94–95.

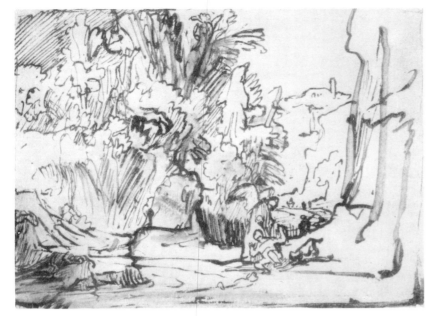

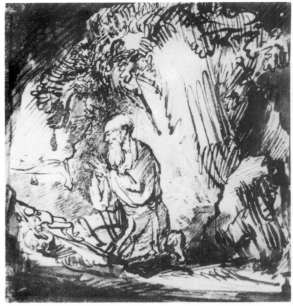

FIG. 30. Attributed to Ferdinand BOL, whereabouts unknown, *Tobias frightened by the Fish* (Benesch 496). Pen and brown ink, 16 × 21 cm.

FIG. 31. Attributed to Ferdinand BOL, Moravska Gallery, Brno, *The penitent St Jerome* (Benesch A29; Sumowski, I, 212x). Pen and brown ink with brown wash, 17 × 16.1 cm.

FIG. 32. Ferdinand BOL, Rijksprentenkabinet, Rijksmuseum, Amsterdam, *Christ appearing to the Magdalene* (Benesch 537). Pen and brown ink, 15.2 × 19 cm.

FIG. 33. REMBRANDT, Rijksprentenkabinet, Rijksmuseum, Amsterdam, *Christ appearing to the Magdalene* (Benesch 538). Pen and brown ink, touched with white, 15.4 × 14.6 cm.

relationship, while in the drawing by Bol this cohesion is lost. Bol's figure of Christ is slackly drawn, and, above all in the hands and feet, more messy and formless. Schatborn notes that for the background buildings, Bol borrowed from Rembrandt's painting of the same subject of 1638 in the British Royal Collection, but allows them too much prominence. Rembrandt, on the other hand, succeeds in drawing them more finely so that they remain in the distance. The difference in expression in the faces is also striking, and shows how extraordinarily incisive Rembrandt's characterizations can be on a small scale. Bol strives to achieve the same impact, but on close inspection he fails. The faces lack expressive force. Schatborn also describes the similarities between the drawings but notes that, typically, Bol sometimes draws lines that become separated from the forms they describe. An example is the winding line which indicates the edge of the rock that divides the composition. In the Rembrandt this division is less definitive than in Bol's drawing. Nevertheless, Schatborn retains a similar dating for the two sheets, in the 1640s.

 This identification of two hands is convincing, and as far as I know has not been challenged, but its repercussions for the respective *œuvres* of Bol

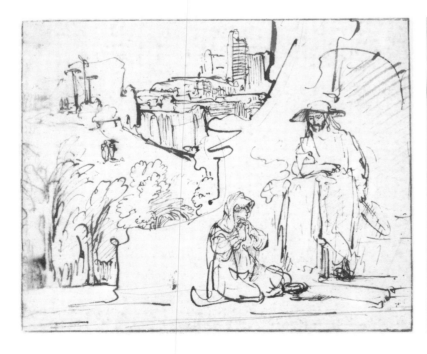

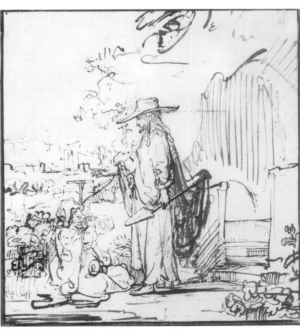

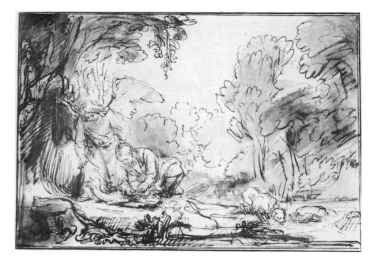

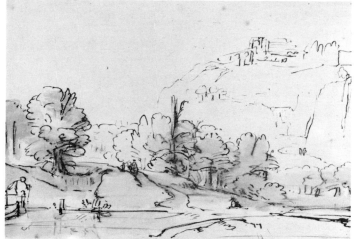

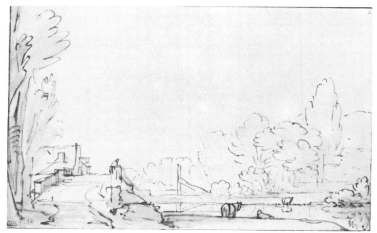

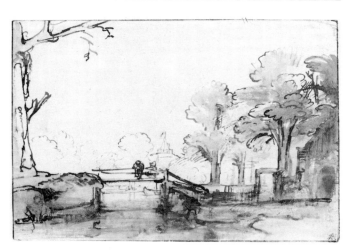

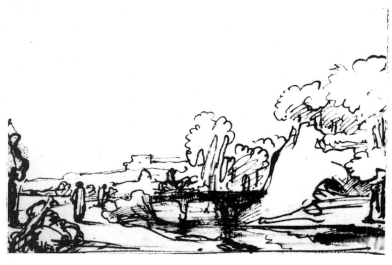

FIG. 34. Ferdinand BOL, Albertina, Vienna, *Tobias cleaning the Fish* (Sumowski, I, 249x). Pen and brown ink and brown wash, 18.9 × 17.7 cm.

FIG. 35. Here attributed to Ferdinand BOL, Niedersächsisches Landesmuseum, Hanover, *Landscape with a Mountain* (Benesch 848A). Pen and dark brown ink, touched with white, 17.6 × 24.8 cm.

FIG. 36. Here attributed to Ferdinand BOL, Cabinet des Dessins, Musée du Louvre, Paris, *Canal Landscape with an Inn by a Bridge* (Benesch 848). Pen and brown ink with brown wash, 13.3 × 21.9 cm. *Photo: Musées Nationaux, Paris.*

FIG. 37. Here attributed to Ferdinand BOL, Teylers Museum, Haarlem, *View by the Polderhuis near the Boerenwetering*, Amsterdam (Benesch 849). Pen and brown ink with brown wash and white heightening, 19 × 27 cm.

FIG. 38. Here attributed to Ferdinand BOL, Ossolineu, Wroclaw, *Landscape with a Bridge* (Benesch 793). Pen and brown ink with brown wash, 11.5 × 15.9 cm.

and Rembrandt have yet to be analysed. I believe they are far-reaching, and they begin with the need to return to Bol quite a large number of drawings that have hitherto passed as Rembrandt's work. The style of the Rijksmuseum's drawing is neater than that usually associated with Bol, and many of the latter's more loosely executed drawings, currently placed in the 1640s, will now have to be assigned to a later period.

For example, Bol's study in the Albertina of *Tobias cleaning the Fish* (Fig. 34), which is currently assigned to the 1640s, should be redated well into the 1650s. In fact there is nothing to mitigate against such a redating. On the contrary, several paintings by Bol of the 1650s are based on drawings currently dated a decade earlier. It is far more logical to date the drawings to the same period as the related paintings, in the 1650s.[15]

[15] For example, Sumowski, I, nos 89, 90, and 93, are all dated earlier than the paintings to which they are related. At least some narrowing of the gap seems warranted.

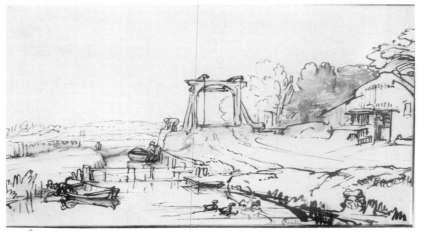

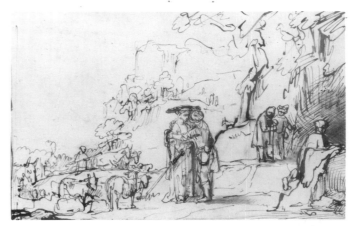

FIG. 39. Here attributed to Ferdinand BOL, Albertina, Vienna, *Landscape with a Drawbridge* (Benesch 851). Pen and brown ink with white heightening, 15.7 × 28.5 cm.

FIG. 40. Ferdinand BOL, Schlossbibliothek, Aschaffenburg, *The Angel appearing to Manoah and his Wife* (Benesch 853; Sumowski, I, 205x). Pen and brown ink with brown wash, 14.7 × 18.6 cm.

FIG. 41. Ferdinand BOL, Albertina, Vienna, *Jacob and Rachel* (Sumowski, I, 255x). Pen and brown ink with brown wash, 17.5 × 29.9 cm.

FIG. 42. Ferdinand BOL, George and Maida Abrams Collection, Boston, *Jacob and Rachel* (Sumowski, I, 260x). Pen and brown ink with brown wash, 18.7 × 26.2 cm.

FIG. 43. Ferdinand BOL, Albertina, Vienna, *Laban and the Sheepshearers* (Sumowski, I, 252x). Pen and brown ink with brown wash, 18 × 29.4 cm.

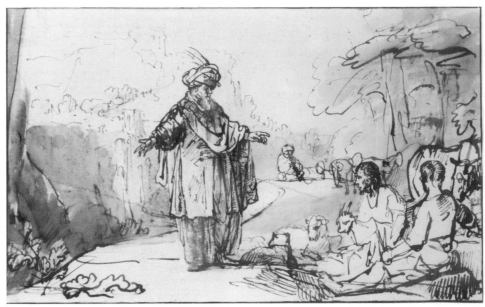

In the field of landscapes, another separation from Rembrandt's *œuvre*, not unlike that made by Schatborn, seems warranted. At the end of the fourth volume of Benesch's *Corpus* there is a homogeneous group of half-a-dozen landscape drawings which cannot easily be related to any that we have studied so far. If they are compared with the documentary drawings in Oxford and New York (Figs 14, 28), the disparity becomes clear. The group includes the imaginary classical landscape in Hanover (Fig. 35). This is generally dated to within a few years of the Oxford drawing, and is illustrated by Benesch on the same double-page as the Getty's *Landscape with a Sailing Boat* (Fig. 15). The Hanover drawing

FIG. 44. Ferdinand BOL, Rijks-museum, Amsterdam, *Porträit of Roelof Meulenaer*, 1650. Oil on canvas, 118 × 96.5 cm.

appears to be a composition study, but in style it diverges from Rembrandt. Even allowing for the different type of subject-matter, an idyllic fantasy rather than a naturalistic study, it must be asked whether the artist who drew the trees with the rather slack, unbroken and unvariegated loops in the Hanover drawing, so that they appear rather flat and with little sense of a third dimension, was the same one who conveyed such a remarkabe feeling of volume and recession in the foliage in the Getty and Oxford drawings. The slacker line in the ideal landscape (Fig. 35), which gives the impression that the draughtsman was loath to lift his pen from the paper, is seen in every part, whether in the foreground, in the delineation of the terrain, or in the more distant trees. Nor does a comparison with the earlier (and much larger) drawing in New York offer close analogies (Fig. 14). The latter has a more nervous and lively handling, and a greater variety of pressure on the pen and of tone in the wash. The technique would seem if anything to belong more logically to a later stylistic phase than the Oxford sheet, lacking both the intensity and precision in the definition of individual details. And yet it is the drawings in the 'Hanover' group which are at present dated earlier. This is because they so clearly do not belong to a later stylistic phase.

Lest it be felt that the disparities can be explained by the different kind of subject, all these characteristics reappear in a drawing in the Louvre

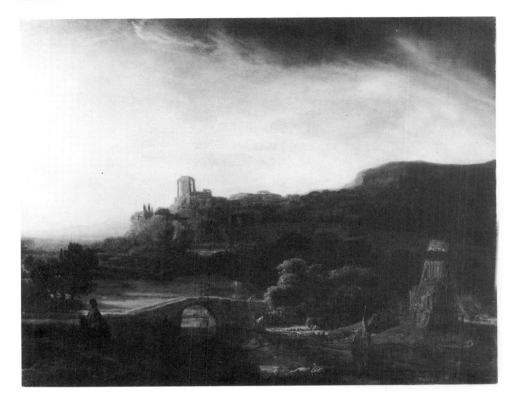

FIG. 45. Here attributed to Ferdinand BOL, Staatliche Kunstsammlungen, Cassel, *Landscape with Ruins*. Oil on panel, 67 × 87.5 cm.

(Fig. 36), which shows a more workaday view of an *Inn by a Bridge over a Canal*. It employs the same slack loops of the pen to describe the foliage and is in every way comparable to the Hanover drawing. One feature not already mentioned is the way the wash is broadly applied in a single tone: across the foreground, over the bridge and extending into much of the foreground foliage on the left. This use of wash, which is clearly not a later addition by another hand, contrasts sharply with that in the Woodner drawing, for example, or the Getty's *Sailing Boat*. Rembrandt invariably uses the wash to give an extra dimension to our understanding of the forms depicted, of the lie of the land, and of the atmosphere in which the scene is suffused.

The breadth and flatness in the application of the wash is most keenly felt, among those drawings in the group, in a drawing now in the Teylers Museum in Haarlem, recently identified as a *View by the Polderhuis near the Boerenwetering in Amsterdam* (Fig. 37). The unbroken, looping lines that are so characteristic of the group as a whole can again be observed. They run through the profiles of the vigorously drawn trees on the right and in the more distant ones by the church, behind the bridge. The same hand was also responsible for a sketchier drawing, one of two versions of a single composition in the Ossilineum at Wroclaw in Poland (Fig. 38). It looks more like an informal preparatory study than a finished composition, and in style the drawing is again easily distinguished from any landscape by Rembrandt that we have looked at so far.

The group also includes the *Landscape with a Drawbridge in the Albertina* that was recently exhibited in Washington (Fig. 39).[16] The comparison between it and the drawing in Oxford (Fig. 28) is as close as any that can be made between this group of drawings and the landscapes that are certainly by Rembrandt, but the disparities remain extremely marked. There seems little point in rehearsing them again in detail, but a few points should be mentioned. On the extreme right of both drawings there is a clump of foliage drawn in a similar way. In the Oxford study, this is drawn on an extension to the original sheet, but is stylistically in tune with the rest of the drawing. And in this motif alone, the greater energy and

16 Walter Koschatsky, *Old Master Drawings from the Albertina*, exhibition catalogue (National Gallery of Art, Washington and Pierpont Morgan Library, New York, 1984–85), no. 30.

volumetric resolution of the Rembrandt compared to the Albertina's drawing is apparent. In the latter, the line wanders almost aimlessly and becomes detached from the form it describes; in the Rembrandt, line and form remain inseparable. This peculiarity is especially marked in the lower right foreground of the Albertina's drawing. The vegetation to the right of the ducks appears almost to have been drawn with a single meandering line, crudely handled and with little variety in the pressure exerted on the page. Again, it seems as if the artist had been disinclined to lift his pen from the paper. In the Rembrandt, the foreground lines are lively and broken up, and the pressure of the pen is remarkably varied. The wash, too, is different. In the Rembrandt, what little wash there is sweeps along the road, describing the lie of the land into the distance, while in the Albertina's drawing the wash is much flatter, applied with an equal intensity by the boat in the foreground, and in a line that stretches from the middle distance on the left, across the canal, in and under the drawbridge, and across to the inn on the right. Only in the trees above the inn, where the handling approaches that of the Haarlem drawing (Fig. 37), is it any darker, but again no attempt is made to use the wash in Rembrandt's manner, that is, to describe form in three dimensions.

That this group of drawings was made by someone other than the master is, in my view, clear. It is, however, less easy to discover who was the artist responsible for them. Yet the draughtsman, without doubt one of considerable merit, can, I believe, be identified. One area that is revealing is the outlines of the trees immediately to the right of the drawbridge in the Albertina's drawing (Fig. 39). Created out of rising curls and loops, they are typical of the trees found in all the landscapes in this group. It must be conceded that they are at least comparable to the trees in the central area of the Ferdinand Bol in Amsterdam (Fig. 32). In both, the uninterrupted, curling lines of even pressure produce a rather flattened effect in the vegetation. And the similarities between these drawings do not end here. For example, the undergrowth below the trees in the *Christ and the Magdalene* (Fig. 32), just to the left of the wall, is close to what we find in the foreground of the Albertina's drawing, especially on the extreme left (Fig. 39). The same applies to the curls at the upper left edge of the two compositions. There are further analogies in the background figures, which in both drawings are drawn schematically, with heavy outlines. These analogies seem closer still if comparisons are drawn with the sketchier sheet in Wroclaw (Fig. 38). And in the unbroken profile of the rock there are further similarities with Bol's drawing in Amsterdam.

The more rapid study in Wroclaw has features in common with drawings that are now universally agreed to be Bol's work. For example, the sketch, probably representing the *Angel appearing to Manoah and his Wife* and formerly in the Schlossbibliothek at Aschaffenburg (Fig. 40), was given to Bol by Valentiner and Benesch. Benesch, however, believed that it was extensively reworked by Rembrandt, not least in the landscape, but Sumowski is surely right to follow Valentiner in believing that the whole drawing is by Bol. Much of the landscape here is in the foreground, and is broadly drawn in a manner comparable to that found in the drawing in Haarlem (Fig. 37), but the tree immediately behind Manoah is an exception. Placed in the middle-distance, this single feature is quite remarkably close to the tree immediately above the bridge in the drawing at Wroclaw (Fig. 38). Both are formed by a profile of uniform curls, which turns without a break into a series of rising and falling arches. Furthermore, in the foreground, in the unbroken line in the ground below the angel in the Aschaffenburg study (Fig. 40), there is a repetition of the meandering pen-work that was observed in the foreground of the sheet in Vienna (Fig. 39).

The drawing in Wroclaw is comparable to the backgrounds of numerous sheets by Bol. The *Jacob and Rachel* in the Albertina (Fig. 41), a drawing never included in Benesch's Rembrandt *Corpus*, is a typical example of Bol's work, with all the stylistic features we have observed, not least in the use of the wash, repeated in the distant landscape. This is particularly clear in the view of far off mountains. The Abrams Collection includes a second, somewhat sketchier version of the same subject (Fig. 42), no less apposite for the comparisons we are making. Yet another drawing by Bol in the Albertina, of *Laban and the Sheepshearers* (Fig. 43), also has a similar landscape background, and again shows the typical meandering pen-lines in the left foreground.

Returning to the more finished drawing in the Albertina once more (Fig. 39), it can be employed in a comparison that will help to date the group as a whole. Because in examining Bol's paintings, such as the *Portrait of Roelof Meulenaer* in the Rijksmuseum (Fig. 44), many of the stylistic features are repeated. The trees are flat, their outlines are simply curved, and there is little sense of the third dimension. In fact the outlines formed by the foliage to the right of the bridge in the Albertina's drawing are remarkably close to those made by the trees immediately behind the sitter in the painting. And the painting is signed and dated 1650. Benesch's date of *c.* 1648–50 for the drawings in the group that we must now assign to Bol therefore remains unchanged.

To end, there is another new attribution that is inescapable in view of what has gone before. The celebrated painting, the *Landscape with Ruins* at Cassel (Fig. 45), generally accepted as a masterpiece by Rembrandt of *c.* 1650, belongs entirely in composition and style with the landscapes we can now attribute to Bol.[17] The painting was in fact executed in two stages, as is revealed by X-rays. But the vast majority of the work seems certainly to have been done by a single hand, and that hand, I believe, is Ferdinand Bol's. The painting differs greatly from Rembrandt's other landscape oils, yet it is executed in a similar fashion to the landscape backgrounds of some of Bol's history and portrait paintings, including the Amsterdam *Portrait of Roelof Meulenaer* (Fig. 44). In its tranquil mood and classical balance, the Cassel landscape is inseparable from the drawings we have considered. In fact, it seems possible that the Hanover sheet (Fig. 35) served some preparatory function in the creation of the painting. The drawing shows a mountain capped by ruins, quite like the one in the painting. The sketch also has, on the left, an isolated tree, the profile of which closely resembles that of the tree silhouetted towards the left of the painting. Furthermore, if the line of trees in the painting is followed a little further to the left, a slim tree can be seen that resembles a poplar, followed by a clump of trees; this passage also seems to reflect a knowledge of the Hanover drawing, where a similar group of trees, beginning with the vertical poplar, occurs in the centre.

The inescapable conclusion that the Cassel painting is by Ferdinand Bol is one that I reached only recently, and I was frankly nervous of announcing in this lecture today, without discussing it with another Rembrandt specialist. I therefore telephoned Professor J. Bruyn, the chairman of the Rembrandt Research Project that is currently producing a new *corpus* of Rembrandt's paintings, last Monday (12 October 1987). And I am able to report, with Professor Bruyn's permission, that for different reasons, based on the painting's style and technique, and without reference to any drawings, that he and his team have come, independently, to the same conclusion about the painting's attribution.

Bol's name has been used for a long time as a kind of dustbin into which paintings and drawings that are not quite good enough for Rembrandt have been consigned. As a result, his *œuvre* has become

17 See A. Bredius, *Rembrandt, the complete edition of the paintings, revised by H. Gerson* (London and New York, 1969), no. 454.

perhaps even more corrupt than his master's. But Bol was a considerable artist, not simply a shadow of Rembrandt, and an artist who enjoyed wide acclaim in his own day. Landscape paintings and drawings by him are recorded in early documents and sale catalogues, but only one landscape painting, now missing, has been known until now.[18] It is to be hoped that the rediscovery of Bol's work as a landscape draughtsman, and of his responsibility for the Cassel painting, will help to generate more interest in the tasks of reconstructing Bol's *œuvre* as a whole, and of assessing the separate, and stylistically distinct contributions that he, and Rembrandt, made to the development of landscape in the Netherlands.

[18] See Werner Sumowski, *Gemälde der Rembrandt-Schüler*, 1 (Landau-Pfalz, 1983), no. 185; A. Blankert, *Ferdinand Bol (1616–1680) Rembrandt's Pupil* (Doornspijk, 1982), no. 183, pl. 196.

A *new* drawing by Guido Reni for the Crocefissione dei Cappuccini

by NICHOLAS TURNER

All too frequently the student of Old Master drawings has to decide whether or not a given work is an original or a copy. The choice is not always easy. Some conclusions may challenge our understanding of an artist and introduce us to hitherto unknown aspects of his work. But if those conclusions are open to question, they may lead to an unjustifiable confusion, imposing works on the artist for which he was not responsible.

The case under consideration here is a drawing of *Christ on the Cross* attributed to Guido Reni, which was purchased recently by the British Museum (Fig. 1).[1] It is evidently related to the famous altarpiece of the *Crocefissione dei Cappuccini*, painted in *c.*1617–18 for the Capuchin church outside Bologna and now in the Pinacoteca Nazionale (Fig. 2).[2] The *Crocefissione dei Cappuccini* was the first of several paintings of the subject that the artist was to make in his career and is one of his most outstanding early altarpieces. Is the drawing by Reni, or is it a copy? That is the question that must now be explored.

The celebrated biographer of Bolognese artists, Carlo Cesare Malvasia, describes the altarpiece in glowing terms:

> Nè si creda disegno, per fondato, e profondo che si sia; nè colorito per morbido, e carnoso che riesca, d'aver mai saputo esprimere, e rappresentare un torso il più intelligente, e pastoso. La testa dell'agonizante Redentore, che rivolta al Cielo, par che spiri quell'ultime parole, ci dà a conoscere qual esser potesse in quell'atto la Divinità Humanata.[3]

Even if the Counter-Reformation religiosity so typical of the period in which Guido Reni lived seems alien to us, the emotional tenor — both restrained and at the same time almost unbearably intense — is characteristic of the artist's production at the height of his powers. So admired was the work that Malvasia reports that the copies after it were innumerable:

> Una di Monsù Bolanger mandata in Fiandra: due del Gessi, una delle quali è ne' Cappuccini di Modana: una del Bolognini nelle Capuccine di Parma: una nella Confraternità delle Stimmate di Modana, mal fatta, cangiata la Maddalena in un S. Francesco; e tante altre, le quali non è mio fine registrar qui tutte.[4]

All of this puts us on our guard when considering the British Museum drawing. The sheet is large and is drawn in Reni's favourite technique of black, red and white chalk on tinted blue-grey paper (now unfortunately faded). Although at first sight undoubtedly impressive, there are several features that arouse suspicion. First, the figures correspond closely, giving the impression that the one was copied from the other. Secondly, the drawing is unusually highly finished, more so than any other known drawing by Reni in this same technique. The shading behind the figure is as exceptional. In general, when such shading occurs, it is usually the mark of a copyist working from a painting; regrettably, this shading includes the

[1] British Museum, London: inv. no. 1987–7–25–9, black, red and white chalk on (faded) blue-grey paper; 34.5 × 28.2 cm. The drawing was sold at Bonham's, London, 20 February 1986, lot 7, as '18th-Century Flemish School, *Christ the Man of Sorrows*' (one of a lot of three Old Master drawings). It was later sold at Sotheby's, New York, 14 January 1987, lot 88, as 'attributed to Guido Reni', to Richard Day, from whom it was purchased by the Museum.

Since this paper was first presented at the Woodner Symposium held at the Royal Academy, London, on 17 October 1987, I have been told of the existence of two additional drawings related to the British Museum *Christ*, besides those discussed in this note. One, placed as 'attributed to Guido Reni', is in the National Gallery of Art, Washington D.C. inv. no. 1986.5.1, and was kindly brought to my attention by Dr Andrew Robison. It shows the head, shoulders and body of Christ only and is drawn in black chalk with white heightening; 35.6 × 21 cm; the drawing was sold at Christie's, London, 25 June 1974, lot 179, as 'Guido Reni'. The other, in the Hermitage, Leningrad, inv. no. 27267, was kindly pointed out to me by Dr Veronika Birke. This drawing more closely resembles the British Museum drawing in showing the entire figure of Christ.

[2] Dr Stephen Pepper, *Guido Reni: a Complete Catalogue of the Works with an Introductory Text* (Oxford, 1984), pp. 234 ff., cat. no. 55, pl. 82.

[3] C. C. Malvasia, *Felsina Pittrice*, vol. 2 (Bologna, 1678), p. 30.

[4] Ibid.

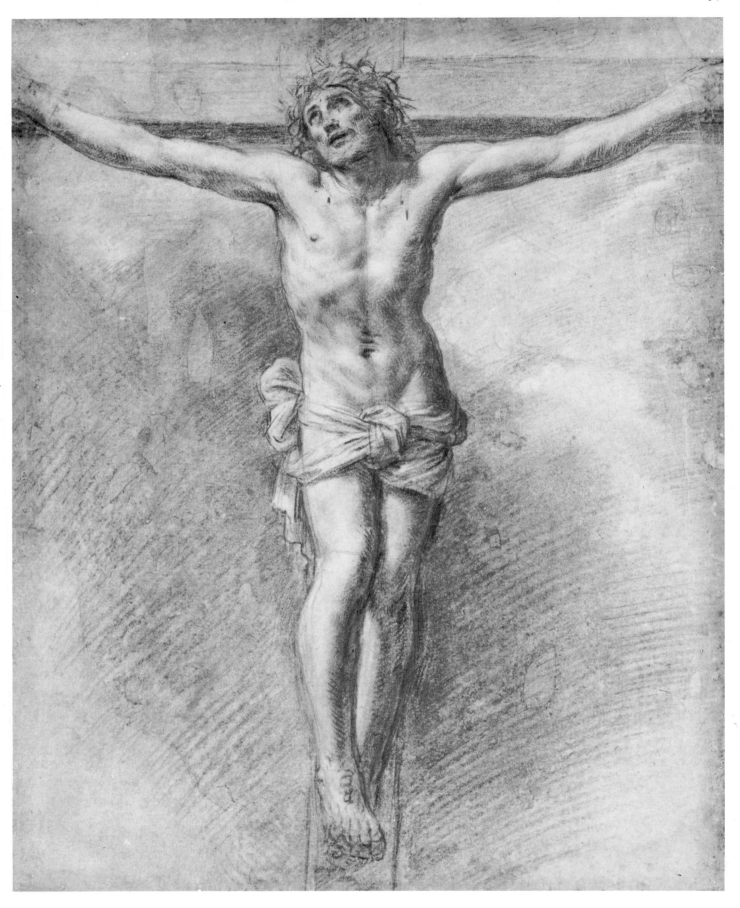

FIG. 1. Guido RENI, British Museum, London, *Christ on the Cross*. Black, red and white chalk on (faded) blue-grey paper, 34.5 × 28.2 cm.

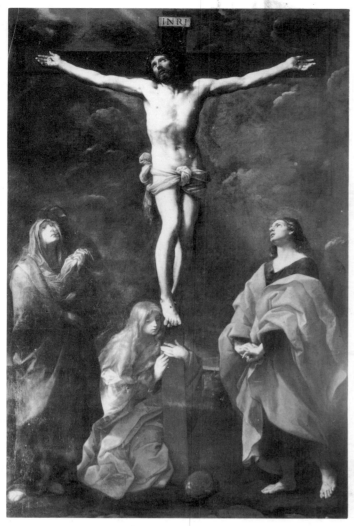

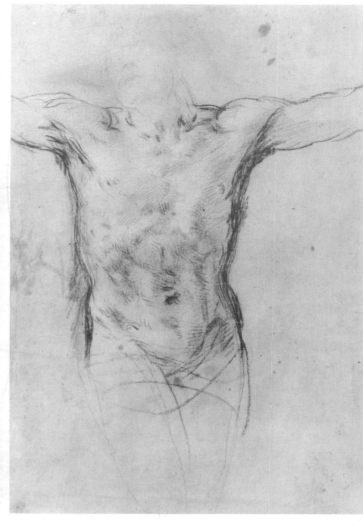

FIG. 2. Guido RENI, Pinacoteca Nazionale, Bologna, *Crocefissione dei Cappuccini*, *c.* 1617–18. Oil on canvas, 3.97 × 2.66 m.

FIG. 3. Guido RENI, Pierpont Morgan Library, New York, *Study for Christ on the Cross*. Black and white chalk, with a few strokes of red chalk, on grey paper, 37.1 × 25.2 cm.

[5] Pierpont Morgan Library, New York: inv. no. 1961.34, black and white chalk, with a few strokes of red chalk, on grey paper; 37.1 × 25.2 cm. Cara D. Denison and Helen B. Mules, with the assistance of Jane V. Shoaf, *European Drawings, 1375–1825*, exhibition catalogue (Pierpont Morgan Library, New York, 1981), no. 39, with previous bibliography. See also Veronika Birke, *Guido Reni: Zeichnungen*, exhibition catalogue (Albertina, Vienna, 1981), no. 61.

inept but well-intentioned interventions of a restorer, which throws one off the scent. Most of Reni's figure-studies, it will be remembered, are confined to the figure alone without any hint of background context. And finally, the droplets of blood on Christ's chest seem to echo too exactly those that occur in the picture.

Also militating against the drawing is its poor condition. There is a loss in the bottom left corner, which has been badly made up, as well as scattered patches elsewhere in the sheet. But the main part of the drawing, that of the figure, is in surprisingly good condition.

Having called attention to what might seem defects, what about the drawing's merits? The plastic effect of the torso is worthy of a great artist. The way the light and shade reveal the musculature is consummately achieved and the torsion in the area of the sagging belly could only have been done by a copyist of superior imagination to that of Guido himself, because in some respects it seems to improve upon its model. Furthermore, the combination of red, black and white chalk on grey paper gives the figure that brittle, porcelain look so well known in Reni's pictures.

In the drawing's favour are several other points, only the more important of which we can consider here. If we look at another drawing for the torso alone, that in the Pierpont Morgan Library, New York, presumably drawn at an earlier stage than the British Museum drawing, we may see some analogies in the handling of the chalk, though, of course, the Pierpont Morgan Library drawing is far more sketchily drawn (Fig. 3).[5] The media are roughly the same, though the use of red chalk is more sparing. In the Morgan Library drawing the flecks of chalk, which soften

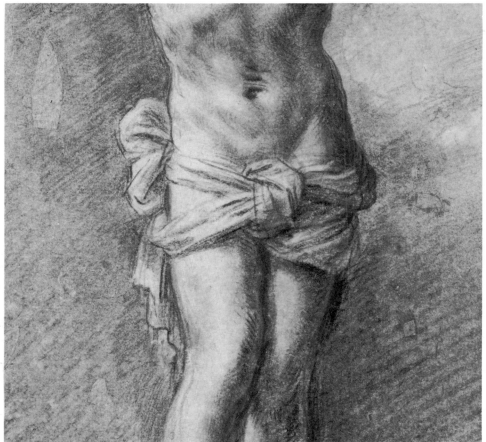

FIG. 4. Guido RENI, British Museum, London, *Christ on the Cross*. Detail of Fig. 1 showing the figure's waist.

FIG. 5. Guido RENI, Cabinet des Dessins, Musée du Louvre, Paris, *Head of Christ*. Black, red and white chalk, 31.5 × 26 cm.

FIG. 6. Guido RENI, British Museum, London, *Christ on the Cross*. Enlarged detail of Fig. 1 showing the figure's head.

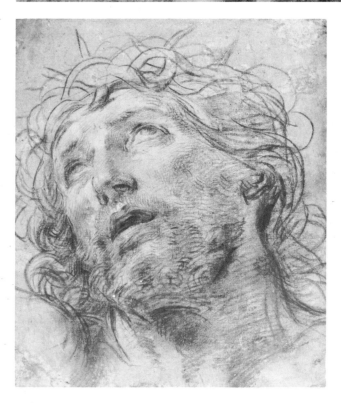

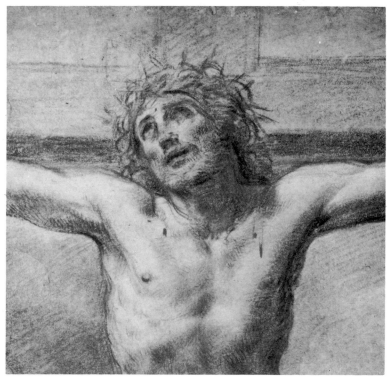

the shadows in the beautifully modelled torso, are more loosely applied. But there is a pronounced similarity in the texture of the heavily scored lines at the main contours to the left and right.

In the Morgan Library drawing we can see the artist labouring at these two main contours. Of these, the contour at the right has exercised him more than the other, for the body on that side is in shadow. The problem is further complicated by the fact that in the finished work the body must also

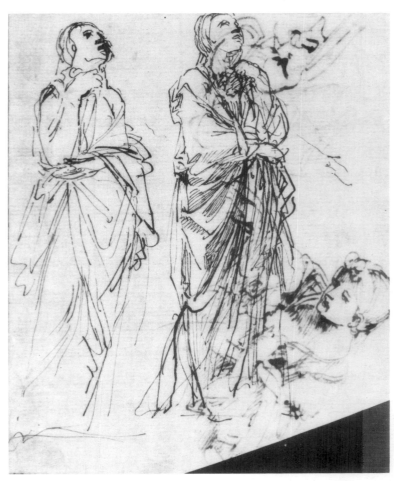

FIG. 7. Guido RENI, Royal Library,
Windsor Castle, *Two Studies for the
Figure of the Standing Virgin*. Pen and
brown ink, 14.9 × 12.2 cm. *Reproduced
by Gracious Permission of Her Majesty the
Queen.*

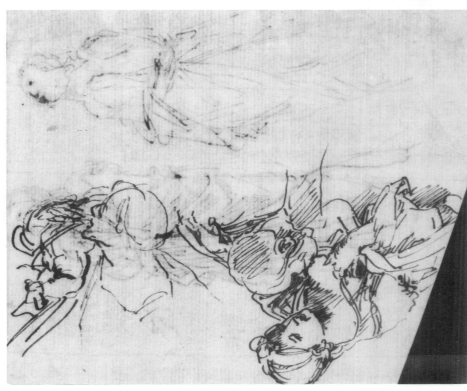

FIG. 8. Guido RENI, Royal Library,
Windsor Castle, *Head and Shoulders of a
Woman holding a Baby; Roman Charity*
(*verso* of Fig. 7). Pen and brown ink, 14.9
× 12.2 cm. *Reproduced by Gracious Permis-
sion of Her Majesty the Queen.*

show up against the dark sky behind and come well forward from it. The
contours are made up of a series of lines drawn one on top of the other. The
resultant effect is a long ragged patch of dark tone, somewhat resembling
tarred rope frayed at the edges. This effect may be seen in the selfsame area
in the British Museum drawing, though it is a little tidier; and elsewhere,
for example, along the legs of the figure. The pentiments in the shoulders

and arms, easily seen in the Pierpont Morgan drawing, are also still
discernible in the British Museum drawing.

Looking at the altarpiece again, how does Reni achieve the elegant
form of that stark figure seen high up against the dark sky? One of the ways
he has done this is by establishing the most precise and the most elegant
outline conceivable, thereby creating a form of almost abstract beauty — a
sort of arabesque. He sets up in this figure a series of subtle curves and
counter-curves. This linear approach is a hallmark of Reni's painting, even
in his late years.

His obsession for contour explains the reworking of the British
Museum drawing in the torso and arms. Even though the drawing looks
fully resolved in these parts, the artist was still working out that all
important contour. This can be seen in the legs. If you compare the legs in
the drawing with those in the altarpiece, you will see that they are too short
in the drawing. Suffice it to compare the distance between the loin cloth
and the knees in the drawing with that in the altarpiece. An enlarged detail
of this central part of the drawing well illustrates this difference (Fig. 4).
The outward curve of the strongly illuminated right calf in the painting has
not been fully resolved. Careful examination of this part of the drawing
will reveal still further pentiments. Nor has the artist properly worked out
the patch of light on the inside of the left leg. This same leg is also too thick
as it nears the foot and this would surely have prompted the artist to make
both legs longer and more tapering.

Two other drawings for the figure of Christ should be considered
briefly in relation to the British Museum drawing. One of them, in red
chalk, is at Bremen and seems to show the figure of Christ at an early stage
of development, almost certainly drawn from the life.[6] There is something

FIG. 9. Guido RENI, Pinacoteca
Nazionale, Bologna, *Massacre of the
Innocents*, *c*. 1611–12. Oil on canvas,
2.68 × 1.70 m.

FIG. 10. Guido RENI, British Museum,
London, *Kneeling Woman*. Black and
white chalk on grey paper, 37.8 ×
30.3 cm.

[6] Kunsthalle, Bremen: inv. no. 53/211, red
chalk; 38 × 27.1 cm. See Birke (1981), p. 97
and n. 3, abb. 24. Vitzthum was the first to
point out the drawing's connection with the
Crocefissione dei Cappuccini.

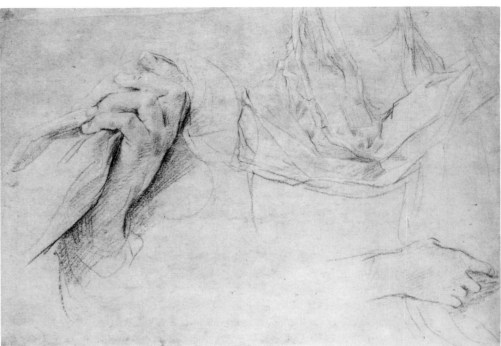

Fig. 11. Guido RENI, Museo di Capodimonte, Naples, *Study for the Figure of the Standing Virgin*. Black and white chalk on grey paper, 42.6 × 23.9 cm.

Fig. 12. Guido RENI, Art Market, London, 1987, *Study for the Hands and Drapery of the Virgin*. Black and white chalk on buff-coloured paper, 27.8 × 40 cm.

[7] Louvre, Paris: inv. no. 8902, black, red and white chalk; 31.5 × 26 cm. See Birke (1981), no. 62.

[8] Royal Library, Windsor Castle: inv. no. 2304, pen and brown ink; 149 × 122 mm. See R. Wittkower, *The Drawings of the Carracci in the Collection of Her Majesty the Queen at Windsor Castle* (London, 1952), nos 108 and 110, as 'Agostino Carracci'.

[9] In discussing the pose of this figure, Wittkower, op. cit., commented that the type seemed to have been based on a Classical source and he cited the 'Herculaneae'. Prof. Michael Jaffé also commented (orally) on its resemblance to the 'Venus Pudica' type.

[10] These pen-studies include Wittkower (1952), nos 109 (RL 2301); 112 (RL 2305); 113 (RL 2284); 156 (RL 2278); 261 (RL 2282); and possibly 124 (RL 2300).

in the tubular simplification of the limbs that recalls the treatment of the arms, tapering off into formless shapes instead of hands, in the British Museum drawing. The other drawing is in the Louvre and is for the head of Christ (Fig. 5).[7] It is done in the usual technique of red, black and white chalk on grey-blue paper. A marked similarity of handling is evident when this is compared with the enlarged detail of the head of Christ in the British Museum drawing (Fig. 6). The Louvre drawing was probably made first, since the position of the head, Christ's gaze and the lighting on His neck are subtly different from the finished result. The final solution is closely reflected in the British Museum drawing.

The sheer range of an artist's drawing can surprise the unwary. If the laborious finish of the British Museum drawing is unexpected, so too is the rapidity of touch seen in a sheet of pen-studies for the figure of the standing Virgin at the bottom left of the composition in the Royal Library, Windsor Castle (Fig. 7).[8] Few of us would think immediately of Guido Reni for this drawing, especially after considering the carefully modulated chalk studies that we have just seen. These latter, because they are more familiar, perhaps make us forget the important part played by the rough sketches which the artist must have made in large numbers to explore his first ideas. The *recto* of the Windsor sheet shows two studies for the figure of the standing Virgin. The head and shoulders of a woman bottom right show through from the *verso*. The study on the left seems to have been drawn first and shows the Virgin cupping her right elbow in her left hand. In the second study, as in the finished picture, she holds her left elbow in her right hand.[9] The drawing is one of a small group of pen-studies at Windsor Castle which are placed among the drawings by the Carracci but which I believe to be by Guido Reni. The attribution of some of the group of drawings, I am glad to say, was accepted by Dr Stephen Pepper in the autumn of 1985.[10]

One of the two studies on the *verso* of the Windsor drawing further supports Reni's authorship: the head and shoulders of a woman seen in profile on the left holding the backside of an infant over her right shoulder (Fig. 8); this study is drawn the other way up from the principal study of a *Roman Charity*. Wittkower long ago recognized the connection between the study of the woman and her baby and the figure kneeling in the left

foreground of the *Massacre of the Innocents* in the Pinacoteca Nazionale, Bologna (Fig. 9).[11] Having ruled out Reni's authorship in favour of that of Agostino Carracci, he was forced to conclude that the study was connected with an earlier work by Agostino, which was subsequently to serve as Reni's prototype. The appearance together on one sheet of studies for two of Reni's most important paintings of the second decade of the century, the *Crocefissione dei Cappuccini* and the *Massacre of the Innocents*, is most illuminating and would seem to show that the artist was planning these two great works at much the same time. But according to the chronology generally accepted by scholars, the *Massacre* is dated *c.* 1611–12, some five years earlier than the *Crocefissione*.

The *Roman Charity*, which is also studied in another drawing by Reni at Windsor, likewise given to Agostino Carracci, was related by Wittkower to a picture then in a private collection in Germany.[12] Reni treated this subject several times, and it is possible that the study was made for one of them.[13]

While digressing on the subject of the *Massacre of the Innocents*, it is worth calling attention to an important, hitherto unpublished study almost certainly for the figure of the woman kneeling on the right of the composition, until recently placed with the anonymous drawings in the British Museum (Fig. 10).[14] It is drawn in black and white chalk on grey paper and, though differing considerably in pose from the figure as painted, compares well with another study evidently for the same figure in the Uffizi.[15] In the painting the woman turns her head upwards and slightly towards the spectator. The beautiful profile of the woman with her head leaning slightly away from the spectator in the British Museum drawing was used, with differences, for the figure of the woman on the left of the composition holding the baby over her shoulder — the same woman as that studied on the *verso* of the Windsor drawing.

Returning now to the *Crocefissione* and to the figure of the standing Virgin, two other drawings should be mentioned, one in a private collection,[16] and the other in the Capodimonte in Naples (Fig. 11).[17] Both show how Reni has developed his early pen-study into a figure of more sculptural presence, more closely resembling its counterpart in the altarpiece. Particularly in the Capodimonte drawing he begins to analyse the all important suggestion of light in the drapery in the area of the right knee. This device suggests the figure's *contrapposto*, counterbalancing, as it does, the raised left hand. The style of the drawing has something of the roughness of the pen-studies but not yet the refinement of, say, the Pierpont Morgan or British Museum drawings.

In conclusion, I wish to add yet another new drawing for the altarpiece of the *Crocefissione*, which was at the time of the Woodner Symposium in 1987 on the London art market (Fig. 12).[18] It is both ironic and typical of the way in which a subject can gain momentum that this drawing too had only recently come to light. Again, it is of a different type of drawing than the ones we have been looking at, since it is primarily a study for the details of the hands and drapery of the figure of the Virgin. Looking at those unresolved lumps at the ends of the arms of the figure of Christ in the British Museum drawing, we could have guessed that Reni would have made such preparatory studies for the picture. The drawing on the art market is exquisitely handled, with the left hand drawn with the utmost care and finish, but not yet in quite the same position as in the painting. The right hand is not at the same stage of development. Both studies, I believe, would have been made after the very careful drawing of the Virgin's veil. There must have been numerous other studies for this same figure, for example, a drawing of the Virgin's upturned head such as that of the head of Christ in the Louvre.

[11] See Pepper (1984), pl. 49.
[12] The other Windsor drawing for a *Roman Charity* is Wittkower (1952), no. 109 (RL 2301).
[13] For the various treatments of the theme of Roman Charity by Reni, see Pepper (1984), pp. 300 ff., no. C 9.
[14] British Museum, London: inv. no. 1946–7–13–1297, black and white chalk on grey paper; 37.8 × 30.3 cm. A. E. Popham, *Catalogue of Drawings in the Collection formed by Sir Thomas Phillipps, Bart., F.R.S., now in the Possession of his Grandson, T. Fitzroy Phillipps Fenwick* (Cheltenham, privately printed, 1935), p. 118, no. 13, as 'possibly by one of the Dandini of Florence, possibly French'. The drawing had been included in Samuel Woodburn's sale at Christie's, London, 12 June 1860, lot 1085: 'Various others, by S. Rosa, Tintoretto, P. Testa, &c.', bought by Sir Thomas Phillipps. It entered the Museum in 1946 with the Phillipps-Fenwick Collection.

A study for the same figure, half-length, which is far closer to the finished result, was sold at Sotheby's, London, 6 July 1982, lot 34, as 'Guido Reni'. Although disconcerting in its literalness and its high degree of finish, especially when compared with the more fluent handling of the Uffizi and the British Museum drawings, it must surely be by Guido Reni. Not only is the handling consistent with his, but there are also many minor differences of detail compared with the painting.
[15] Uffizi, Florence: inv. no. 1429 E, black and white chalk on faded blue paper; 25.5 × 18 cm. See Birke (1981), no. 57.
[16] See Birke (1981), p. 94, abb. 22.
[17] Capodimonte, Naples: inv. no. 685. See Birke (1981), p. 94, abb. 23.
[18] Art market, London: black and white chalk on buff-coloured paper; 27.8 × 40 cm.

A simple observation ends this note. It is important to bear in mind that our view of the production of any draughtsman is always changing, as is our understanding of his capacities. New drawings often force us to adjust the stereotypes we hold of an artist's work. The variety of styles of different drawings made by one artist at the same time for any given work is a warning to those who would limit an artist's work too severely.

The charcoal drawings of Odilon Redon

by VOJTĚCH JIRAT-WASIUTYŃSKI

Odilon Redon used charcoal as his preferred medium for finished drawings from the 1860s to the 1890s. It served him in a pictorial technique of amazing subtlety and richness for both landscape and subject pictures.

Landscape with Two Figures (Fig. 1) in the Gemeente Museum, The Hague, presents us with a forest glade in which sunlight and shadow mix delicately. A still and poetic atmosphere envelops the trees and surrounds the figures; it is created by the most varied manipulation of the powdery, volatile charcoal particles. Redon had by this time, in the late 1870s, mastered the full array of charcoal drawing techniques. The tonal range is not wide in The Hague drawing and the support is a buff-coloured paper. Redon appears to have first applied broadly rubbed areas of charcoal to the paper in order to establish the general tonal structure of the sky and land, and in order to 'activate' the empty sheet. He probably worked with a large charcoal stick, using the side and then rubbing with a cloth. He then blocked in the two tree-trunks with the point of the stick; the figures would have been added at a later stage. Lights were erased with a stump, cloth or fine eraser, in the sky, figures, trees and leaves. Shadows were deepened by reworking with a softer and darker charcoal stick. Outlines and important details were redrawn with a finer point to give them added definition.

Real skill is involved in such an elaborate technique since charcoal can so easily be overworked and become dull, flat and 'dead' in appearance. Redon's richly worked, delicate surface seems to be 'alive' with light, which penetrates even the darkest shadows. By patient elaboration of a humble medium, on a sheet of paper no larger than 52×37 cm (*c.* 21×15 in), Redon has recreated a whole landscape. Everything is suggested, nothing is defined; fact and fantasy mix.

The magnificent *Cactus Man* (Fig. 2) from the Woodner Collection is an excellent example of Redon's early fantastic subjects. It has been dated 1881.[1] At first glance, this image of the grotesque head of a man in a planter may seem less refined technically even though it is about the same size. It is certainly bolder, more dramatic in conception; Redon adopts a different mode for the images of his fantasy. Yet the *Cactus Man* reveals the full range of effects created by the techniques employed in The Hague landscape: an initial tonal lay-in by rubbing charcoal on the buff paper, dark blocking in of forms, the use of cloth and stump to erase lights, and the addition of sharp black lines to accent form and details apparent in the broad, painterly treatment of the face and neck, and in the flickering shapes and half-shadow of the planter.

Expert technique coincides with richness of meaning in these works. Redon has reconquered the 'droit de fantaisie' which he found lacking in contemporary realist art when he wrote his review of the Paris Salon of 1868.[2] The ambitious nature of Redon's charcoal production is clear: the great tradition of master painters and draughtsmen such as Leonardo, Michelangelo, Raphael, Dürer and Rembrandt was his reference point. Yet, traditionally, charcoal had been used for preparatory drawings, as part of workshop procedure, and in the actual underdrawing of finished images, usually paintings.[3] Redon's *fusains* are exhibition drawings, presented as independent works with the aesthetic value and aspiration of

[1] Museum of Modern Art, *Odilon Redon — Gustave Moreau — Rodolphe Bresdin* (New York, 1962), p. 176, no. 100, presumably on the basis of information supplied by Roseline Bacou, based on the artist's account book.

[2] O. Redon, 'Salon de 1868', part III, *La Gironde*, 1 July 1868; now available in Robert Coustet, *Odilon Redon, Critique d'art* (Bordeaux, 1986).

[3] Thea and Vojtěch Jirat-Wasiutyński, 'The Uses of Charcoal in Drawing', *Arts Magazine* (October 1980), p. 129 (subsequent references as Jirat-Wasiutyński (1980)).

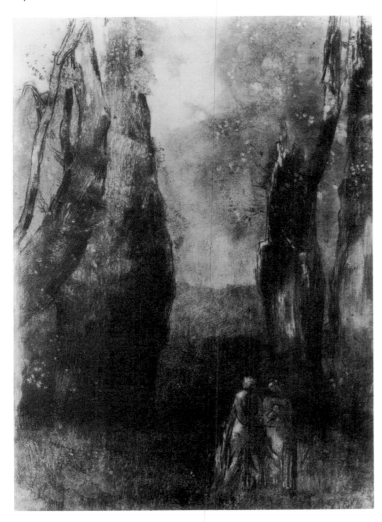

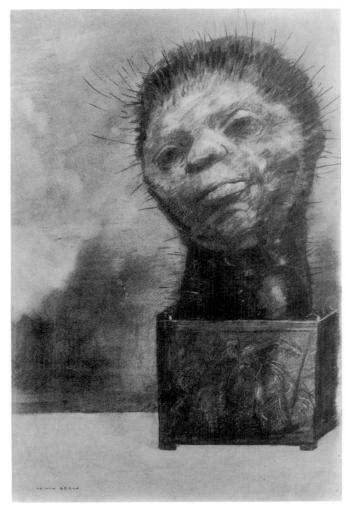

FIG. 1. Odilon REDON, Gemeente Museum, The Hague, *Landscape with Two Figures*, c. 1875–80. Charcoal on buff wove paper, 52.2 × 37.2 cm.

FIG. 2. Odilon REDON, Ian Woodner Collection, New York, *Cactus Man*, 1881. Charcoal on tan wove paper, 49 × 32.5 cm.

[4] For the aesthetic of the exhibition drawing, albeit in Britain, see Jane Bayard, *Works of Splendor and Imagination: the Exhibition Watercolor, 1770–1870* (Yale Center for British Art, New Haven, 1981), passim.

[4a] See now Thea Jirat-Wasiutyński, 'Tonal Drawing and the Use of Charcoal in 19th Century France', *Drawing*, XI, no. 6 (March–April 1990), pp. 121–24.

[5] Jirat-Wasiutyński (1980), pp. 130–31; for Bonvin, see Gabriel Weisberg, *Bonvin* (Paris, 1979), nos 223, 227, 230, 245, etc.

contemporary paintings at the Salon.[4] How was this possible? How did such a change in the status of the humble charcoal medium occur?[4a]

The answer requires a combination of technical and historical research. The general question about the change in the valuation of the medium raises more particular ones. When did Redon turn to charcoal for the execution of his major finished drawings? Why did he do so? When did drawing in charcoal develop the technical sophistication necessary for it to function as a full pictorial medium? How did Redon acquire the extensive techniques noted above in his *fusains* of the late 1870s? Consideration of the artist's development in the charcoal medium will also lead to an examination of its relation to his lithographs, created 'to multiply my drawings', and to the colouristic media of pastels, oils and tempera as they emerge in the 1880s and 1890s and supplant *les noirs*.

Traditional uses of charcoal for preparatory drawings, under-drawing, and portrait head studies persist into the modern period. Edgar Degas used charcoal for many of his preparatory figure drawings and in order to underdraw his pastels. While teaching at the Ecole des Beaux-Arts, Thomas Couture recommended that his students underdraw their paintings in charcoal. François Bonvin used charcoal to draw simple studies of heads and figures in bold contrasts of light and dark.[5] The widespread popularity that charcoal had achieved as a medium by mid-century extended well beyond its traditional areas of use. Romanticism gave new prominence to humble media by sanctioning appreciation of sketches and studies as evidence of creative genius. But it was the tonal vision of the landscape school in particular that guaranteed charcoal, as a broad tonal medium, new prominence.

Starting in the 1830s, charcoal was often used in conjunction with other media to achieve the effects of drama and colour found in contemporary paintings. Alexandre-Gabriel Decamps is often cited as being the first to practise charcoal drawing in the modern spirit, probably because he exhibited a large charcoal and pastel version of his *Bataille des Cimbres*, 1833, at the Salon of 1842 and a series of drawings in charcoal and gouache of the biblical story of Samson at the Salon of 1845.[6] Even a monochrome charcoal drawing by Decamps, such as the *Patrol of Camel Riders* (Fogg Art Museum, Cambridge, Mass.), probably from the 1850s, creates colouristic effects because of the buff paper used as a middle tone, the dramatic contrasts of light and dark and the painterly handling of the medium.[7] Such Orientalist drawings parallel effects created in Decamps' watercolours and smaller oils. It is possible, I believe, to speak of an incipient 'charcoal aesthetic' in such drawings. Redon was familiar with the work of Decamps and copied at least one of his Orientalist watercolours.[8] He also imitated him in numerous images of battle scenes in the 1860s.

The rise of naturalistic landscape favoured the use of charcoal both as a rapid sketching medium and as a full pictorial technique for exhibition drawings. Corot and the Barbizon artists used charcoal at various times to record landscape *en plein air*. *La Chasse* (Museum of Fine Arts, Boston), a landscape from the 1830s now attributed to Georges Michel, shows the possibilities of a simple and direct use of this broad, friable medium. The artist used twig charcoal and the drawing has been fixed by application of liquid to the front with a brush.[9] Theodore Rousseau occasionally used charcoal combined with other media for his landscape studies; Daubigny, Millet and Corot, hardly at all, preferring black chalk or crayon. However, Corot's late use of charcoal presents a special case. The change to a new lyricism of subtle lighting and diffused forms in his paintings affected his drawings directly in the 1860s and 1870s. They are either broadly conceived and executed landscape studies or evocations of paintings from memory for the benefit of the artist's friends (e.g. *Orpheus* and other drawings in the Louvre).

Redon's landscape drawings reflect the new status of charcoal in the 1860s as a broad, painterly medium capable of producing the *effects*, colouristic and dramatic, found in contemporary painting. The new prominence of the medium is attested by the publication of the handbook *Le Fusain* in 1869, in which Maxime Lalanne wrote: 'C'est le mode de dessin qui se rapproche le plus des effets de la peinture, dont il a toute la couleur et l'éclat.'[10] Was Redon familiar with the charcoal drawings of this artist from Bordeaux? Did he read Lalanne's treatise as he became more deeply involved with the medium?

The Chicago *Landscape with Two Figures in Conversation*, (Fig. 3) signed and dated 1868, is an outstanding example of an early charcoal drawing by Redon. It shows the unkempt, semi-barren landscape of 'les landes' near Peyrelebade, to which the artist had a strong emotional attachment from childhood. The well-developed technique, the rich *matière*, careful composition and relatively large scale of the drawing (53.5 × 75.5 cm) signal it as intended for exhibition. Redon used a warm cream wove paper; the fine texture of the paper caught the friable grey-black particles, creating a rich surface effect. As Lalanne recommended, Redon established the general light tone of the sky first, rubbing it with cotton wool or a cloth and then drawing, that is, erasing, with stump or kneaded bread for the clouds. The light mid-tone of the paper is allowed to shine through in foreground and background, especially where it has been revealed by subtractive drawing with the stump. The richer blacks of the foreground are possibly achieved by added pressure in drawing with a

[6] Dewey F. Mosby, *A.-G. Decamps. 1803–60* (New York and London, 1977), pp. 16–17.
[7] For illustrations of the drawings by Decamps, Michel and Corot, discussed here and below, see Jirat-Wasiutyński, 1980.
[8] Cabinet des Dessins, Musée du Louvre, *Donation Ari et Suzanne Redon*, by Roseline Bacou (Paris, 1984), no. 150 (subsequent references as *Donation*, 1984).
[9] The attribution to Michel was pointed out to me by Robert Herbert. Roy Perkinson and Elizabeth Lunning examined the drawing with me in the Paper Conversation Laboratory at the Boston Museum of Fine Arts. I would like to thank them for their assistance and for their help in interpreting what I saw through the microscope.
[10] M. Lalanne, *Le Fusain* (Paris, 1869), p. 7 (subsequent references as Lalanne, 1869). Lalanne was well known as an etcher before developing his expertise in charcoal drawing: see his *Traité de la Gravure à l'Eau-Forte* (Paris, 1866).

FIG. 3. Odilon REDON, The Art Insti-
tute of Chicago, *Landscape with Two
Figures in Conversation*, 1868. Charcoal
on buff wove paper, 53.5 × 75.5 cm.
Courtesy of The Art Institute of Chicago.

FIG. 4. Odilon REDON, Cabinet des
Dessins, Musée du Louvre, Paris, *Tree*,
c. 1865. Conte on buff wove paper, 32 ×
25.5 cm.

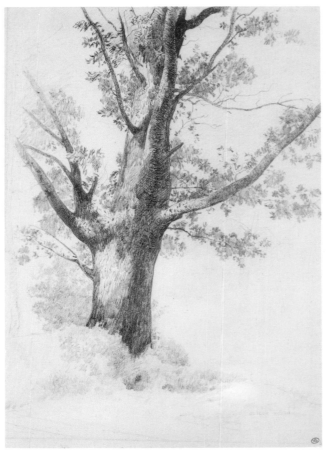

soft black charcoal; the densest blacks in the foreground reeds have, however, been added in black conte crayon.[11] Highlights on the figures and in the tree, where the oblique sunlight of an advanced afternoon catches the edges of backlit forms, are again created by erasing. There are few, if any, outlines in the drawing; the elaborate handling establishes charcoal as a painterly medium, 'exprimant l'idée de la peinture' in Lalanne's words.[12]

The Chicago *Landscape* is conceived like a Romantic painting. It reflects the painting conventions of a darkened foreground, back-lit repoussoir in the middle distance, and a diagonal entry into the picture space which stretches to the distant horizon. Careful documentary studies, such as the *Tree* (Fig. 4), which Redon kept hanging in his studio all his life,[13] prepared the finished drawing. Redon's *Landscape* is more conventional than the work of the Barbizon artists, although there are definite affinities of mood and lighting. There is more than a hint of Decamps still

FIG. 5. Odilon REDON, S. Crommelin Collection, Laren, *Dante and Vergil*, 1865. Charcoal on buff wove paper, 23.5 × 36.5 cm.

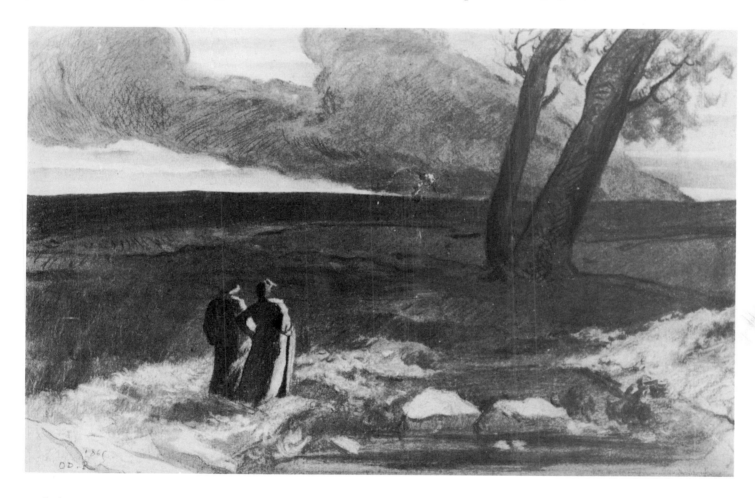

and the tradition of Dutch Baroque landscape. An obviously Romantic view of nature is created by the small scale of the figures in relation to the tree and by the dramatic backlighting of the *motifs*.

Redon discovered charcoal as his preferred medium for exhibition drawings between 1860 and 1870. The Romantic themes which preoccupied him at this time demanded a rich tonal treatment. Crayon and pen-and-ink drawings might serve for studies or on a small scale, but only charcoal could provide the breadth of handling and the tonal subtlety which Redon sought in a finished drawing.

The earliest datable charcoal drawing by Redon is a panoramic landscape from 1862, *Person Seated Viewing The Mountains* (Professeur H. Mondor, Paris). This modest drawing (30 × 25 cm) shows the view from the French Pyrenees above St Jean-Pied-de-Port into the arid hills of the Basque provinces of Spain. The simple treatment of the medium,

[11] This became clear in a recent examination (June 1988) by Thea Jirat-Wasiutyński, who is undertaking a systematic study of charcoal-drawing technique in the nineteenth century. Her paper on 'Charcoal Drawing in the Nineteenth Century: the Evidence of the Drawings and the Technical Manuals' (Symposium 88, Canadian Conversation Institute, Ottawa, October 1988) will be published in the near future.

[12] Lalanne, 1869, p. 11. In some drawings, Redon and his contemporaries used a wet brush to work the charcoal as Thea Jirat-Wasiutyński reported in the Ottawa Symposium.

[13] Bacou in *Donation*, 1984, no. 347.

reminiscent of the early work of Decamps, indicates that we are looking at the very beginnings of the artist's charcoal practice. Charcoal drawings remain rare until 1865. It was more usual for Redon to use crayon or pen-and-ink to recreate his impressions of the Pyrenees, as in the *Mountain Landscape with Two People Conversing*, *c.* 1865 (Musée du Petit Palais, Paris). Here he has had to add a dark ink wash to create the dramatic effect desired. Redon's dissatisfaction with the linear media made him turn increasingly to charcoal. The early charcoal drawings of Peyrelebade and its environs are modest in size and treat themes of solitude, companionship and adventure, as did those of the Pyrenees. The technique is also simple, the conception bold. *Dante and Vergil*, signed and dated 1865 (Fig. 5), and others are characterized by banded space, diagonals and strong tonal contrasts. We have already seen the masterful development of this early approach in the larger exhibition drawing from 1868, now in Chicago.

After 1870, the landscapes from Peyrelebade become still and mysterious; light and shadow flicker subtly across glades and under-growth. Charcoal is no longer used for dramatic effects, but is now patiently exploited for the subtlest chiaroscuro. The model in nature for drawings such as The Hague *Landscape with Two Figures* (Fig. 1), discussed above, was the estate at Peyrelebade as was still evident several years ago. At the same time, the delicate tonal handling connects these *fusains* to the later paintings of Corot, such as the *Souvenir de Mortefontaine*, 1864 (Musée du Louvre, Paris). Redon had probably met the older master that year and had certainly been to Corot's studio to see his work by 1868.[14] He had been shown pen-and-ink drawings from nature, but no charcoal drawings are mentioned in *À Soi-Même*. Corot offered the oft-quoted advice that Redon should return each year to study the same corner of nature, the same tree. This counsel fitted with Redon's established practice of spending each prolonged summer at Peyrelebade. By the 1870s, he had also adopted the master's exhortation to place 'à côte d'une incertitude une certitude' in order to evoke the site and its association.[15]

The drawing from The Hague can be dated to the second half of the 1870s because of its careful tonal orchestration and varied technique. Redon's drawing must be seen in the context of the success of charcoal drawing as a full-fledged medium for finished drawings in the 1870s. Lalanne's text of 1869, which Redon may have known, had been quickly followed by more elaborate 'how-to-do-it' manuals by Auguste Allongé and Karl Robert (pseudonym of Robert Meusnier) in the 1870s and 1880s. Allongé's drawings, such as *Landscape* (Museum of Fine Arts, Boston), were reproduced as lithographs in a portfolio of models for students to copy.[16] The popularity of charcoal drawing with artist and especially amateur derived, in good part, from the seeming ease with which its use could be learned, combined with the richness of painterly effects that could be created by the beginner. A flourishing trade in papers, charcoal sticks and pencils, stumps and erasers, fixatives and even portable sketching boxes and easels seems to have developed. The artist's supplier Louis Berville was the principal specialist shop and publisher of manuals.[17]

The entrepreneurial approach affected the medium itself. The tonal range and density of charcoal was extended at this time beyond the possibilities of natural stick charcoal by the manufacture of compressed charcoal from charcoal dust.[17a] Although full analytical studies have not yet been carried out, it is clear that, visually, this development narrowed the gap between charcoal and the other media, especially chalk and crayon. It was typical of the entrepreneurial spirit of this period to want to improve the natural product. Some of the richer black accents or reworkings in Redon's drawings, which were achieved by using conte in

[14] John Rewald, in *Redon — Moreau — Bresdin* (1962), p. 15, dates the first meeting to 1864. Dr Ted Gott has pointed out to me that Ernest Redon's letter (*c.* 1864) to his brother would seem to imply as much, as Roseline Bacou noted: 'Avec Gérôme et le père Corot tu peut marcher...' (in *Lettres à Odilon Redon* (Paris, 1960), p. 38). Ernest also refers to his brother's intention to produce historical landscape. The first mention of Corot in Redon's journals, as published, occurs in May 1868 (*À Soi-Même*, Paris 1922, pp. 35–36, subsequent references as *À Soi-Même* (1922)).

[15] *À Soi-Même* (1922), pp. 35–36.

[16] Auguste Allongé, *Le Paysage au fusain: Cours progressif composé de cinquante-quatre planches, dessinées d'après nature* (Paris, n.d.).

[17] Jirat-Wasiutyński (1980), p. 131.

[17a] Since this paper was given, limited analysis at the Canadian Conservation Institute in Ottawa has revealed no binder in contemporary compressed charcoal.

the earlier drawings, must be ascribed to the use of compressed charcoal and, at times, manufactured black chalk in the works of the later 1870s and after.

Redon's charcoal drawings of landscape do not, however, resemble the more naturalistic images of Lalanne or Allongé. They are much simpler in conception: Redon works with fewer elements in an additive composition. No deep, nor extensive description of the landscape is given the viewer; only suggestive fragments, for a poetic reverie. Redon's technique is also freer, less orthodox than theirs. We have seen that the closest affinities are with the later paintings of Corot. In the delicate, late afternoon light of these landscapes, nymphs and other mythical creatures appear quite naturally. In a similarly poetic and natural way, the ancient, dense forest bathed in mysterious half-light in Redon's *Landscape* (Fig. 1), seems to body forth two figures in intimate dialogue holding a child.

In his review of the 1863 Salon, Redon had revindicated the right of the artist to draw on the traditions of mythology and literature, in a word, to be a poet rather than a realist. His early drawings evoke Dante and Vergil, Faust and Mephistopheles, and centaurs in landscape settings. With Redon's adoption, c. 1875, of esoteric imagery,[18] a new category of fantastic drawings appeared. These drawings, which now treat the realm of ideas directly, became the equivalent of history painting in the traditional sense. Their genesis also gives a more visible role to imagination: charcoal becomes an improvisational as well as a suggestive medium. It is this last aspect which I would like to examine in the context of our further study of Redon's use of charcoal.

Le Météore, c. 1875–80 (Fig. 6), is striking by the power of its almost impenetrable blacks. The subdued contrast of a mournful eye set in a brutish head is reinforced by the simple, spherical geometry and luminous, schematic comet's tail. What we 'see' is a heavenly spirit, represented by the head, falling like a meteor or shooting star to earth, into the dark, inhospitable world represented by the watery surface stretching to the horizon. The elements used by Redon are few and very simple: sphere and horizon, light and dark, directional movement indicated by placement and a conventional sign. With these elements the artist can, according to Mesley, indicate the major themes of spiritual devolution and evolution, spiritual quest and initiation in his work.

In the Chicago Art Institute's *Winged Head above Water* (Fig. 7), also c. 1875–80, daylight replaces night and the spirit head floats, propelled by a minuscule wing, above the waters. The enlarged eye and grotesque features make it a close cousin of *Le Météore*. The image of a seemingly giant, disembodied head, juxtaposed with a distant horizon, small sailboat and undifferentiated expanse of the sea, introduces us to the incommensurable spaces of Redon's esoteric fantasy. Here, more easily than in the black *Météore*, we get some sense of the searching and creative improvisation, charcoal in hand, that took place as the image was developed. Redon was clearly concerned with the geometric structure of the image and the precise placement of the head and horizon line. The grotesque head has been flattened and schematized in order to suggest the ideal geometry of a sphere, centred on the eye. It is conceivable that the head could have been developed otherwise, by being set in another context and by acquiring a halo or aura, a body and a proximate landscape.

We do possess a more or less contemporary document of Redon's transformative creative procedures. Page 6 *recto* of the *Chicago Sketchbook* (Fig. 8), which is dedicated to René Philipon and can be dated c. 1880,[19] shows a drawing worked in two stages. First Redon sketched his wife asleep, reclining head on pillow; then he reworked the image, in darker graphite lines, geometricizing the features and surrounding the

[18] Roger Mesley has argued convincingly in his unpublished Ph.D. dissertation, *The Theme of Mystic Quest in the Art of Odilon Redon* (University of Toronto, 1983), that Redon's fantastic imagery can best be interpreted in terms of the major themes of esoteric mysticism. He is preparing a book on the subject.

[19] One page of the sketchbook is inscribed Soulac, the name of a village in the Médoc, and dated 1880. Other pages can be related to the procedures and images of that period. The sketchbook is reproduced on microfiche in The Art Institute of Chicago, *French Drawings and Sketchbooks of the Nineteenth Century*, by Hans Joachim. Compiled and edited by Sandra Haller Olsen (University of Chicago Press, 1979), nos 4F4 to 5D5.

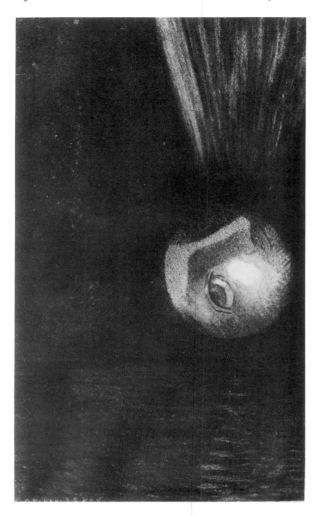

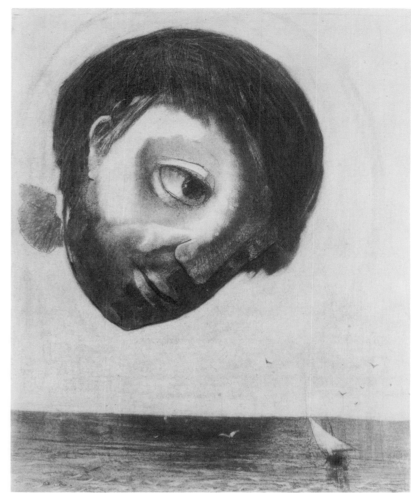

FIG. 6. Odilon REDON, Private Collection, Bordeaux, *Le Météore*, c. 1875–80. Charcoal on tan wove paper, 33.5 × 21 cm.

FIG. 7. Odilon REDON, The Art Institute of Chicago, *Winged Head above Water*, c. 1875–80. Charcoal on buff wove paper, 46.5 × 37.2 cm. *Courtesy of The Art Institute of Chicago.*

head with a radiant aura, and establishing a distant horizon line. Immediately, the new disembodied head floats above a seascape of water, sailboat and rocky coast! Odilon Redon had married Camille Falte on 1 May 1880 and they spent their honeymoon in Brittany. Sleeping wife and Breton coast have been combined in the sketch to produce a metaphoric image of spiritual presence.

A similar strategy was surely followed by the artist in producing the charcoal drawing from Chicago. Redon's evocative studies of the back-country peasants of the Médoc, physically and mentally brutified, have been combined with his experience of the ocean and the estuary of the Gironde. In 1875, Redon noted the impressions received on a visit to Soulac on the Atlantic coast overlooking the estuary. 'On est si seul là-bas, *aux fins des terres*... La mer est là, magnifique, imposante et superbe, avec ses bruits obstinés... Les voix d'un infini sont devant vous... Sur le haut horizon, pas un navire; un voile à demi cachée est en plein océan...'. And he exhorts painters to go and study the sea for its light and colour; musicians to listen to its harmony; and poets to chant the mystery of the infinite.[20]

Redon is the poet of the infinite in several other early charcoals. An early drawing, now in the Museum of Modern Art in New York, also combines the landscape of the Médoc with a floating eyeball in a metaphoric image. It (Fig. 9) was probably developed from existing landscape studies and, again, traces of Redon's search to establish the final image remain visible. The image shows an eye-balloon raising a suspended platter with skull-head, evocative of the head of John the Baptist or Orpheus, above the barren shores of the Gironde. The charcoal drawing is usually known by the title of the corresponding lithograph from 1882

[20] *A Soi-Même* (1922), p. 49.

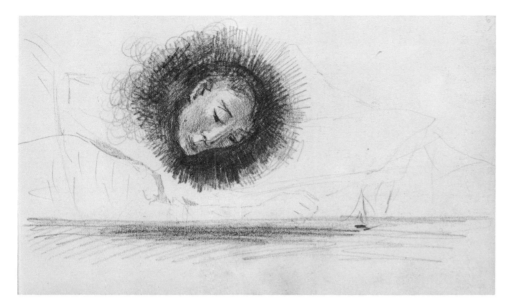

FIG. 8. Odilon REDON, The Art Institute of Chicago, *Sketchbook Dedicated to René Philipon*, page 6 recto, c. 1880. Graphite on white wove. *Courtesy of The Art Institute of Chicago.*

FIG. 9. Odilon REDON, Museum of Modern Art, New York, *The Eye Like A Strange Balloon ...*, c. 1875–80. Charcoal on buff wove, 42.2 × 33.2 cm.

FIG. 10. Odilon REDON, The Art Institute of Chicago, *The Eye Like A Strange Balloon ...*, 1882. Transfer lithograph on applied tissue, 26.2 × 19.8 cm. *Courtesy of The Art Institute of Chicago.*

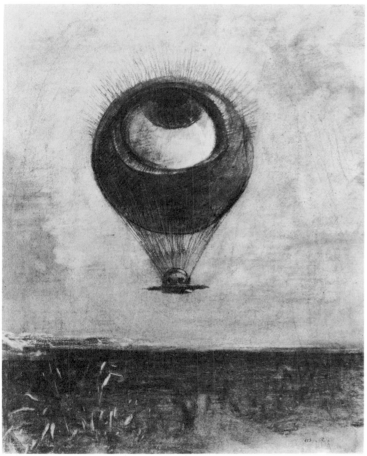

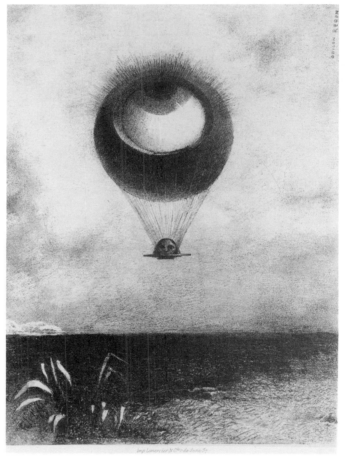

(Fig. 10), *The Eye Like a Strange Balloon Mounts toward Infinity*. That title refers to a fantastic tale, the *Extraordinary Adventures of One Hans Pfall* by Edgar Allan Poe and suggests that literature, as well as nature and the imagination, could serve as stimulus to Redon. The album of 1882 is titled *À Edgar Poe*. Pfall flees the earth for the moon in a balloon and remains there, having found a superior existence beyond earthly cares and suffering, presumably at the price of death. Redon's balloon is directed upward by the questing eye and carries a martyr as its heaven-bound cargo.[21]

The Eye Like a Strange Balloon... raises the issue of the relation of Redon's charcoal drawings to his black-and-white lithographs. These are quite often used to date and explain the drawings in the literature. What

[21] Redon had been introduced to the writings of Poe, in Charles Baudelaire's translations, by Armand Clavaud in Bordeaux in the 1860s (*À Soi-Même* (1922), p. 20).

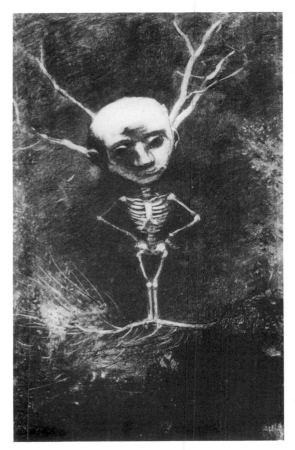

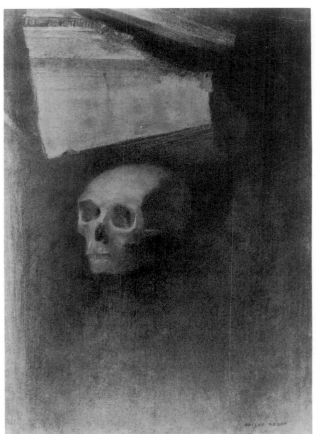

FIG. II. Odilon REDON, Ian Woodner Collection, New York, *At The Entrance to The Walks ... The Spectre Took Shape*, 1886. Charcoal and white chalk on tan wove paper, 45.7 × 28.5 cm.

FIG. I2. Odilon REDON, Ian Woodner Collection, New York, *The Wall of The Room Opened A Crack and A Death's Head Appeared*, 1886. Charcoal on tan wove paper laid down, 43.2 × 30.5 cm.

[22] *Lettres d'Odilon Redon 1878–1916* (Paris and Brussels 1923), p. 30, to André Mellerio, 21 July 1898 (subsequent references as *Lettres d'Odilon Redon* (1923)).
[23] *Lettres à Odilon Redon* (Paris, 1960), p. 80 from Mme de Rayssac, 27 September 1879.
[24] Since this paper was presented, Dr Ted Gott has kindly informed me that at least one charcoal drawing clearly related to the series survives in the National Museum, Belgrade.
[25] André Mellerio, *L'Oeuvre graphique complet d'Odilon Redon* (Paris, 1913), (subsequent references as Mellerio (1913)) mentions 'dessins antérieurs' for many lithographs, including M32 and M33 for *Dans le Rêve* and M37, M38, M39, M42 and M43 for *À Edgar Poe*. 'Dessins antérieurs' does not specify medium and a variety of source drawings must be assumed. Preparatory drawings for all of the above prints have turned up; but, so far, there are only two charcoal drawings among them.

was the relation of the two media in the artist's developing *œuvre*? There can be little doubt about the primacy of the charcoals, but the relation is a complex and changing one. Redon turned to lithography 'to multiply his drawings' at a time when his charcoals were being rejected at the Paris Salon.[22] Fantin-Latour suggested that he use transfer paper to produce lithographs from his drawings. The earliest album, *Dans le Rêve*, was published in 1879; the second, *À Edgar Poe*, was in preparation by the end of that year but not published until 1882.[23]

Dans le Rêve made use of no finished charcoal drawings, as far as I know.[24] For some of the images, Redon worked up small studies on transfer paper and completed them on the stone. *À Edgar Poe* includes at least one lithograph based on a charcoal drawing, which we have just been examining.[25] The drawing was clearly the direct source for the print, which follows the image very closely. Yet the 'feel' of the print is quite different. First of all, the artist has tightened and clarified the partially improvised drawn image in the very procedure of reproducing it on a reduced scale with a fine crayon on lithogaphic transfer paper and by retouching it on the stone. The smaller lithographic image is also crisper as a result. It is printed on a cream applied tissue, which produces a contrasting, luminous support for the denser blacks of the print. As Redon's familiarity with the medium increased, he sought to achieve the subtle and varied effects found in his charcoal drawing in the lithographs of the 1880s by painstaking work with the crayon and with a variety of scraping tools.

It is obviously unwise to use the date of a lithograph for its source drawing, as is often done. The charcoal drawing, which served as the source for *The Eye Like a Strange Balloon...*, was probably produced several years before the print. Other instances come to mind: *Profil de Lumière*, published as a lithograph in 1886, derives from a charcoal drawing in the Petit Palais, Paris, dated 1881 in Redon's account book. *L'Ange perdu*, in the 1886 album *La Nuit*, is based on a very early *fusain*

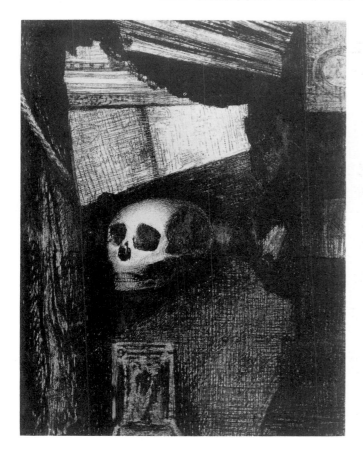

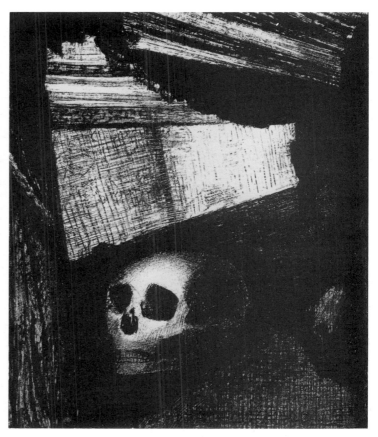

dated 1871, now in the Kroeller-Mueller Museum, Otterlo.[26] On the other hand, if due allowance is made for the difference in media, I think that drawings and prints with distinct subjects can be compared for style and chronology.

In 1886, Edmond Picard, Brussels lawyer, directing spirit of *L'Art moderne* and founding member of 'les XX', asked Redon to illustrate a fantastic tale, which he had written, called *Le Juré*. This well-documented commission presents us with a special case of the relation of drawing and print, as well as a test case of the artist's response to the problem of illustrating a literary text.[27] Redon accepted the commission, stipulating that he would invent the images in charcoal first and then transpose them into lithography. In the end, Picard received a dozen or more *fusains*, seven of which were turned into lithographs, issued both as illustrations and in an independent album. The Woodner Collection now includes two of the original drawings for *Le Juré*, best referred to by the lines from Picard's text which they interpret. Both *At The Entrance of The Walks... A Spectre Took Shape* (Fig. 11) and *The Wall of The Room Opened A Crack...* (Fig. 12) present us with the images of death which haunt the juror of the book's title and drive him to his death. In both cases, overwhelmed by feelings of guilt for having helped convict a man accused of murder, the juror imagines that he sees a skeleton or skull in a perfectly normal, everyday setting, on a garden path or in his bedroom. Redon used charcoal in the Woodner drawings to do what it had always done best in his work: suggest the intersection of spiritual and physical realities.

Comparison of the latter charcoal drawing with the resulting lithograph, state 1 of *Through a Crack in the Wall, a Death's Head Appeared* (Fig. 13), reveals much about Redon's attitude to the two media. The charcoal is remarkable for the subtlety of its cloth-rubbed tones and suggestive ambiguity of the light areas erased with a stump. In comparison, the lithograph shows strong tonal contrasts and marked textures. The lithographic crayon is much denser and, therefore, blacker than charcoal.

FIG. 13. Odilon REDON, The Art Institute of Chicago, *Through The Crack in The Wall A Death's Head Was Projected*, State I, 1887. Transfer lithograph on applied tissue, 23.8 × 18.4 cm. *Courtesy of The Art Institute of Chicago.*

FIG. 14. Odilon REDON, British Museum, London, *Through The Crack in The Wall A Death's Head Was Projected*, State II, 1887. Transfer lithograph on applied tissue, 18 × 15.1 cm.

[26] The drawings have been dated by Roseline Bacou in Orangerie des Tuileries, *Odilon Redon*, exhibition catalogue (Paris, 1956), nos 37 and 115.
[27] *Le Juré*, Redon and Picard are the subject of a separate study which I am preparing for publication.

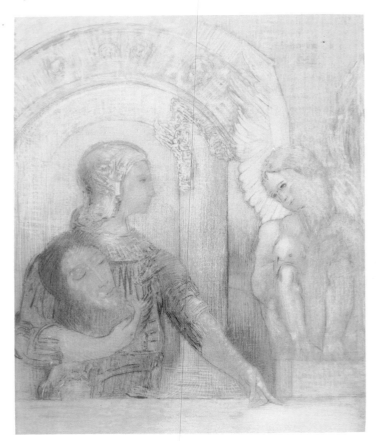

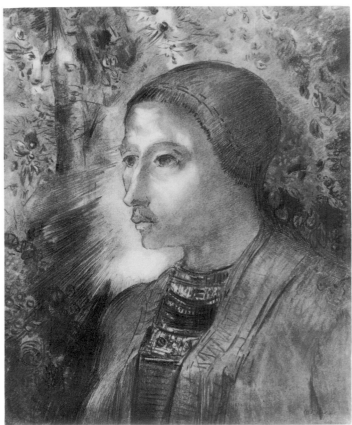

FIG. 15. Odilon REDON, Musée des Beaux-Arts, Bordeaux, *Mystic Knight*, c. 1880–85. Charcoal and pastel on paper mounted on canvas, 100 × 81.5 cm.

FIG. 16. Odilon REDON, Museum of Fine Arts, Boston, *La Bretonne*, c. 1890–95. Charcoal and black chalk on tan paper, 43 × 36 cm. *Courtesy of Museum of Fine Arts, Boston.*

Redon may have 'borrowed' the textures of certain passages, for example the drapes on the left, by placing the transfer paper on a textured surface, such as a wooden tabletop or a piece of cloth, when drawing. *Frottage avant la lettre*![28] In moving from drawing to lithograph, he seems to have been very conscious of the different resources of the two media. The charcoal drawing achieves its effects by subtle gradations of tone which create an indeterminate, suggestive ambience for the fantasy; the lithograph depends for its suggestiveness on the power of the rich blacks, strong shapes and textured surfaces of a planographic print. Redon was not satisfied with the first state of the print, now preserved in the remarkable collection of the Chicago Art Institute. The narrative detail of the descriptive bedpost and the allegorical hour-glass were eliminated in the second and final state (Fig. 14). Redon reduced the size of the image and thereby focused the viewer's attention on the emerging death's head. This tight, powerful lithograph returns the image to its original function as hallucinatory surrogate, first realized in the charcoal drawing from the Woodner Collection.

After the special circumstances of *Le Juré*, the lithographs for the two albums based on Gustave Flaubert's *Tentation de Saint Antoine* seem to have been generated more freely. The text was one of Redon's favourite readings, but I am unaware of any surviving charcoal source drawings for either the first (1888) or second (1889) album.[29] Several of the lithographs reveal a dynamic new breadth and improvisational freedom. This may be a general development in the artist's work, reflected also in the charcoals of the later 1880s, such as *Pegasus*, c. 1888 (National Gallery of Canada, Ottawa).

It has been claimed that Redon 'discovered' colour c. 1890 and rapidly abandoned charcoal drawing and black-and-white lithography shortly thereafter. This is obviously an oversimplification. Redon painted nature studies, what he called his 'études pour l'auteur', throughout the

[28] Douglas Druick and Peter Zegers suggested that Redon used such procedures in his early lithographs in *La Pierre parle: Lithography in France 1848–1900*, exhibition catalogue (Ottawa, 1981), e.g. cat. no. 450.
[29] Mellerio, 1913 cites a 'dessin antérieur' for M88 (*Tentation de Saint Antoine*).

1870s and 1880s. More importantly, he painted the occasional fantastic subject in oils in those years and turned to pastel seriously. as early as c. 1880. Naturally, there is a close thematic and stylistic relation between the charcoal and pastel drawings.

Mystic Knight, now in the Bordeaux Museum (Fig. 15), can be dated to c. 1880–85. Sandström suggested that it was begun as a charcoal c. 1869 and had been reworked c. 1890 in pastel.[30] Visual examination suggests no technical evidence for such a hypothesis; the pastel seems to have been executed in one campaign. Strong links can be established with dated works produced between the late 1870s and mid-1880s. The schematic, flat geometry of figures and features in *Mystic Knight* resembles that found in early charcoal drawings such as the *Head of a Martyr* (Kroeller-Mueller Museum, Otterlo), dated 1877. In fact, the theme of Orpheus and the disembodied head place the *Mystic Knight* in the context of Redon's admiration for Gustave Moreau, which peaked in the later 1870s.[31] The imagery of sacred ritual and initiation also links the pastel with Redon's early albums: handling and architectural elements in *The Priestesses Were Waiting*, from *La Nuit*, 1886, are remarkably close. Only, in the pastel, black has been replaced by blue, white by yellow in an emerging colour symbolism of sacred light and revelation. By contrast with the pastels and mixed media works of the 1890s and after, however, *Mystic Knight* is a sombre pastel indebted to charcoal drawing for its tonal structure. The restrained colour functions locally rather than to establish an overall decorative harmony as in the latter, fully colouristic works.

By the later 1890s, colour dominated certain themes in Redon's *œuvre* such as the idealized woman's profile in a window. Light is no longer only celestial radiance falling from above to illuminate a dark world below; it has become immanent spiritual light dwelling in matter.[32] The physical world is lit up by an inner glow which can be translated particularly effectively by colour. Redon's improved personal and artistic fortunes and his contact with Paul Gauguin, Émile Bernard and the Nabis encouraged the emergence of a more sensual and decorative art. These developments in pastel, tempera and oils affected Redon's contemporary charcoal drawings.

La Bretonne, c. 1895 (Museum of Fine Arts, Boston), (Fig. 16), is endowed with a magical, yet physically and dramatically real presence. She appears in the mysteriously lit Breton forest of Celtic legend. Her head emanates light and her stare fixes some distant or inward vision. The modelling is strong and a rich palette of greys and blacks, applied to a buff paper, creates a colouristic effect. Redon here used the full range of *fusiniste* techniques, but with a new breadth and richness. Figure and trees were drawn over a full tonal ground of rubbed charcoal. The image was worked extensively with stumps and eraser to create the lights. Different kinds of charcoal, including compressed charcoal, left visibly differently coloured strokes. The drawing was fixed at this stage, the fixative being applied from the front with a fine brush. Finally, to complete and focus the image, Redon reworked areas of the sweater, cap and forest with manufactured black chalk over the fixative layer.[33] The vibrant richness of the media and the golden, varnish-like glow of the fixed drawing cannot be appreciated in a black-and-white reproduction. Works such as this and the magnificent *Christ Crowned with Thorns* (British Museum, London) are the culmination of Redon's charcoal aesthetic. Their aesthetic reference is to the tradition of painting by the masters, from Leonardo to Rembrandt.

Shortly after, Redon abandoned charcoal, as well as black-and-white lithography; his interest had turned fully to the freely improvised use of pastel, tempera and oil.[34] The isolated use of charcoal in a drawing such as *Chimère*, 1902 (Musée du Louvre, Paris), belongs with the *tachiste*

[30] Sven Sandström, *Le Monde imaginaire d'Odilon Redon* (Lund, 1955), pp. 47–48.

[31] Redon discusses the works of Moreau at length on two occasions, in *À Soi-Même* (1922), pp. 62–64 (May 1878), and in a letter, *Lettres d'Odilon Redon* (1923), pp. 38–39 (29 January 1900); his initial enthusiasm was tempered with criticism by 1900. By his own account, Redon discovered Moreau in 1865 and saw the works displayed at the Exposition Universelle of 1878. *Young Thracian Maiden Carrying the Head of Orpheus*, is particularly close to *Mystic Knight*; it was shown at the Salon of 1866 (no. 1404) and at the Exposition Universelle of 1867 (no. 485). According to P.-L. Mathieu, *Gustave Moreau* (Fribourg, 1976), p. 300, it was also engraved by E. Gaujean for reproduction in *L'Art* in 1878.

[32] I am indebted to Roger Mesley for this distinction.

[33] These observations were made while examining the drawing with Roy Perkinson and Elizabeth Lunning at the Paper Conservation Laboratory in the Museum of Fine Arts, Boston.

[34] In 1902, Redon wrote to Maurice Fabre, *Lettres d'Odilon Redon* (1923), p. 50, that he was no longer able to work in charcoal; but in 1904, he seemed willing to interpret Poe's tales in charcoal for Gustave Fayet, ibid., p. 57.

experiments represented by pastels and oils such as the *Oannès* in the Woodner Collection.

ACKNOWLEDGEMENTS

Several people have been particularly helpful in my longstanding pursuit of information, technical and otherwise, about Redon and charcoal drawing: David P. Becker, Anselmo Carini, David Chandler, Marjorie B. Cohn, Robert Coustet, Douglas Druick, Thea Jirat-Wasiutyński, Ted Gott, Roger Mesley, Roy Perkinson and Ian Woodner. I would also like to acknowledge the generous assistance of the Advisory Research Council of Queen's University, in Kingston, Ontario and of a French Government Exchange Fellowship.

Pastel: Its Genesis and Evolution to the Twentieth Century

by GENEVIÈVE MONNIER

Pastel: a powdered colour with an infinite range of shades and gradations, always fresh and intense, spans more than one thousand six hundred and fifty nuances of the colour spectrum. It can be handled with ease and rapidity, it allows an immediate transcription of an emotion or idea, and can be easily effaced, easily reworked and blended. The pigments can be rubbed in, made luminous and velvety or given a soft and silky mattness of grain. Pastel is line and colour at the same time. It can also be built up into rich skeins of blended lines, into rapid jottings of all colours.

Sometimes pastel only appears in an artist's work for a brief period, for a few years, or in a few sequences, or at the very end of his life-work, as with Chardin. Some artists, for example, Vivien, La Tour, Liotard, have used pastel for its hazy and vaporous qualities and its effects of stumping and rubbing. Others such as Chardin and Picasso, for its vigorous outlines and hatchings. Many draughtsmen have combined and endlessly varied these possibilities: Perronneau working over a modelled figure with a stump and setting it off with green shading or Degas integrating colour streaks, vaporizations and gumming. For pastel is a medium of great range and diversity. It is lively, multi-coloured, ever-changing: the strokes running straight or zigzagging, breaking into dottings or commas or sweeping curves, hatched in fine parallels or broad squashings, interweaving from top to bottom or left to right or effaced by rubbing and scraping.

The etymology of the world pastel (*pastello*, from *pasta*, paste) would suggest an Italian origin. But Leonardo da Vinci, in referring to this technique, which he calls the 'dry colouring method', says he learned it from a French artist, Jean Perreal, who came to Milan in 1499 with Louis XII. That same year, at Mantua, Leonardo is said to have executed this famous portrait drawing of *Isabella D'Este, Duchess of Mantua* (Fig. 1): a preparatory study in black and red chalk heightened with golden yellow pastel on cardboard; the contours are pricked for transfer, but the final portrait was never painted.

Pastel was applied here only in light touches, to set off with yellow the neck-line of the dress and shade with brown the mass of falling hair. This study is a rare example of its kind; there are very few of them around the turn of the fifteenth and sixteenth centuries. It is the prototype of the portraits that were to be painted in the following century: bust in three-quarter view, head in profile, in close-up; sometimes, as in Bernardino Luini, one hand is visible in the foreground. The idea of pastel-heightening was adopted and amplified by Leonardo's collaborators and pupils. The Albertina's *Portrait of a Lady* is a drawing that was long attributed to Leonardo himself, until it was related to Bernardino Luini's painting of a young woman now in the National Gallery in Washington. Slight touches of colour, pink and white for the flesh tints of the face, yellow and brown for the hair, build up the supple and vibrant

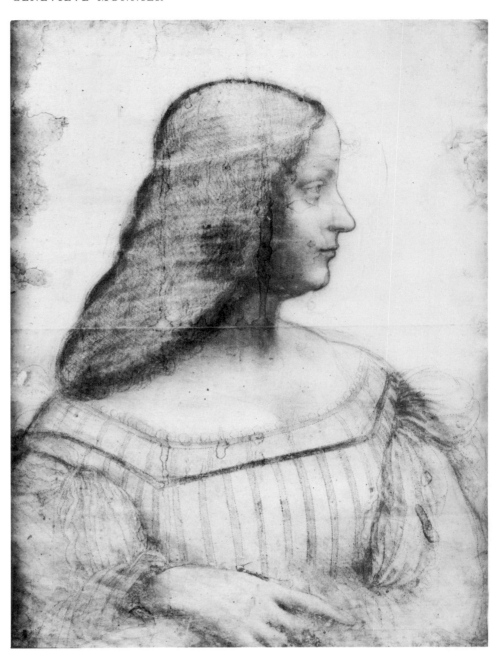

FIG. 1. LEONARDO, Cabinet des Dessins, Musée du Louvre, Paris (Inv. MI 753), *Portrait presumed to be Isabella D'Este, Duchess of Mantua*, 1499. Black chalk and pastel, 60 × 46 cm.

figure. Throughout the sixteenth century, pastel was used to heighten portrait-drawings with a light toning of colour.

The *Portrait of a young woman holding a cat* (Fig. 2), attributed to Pierre Biard, is a half-length in three-quarter view, with the face in profile. This pose continues the tradition begun by Leonardo. The anecdotal element introduced by the cat is unusual for this early period. The bluish grey paper contributes appreciably to the lifelike effect, adding to the relief and modelling and the use of coloured papers, in a wide range of hues, became increasingly frequent. From the beginning, approaching their themes with a naturalistic simplicity, pastel painters were concerned with the representation of narrative images and their details: the study of a face or silhouette, the sketch of a portrait. Then, the various elements were organized on the picture surface, creating a better ordered relation between figure and setting, and developing the scene as a whole.

Charles le Brun used pastel for his portraits of *Louis XIV* (Fig. 3), which were done rapidly in front of the king, whom the artist represents with great mastery *c.* 1665. The sense of immediacy is gripping. The peruke and the coloured details of the costume are rendered economically,

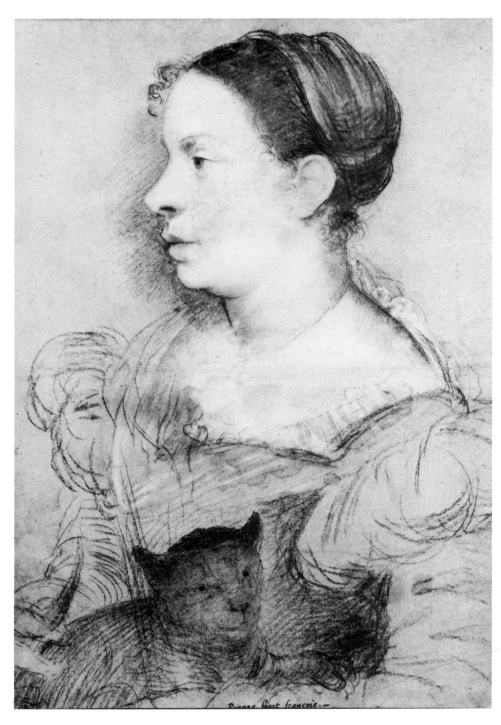

FIG. 2. Attributed to Pierre BIARD, Cabinet des Dessins, Musée du Louvre, Paris (Inv. RF 2360), *Portrait of a young woman holding a cat*. Black chalk and pastel highlights on grey-blue paper, pasted on board, 47.8 × 33.5 cm.

with a sure and sober hand. These direct vigorously executed studies were intended for one of the many compositions illustrating the life of the king.

For all their different styles, the ultimate aim of all these portraits is to be lifelike; some of them are more or less from reality, some are built around ritual poses, some evoke home life. The elaborate costumes and pompous setting and attitudes represent the prototype of the official portrait, which appears in the early eighteenth century just as the picture format becomes larger. From then on, all the effigies of kings, princes and princesses will be conceived on the same pattern by the artists of following generations: haughty poses, showy costumes. The solemnity of this court art is common to all Europe in the seventeenth and eighteenth centuries. At first the personnage often leans on his sword pommel or cane; later he is usually seen in half-length, seated and leaning on a table or over a book. The tendency is towards a freer pose, a more familiar, more intimate attitude. In 1701, Joseph Vivien was admitted to the French Academy as a

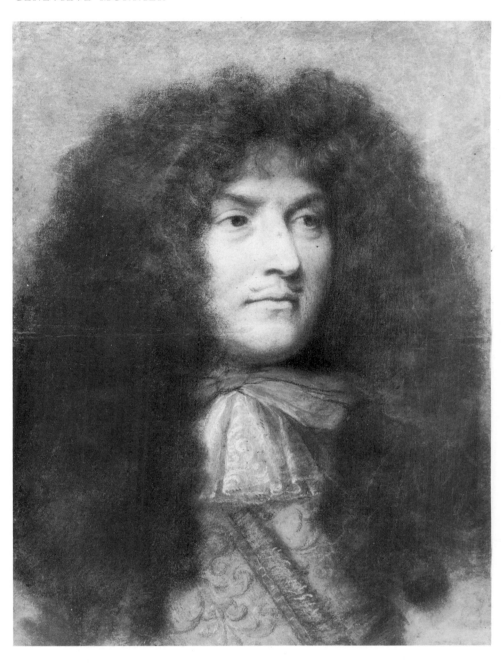

FIG. 3. Charles LE BRUN, Cabinet des Dessins, Musée du Louvre, Paris (Inv. 29.874), *Louis XIV*, *c*.1665. Pastel painted on board, 52.3 × 40.2 cm.

'Pastel Painter'. He created then the prototype of the solemn, majestic, life-size portraits so much in demand in France throughout the eighteenth century. Vivien's pastels present delicate strokes of shaded, blending colours. The reflection on armour and the shimmer of light on fabrics are rendered to perfection. This is an art of surface effects, and modelling is hardly suggested. For Vivien, the pastel was not a mere study: it was an end in itself, a complete and finished work, as large and imposing as an oil painting, whose effects he deliberately copied. The prolific eighteenth-century production of pastel portraits grew out of these examples, in which the sitter is generally shown in half-length, with his social or professional attributes; looking out at the viewer, he stands very much on show, with a touch of pomp and stiffness.

Vivien made at least two versions of his portraits of the grandsons of Louis XIV; one of them is *Louis de France, Duc de Bourgogne*. A set of three pastels made for the King is preserved in the Louvre; the other set of pastels (of smaller size but all signed and dated 1700) is now in Munich. It illustrates the multiplicity of these portrait commissions, executed in one or more copies for different members of a ruling family. Vivien had a dominant influence on several artists; on the Swede Gustav Lundberg as

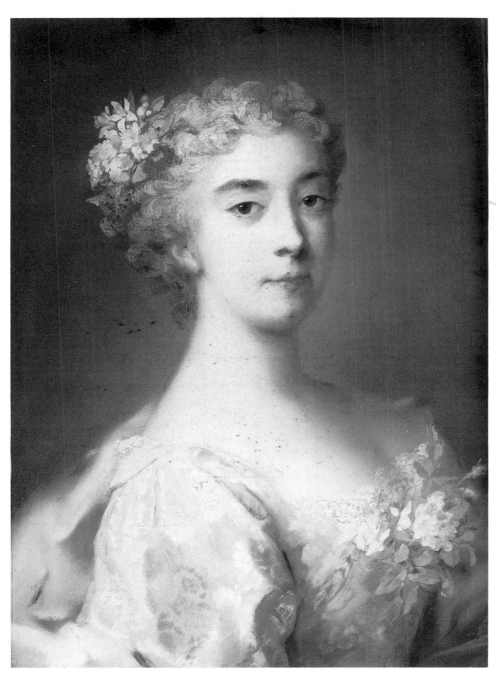

FIG. 4. Rosalba CARRIERA, Galerie des Offices, Florence (Inv. 829), *Portrait of Henrietta Sofia of Modena*, 1723. Pastel on paper, 59.5 × 46.5 cm.

for example his *Portrait of the painter Charles Natoire*, (Musée du Louvre) and even on Maurice Quentin de la Tour in his early work.

Magistrates, burghers, artists, musicians and philosophers are recorded for posterity at a telling moment of their professional life, as suggested by an open book, a manuscript, a portfolio of drawings, a print, a letter, a penholder, musical score.

The Venetian artist Rosalba Carriera made a genuine innovation when she turned to pastel for her Italian society portraits, her success was such that she went to Paris in 1720, at the invitation of the French banker and collector Pierre Crozat. Carriera's work consists mainly of portraits of women. In addition to her superb mastery of the pastel technique, she had a distinctive approach of her own: a more graceful conception of portraiture, in which nudity could be justified by the allegorical context; the use of seductive devices such as flowers in the hair and low-necked dresses; and a subdued palette of pinks, blues and whites. With her, for the first time, we find a discreet emphasis on grace and seductiveness, which from then on, throughout the eighteenth century, became one of the keynotes of pastel painting.

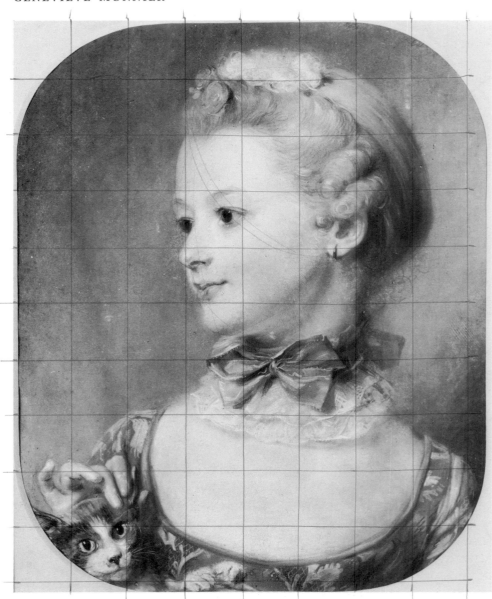

FIG. 5. Jean-Baptiste PERRONNEAU, Cabinet des Dessins, Musée du Louvre, Paris (Inv. MI, 119), *The Girl with a Cat*, 1747. Pastel on parchment, 47 × 37.6 cm.

The novelty lay in her use of unusually mellow colours, applied in broad flat areas, with a velvety, vaporous texture, and subtly harmonizing and re-echoing each other. The drawing and structure are firm and accurate. Eyelids and nose were often laid-in beforehand with a stroke of red chalk or red pastel; then the outlines were skilfully shaded off, so that the resulting forms were solidly structured. The soundness of the preparatory work is concealed by the outward lightness of the figure, which leads to an idealized effect, casting an aura of mystery and unreality over the sitter.

Carriera always works with dry pastel sticks, with a lavish use of the shading stump, a technique which made reworking easy and she was especially fond of light-toned colours.

During a visit to Modena in 1723 she painted the *Portrait of Henrietta Anna Sofia of Modena* (Fig. 4), one of the three daughters of the reigning Duke, Rinaldo d'Este. The purpose of these portraits, executed in several versions, was to make the princesses known to prospective husbands.

It was in Venice, where the intellectual and social role of women was then fully recognized, that Rosalba painted many portraits of the outstanding figures of the Venetian intelligentsia. In all her portraits we find the same haughty grace, due to the position of the head, proudly thrown back. Her influence is evident in the evolution of woman portraits much in favour throughout the eighteenth century. At the time, the portrait

of a woman started being used for mythological subjects and so merged with historical painting.

Almost all the French pastellists of the mid-eighteenth century used a playful, spontaneous style, as we find it illustrated in the work of François Boucher and Jean-Baptiste Perronneau. They are at their best in portraits of smiling children sketched from life. In Perronneau's *The Girl with a Cat* (Fig. 5), the figure is shown in bust length, cut off so that only one hand is visible. The shoulders are in front view, the head in profile to suggest mobility — a stock device of portrait painters. The colour scheme, all in bright, delicate, translucent hues, with soft, plastic modelling for the face of the girl sets off the velvety texture of the handling, for this portrait is executed on vellum in an unusual combination of colours: greens and blues. Perronneau was one of the first, as early as 1747, even before Chardin, to render shading by green hatchings, a wholly new departure; in *The Girl with a Cat* it can be seen in the strokes running along the neck of the young girl. This tender response to childhood is common to many eighteenth-century artists. It was new in French portrait painting, and becomes even more marked in the nineteenth century.

The pastels of Maurice Quentin de la Tour are technically unsurpassed. His figures, such as *Gabriel-Bernard de Rieux*, President of the Paris Parliament (exhibited at the 1741 Salon and now in a private collection), are rendered in the characteristic attitude and 'native' setting (Gabriel-Bernard in his study) with a texture so finely diversified that it suggests to perfection all the different materials represented: silks, velvet, brocades, carpets, lace, woodwork and so on, without disrupting the serene amplitude of the whole.

In his *Madame de Pompadour* (Musée du Louvre) commissioned in 1751, only the head was executed from life; it was done, on a separate sheet of paper(whose irregular edges are visible in a raking light) which was then pasted on to the full-length portrait, which itself was made up of several sheets of paper assembled and pasted together. The King's favourite is surrounded by various objects evoking her role as a patroness of the arts.

In the latter half of the eighteenth century (with the work of Chardin) there is a renewed emphasis on realism, naturalness and sincerity and less affectation and abundance of accessories. The artist is more concerned with the texture and colours of pastel. This shift of taste brings about more spontaneity and intimacy.

Chardin turned to pastel in the later years of his career, when his eyesight was beginning to fail. In his *self-portraits* he comes before us with unusual simplicity and modesty. No pose, no attitude, the artist is shown in his studio, in working garb, with no wig. More than any other French artist of his time, he expresses the dignity and simplicity of the individual human being. Two of his innovations were momentous. One was his system of parallel hatchings of pure colour which determine the modelling and render form, relief and light at the same time. The other was his thick texture of superimposed layers of colour recalling his oil paints. With successive layers, he aimed for the utmost perfection in the structure, tonalities and grain of the paintwork. He conceived the idea of leaving his broad hatchings plainly visible by superimposing them and criss-crossing them; in other words, he deliberately emphasized texture and paintwork at the expense of contours, which, up to then, had been given priority in accordance with academic tradition. Here Chardin gives a foretaste of the innovations to come a century later with the divided brush-stroke. With him, one line of development of the portrait reaches fulfilment — the portrait focused on the face in close-up. With him, it becomes a complete presence, both physical and existential. Chardin employed pastel boldly,

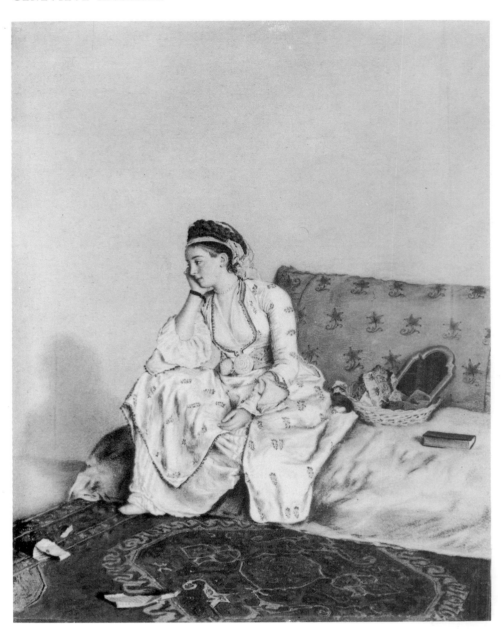

FIG. 6. Jean-Etienne LIOTARD, Fondation Gottfried Keller, Musée d'Art et d'Histoire, Geneva (Inv. no. 1930-2), *Portrait presumed to be the Duchess of Coventry*, 1749. Pastel on parchment 23.5 × 19 cm.

crushing the powdery stick against the paper and patterning it with streaks which harmonize with the whole seen from a distance. This technique of separate strokes was revolutionary at the time.

Jean-Etienne Liotard was exclusively known for his portraits which are executed in pastel but also, sometimes, in oil and miniature on enamel.

The supposed *Portrait of the Duchess of Coventry* (Fig. 6), was done by Liotard in, at least, three versions, with variants in the face, colour scheme and accessories. In all three, we have the same Oriental costume, with which the artist could have dressed several different sitters. In the pastel version in Geneva, illustrated here, Liotard is probably using the layout, setting and figure pose of a portrait painted several years earlier, with the change of certain details.

Some twenty years later in 1782, Liotard disregarded the usual rules of perspective when he drew this pastel: *Still Life* (Fig. 7). The space of this still-life is constructed in such a way that the spectator has the impression of seeing the level top on which the fruit lies as if it had been uptilted on a vertical plane. By a distortion of the picture plane, giving the effect of a sharp incline, the artist contrives to give a more synthetic view of the objects. This device was a novelty for the time; it was employed a century later in Cezanne's still-lifes. The half-open drawer, a device already used by

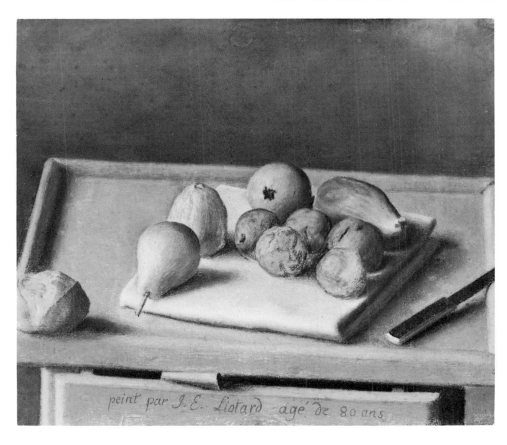

peint par J. E. Liotard agé de 80 ans

FIG. 7. Jean-Etienne LIOTARD, Musée d'Art et d'Histoire, Geneva (Inv. no. 1897–10), *Still Life*, 1782. Pastel on parchment, 33 × 37 cm.

Chardin, adds a further effect of relief in the foreground but, in Chardin, the picture space is built up of traditional linear perspective with a central vanishing point. Chardin often used a diagonal line, in the shape of a knife-handle or a flower-stalk, to break up the horizontal plane of a table placed in the foreground. Liotard, here, does not use the diagonal for this purpose, but rather to balance the composition and fill out the right side. Intersecting colour areas catch and hold the spectator's eye: the accord between the purplish blue plums and the blue cloth sticking out of the drawer and between the alternating greens of the figs — to right and left, heightened by the reddish-brown tone, runs along a diagonal trajectory starting from the left side of the picture. Liotard connects the colours together by an abstract geometric pattern, while Chardin connected forms and colours by an impinging light that modified the shadings on objects.

With the Romantic painters, pastel comes back to the fore. The intensity of the colours and the dramatic emotion of faces and gestures command attention.

Delacroix saw pastel as a highly suitable medium for preliminary studies for his large paintings; it was flexible, quick, allowed him to indicate colours and highlights, and gave him a rough sketch of form, outline and lighting. This pastel sketch of a *Nude Woman* (Fig. 8) for his early painting *The Death of Sardanapalus*, showing her bent over backwards and about to be stabbed, captures movement, volume and light effects all in one. Delacroix used pastel not only for figures but also for landscape studies, chiefly twilight and night scenes, in an early nineteenth-century anticipation of subjects that the Impressionists will take further.

In the second half of the century with Millet and, above all, with Degas, the art of close-up is a real innovation. The new angles of focus used by Millet in the 1860s stem essentially from his choosing isolated figures and studying them in close-up, to borrow a term from the language of photography and the cinema. Millet's other, parallel invention was drawing with heavy hatching in pure colour. This twofold innovation.

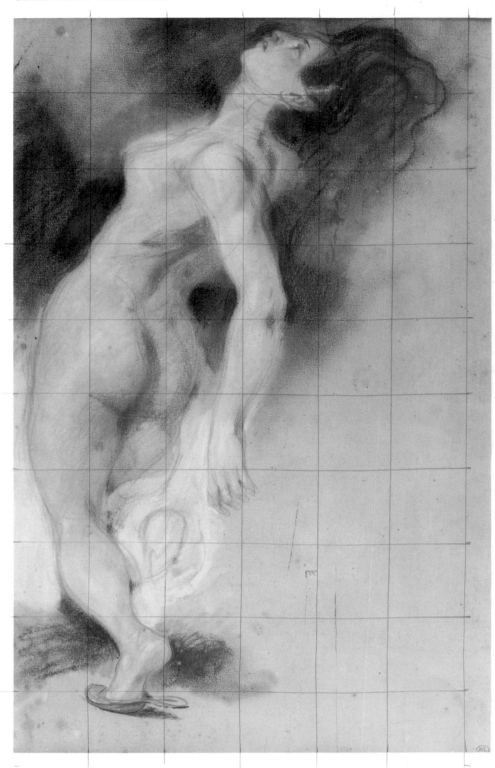

FIG. 8. Eugène DELACROIX, Cabinet des Dessins, Musée du Louvre, Paris (Inv. RF 29666), *Sketch for a Nude Woman* in *The Death of Sardanapalus*. Pastel.

quintessential to pastel, was to influence several later artists such as Degas, Van Gogh, and eventually Picasso. In the *Noonday Rest* of 1865 (Philadelphia Museum of Art, William L. Elkins Collection), the painter's eye is level with the ground on which the two figures are stretched out asleep. Millet came to pure colour by progressive stages: from the 1850s he used pastel only for adding colour highlights to the black-crayon lines of his preliminary drawings; the black crayon gradually disappeared, leaving the pastel on its own.

Degas owned several works by Millet, and their influence on him is very obvious. Degas took the importance of focus and the use of close-ups a stage further. But he gave even more importance to lighting from below. More than Millet, he liked strident colours and tonal relationships (gold, brown, salmon pink, green) set off by a few blacks (the glove worn by his

FIG. 9. Edgar DEGAS, Bequest of Collection of Maurice Wertheim, Class of 1906. The Fogg Art Museum, Cambridge, Mass., *Singer with a Glove*, *c.* 1878. Pastel and liquid medium on canvas, 52.8 × 41.1 cm. *Courtesy of The Fogg Art Museum.*

Singer with a Glove (Fig. 9), and the background on the right against which, her head stands out). The strangeness of the composition is intensified by the arm cut diagonally across the part of the background where the colours unfold in vertical bands of different widths. Degas made a point of diversifying the texture of his paintwork, using moistened pastels for his flat tints, while he employed dry, powdery pastel to hatch certain details.

Degas sometimes combined in one picture certain very precise elements such as an attitude or a face with other elements that he left unclear in shaded areas. *The Star Dancer on Stage* (Musée du Louvre) is an example of this, showing several important Degas inventions: the impression of artificial light illuminating the body of the dancer from below (picking out her throat and chin with a flash of white) the diagonal composition (a large void in the lower left-hand portion of the picture corresponds to the stage), and the dazzling colours laid down in brisk zigzags, the strokes being left clearly visible. Here, pastel possibly conveys, better than oil, all the speed, indeed instantaneity, of the subject, which is what Degas was after. The brightest colours co-exist side by side and even overlap, set off by contrasting browns or blacks, as in the silhouette of a

man in evening dress standing out of sight behind the set, briefly sketched in with a few strokes.

While the portrait, in its earlier form, was first a factual statement, offering an overall view slightly distinct from the sitter, by the latter half of the nineteenth century, with Millet and Degas, it had undergone a radical change, being brought into focus in close-up with more and more subtle effects of daylight or artificial light.

Pastel was equally well suited to seizing a snapshot image. Degas focused on new and marginal figures (jockeys, dancers, women in their bath, laundresses, milliners), approaching them closely and observing their every gesture from every side. With his odd angles of focus and off-centre composition, he marks a decisive break with long-standing traditions of pictorial representation.

Degas' other innovation, and the one that opened up a whole new field for the twentieth century, was his use of a mixed media. In his constant efforts to build up his blended, variously textured layers of colours, he would resort to one medium after another in the same work, combining pastel, gouache, tempera and oils diluted with turpentine. Whether used as a dry pigment or mixed with water, pastel permitted him to rework again and again the details of his compositions, enabling him to suppress the old distinction between powdered pigments and brushwork, between the craft of the draughtsman and that of the painter.

In his *Blue Dancers c.* 1899 (Puskin Museum, Moscow), Degas used the medium in a new way. Aged over sixty and with failing eyesight, he managed to give his surface textures a power that possibly no one before him had attained in pastel, using a less precise linear design, retracing his contours with numerous alterations, and superimposing layers of different colours. He also varied the execution, using parallel lines or criss-cross hatchings, zigzags, short broken strokes, and white chalk highlights applied in comma-like strokes.

In these pastels, such as *The Chocolate Cup* (Galerie Beyeler), form and colour merge while the figure is more fully integrated into the background, drenched in colour and light, anticipating the style of Vuillard and Bonnard.

For the Impressionists, pastel offered a medium well suited to recording the sudden excitement of visual sensations, the fresh colours of nature and fleeting effects of light. The fragility of its texture corresponded to the evanescence of sensual perceptions.

For Edouard Manet, pastel was not just a way of studying an oil painting before tackling the final version, but a self-sufficing medium that enabled him to produce highly finished portraits, whether bust or half-length, in profile or three-quarter view. As regards technique, apart from the usual canvas support Manet was also fond of cardboard — because of its matt finish which he occasionally allowed to show through in places. The density of his pastel comes from his rubbing large flat areas with a stump. He used few colours but much black — that peculiarly intense black that we find throughout his work — as in the portrait of *Méry Laurent with a large hat* (Fig. 10).

The relief on the face is very light, stressing principally the eyes, nostrils and lips. The impression given is one of great expressive mobility and the delicacy of this is in marked contrast to the dark mass of the suit and hat. Manet hardly ever specified his backgrounds, giving them one colour only.

At a time when the impressionist experiment was already in the past Renoir's large *Conversation* of 1895 (Private Collection, Switzerland) shows the artist striving for maximum saturation with light. In each shade of colour, we can see the precision of his drawing, the sweep of his

FIG. 10. Edouard MANET, Musée des Beaux-Arts, Dijon, *Méry Laurent with a large hat*, 1882. Pastel on board, 54 × 44 cm.

composition, the definition of the two attitudes and the expression of instantaneity. The treatment in criss-crossing stripes creates an envelope of luminous highlights. Some of the broadly shaded or flattened hatching is echoed in finer lines on the surface. The finished execution as well as the equal treatment of the central figure group and the background suggest a parallel between pastel and oil painting. (This pastel may possibly be an earlier variant of the painting on the same subject.)

Monet, as shown in a fairly late pastel *Waterloo Bridge in London*, *c.* 1900–03 (Musée du Louvre), used the medium to render the impression of blurring fog. Concentrating on the reflections of the sky in the water, he managed to convey the merging aspect of the two elements, the clouds and the river coming together within the same subdued range of greys, mauves and blues.

For the Symbolists, pastel was no longer a means of recording reality, but rather a means of expressing the inner life, the world of dreams, of imagination, of the unconscious. The themes changed accordingly, and so did their titles: Silence, Meditation, Solitude, Melancholy. The portrait and the self-portrait remained important subjects, but they were treated as evocations or disquieting apparitions. The Symbolists cultivated an art of calculated haziness, or soft-focus effects, in order to give a sense of mystery

to their scenes. With them, a single colour often predominates, becoming indeed the essential subject of the picture. Their concern was the picture for its own sake, not a representation of the outside world. For example, they used the arabesque for decorative purposes. In this, and in their exploration of the expressive power of colour and distortion, they influenced early twentieth-century art, marking both the Fauves and the Expressionists. Around 1895, Redon rediscovered colour with pastel which became one of his favourite techniques. He had begun with portraits from life whose simple profile presentation prefigured his later meditative approach in these works, imagination progressively outweighs reality. Several of his themes (*Profile of Light, Virgin and Child, Angel*) reveal the deeply mystical spirit that informed Redon's work.

This spiritual intensity is evident in his *Blue Profile* (British Museum, London) which shows an androgynous face with closed eyelids and lips pressed together as if in silent prayer. The angular features are sharply delineated with a stroke of pastel and stand out like a medallion profile against a gold ground worked in relief as if guilloched, recalling the gold backgrounds of medieval paintings. The blue is a product of superimposed crushings of pure pastel. The strangeness of this vision is heightened by the fragmentary way in which Redon framed the face, perhaps to stress the idea of a fleeting apparition.

In the early 1900s, he began to devote a great many pastels to studies of bunches of flowers as for example *Flower Piece with Japanese vase* (Private Collection), a subject he pursued in parallel with his underwater visions. Through these two subjects, in fact, the artist seems to have escaped any form of anguish and avoided all symbols so as to create, with pastels of dazzling colours, compositions whose primary intention is decorative. Occasionally, there is still an ambiguous duality where a figure or a face emerges from amid an avalanche of flowers or a bed of seashells. Even if it remains just as easy to recognize a real flower, the chief impression conveyed is, however, that of a boundless imagination. The japanese vase is entirely real and belonged to the artist. The linear structure of Redon's earlier works, with the figures standing out against a background like that of a stained-glass window, has disappeared. From now on, his work is all splashes of colour in broad flat tints or little touches floating all over the surface of the paper, as if in suspension in what has become an abstract space. He became progressively more responsive to the art of ceramics, silks, and tapestries, which possibly encouraged him to start using pastels in pure colours laid side by side, producing some unusual and intense harmonies of violet, carmine, blue and yellow.

Fernand Khnopff was equally happy working with pastel and with coloured crayons, sometimes using both at once, one on top of the other. Coloured crayons offered a more precise, more delicate medium, the paler colours calling for a more meticulous treatment, while pastel offered greater intensity in terms of line, colour and grain. In fact, one of the characteristics of Khnopff's work is this special grainy texture in the colouring medium, obtained without making use of the grain of the paper surface as Seurat did in his drawings. His method resembled pointillism, the pastel strokes just touching the paper. Khnopff's colour schemes often play on melancholy harmonies of white, grey and mauve. His faces are very pale, almost bloodless; they belong to creatures with reddish hair and strange-coloured eyes (like icy water or crystalline rock), wandering in another world, a world beyond the mirror. Their fixed and lifeless look is a key element here: either the eyes are staring intently or the eyelids are closed. The typically symbolist theme of silence conveys the idea of the frontier between life and death.

FIG. 11. Frank KUPKA, Musée National d'Art Moderne, George Pompidou Centre, Paris, *Woman picking flowers*, c. 1907–08. Pastel on white paper, 48 × 52 cm.

A number of formalist elements: the organization of the composition, the use of arabesque, the end of imitation of reality, show the influence of pastel on the works dating from the beginning of the twentieth century.

One of the first to use colour as a vector leading directly to abstraction was Kupka, who juxtaposed colour patches (based on the laws of simultaneous contrasts), according to a rhythmic and linear pattern. Then, progressively freer from any descriptive function, colour surged forward, following the explosion of the imagination.

The pastel of a *Woman picking flowers* (Fig. 11) was painted by Kupka in 1907–08 when the young Czech artist was combining abstract and figurative elements; he used colour to express their relation to movement and their breakdown into successive states within a given space. Broad vertical bands of pastel, in different colours, are cut off, divided into segments, across a woman's silhouette in side view, as she walks and bends forward to pluck some flowers (she bends down obliquely, by degrees, towards the left side of the picture). Dividing the space into parallel sections, Kupka creates an interacting pattern, one vertical and fixed, like a grid through which the figure follows a double path of movement: the horizontal walking movement towards the left and the oblique trajectory of the stooping figure. Kupka made a series of at least fifteen studies of this theme, superimposing planes and colours in an interlocking pattern of geometric space. Here, he used a wide range of colours: brown, orange, blue, violet, green and yellow.

With these experiments, Kupka anticipated by several years, the idea of a sequential breakdown of movement which Marcel Duchamp

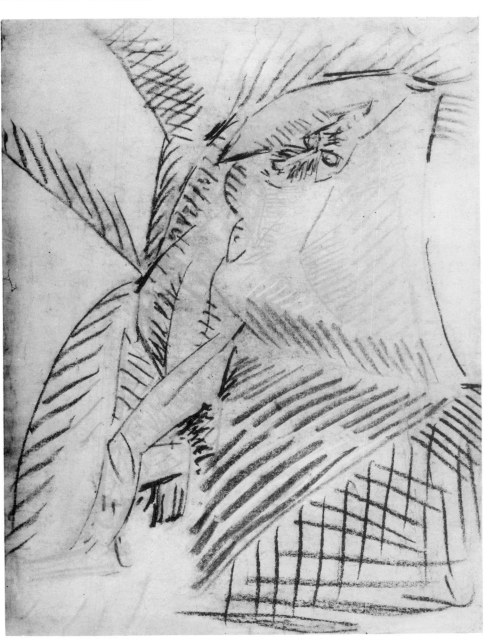

FIG. 12. Pablo PICASSO, Musée
Picasso, Paris (Inv. MP 547), *Nude
sleeping*, c. 1907. Pastel on paper, 48 ×
63.2 cm.

embodied in his famous painting *Nude descending a staircase* 1912
(Philadelphia Museum of Art).

In the years between 1901 and 1904, Picasso painted largely in a blue
monochrome, producing an impressive series of figure compositions and
self-portraits which break sharply with the 'belle époque' style of the
previous years. These pictures include pastels, treated in fine hatchings
with stumped areas which create modelling. The summer of 1904 was the
beginning of his Rose Period, in which a similar monochrome was used
with a new harmony and plenitude in the treatment of nude figures.

In the summer of 1907, following the experiments which had
culminated in the *Demoiselles d'Avignon*, Picasso worked on his *Nude
sleeping* (Fig. 12). For this picture, he made several pastel studies of details
and figures closely related to those of the *Demoiselles d'Avignon*. These
pastels mark a further stage in the simplification of forms, the distortion of
bodies, the abstract geometrization of faces. He amplified the pattern of
parallel hatchings of different colours occupying triangular, asymmetrical
zones of space (closed eye, open eye). This prefigures the breakdown of
volumes into multiple facets characteristic of Cubism in the years
1910–11. The imaginary forms are treated in accordance with an abstract

patterning and enclosed in narrow margins. This style of drawing stemmed from Picasso's discovery, in the summer of 1907, of African woodcarvings in the ethnographic rooms of the Trocadero Museum in Paris.

Kirchner loved bursts of flamboyant colour and his sources of inspiration were similar to those of Fauvism. After an early period in Dresden from 1905 onwards, characterized by stylized forms and outright borrowings from the primitive arts, he went on towards a stricter design and a more controlled but ever more powerful affirmation of expressionism. All his work is distinguished by an unhesitating speed of execution. The very rapidity of the pastel strokes, applied in abrupt and jerky parallels, further emphasizes the deformation of the silhouettes and the distortion of the urban space — the streets of Berlin — in which they move. In his *Street with woman in red* of 1914 (Staatsgalerie, Stuttgart) the central axis formed by the woman's long slender figure creates a dynamic composition with a pendulum system that animates the whole scene. This approach is similar to that of the Italian Futurists (Boccioni, Balla, Severini, Carra). Like them, but independently, Kirchner conveys objects and settings from interacting viewpoints and, by way of that synthetic image, symbolizes movement and the idea of walking.

The American artist Arthur Dove spent two years in Europe from 1907 to 1909. He worked, for the most part, in oils, watercolours and pastels; after 1920, he devoted himself chiefly to collages. His pastel *Plant forms* 1915 (Whitney Museum of American Art, New York) is among the first of his compositions in which abstraction prevails over the highly stylized figurative motif. It is the pictorial expression of a dynamic force in concentric movement, built up chiefly in semi-circular forms. The vocabulary is almost cubist, with its definition of a three-dimensional space, the intersecting curves, the transposition of natural motifs into geometric figures. Made up of broad areas of thick pigment with a velvety, lustreless texture, this pastel emphasizes the contrasts between the brighter zones of colour firmly set into a network of dark volutes and outlines. In the energy and intensity of the movement, this picture recalls the expressionism of Kandinsky and Franz Marc.

In Paul Klee's work the support plays an essential and singular role as for example in *The Eye* of 1938 (Private Collection, Switzerland), executed on a strip of jute from a gunny sack, with frayed edges and loose weave, laid over cardboard. The pastel powder was applied to the previously moistened fabric and then quickly absorbed. The result is a thin layer of pigment, allowing the weave to show through and giving a light, airy texture, similar to that of watercolour. The three broad colour surfaces, pink, green and grey, are set off by five black lines and the white patch of the eye.

After joining the Surrealist Group, Miro developed the art of combining plant, animal and human figures with a fanciful spawning of abstract or imaginary forms. As he advanced, he gave more and more importance to cosmic motifs. About 1929 his calculated breaking-up of figures began: he himself described this experiment as 'the assassination of painting'. Executed in pastel, gouache and indian ink, *Women and bird in front of the sun* (The Art Institute of Chicago), of 1942, stages a play of elements and movements, of rhythms and trajectories, evoking the fourth dimension — a theme which Miro had been developing in his *Constellations*, a series of gouaches which he had begun in January 1940. They were a hymn to the sun, in reaction against the grimness of the war years. Pastel is used rather as a priming coat; its patches, rubbings and stumpings are worked over with gouache and indian ink.

With Andre Masson, pastel reached great intensity and gestural violence. Dating from 1943, *La Pythie* (Private Collection, Paris) was

executed on grey-buff paper during Masson's American exile in New England. Beginning *c.* 1925, Masson employed pastels in combination with pencil and coloured crayons. He sought out rather extreme schemes of acid, clashing blues, violets, reds, yellows; indeed almost all the colours of the palette are there. Line only partly corresponds to contours. It serves to mark out certain colour fields, which combine and clash in a pendulum rhythm, heightening the sense of instability. All over the colour fields there is a strong pattern of curves, zigzags, strokes and hatchings.

In the hands of the Surrealists, pastel was a further means of transgression in the often puzzling shape of composite images, recreated spaces and iridescent colours. The alliance of imagination, abstraction and narration has continued throughout the twentieth century.

Technically its possibilites are infinite but certain characteristics remain unchanged, like the intensity of its colour, the matt effect of its pigment grain, magical because multiform.

An unknown collection of drawings in the eighteenth century

by TILMAN FALK

The title or subtitle of this short essay should perhaps read 'The Jabach tradition, an unusual group of drawings at Basle, an unknown collector of the eighteenth century, and a misleading reference in Lugt's *Marques de Collections*'. To start with the last point: I am a great admirer of Frits Lugt's fascinating standard works and I have no intention to criticize; but a mistakenly identified collector's monogram was the clue to the whole story. It all started in 1973 when I had to prepare and mount a small exhibition of seventeenth-century drawings for a special occasion at the Basle Print Cabinet. In the introduction to the catalogue[1] I gave some preliminary information about this previously unnoticed collector and his assembly of drawings.

The collection of old master drawings at the Kupferstichkabinett Basle is very strongly determined even today by the origins of its three-century-old history. Its foundations have been laid by two remarkable collectors of the sixteenth and seventeenth century: namely Basilius Amerbach (1533–91), and Remigius Faesch (1595–1667). Basilius Amerbach, son of Bonifatius, a close friend of Erasmus of Rotterdam, and grandson of Johannes, a printer of early books at Basle, was one of the earliest systematic collectors of prints and drawings in the sixteenth century.[2] Having travelled in Germany, France and Italy, as many students of humanist breeding did, and having achieved his doctorate of law at Padua, he lived only a few years of professional life at Basle, retiring soon to his private interests; learned correspondence with other humanists, collecting and having his *Kunstkammer* built, where he combined his prints, drawings, coins and a few paintings with many other items of antiquarian interest.[3] Among the documents referring to his collection exists a remarkable inventory of prints, of some three hundred pages, very probably the oldest of its kind, which has so far never been published.

Remigius Faesch, aiming at a more universal *Kunst- und Wunderkammer* (including objects of natural history), did not specialize in any field of art.[4] In collecting drawings, both collectors drew on the remarkable rich local sources; one has to bear in mind that the Upper Rhine region had formed a centre of artistic production in the decades around 1500. Amerbach was fortunate to acquire the workshop remains of Hans Holbein the Younger (some two hundred drawings), most of the drawn *œuvre* of Urs Graf and Niklaus Manuel Deutsch, as well as other precious groups from the Schongauer and Dürer generation. Faesch, on the other hand, strangely did not care much for the art of his time (Rembrandt or Claude, the Carracci or Guercino for example), except for engravings after Rubens because of their apparent iconographical interest. Instead, like Amerbach he assembled old German masters and, predominantly a Swiss speciality, *Scheibenrisse*, drawings for stained glass.

While the Amerbach collections had been acquired by the city of Basle in 1661, to form the oldest public art collection in the world (a few years

[1] Exhibition catalogue (Ed. T. Falk), *Zeichnungen des 17. Jahrhunderts aus dem Basler Kupferstichkabinett* (Basel, 1973), cited: Cat. Basel 1973.

[2] See: (Ed. T. Falk), *Katalog der Zeichnungen des 15. und 16. Jhs. im Kupferstichkabinett Basel*, Teil I (Beschreibender Katalog der Zeichnungen, Band III,1) (Basel/Stuttgart, 1979), pp. 11 ff.

[3] See note 2, and E. Landolt, 'Künstler und Auftraggeber im späten 16. Jh. in Basel', *Unsere Kunstdenkmäler*, XXIX (1978), pp. 310 ff.

[4] E. Major, 'Das Fäschische Museum und die Fäschischen Inventare', *Öffentliche Kunstsammlung Basel, Jahresbericht*, NF IV (1968), Beilage, pp. 1 ff. (see also note 2, 24 ff.).

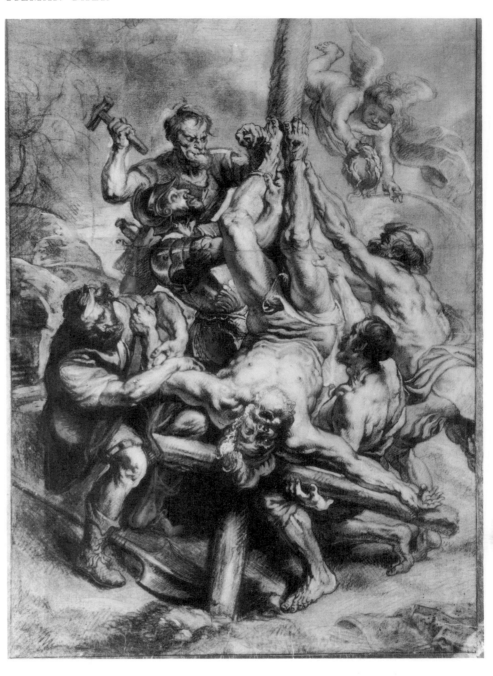

FIG. 1. Peter Paul RUBENS (and studio),
Kunstmuseum, Basle (Inv. no. U. IV 97),
The Martyrdom of St Peter. Black and
grey chalk, retouched with brush in black
and different grey tones, white heigh-
tening, 45.9 × 33.6 cm. (Checklist
no. 16.)

older than Paris), the Faesch family inheritance was joined to it only in
1823. This basic stock of drawings and prints remained practically
unchanged up to the time of Jacob Burckhardt and into this century.
During the last decades enriched by highly important acquisitions of
'Altdeutsche Meisterzeichnungen',[5] the Basle cabinet can now boast one of
the world's largest and most oustanding collections of German and Swiss
drawings. This predominance is so marked that little attention was given
to the few Dutch or Flemish, Italian or French drawings there (I cannot
recall even one English drawing). This introduction was necessary to
explain the quite unusual features of the following.

When assembling the material for the seventeenth-century drawings
exhibition at the Basle Print Cabinet, I was highly surprised to come across
several non-German drawings of rather exceptional quality, among which
at least two, from the type of their mounting or other evidence, must have
come from the famous collection of Everard Jabach (1618–95). It is well
known that the Cologne banker, spending a great part of his active life in
Paris under Louis XIV, fell into financial difficulties some time before 1671
and had to sell his marvellous 'first' collection of paintings and drawings to

[5] G. Schmidt, 15 Handzeichnungen Deut-
scher und Schweizerischer Meister des 15. und
16. Jhs. Hrsg. von der CIBA aus Anlass ihres
75–jährigen Bestehens... (Basel, 1959).
H. Landolt, 100 Meisterzeichnungen des 15.
und 16. Jhs. aus dem Basler Kupferstichka-
binett (Basel, 1972).

the King. Within the next twenty years, however, he built up a second collection of drawings of almost equal fame, known through an inventory of 1696, and again totalling more than four thousand objects. These have later been dispersed by his heirs (which explains why so many drawings with the Jabach provenance are to be found in collections everywhere).[6]

The most remarkable object within this group of non-German drawings at Basle is a vigorous pen-and-wash sketch by Rubens or, perhaps, his studio, a *Martyrdom of St Peter* (Fig. 1), itself unduly neglected by Rubens' specialists, with a highly interesting and easily reconstructed early history.[7] The sketch is — to summarize briefly the opinions on this work — connected with one of Rubens' most important late commissions, the high altar of St Peter's at Cologne, commissioned by the Jabach family.

The sheet is, however, not a preliminary drawing, as it may seem, rather a parallel achievement or an afterthought to the altar painting. I am convinced that a communication made by Ludwig Burchard as early as 1936 to the museum of Basle can still be regarded as valid in its decisive points. He believed it to be a design for an engraving, more precisely, a sketch executed in its original and underlying form in chalk by Hans Witdoek (the latest of the Rubens' engravers and the only one active in his workshop at this time, 1638/40), retouched extensively and finished by Rubens himself. Hans Vlieghe recently confirmed this evaluation (orally, *c.* 1975). There are a number of similar examples to be found for such a procedure by Rubens.

The drawing, mounted on strong cardboard and surrounded by a golden border strip (as are the other *dessins d'ordonnance* of the Jabach collection), was described in the inventory of 1696. It was sold afterwards to Pierre Crozat 'le roi des collectionneurs de dessins' (Lugt), in whose collection Watteau saw and copied it (drawing now in the Print Cabinet at Stockholm).[8] At the Crozat sale (1741) it figured as no. 818 and was bought by another famous connoisseur and collector, Jean Pierre Mariette. This is recorded by Mariette himself in his *Abecedario*, where he adds that he finally presented the drawing to one of Everard Jabach's grandsons, Gerard Michael.[9] So it returned once more to the family from which it originated. Gerard Michael Jabach, living at Livorno, boasted to have found and preserved a good part of his grandfather's drawings. When he died, these drawings were sent to Amsterdam and auctioned in 1753. The catalogue of this sale is extremely rare. After the only known copy at Orléans, of which an old photostat is preserved at the RKD The Hague, had been burnt during the last war, there emerged another copy, once owned by Ploos van Amstel, and now owned by the Institut Néerlandais at Paris.[10] Although this catalogue will prove to be important for our purposes, the Rubens' drawing, unfortunately, does not figure in it. The probable reason for this is told by Mariette (see note 9). While looking for the provenance history in the Basle records (the drawing had been mistakenly given an Amerbach inventory number, which of course made no sense), it was possible to discover it had been donated to the museum in 1865 by a certain Rudolf Vischer-Christ (or 'the heirs of Vischer-LeGrand'). In fact, all of the questionable group of non-German drawings came from this same source; moreover, it could be established that they all had been pasted onto empty pages of a volume of engravings after Claude Lorrain. This volume still exists, but gives no reference to earlier owners. What happened, then, to the Rubens between *c.* 1750 and 1865? The mount bears no collectors' marks, except a handwritten 'ff' (= Lugt 960a) by Jabach himself on the *verso*.

The matter was further complicated, but at the same time came closer to solution by a second Jabach drawing among the Basle group, an

[6] See a.o. the article in: F. Lugt, *Marques de Collections ...* (Amsterdam, 1921), at no. 2959. Catalogue (Ed. R. Bacou), *Collections de Louis XIV. Dessins, albums, manuscrits* (Paris, Orangerie, 1977/78). R. Bacou, 'Everard Jabach, Dessins de la seconde collection', *Révue de l'art* (1978), pp. 141 ff.

[7] Cat. Basel, 1973, no. 46. See no. 16 of our checklist.

[8] K. T. Parker/J. Mathey, *Antoine Watteau, Dessins,* I (Paris, 1957), no. 311. Catalogue (Ed. W. Schmidt) *Dialoge, Kupferstichkabinett der Staatlichen Kunstsammlungen* (Dresden, 1970), no. 114.

[9] *Abécedario de P. J. Mariette* (Paris, 1854/56 reprint Paris 1966), vol. III, pp. 1 f. '... J'avois acheté, a la vente de Crozat, le beau dessein du Crucifiement de S. Pierre de Rubens, et l'avois cédé à (Gerard Michael) Jabach, qui étoit mon ami. J'aurois bien voulu le ravoir; mais ses frères m'ont écrit qu'ils avoient résolu de le garder dans la famille, pour mémoire de ce que le tableau original de Rubens, qu'on voit à Cologne dans la paroisse de Saint-Pierre, avoit été ordonné par leur aieul et donné par lui à cette église.' This is also taken up by R. Bacou, in Révue de l'art (1978), p. 149 (without giving a reference to the present whereabouts of the drawing).

[10] *Catalogus van ... Schilderyen.* Benevens een Extra schoone Verzameling van Originele Italiaansche, Fransche en Nederlandsche TEKENINGEN ... Alles Nagelaten door den Heer G. M. JABACH, te Livorno. Amsterdam (16 October 1753, door Hendrik de Leth. The drawings, 1085 lots and some volumes, are catalogued on pp. 7–42 rather cursorily. I am grateful for help in this matter to the staff of the RKD at The Hague and to Carlos van Hasselt, Paris.

FIG. 2. Giovanni Battista FRANCO, Kunstmuseum, Basle (Inv. no. Z 557), *The Adoration of the Kings*. Pen and wash in brown ink, white heightening, 13.4 × 13.7 cm. (Checklist no. 5.)

FIG. 3. *Verso* of FIG. 2.

Adoration of the Kings (Fig. 2), from the hand of Giovanni Battista Franco, unpublished up to now. A drawing with pen and brush in brown, heightened with white, only 13.4 × 13.7 cm in size, but highly finished and of rare beauty. It is enhanced by the golden border of the Jabach mounting. Philip Pouncey saw it in 1969 and confirmed it as a late drawing by Franco, possibly around 1550, when he was involved with the Grimani Chapel of S. Francesco della Vigna at Venice, where an *Adoration of the Kings* was placed on the high altar.[11]

The drawing bears in the middle of its lower border a monogram in dark brown ink, composed from the letters F and h, with something like a hook in between, and more to the right, written in the same ink, the inscription 'B.ta Franco'. This same handwritten monogram was also found on other sheets of the Basle group, always in the same place on the *recto*. Turning to Lugt's *Marques de Collections*, it can be identified, not under the letter F as expected, but in the Supplement volume under no. 1468a, as belonging to Ignazio Enrico Hugford, a British artist and collector living at Florence around the middle of the eighteenth century. Lugt states that a drawing at Oxford from the Raphael school bears this mark,[12] which Samuel Woodburn in the nineteenth century had claimed as having belonged to Hugford. There exists some literature about this personality who also won a certain fame in more recent times as a possible forger.[13] Consequently, I tried to find this so-called Hugford monogram on documented remains of the Hugford collection, such as a series of portraits by the Clouet school at the British Museum and a Benedetto Luti drawing at Christ Church, Oxford, but without any success. On the other hand, I could not trace the slightest connection of Hugford or the Hugford family with anyone living at Basle.

The solution was near when finally the Franco drawing with its Jabach mount was removed from the modern *passe-partout* (Fig. 3). On the *verso* the different marks and notes were clear. Besides two old numbers '335' and '41', the significance of which I do not know, we find the attribution 'Btta Franco' again with the note 'de M. de la *Noué*, et d'après coll. de M. Jabach'. Below this, two of the letters and *paraphes* which are convincingly given to Jabach himself, appear written in chalk. Finally, still lower down, there is an inscription in dark brown ink 'Faesch /

[11] See our checklist no. 5. The drawing can be clearly identified in the Gerard Michael Jabach sale of 1753 as lot 335 (see later). No corresponding painting seems to exist. Cf. W. R. Rearick, 'Battista Franco and the Grimani 'Chapel', *Saggi e Memorie di Storia dell'Arte* 2 (Venice, 1959), pp. 129 ff.

[12] No. 9 of our checklist.

[13] J. Fleming, 'The Hugfords of Florence', *Connoisseur*, October 1955, pp. 106 ff. and November 1955, pp. 197 ff. (esp. p. 199). B. Cole, U. Middeldorf, 'Masaccio, Lippi or Hugford?' *Burlington Magazine* (1971), pp. 500 ff.

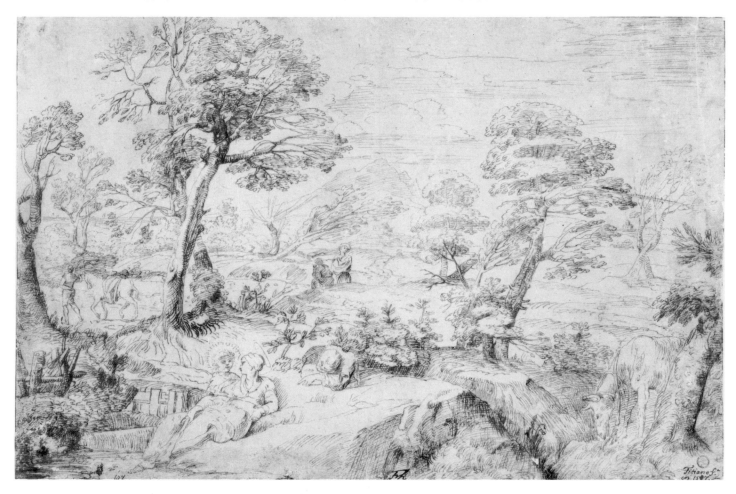

FIG. 4. Workshop of Annibale CARRACCI, Kunstmuseum, Basle (Inv. no. U. IV. 96), *Landscape with the Rest on the Flight into Egypt*. Pen and brown ink, mounted on cardboard, 27.8 × 42.5 cm. (Checklist no. 2.)

am Seidenhof / 6' — the first letter F showing the same 'hook' as in the monogram on the *recto*.

Faesch, as had been mentioned above, was a prominent Basle family connected with the local museum's history. But nowhere in the museum's records was found a reference to a 'Faesch am Seidenhof', so that archival research had to disclose his personality. Finally, the following facts came to light: the so-called Seidenhof, a large and in part medieval palace on the famous Rhine front of the town, was owned or inhabited at this time by a certain Johann Jakob Faesch (1732–96). He was a merchant who, after a short military service until 1751, went to Amsterdam. He travelled to the colonies several times but always returned to Amsterdam where he married a certain Catharina de Hoy in 1758(9). It is very likely therefore that he was there at the time of the Gerard Michael Jabach auction. Only much later, after the death of his wife in 1765, did he move to his home town Basle where he established himself in the Seidenhof palace. Evidently he was living as a wealthy man, who re-married and became councillor of the town (*Ratsherr*), and was mentioned in contemporary literature, at least from 1779 onward, as a collector. These fortunes, however, did not make him happy, and in a wave of depression, as tradition has it, he committed suicide by throwing himself into the Rhine, directly from one of the windows of his palace (which was, at that time, indeed possible, as contemporary topographical views clearly show).[14]

A letter from his hand at the University Library Basle[15] confirms the handwriting and signature to be identical with that on the Franco drawing. Moreover, J. J. Faesch was not completely unknown in the contemporary art collectors' scene. While the German writer Johann Georg Meusel in 1779 described only a collection of Dutch paintings assembled by him,[16] three years later another Basle amateur and collector, Achille Ryhiner, almost a neighbour of Faesch, mentioned drawings also. In his (very rare)

[14] I am grateful to the staff of the Staatsarchiv Basle for the help given so many years ago. The main source is a Familienchronik Faesch (Privatarchive 399, D3 and 4).

[15] Letter of one page to J. Schweighauser, 9 February 1788, Basle, Universitätsbibliothek, Autographen-Sammlung F.

[16] Johann Georg Meusel, *Miscellaneen artistischen Inhalts*, 2 (Heft, Erfurt 1779), pp. 26 ff. 'In Basel besitzt Hr. Jacob Fesch, Handelsmann, eine Gemäldesammlung, die bekannt zu werden verdient. . .' This collection was also known to Lugt, who mentions it in Marques de Collections, 413, at no. 2206 (article on Johann Rudolf Faesch): 'Cette collection ne doit pas être confondue avec la galerie des tableaux hollandais réunie par Johann Jacob Faesch, au Seidenhof. . . vendue après sa mort.' The Kupferstichkabinett Basle owns a very amateurish pencil drawing (16.2 × 21.7 cm; without inv. no.), signed 'fecit Joh: Jacob Faesch. A.o 1791. 'A Landscape with River', eventually after a Dutch painting in his collection, or rather of his own invention.

FIG. 5. Luca CAMBIASO, Kunst-museum, Basle (Inv. no. Z 558), *The Holy Family with the Infant St John in a landscape*. Pen and brown ink, 26.9 × 37.6 cm. (Checklist no. 1.)

booklet: *ITINERAIRE alphabétique de la ville de Bâle et ses environs...* of 1782 one may read: 'Faesch, M.le conseiller, demeurant au Seydenhof, possède une très belle et nombreuse collection de tableaux flamands, et quelques dessins originaux...'.[17]

So we have sufficient evidence to assume that these marked drawings were his, the more so as his descendants are known down into the nineteenth century when the remaining objects (the paintings had been sold early) were given to the museum. It was a grand-daughter of Johann Jakob Faesch, named Anna Maria Vischer LeGrand, who must have decided to make a donation, because the name of Vischer LeGrand is mentioned with reverence when her son (Rudolf Vischer-Christ, thus a great-grandson of the collector) fulfilled the promise fifteen years after her death.

With these facts the gap in the history of the Rubens' drawing has been filled and the presence of Jabach drawings at Basle explained. Fortunately, there is much more that can be discovered about this previously unnoticed collection.

Three more of the Basle drawings bear the collector's monogram: firstly a *Landscape with the Rest on the Flight into Egypt* (Fig. 4), inscribed 'Titiano fecit anno 1507' in the lower right corner (Checklist no. 2). The Faesch monogram appears as usual in the centre below. This composition seems to have been successful because it exists in at least four other versions (at Chatsworth, Budapest, Paris and Windsor Castle). Michael Jaffé claims the Budapest drawing as the original.[18] It was etched twice in the eighteenth century, by Louis Garreau as 'Domenichino' and by the Conte de Caylus, remarkably, as by Annibale Carracci. This latter etching exists at Basle, probably from the Faesch collection, although it seems as if the print had been executed not after this, but after the Chatsworth version. There is also a corresponding painting which featured in the famous exhibition 'L'ideale classico del Seicento' at Bologna in 1962. Both painting and the invention of the drawing (of which the original may even be lost) are now attributed as early works of Annibale Carracci. The Basle drawing is pasted onto a modern *passe-partout*, so it is not possible at present to look for any marks on the *verso*.

[17] Copy at the Universitätsbibliothek, Basle. The citation is from p. 22.
[18] For bibliography of this and the following drawings see the references in the checklist pp. 189 ff.

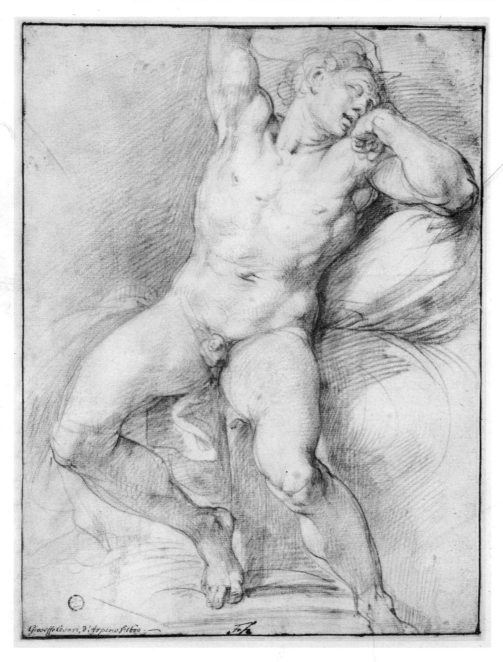

FIG. 6. Giuseppe d'Arpino CESARI, Kunstmuseum, Basle, *Male nude, resting*. Black chalk mounted on cardboard, 27.8 × 20.4 cm. (Checklist no. 3.)

The second of these drawings is a *Holy Family* (Fig. 5), with a sleeping Joseph and the child St John, one of many similar compositions by Luca Cambiaso (Checklist no. 1), drawn hastily but with a certain firmness; among three so-called Cambiaso sheets at Basle it is possibly the only genuine one. It shows the Faesch monogram in its usual place but as the *verso* is completely blank, its earlier provenance cannot be traced.

The third drawing is that of a reclining, sleeping and completely nude youth (Fig. 6), bearing the inscription 'Gioseffo Cesari, d'Arpino f. 1600', which seems a good attribution and one confirmed by Herwarth Röttgen (Checklist no. 3). Its most exciting feature, however, is its resemblance to the famous antique statue of the *Barberini Faun* (Munich), and the drawing seems to offer an ideal reconstruction for the statue's arms and lower legs. Unfortunately, the *Barberini Faun* had been found and excavated, (as far as is hypothetically known), about twenty years after the probable date of the drawing! Unless new documents about its discovery emerge, the similarity must therefore be regarded as a coincidence. The drawing has an old cardboard mount which is pasted onto a *passe-partout*, so that the *verso* is not accessible. From its quality and the appearance of the old mount it might also have come from Jabach's collection.

FIG. 7. Copy after MICHELANGELO, Kunstmuseum, Basle (Inv. no. Z 581), *Group of Figures from the Last Judgement*. Red chalk, 30.5 × 30.1 cm. (Checklist no. 7.)

Among these drawings, which all had been inserted before 1865 in the 'Claude Lorrain' volume, was another, without the Faesch monogram (Checklist no. 7): a red chalk copy after a small portion of Michelangelo's *Last Judgement* (Fig. 7) depicting demons from the lower right corner, which in the fresco are dragging the boat with damned souls towards the abyss. From some time it had been discussed (by Müller Hofstede and others) as one of the copies by Rubens (which exist elsewhere), but in those sheets the body surfaces show more detail, as in anatomical drawings, and less concentrated power. This is clearly a Renaissance drawing, even if not by Sebastiano del Piombo as the old inscription claims, but the paper and watermark are Italian from the middle or second half of the sixteenth century. The handwriting of the inscription seems to be identical with that on the Cesare d'Arpino drawing and there can be no doubt that this sheet belongs to the Faesch group.

With the last of these drawings at Basle, a large *Diana and Actaeon* (Fig. 18), by the French artist François Verdier, we cannot feel as certain (Checklist no. 18). It came to the museum in 1865, possibly from the same source, but there are no traces in the Claude volume where it could have been inserted. It is remarkable in that it is the first French drawing we have found in the collection.

From the Rubens' *St Peter* and the Michelangelo copy it emerges, and must be kept in mind, that Johann Jacob Faesch did not mark <u>all</u> of his drawings with his characteristic monogram. This will make it impossible to reconstruct his collection completely. So far we have now assembled six or seven (Verdier included) drawings at Basle which seem to form the nucleus of a collection still to be discovered; five of them Italian, and all of a more than average if not excellent quality.

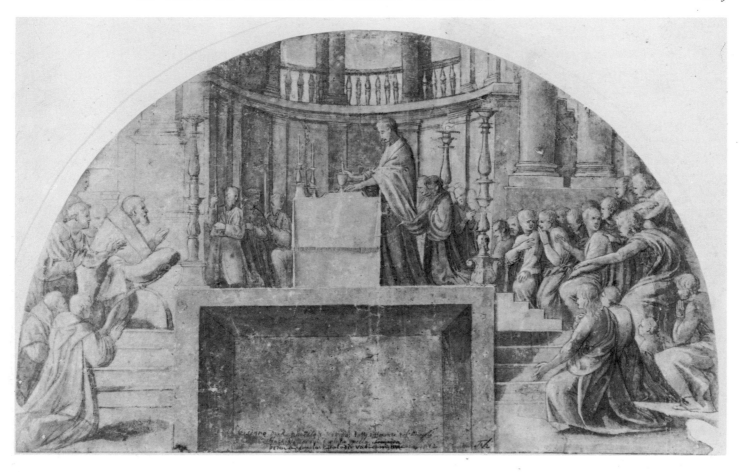

FIG. 8. Studio of RAPHAEL, Ashmolean Museum, Oxford, *The Mass of Bolsena*. Pen and wash in brown ink, heightened with bodycolour, 24.9 × 41 cm. (Checklist no. 9.)

Briefly, I will discuss the remaining drawings which I have found up to now. I will begin with the Raphael School drawing at the Ashmolean, *The Mass of Bolsena* (Fig. 8), which I mentioned earlier as the sheet thought by Lugt — following a communication by Sir Karl Parker — to have been part of the 'Hugford' collection. As the drawing had been in the hands of both Sir Thomas Lawrence and Samuel Woodburn, it proves that at least some of the Faesch drawings must have been dispersed shortly after his death. The Supplement and Index of the Ashmolean's catalogue make it clear that this collector's mark does not appear on any other of their Italian drawings.

At the British Museum, however, there is another Raphael School drawing with the Faesch monogram, *God the Father dividing Light from Darkness* (Fig. 9) from a stylistic group that is now usually attributed to Giovan Francesco Penni.[19] It is of special interest here, as its provenance again goes back to Desneux de la Noué and Everard Jabach; like the Franco drawing it should therefore have passed through the Gerard Michael Jabach auction at Amsterdam, and it can indeed be identified in this catalogue.[20]

The next drawing to be discussed is a red chalk-study by Parmigianino *Daniel in the Lions' Den* (Fig. 10) now preserved at the Städel at Frankfurt. It bears an old attribution to the artist, the Faesch monogram in the middle, and at lower right, numbers and a sign which point to the collection of Desneux de la Noué. Jabach ownership is therefore probable, but not proven. The drawing is mentioned in the Frankfurt collection of Grambs before 1817 (the year of his death).

The Graphische Sammlung at Munich also owns one drawing with the Faesch monogram: Ventura Salimbeni's, *Last Judgement with St Michael* (Fig. 11) (Checklist no. 11) which repeats the composition of a Beccafumi altarpiece. As provenance the Munich catalogues state merely that it was bought on the local art market in 1925; but on the *verso* is to be

[19] Checklist no. 10. John Gere must be thanked for his kind communications about this and other drawings.
[20] Lot 134 in the sale of 1753 (as by Raphael), see later.

FIG. 9. Studio of RAPHAEL (Giovanni Francesco Penni?), British Museum, London, *God the Father dividing Light from Darkness*. Pen and wash in brown over black chalk, white heightening, squared for transfer, mounted on cardboard, 18.8 × 20.3 cm. (Checklist no. 10.)

found the stamp Lugt 1008: a Basle antiquarian firm which Lugt tentatively calls Füssli and Compagnie, but in reality bore the name of 'Falkeisen and Huber', existed *c.* 1800, and after 1812 (the stamp discarded) continued as 'Birmann and Huber'. Thus we know the way by which drawings from the Faesch collection appeared on the art market already in these years around 1800, at the latest by 1812.

Another sixteenth-century Italian drawing in the Faesch collection, now attributed to Marco Marchetti da Faenza, is a *Virgin with Child* (Fig. 12), small in size but charming, and now in a private collection.[21] It suggests that Faesch did not collect only so-called capital pieces, but, it seems, objects of a good reputation. This drawing bears in the lower right corner the stamp of Jan Pietersz Zoomer, one of the oldest known collectors' marks. The Dutch pedigree however, makes it again probable that Faesch acquired the drawing during his years at Amsterdam.

Early in 1987 I was notified that another sheet with the sought-after monogram turned up on the art market, from the collection of Michel Gaud which was to be sold at Monaco.[22] It is by Ciro Ferri, *Scene of a Baptism (St Ambrose?)* (Fig. 13) and bears an old attribution to Pietro da Cortona. This time the inscription of the artist's name seems to me by the same hand as on the Cesari drawing and the Michelangelo copy.

Two more drawings are preserved at Dijon, as Mr John Gere has kindly pointed out to me. The first (Fig. 14), bearing an old attribution 'Titiano de 1520', has been published by the Tietzes already in 1944 as *Five children playing in a landscape*. To them it seemed of restricted value, and Hans Tietze judged: 'The dry and rather poor drawing could be a copy from an original by Titian of 1520 or by Domenico Campagnola, the two artists at that time being close to each other.' As the children group appears on a woodcut from the Titian circle, it may be a pastiche of at least some documentary importance.[23]

The second Dijon drawing is a *Female allegorical figure* (Fig. 15), by Taddeo Zuccaro or his workshop, in connection with a fresco at the

[21] Checklist no. 6. Published in 1967, then with Kurt Meissner, Zürich; now in a German collection.
[22] Sale of Sotheby's, Monaco, 20 June 1987. I am grateful to Elizabeth Llewellyn for signalling this drawing to me. See checklist no. 4.
[23] H. and E. Tietze, *The drawings of the Venetian Painters...* (New York, 1944), p. 328. Peter Dreyer kindly called my attention to the fact that the woodcut in question is published in the Catalogue (Ed. M. Muraro/ D. Rosand), *Tiziano e la xilografia Veneziana del Cinquecento* (Venice, Fondazione Cini, 1976), no. 39. The artist (Domenico Nicolini?) has not been identified with certainty.

FIG. 10. PARMIGIANINO, Städel-sches Kunstinstituit, Frankfurt (Inv. no. PII 642), *Daniel in the Lion's Den*. Red chalk, some white heightening, 8.3 × 14.9 cm. (Checklist no. 8.)

Palazzo Farnese, Rome. There exist several versions and variants of the drawing, this one not known to John Gere at the time of his *Zuccaro* monograph, but evidently, with an old Lanièr provenance, among the better ones, if not from the hand of Taddeo himself.

After the Woodner Symposium at London, two more drawings with the 'Faesch' monogram have been kindly brought to my attention: an anonymous seventeenth-century Italian sketch (Fig. 16), and an Isack van Ostade of a rare subject (Fig. 17). (Nos 14 and 15 of the checklist.) Surprisingly, I came across the collector's monogram also on a well-known Van Dyck drawing (Checklist no. 17): a portrait sketch for his *Iconographia* series, representing the Antwerp painter Adriaen van Stalbemt, and preserved in the Collection Dutuit at Paris (Musée du Petit Palais).

So I started the presentation of the drawings with a Rubens of remarkable destiny, and am ending with a Van Dyck. Except for the Francois Verdier drawing, the inclusion of which in the Faesch group remains somewhat hypothetical, and the recently added Isack van Ostade, all other works are Italian. The seventeen or eighteen drawings assembled so far seem sufficient to draw some conclusions about the collector and his achievement.

As at least three of the drawings definitely came from the Everard Jabach collection, I have to return briefly to the Gerard Michael Jabach sale at Amsterdam 1753. Among the more than one thousand drawings sold at that time, indeed most of the artists' names of the Faesch drawings occur in the catalogue. There are, for instance, a number of landscapes by the Carracci, several portraits by Van Dyck, Holy Families by Cambiaso and so on; but mostly without further specifications for identifying. As mentioned already, the Rubens sketch is not included; this strange fact must be explained by its special role as a family relic. Mariette tells us[24] that he tried in vain to retrieve it, probably after the death of Gerard Michael Jabach in 1751. How, then, Johann Jakob Faesch had been able to take his chance at the moment when the Jabach heirs changed their mind, cannot be resolved; I do not believe, though, that this acquisition was pure coincidence. The two other drawings with certain Jabach provenance, the Raphael (or Penni) sheet at London and the G. B. Franco, are however to be identified in the sale catalogue as no. 134: 'Van Raffaello da Urbino, Een Godde-Vader', and no. 335: 'Gio. Battista Franchi, Een Aanbidding van drie Koninge'. Both have been acquired in the sale, according to the Ploos van Amstel notes in the copy at the Institute Néerlandais, by

[24] See note 9.

FIG. 11. Ventura SALIMBENI, Staatliche Graphische Sammlung, Munich (Inv. no. 1925:77), *Last Judgement with St Michael*. Pen and wash in brown ink, 31.3 × 20.6 cm. (Checklist no. 11.)

25 Lugt, Supplément, under no. 2464a. There is nothing to be found a.o. in R. Cocke, *Pier Francesco Mola* (Oxford, 1972); and J. Byam-Shaw, *The Italian Drawings of the Frits Lugt Collection*, 3 vols (Paris, 1983).

'Rutgers'. This person was one of the well-known *commissaires-priseurs* of the town, a dealer and collector. Thus Faesch did not expose himself as the bidder, if he was present at the auction at all, but possibly used Rutgers as his agent.

Certainly the Faesch collection of drawings was far from complete with these seventeen or eighteen items. On the one hand, it could be established that he did not inscribe all drawings which he possessed with his monogram; on the other, more sheets with the monogram may turn up in the future. Lugt himself states that his 'Hugford' mark is to be found on drawings by 'Mola' an assertion which could not be verified so far.[25] The fact that in some large Print Rooms like London, Oxford and Munich, the mark occurs so rarely, suggests that the collection probably was not large. However, I have not yet made systematic inquiries. My impression is that Faesch collected quality, not quantity. Apparently he esteemed drawings which came from renowned earlier collections, besides Jabach collectors

such as Desneux de la Noué, Zoomer, Lanièr; perhaps hoping the attributions were reliable. Even if not all the drawings are capital pieces, and not all the great names stand up to recent specialist research, there is hardly anything without an appealing quality.

As a collector of paintings, Faesch concentrated on Dutch and Flemish artists. About thirty paintings have been described with painters' names, 'giving a favourable idea of Faesch's honesty and experience' — as Daniel Burckhardt judged in 1901.[26] A 'highly praised' *Holy Family* of Andrea del Sarto seemed to have been the only exception. In collecting drawings he favoured — apparently as a contrast — the Italians, with Rubens and Van Dyck, the leading Flemish masters, being the exceptions.

This indicates consideration and care in selecting, if not a good deal of connoisseurship. His centres of interest were, moreover, the periods of the sixteenth and seventeenth centuries, beginning with the High Renaissance. Whether he excluded his own century completely, of the François Verdier drawing marks a step towards it, cannot be said. As much as he restricted the number of his paintings, he seems not to have amassed drawings, but to have been content to own good examples of the leading masters of different Italian schools. So we find the Venetian, Genovese, Bolognese, Sienese, Roman and Parma Schools. Evidently he bought with good advice and at the right places. So far it remains unclear whether he continued collecting actively in his later years at Basle, but we are able to trace the origins of his collection to Amsterdam and to draw lines of contact to some of the greatest names in the world of connoisseurship. Thus, the scope and the quality of this fragmentary re-discovered collection of drawings deserves to be made known, and the name of Johann Jakob Faesch added to the list of eighteenth-century collectors.

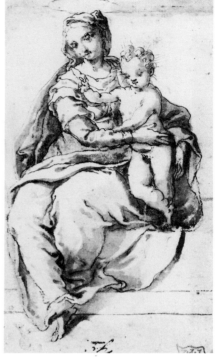

FIG. 12. Marco da Faenza MAR-CHETTI, Private Collection, *Madonna and Child*. Pen and brown ink, some touches of green and reddish wash, 12.3 × 7.3 cm. (Checklist no. 6.)

CHECKLIST OF DRAWINGS FROM THE J. J. FAESCH COLLECTION

A. *Italian Drawings*

1. CAMBIASO, Luca (1527–85)

The Holy Family with the Infant St John in a landscape

Pen and brown ink; 26.9 × 37.6 cm

Below at centre the Faesch collector's mark in ink (= Lugt Suppl. 1468a, as 'Hugford', also Lugt Suppl. 2464a). To the left the stamp of the Kupferstichkabinett Basle. *Verso* empty.

Kunstmuseum, Basle: inv. no. Z 558; given 1865 by R. Vischer-Christ.

When given to the collection, the drawing had been pasted onto fol. 36 of volume K. 52 (engravings after Claude Lorrain). The composition is known in numerous variants, among them several in the Uffizi; see for instance: P. Torriti, *Luca Cambiaso — Disegni* (Genova, 1966), pl. XIX, XXXIV.

Literature: unpublished.

2. CARRACCI, Annibale of workshop

Landscape with the Rest on the Flight into Egypt

Pen and brown ink; mounted on cardboard; 27.8 × 42.5 cm

At centre below the Faesch collector's mark. Below left: no. '68'; below right: 'Titiano f.t/ano. 1507.–'; both inscriptions in brown ink.

Kunstmuseum, Basle: inv. no. U. IV.96; given 1865 by R. Vischer-Christ.

When given to the collection, the drawing had been pasted onto fol. 37 of volume K. 52, as the previous drawing. There exist several drawn versions of this composition, namely at Budapest, Chatsworth, Paris, Windsor Castle, as well as a painting in a British private collection (see: Catalogue L'Ideale Classico del Seicento (Bologna, 1962), no. 1). The version at Budapest has been claimed as autograph (M. Jaffé, in *Bulletin du Musée Hongrois des Beaux-Arts, Budapest*, 25 (1964), pp. 87 ff.).

Literature: Catalogue *Zeichnungen des 17. Jahrhunderts aus dem Basler Kupferstichkabinett*, ed. T. Falk (Basle, 1973), no. 52.

3. CESARI, Giuseppe d'Arpino (1568–1640)

Male nude, resting

Black chalk, mounted on cardboard; 27.8 × 20.4 cm

Below at centre the Faesch collector's mark; at left inscribed 'Gioseffo Cesari, d'Arpino f. 1600 — '; both in brown ink.

[26] D. Burckhardt, 'Die baslerischen Kunst-sammler des 18. Jahrhunderts', *Basler Kunst-verein, Jahresbericht 1901* (Basel, 1902), pp. 29 ff.

FIG. 13. Ciro FERRI, Private Collection, U.S.A.(?), *Baptism scene (The Baptism of St Ambrose?)*. Pen and wash in brown ink, some white heightening, over traces of black chalk, squared for transfer, 17.3 × 19.8 cm. (Checklist no. 4.)

Kunstmuseum, Basle: inv. no. 1865.11; given in 1865 by R. Vischer-Christ.

The drawing was, when given to the museum, possibly pasted onto an empty page of volume K. 52 (see nos 1 and 2). The old attribution is undoubtedly correct, similar motives of Cesare d'Arpino are to be found p.e. at the Städelsches Kunstinstitut, Frankfurt (Inv. no. 4100), and at Sotheby's, London, 21 November 1974, lot 26.

Literature: Catalogue Basle 1973, no. 53.

4. FERRI, Ciro (1634–89)

Baptism scene (The Baptism of St Ambrose?)

Pen and wash in brown ink, some white heightening, over traces of black chalk; squared for transfer; 17.3 × 19.8 cm

Below at centre the Faesch collector's mark; below right the inscription 'Pietro da Cortona'.

Private Collection, U.S.A. (?)

This drawing, dated around 1660, was kindly brought to my attention by Elizabeth Llewellyn of Sotheby's London. So far no execution of the motive is known.

Literature: Sotheby's, Monaco, sale catalogue (coll. Michel Gaud), 20 June 1987, lot 119.

5. FRANCO, Giovanni Battista (*c*. 1498–1561)

The Adoration of the Kings

Pen and wash in brown ink, some white heightening; 13.4 × 13.7 cm

Mounted on cardboard and gilt-bordered in the manner of E. Jabach's 'dessins d'ordonnance'.

Below at left '1550', at centre the Faesch collector's monogram, at right 'B.ta Franco', all in brown ink. *Verso*, on the mount (Fig. 3): 'B.tta Franco, de M.r Dela Noué, et d'après coll.n de M.r Jabach', followed underneath by a large 'Q' and paraphe Lugt 2959 or 2960; below, in brown ink as the inscriptions on *recto*: 'Faesch, au Seidenhof 6'.

Kunstmuseum, Basle: inv. no. Z 557; given 1965 by R. Vischer-Christ.

This drawing with its Jabach mount and its inscriptions is the decisive sheet for disclosing the collector's identity. Clearly the monogram on the *recto*, the artist's name ('B.ta Franco') and the address on the *verso* are written by the same hand. It passed into the Faesch collection after the Gerard Michael Jabach sale of 1753, where it had been lot 335: 'Gio.Battista Franchi, Een Aanbidding van drie Koninge.' When given to the museum by R. Vischer-Christ, a great-grandson of the collector, it was pasted on fol. 39 of volume K. 52 (see no. 1). The old attribution has been confirmed by Philip Pouncey in 1969, but the drawing has not yet found further attention.

Literature: unpublished.

FIG. 14. Anonymous Venetian, sixteenth century, Musée des Beaux-Arts, Dijon (Inv. no. T 68), *Five children playing in a landscape*. Pen and brown ink, 24.9 × 20.7 cm. (Checklist no. 13.)

6. MARCHETTI, Marco da Faenza (d. 1588)

Madonna and Child

Pen and brown ink, some touches of green and reddish wash, 12.3 × 7.3 cm

Faesch collector's mark at centre below; stamp of Jan Pietersz Zoomer in lower right angle (Lugt 1511); two more unidentified stamps on *verso*.

Private Collection.

An old attribution to Francesco Vanni has been discarded; the present attribution was given by Mina Gregori. Philip Pouncey, without renouncing it, saw similarities with the work of Girolamo Siciolante da Sermoneta.

Literature: Catalogue *Handzeichnungen Alter Meister aus Schweizer Privatbesitz* (Bremen/Zürich 1967), no. 64.

7. MICHELANGELO copy after

Group of Figures from the Last Judgement

Red chalk; 30.5 × 30.1 cm

Watermark: Stars in a circle (Italian, *c.* 1550–70). Inscribed at bottom: 'Sebastiano del piombo, da Michael angelo, 1540 – – – in Giuditio.' (Same hand as nos 2, 3, and 4?) No Faesch collector's mark!

Kunstmuseum, Basle: inv. no. Z 581; given 1865 by R. Vischer-Christ.

The drawing had been pasted on fol. 38 of volume K. 52 (see nos 1 and 2) when given to the museum; therefore the Faesch provenance must be regarded as certain. A recent attribution to Rubens as copyist must be discarded as the paper is sixteenth century, moreover the demons are showing their nude state before the overpaintings of Daniele da Volterra.

Literature: J. Müller-Hofstede, *Wallraf-Richartz-Jahrbuch* XXVI (1965), 271–74.

FIG. 15. Taddeo ZUCCARO (or studio), Musée des Beaux-Arts, Dijon (Inv. no. T 61), *Allegorical figure: Seated woman with staff*. Pen and wash in brown ink, white heightening, 34 × 25.3 cm. (Checklist no. 12.)

8. PARMIGIANINO, Francesco Mazzola (1503–40)

Daniel in the Lion's Den

(*Verso*: a variant of the motive)

Red chalk, some white heightening; 8.3 × 14.9 cm

Below left inscribed: 'Franc.o Parmigiano'. At centre the Faesch monogram. Below right: Lugt 3014 (Desneux de la Noué) and paraphe (Lugt 2951, Crozat?). On *verso* the stamp of the Städel Collection (Lugt 2356).

Städelsches Kunstinstitut, Frankfurt: inv. no. 405.

The drawing, which cannot be connected definitely with an executed work, was in the collection of J. G. Grambs at Frankfurt before 1817, testifying the early dispersion of the J. J. Faesch collection.

Literature: A. E. Popham, *Catalogue of the Drawings by Parmigianino* (New Haven/London 1971), no. 139. Catalogue (Ed. Lutz S. Malke), *Städel, Italienische Zeichnungen des 15. und 16. Jahrhunderts* (Frankfurt, 1980), no. 29.

9. RAPHAEL studio of

The Mass of Bolsena

Pen and wash in brown ink, heightened with bodycolour; 24.9 × 41 cm

Faesch collector's mark on the right-hand frame of the window below; at the centre a lengthy inscription in Italian (not in the hand of Faesch).

Ashmolean Museum, Oxford: inv. no. P II 642.

The drawing passed through the Lawrence and Woodburn collections; there is, however, no proof that it once belonged to 'Hugford'. This statement seems to originate from the erroneous identification of the Faesch monogram. According to Hugh Macandrew's Index in the supplement to Parker's catalogue (1980, p. 355) the 'Hugford'-Faesch mark does not appear on any other Italian drawing in the Ashmolean collection.

Literature: K. T. Parker, *Catalogue of the Collection of Drawings in the Ashmolean Musuem*, II, Italian Schools (Oxford, 1956), no. 642.

10. RAPHAEL studio of (Giovanni Francesco Penni?)

God the Father dividing Light from Darkness

Pen and wash in brown over black chalk, white heightening; squared for transfer; mounted on cardboard; 18.8 × 20.3 cm

At centre below the Faesch collector's mark; below right inscribed: Raphael (by another hand); below left in pencil: H.V. (= Vaughn). *Verso* on mount inscribed in ink: 'N:3 Raphaello da Urbino, De la colleccion De Mr. De la Noue, e ensuite, de Mr. Jabach.'

British Museum, London: inv. no. 1900–8–24–109.

As the inscription proves, the drawing came from the collections Desneux de la Noué and E. Jabach, as the no. 5 (and 8?) of our checklist. In the Gerard Michael Jabach sale of 1753, it is to be identified as no. 134: '1 Godde-Vader' ('Var. Raffaello da Urbino ... op bruyn papieren met wit gehoogt'). There is another, rather weak, version of the subject in the Basle Printroom: inv. no. Bi. 393.9) from the eighteenth-century collection of Achille Ryhiner, contemporaneous with J. J. Faesch; both sheets seemingly have nothing to do with each other. For the problem of attribution of this stylistic group see also: M. Winner, in Catalogue *Vom späten Mittelalter bis zu Jacques Louis David*, Berlin (SMPK) 1973, at no. 46.

Literature: K. Oberhuber, *Raphaels Zeichnungen*, IX (Berlin, 1972), no. 455. J. Gere/Philip Pouncey, *Italian Drawings in the Department of Prints and Drawings in the British Museum. Raphael and his Circle* (London, 1962), no. 64.

11. SALIMBENI, Ventura (1557–1613)

Last Judgement with St Michael

Pen and wash in brown ink; 31.3 × 20.6 cm

FIG. 16. Anonymous Italian, seventeenth century, Stiftung Ratjen, Vaduz, *Latona transforms the Lycian peasants into frogs*(?). Pen and wash in brown ink, 20 × 27.1 cm. (Checklist no. 14.)

Below at centre the Faesch collector's mark; in the lower right corner inscribed: 'Ventura Salimbeni'. On *verso* stamp Lugt 1008 of the Basle antiquarian firm Falkeisen & Huber (not 'Füssli & Cie.'), existent until 1812.

Staatliche Graphische Sammlung, Munich: inv. no. 1925:77.

The drawing repeats the composition of an altarpiece by Domenico Beccafumi (Siena, S. Maria del Carmine; see: H. Voss, *Die Malerei der Spätrenaissance in Rom und Florenz* (Berlin, 1920, vol. I, 198–99). Its attribution to Salimbeni has, to my knowledge, not been questioned. The stamp on its *verso*, applied before 1812, testifies the early dispersion of the Faesch drawings collection.

Literature: P. Halm, B. Degenhart and W. Wegner, *Hundert Meisterzeichnungen aus der Staatlichen Graphischen Sammlung München* (München, 1958), no. 72.

12. ZUCCARO, Taddeo or studio (1529–66)

Allegorical figure: Seated woman with staff

Pen and wash in brown ink, white heightening; 34 × 25.3 cm

Faesch collector's mark at centre below; to the right of it and higher up twice the star-shaped stamp of Laniér (Lugt 2885?). Inscribed in lower right corner 'Tad.o Zucchero, A.o 1560.–'

Musée des Beaux-Arts, Dijon: inv. no. T 61, Legs Trimolet, 1878.

This study, which was kindly brought to my attention by John Gere, is connected with a fresco of the Zuccaro workshop at the Sala dei Fasti Farnesiani, Palazzo Farnese, Rome. Among several drawn variants the squared drawing at the British Museum may be an original, while the Dijon version seems closer to Taddeo's style and superior to the recently published sheets at Philadelphia, Rosenbach Foundation (see J. Gere in *Master Drawings* VIII (1970), pp. 134 f. and Fig. 6), and at Niedersächsische Landesgalerie, Hanover (see *Catalogue Die Italienischen und Französischen Handzeichnungen*, ed. M. Trudzinski (Hanover 1987), no. 108, ill.).

Literature: cf. J. Gere, *Taddeo Zuccaro. His development studied in his drawings* (London, 1969), at no. 96. J. Gere and Ph. Pouncey, *Italian Drawings in the Dept. of Prints and Drawings in the British Museum. Artists working in Rome c. 1550–c. 1640* (London, 1983), at no. 333.

13. Anonymous Venetian, sixteenth century

Five children playing in a landscape

Pen in brown ink; 24.9 × 20.7 cm

At centre below the Faesch collector's mark; inscribed in lower right corner 'Titiano fe: 1520.–' (same handwriting as nos 2, 3, 4 and 7?).

Musée des Beaux-Arts, Dijon: inv. no. T 68, Legs Trimolet, 1878.

A drawing which seems to belong to a group using motives from woodcuts of the Titian circle, and which has not been studied properly. The group of children appears in a woodcut signed DN (according to Mme Claudie Barral, Dijon, to whom I am grateful for information).

Whether the inscriptions on nos 2, 3, and 13 are by J. J. Faesch or an earlier collector, cannot be judged at present.

Literature: H. and E. Tietze, *The Drawings of the Venetian Painters in the fifteenth and sixteenth centuries* (New York, 1944), no. 1985, Fig. CXCIII.

14. Anonymous Italian, seventeenth century
Latona transforms the Lycian peasants into frogs (?)
Pen and wash in brown ink; 20 × 27.1 cm
Faesch collector's monogram below at centre. From the collection of Herbert List.
Stiftung Ratjen, Vaduz.

There has been no convincing attribution yet for this spirited study which has been kindly brought to my attention by Wolfgang Ratjen. It cannot be excluded completely that it is a German, not even an Italian drawing.
Literature: unpublished.

B. Non-Italian Drawings

15. OSTADE, Isack van (1621–49)
View of a Cottage
Pen and wash in brown ink over traces of black chalk; some red and yellow chalk and blue washes; 17.9 × 20.3 cm
Below at centre the Faesch collector's mark; on *verso* the stamp Lugt 1008 (= Falkeisen & Huber, Basle, until 1812; see no. 11).
Courtauld Institute Galleries, London (Witt Bequest, no. 3991).
The drawing had been brought to my attention by Noel Annesley, London, after the London Symposium. It casts some doubt on my supposition that J. J. Faesch collected almost exlusively (see also the following two numbers) Italian drawings. Like the no. 11 of the checklist it passed through the hands of the Falkeisen & Huber firm at the beginning of the nineteenth century.
Literature: B. Schnackenburg, *Adriaen van Ostade, Isack van Ostade. Zeichinimgen und Aquarelle* (Hamburg, 1981), no. . . . Catalogue (Ed. D. Farr and W. Bradford), *The Northern Landscape* (London, 1986), no. 54.

FIG. 18. Francois VERDIER, Kunstmuseum, Basle (Inv. no. 1865.12), *Diana and Actaeon*. Black chalk, grey wash, white heightening on brown paper, mounted on cardboard, 31.2 × 45.5 cm. (Checklist no. 18.)

16. RUBENS, Peter Paul (and studio) (1577–1640)

The Martyrdom of St Peter

Black and grey chalk, strongly retouched with brush in black and different grey tones, white heightening; 45.9 × 33.6 cm

Mounted on cardboard and gilt-bordered in the manner of E. Jabach's 'dessins d'ordonnance'.

No Faesch collector's mark. On back of the mounting no. '62' and 'f.f.' in red chalk (= Lugt 960a). From the collections of E. Jabach, Crozat, Mariette, and Gerard Michael Jabach.

Kunstmuseum, Basle: inv. no. U.IV.97. Given to the museum in 1865 by R. Vischer-Christ.

The composition is corresponding to Rubens' late altar-piece for the Jabach family in St Peter's, Cologne, which however, has a rounded top. According to Ludwig Burchard (1936) it had been originally drawn in chalk by a member of Rubens' workshop (Hans Witdoek?). The widening of the space around the figures — in comparison to the painting — seems a typical feature of preparation for a Rubens' print. The extensive retouching, especially in some heads and St Peter's body, has the quality of being by the master's hand himself. For the history of the drawing and its evaluation see the text above and the catalogue of 1973. As it was not auctioned in the Gerard Michael Jabach sale of 1753, the circumstances of transition into the Faesch collection are unknown. When given to the museum, it had been pasted onto fol. 47 of volume K. 52 (See nos 1 and 2 of the checklist.)

Literature: Cat. Basel 1973, no. 46.

17. VAN DYCK, Anthony (1599–1641)

Portrait of the painter Adriaen van Stalbemt

Black chalk; 26.8 × 21.5 cm

Faesch collector's mark at centre below. From the collections of Galichon, Suermondt (Lugt 415), and Dutuit (Lugt 709a). Underneath Lower border line inscribed: 'Adrianus Stalbent — Ant.i van Dijk fec.t:'

Musée du Petit Palais, Paris (Coll. Dutuit, no. 1035).

One of van Dyck's autograph chalk studies for the *Iconographia* series. Mentioned twice in Lugt (*Marques de Collections I*, pp. 71 and 185) as a prominent piece in nineteenth-century collections and sales.

Literature: H. Vey, *Die Zeichnungen Anton van Dycks*, I (Brüssel, 1962), no. 267, pl. 321.

18. VERDIER, François (1651–1730)

Diana and Actaeon

Black chalk, grey wash, white heightening, on brown paper; mounted on cardboard 31.2 × 45.5 cm

No Faesch collector's mark and no others, except the Basle collection stamp.

Kunstmuseum, Basle: inv. no. 1865.12; given to the museum 1865 by R. Vischer-Christ.

This is the only French drawing so far which can be identified as having most probably belonged to the J. J. Faesch collection. Though it does not show the collector's monogram it had been given in 1865 by his great-grandson, and may have been inserted in volume K. 52 with the others (see nos 1, 2, 5, 7, and 16 of this checklist).

Literature: (Ed. Y. Boerlin-Brodbeck), *Catalogue Zeichnungen des 18. Jahrhunderts aus dem Basler Kupferstichkabinett* (Basel, 1978/79), no. 158.

Patterns of drawing collecting in late seventeenth- and early eighteenth-century England

by DIANA DETHLOFF

In *A Discourse on The Science of a Connoisseur* first published in 1719, its author, the painter Jonathan Richardson senior wrote that in England 'We are not without our Share of Drawings'.[1] Richardson's claim was made approximately half-way through the period 1670–1730 when a number of important collections were formed in this country, some of which had lasting effects on the history of English drawing collecting. In this paper I intend to concentrate on old master collections and to demonstrate, with reference to specific collections, that despite the increasing availability of drawings, attitudes and priorities of many English collectors remained markedly consistent.

Surprisingly large numbers of catalogues for drawings' sales survive from this period, although their economical, often ambiguous, contents allow for only a tentative analysis to be made from this source. Such descriptions as 'drawings by the most eminent European masters' or 'very large drawings curiously done' are clearly not especially revealing, and even when the name of the artist or subject matter is given, the final impression formed can still be confusing and misleading. Like painting sales, those for drawings — which during this period are always sold jointly with prints and/or paintings, sometimes sculpture also — were advertised in the small number of contemporary newspapers, but even though this convenience was, according to one early eighteenth-century visitor, Count von Uffenbach, quite unique to England,[2] the information again tends to be rather generalized. It is only when newspaper and catalogue references are combined with details of the actual collections themselves, that a fuller and more accurate picture can be formed.

Many collections were called the 'best in Europe' but in terms of its size and obvious quality, that formed by the artist Sir Peter Lely would seem to merit this tribute by the artist Charles Beale.[3] Despite generating such an extraordinary degree of contemporary interest at the two sales organized by Lely's executors in 1688 and 1694, there are remarkably few references to its contents. Buyers at the 1682 sale of Lely's picture collection, were told in the catalogue, that there would also be sold

> a great number of drawings of Raphael, Julie Romain and Michelangelo, all of their own hand and their best pieces in good condition and well preserved[4]

and shortly before the sale itself, which began on 16 April 1688, the London Gazette for 13 February carried the following notice

> Upon Monday in Easter Week will be Exposed by publick Auction, a most curious and valuable collection of drawings and prints made with great Care and

[1] J. Richardson, *A Discourse on the The Science of a Connoisseur* (1719), p. 53.
[2] *London in 1710*. From the travels of Z. C. von Uffenbach (i.e. extracts Herrn Zacharias Conrad von Uffenbach merkwiirdige Reisen durch Niederasachsen, Holland und Engelland). Trans. and ed. W. H. Quarrell and Margaret Mare (London, 1934).
[3] Bodleian Library, Rawl. 8572, 14 June 1677.
[4] The *Burlington Magazine*, LXXXIII (August 1943), pp. 185–89.

Expence by Sir Peter Lely, Painter to his late Majesty. The Drawings are all of the most eminent masters of Italy etc, being originals and most curiously preserved.

Since the catalogue, compiled so carefully by one of the executors, Roger North,[5] is now lost, the only means to re-construct Lely's collection is from the distinctive PL mark placed meticulously by North on the *recto* of every drawing (and print) in the collection

> Having obtained a little brass stamp cut with the initials PL and applying a little printing ink, I stamped every individual paper and not only that but having digested them into books and parcells, such as we call portfolios and marked the portfolios AA, AB, AC, Aa, Ab etc so consuming four alphabets, I marked the letter of the book and the number of the paper in that book, so that if they had all been shuffled together I could have separated them into perfect order as at first. Then I made lists of each book and described every print and drawing with its mark and number, the details of which were near 10,000.[6]

From a survey of some six major print rooms in this country and Sotheby's and Christie's sales over the last thirty years, it is clear that Lely's collection was strongest in sixteenth-century Italian drawings, with smaller numbers of examples from the fifteenth and seventeenth centuries. Roman, Florentine and Venetian artists predominate but examples from most Italian schools are present. Parmigianino is by far the best represented artist (101 drawings listed in Popham's *Catalogue of Parmigianino Drawings*[7] have the Lely provenance) although as Popham suggests, this could be explained by the enterprising North cutting up large sheets of studies into individual drawings. Large numbers of drawings now attributed to Domenico Campagnola, Raphael, Correggio, Gulio Romano, Paolo Farinati and Polydoro also bear the Lely mark which also appears on slightly fewer drawings by both Taddeo and Federico Zuccaro, Perino del Vaga, Peruzzi, Battista Franco and Veronese. The reference in the picture catalogue to Michelangelo seems unduly optimistic as, not surprisingly, only a very small number of drawings bear Lely's stamp. From the fifteenth century it appears on drawings by Bandinelli, Leonardo (some of which are now considered 'followers of'), Primaticcio and Carpaccio and seventeenth-century examples by Albani, all three of the Carracci, Pietro da Cortona and Maratta.

Although forming a much smaller part of the collection, Lely also owned Dutch and Flemish drawings, including landscape drawings by Martin van Heemskerk, drawings of religious subjects by Rottenhammer and Jan van Swart and a Sketchbook by Van Dyck, now in the British Museum, which records in a small quarto volume of 124 pages studies Van Dyck made whilst in Italy, after sixteenth-century Italian artists, in particular Titian, Raphael and Veronese. His mark is also found on a small number of English drawings, including several by Isaac Oliver and various red chalk portrait heads now classified as 'Anon 17th century English' and on an equally small number of French seventeenth-century drawings by, for example, Poussin and Le Brun.

The subject matter of the majority of these drawings is interesting. Over two-thirds of those surveyed are figurative — individual figures or groups of figures engaged in some form of movement or physical activity, either kneeling, bending, lifting or carrying some object. A large proportion have a strong emphasis on drapery, either in a single drapery study clothing an individual figure or, more usually, in compositions where prominently placed figures are wearing unusually draped garments. Quite distinct from these are a number of portrait studies, usually profile or of children and *écorche* studies and foreshortened limbs. The remaining drawings were much more miscellaneous: finished pen-and-ink landscapes by Campagnola and Grimaldi, elaborate decorative and ornamental

[5] The other executors were Hugh May and Dr Stokeham.
[6] *The Autobiography of Roger North*, ed. Augustus Jessop (London, 1887), Ch. XV.
[7] A. E. Popham, *The Drawings of Parmigianino* (with an introduction and catalogue by A. E. Popham) (1953).

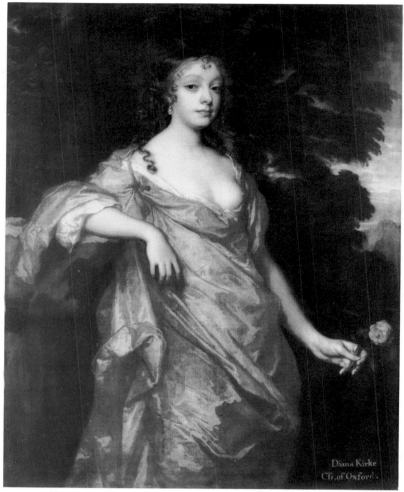

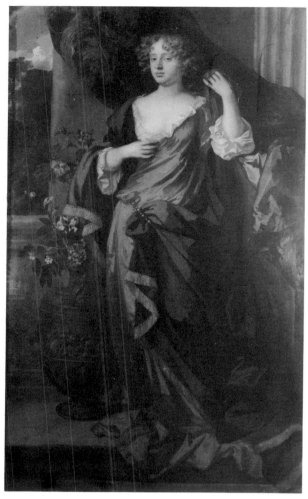

FIG. 1. (above left) Sir Peter LELY, Paul Mellon Collection, Yale Center for British Art, New Haven, *Diana Kirke, Countess of Oxford*. Oil on canvas, 132.1 × 104.1 cm. *Photo: courtesy of Christies.*

FIG. 2. (above) Sir Peter LELY, His Grace the Duke of Norfolk, *Jane Bickerton, Countess of Norfolk*, 1677. Oil on canvas, 224.2 × 134 cm.

FIG. 3. (far left) PARMIGIANINO, British Museum, London, *A draped figure turned to the right*. Red chalk, 14 × 5.1 cm.

FIG. 4. (left) PARMIGIANINO, British Museum, London, *Study of the drapery of a female figure*. Brush drawing on pink-tinted paper, heightened with white, 23 × 9.9 cm.

FIG. 5. PERUZZI, Devonshire Collection, Chatsworth, reproduced by permission of the Chatsworth Settlement Trustees, *Pan with nymphs and satyrs*. Pen and brown ink and brown wash, heightened with white, squared in black chalk, 17.7 × 24 cm *Photo: Courtauld Institute of Art.*

designs by Perino del Vaga and Peruzzi and a small number of finished bird and animal drawings by, for example, Gulio Romano.

Admittedly most drawings produced in the fifteenth and sixteenth centuries, were, in fact, figurative or in some way preparatory to a specific project. But in a period, when it is now generally assumed collectors had to take pot-luck with purchases of unknown quality, the direction of Lely's collection seems quite deliberate. To Bainbridge Buckeridge, writing in *An Essay towards an English School*, the rationale behind it was obvious

> In his younger Days, Lely was very desirous to finish the course of his studies in Italy, but being hindered from going thither by the great Business he was perpetually involved in, he resolv'd to make himself amends by getting the best Drawings, prints and Paintings of the most celebrated Italian Hands ... What advantage he had from this expedient may sufficiently appear by that wonderful stile in Painting which he acquired by his daily conversing with the works of these great men.[8]

Seen in this light and considered with its subject matter, the argument for a didactic intention behind Lely's collection is strong, with the Van Dyck Sketchbook, in particular, providing a valuable substitute to foreign travel which the demands of a busy portrait practice had prevented.

In the catalogue for the 1979 Lely exhibition, Sir Oliver Millar successfully proved that one of Lely's Parmigianinos provided the direct inspiration for his portrait of *Princess Isabella* at Hampton Court and suggested that further research might reveal similar examples.[9] Having spent much time trying to do this, it seems unlikely that Lely's intentions were always so specific and obvious. Instead, I think we should interpret his collection as he himself probably did, as a varied source of potential ideas, postures and compositional groupings, to be adapted and interspersed with examples of his own preparatory drawings. In other words, a pattern book as in Renaissance studies for his assistants and a fund of potential ideas for his own work, and the following three examples suggest, I think, something of this influence. For example, many of his female portraits (Figs 1 and 2) reflect the pose and drapery of his Parmigianino drawings (Figs 3 and 4) and the composition of *Richard Gibson and his Wife* (Fig. 6) has — with obvious modifications! — certain

[8] B. Buckeridge, 'An Essay towards an English School' in R. de Piles, *The Art of Painting and the Lives of the Painters* (London, 1706).
[9] O. Millar, *Sir Peter Lely*, exhibition catalogue (The National Portrait Gallery, London, 1978).

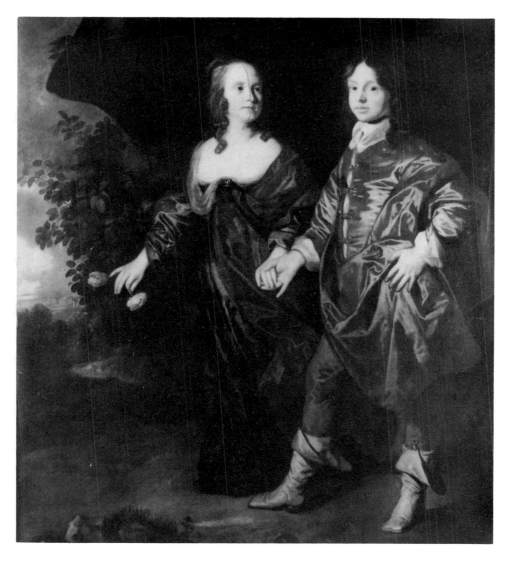

FIG. 6. Sir Peter LELY, Private Collection, detail of *Richard Gibson and his Wife*. Oil on canvas, 165.2 × 122.1 cm. *Photo: courtesy of Sotheby's.*

similarities to the left side of Peruzzi's *Pan with nymphs and satyrs* from his collection (Fig. 5).

Although by no means new in the history of artist-collectors, this apparent didactic intention distinguishes Lely's collection from those of his English contemporaries. Yet in terms of the representative range of artists assembled, it is very similar to others formed at this time. For example, the collection of Richard Maitland, which was sold with his books and prints in a series of auctions between 1684 and 1688, contained, like Lely's, drawings presumed to be by Raphael, Veronese and Perino del Vaga plus a fairly high proportion of seventeenth-century artists such as Andrea Sacchi, the Carracci and Guercino. That of the English-based Flemish artist Willem de Ryck, sold at Exeter Exchange in the Strand on 30 June 1690, consisted, according to the catalogue, of 'a large Collection of the best *Italian* and *French* Prints and Drawings with several Original Heads of *Raphael* etc'. The collection of the landscape painter, Prosper Henry Lankrink, recognizable from his distinct PHL stamp, contained, in addition to large numbers of sixteenth-century Italian drawings bought both independently and at Lely's sale, numerous sixteenth- and seventeenth-century Dutch and Flemish landscape drawings (now classified as 'Anon 17th century Dutch or Flemish') and portrait and landscape studies by both Rubens and Van Dyck.

The contents of all these collections (Lely's presumed intentions apart), confirmed by a judicious reading of surviving sale catalogues, were apparently typical of late seventeenth-century English collections and it was in this atmosphere that the foundations of one of the eighteenth

century's most important collections were laid. In 1733, Orlandi Pellegrini described the collection of the artist Jonathan Richardson senior as consisting of

> the rarest drawings by the best European masters. Mounted with the greatest care on the thinnest paper, they fill about thirty volumes.[10]

After Richardson's death in 1745, 2,434 loose drawings, three books of drawings (including one book of 17 drawings by Pordenone and 25 by Rembrandt) plus 23 portfolios were sold at Christopher Cock's on 22 January 1746. Many of these drawings can be identified by one of the two marks used by Richardson: an artist's palette and a curling capital R and also by various comments in his theoretical writings, which not only explain his ideas on connoisseurship and the critical analysis of works of art, but in some cases, refer to specific drawings in his collection.

Having written in *An Essay on the Theory of Painting*, that

> the Roman and Florentine Schools have excell'd all others in this Fundamental part of Painting and of the first Raphael, Guilio Romano, Polidoro, Pirino del Vaga, etc. as Michelangelo, Leonardo da Vinci, Andrea del Sarto etc have been the best of the Florentines.[11]

his mark is found on a large number of Raphael drawings, many of which are studies for various Roman projects, as for example a drawing of a sibyl for S. Maria della Pace which was sold for ten shillings, together with one of Michelangelo's 'great masks of the Belvedere' as lot 51, on the second night of the sale and described as 'Raphael, sibyl in church of the peace in Rome'. It also appears on a number of Gulio Romano drawings, which, according to their owner, have 'a Spirit, a Beauty, and Delicacy inimitable[12] and likewise by Polidoro, 'on Paper or in Chiaro Scuro one of the foremost in the School of Raphael'.[13] He also appears to have owned a small number of Michelangelo drawings, including the Ashmolean's pen-and brown-ink drawing of *Three men in conversation* which he is clearly referring to in the following passage in *An Essay on the Art of Criticism*,

> A Michelangelo drawing with a Pen upon a large half sheet and consists of three standing Figures which I joyfully purchased from one that had just bought it from abroad [Sir James Thornhill].[14]

He already owned a copy of this (which he acknowledges as such)[15] by Battista Franco plus a number of other drawings by Franco whose draughtsmanship he considered 'exquisitively Fine though his Paintings Contemptible'.[16] Elsewhere in *The Art of Criticism* he writes of owning great numbers of Parmigianino drawings [sixty-six plus one now considered a copy], claiming that

> in his drawings he appears to be a greater Man than one sees in his Paintings or Etch'd Prints ... all the several Manners of Handling, Pen, Red Chalk, Black Chalk, Washing with and without Heightening; on all Colour'd Papers and in all the Degrees of Goodness from the lowest of the Indifferent up to the Sublime.[17]

The Carracci and Domenichino — all 'excellent Designers'[18] — are represented by landscape, portrait and religious studies and despite criticizing the Venetian school for 'lacking the Antique' and being generally incorrect in their draughtsmanship',[19] his mark appears on a number of landscape and portrait drawings by Titian, on figure and portrait studies by Veronese and Tintoretto and a few drawings by Carpaccio.

Of the 'other masters' mentioned in the catalogue preface, Dutch and Flemish artists, criticized for their 'ungracefulness and imitation of nature', account for the largest proportion. He owned landscapes by Brill, Both (described as the 'Italian Bott' in the catalogue), Berchem, Breughel, Swanevelt, Koninck, van der Velde, Wyck and Rademacker; still-lives by

[10] P. A. Orlandi, *L'Abecedario Pittorico, dall'autore ristampato, corretto et accresciuto di molti professori e di altre notizie spellanti alla pittura etc* (Bologna, 1733).

[11] J. Richardson, *An Essay on the Theory of Painting* (London, 1715), p. 138.

[12] J. Richardson, *An Essay on the Art of Criticism* (London, 1719), p. 128.

[13] Ibid., p. 127.

[14] Ibid., p. 187.

[15] Ibid., p. 187.

[16] Ibid., p. 128.

[17] Ibid., p. 137.

[18] J. Richardson, *An Essay on the Theory of Painting* (London, 1715), p. 138.

[19] J. Richardson, *The Science of a Connoisseur etc* (London, 1719), p. 79.

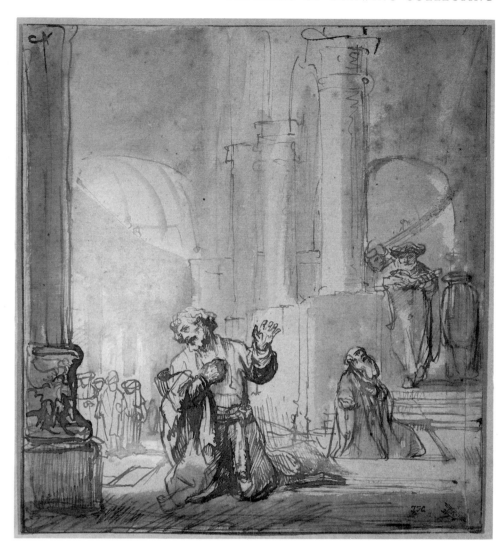

FIG. 7. REMBRANDT, Ian Woodner Collection, New York, *The Parable of the Publican and the Pharisee*. Reed pen and brown ink, brown and grey washes, with touches of white bodycolour, 20.6 × 18.7 cm.

Bloemart and van Huysum and drawings of genre subjects by Teniers and Ostade (exactly which member of each family is not specified). Rembrandt, whose drawings he wrote he had 'in sufficient number' was represented by a fairly large number of religious subjects (referred to as 'scripture stories' in the catalogue), for example, from the Woodner Collection *The Parable of the Publican and the Pharisee* (Fig. 7), portrait drawings, landscape and woodland scenes and copies made by Rembrandt after Italian artists. He also owned portrait and landscape drawings by Van Dyck and by Rubens, studies of religious subjects, portraits and copies after Italian artists. The rest of the collection consisted of a smaller number of seventeenth-century English drawings, including 'One book of Sir Peter Lely's drawings', portraits by Mary Beale and John Riley and a correspondingly small number of seventeenth-century French drawings by Poussin, Le Brun, La Fage and Callot.

Richardson's collection — a mixture of highly finished and preparatory drawings — bears, like Lely's, strong resemblances to many of his contemporaries. The collection of William Cavendish, the 2nd Duke of Devonshire, which benefited considerably from the 1723 purchase of a large part of Nicholas Flinck's collection, was, like Richardson's, strongest in sixteenth- and seventeenth-century Italian drawings, in particular by Raphael, Polidoro and Parmigianino; seventeenth-century Dutch and Flemish; a steadily growing number of English drawings plus a smaller proportion of French and German examples. Comparison with other early eighteenth-century collections, for example those of Richard Topham or Dr Richard Mead, would have reflected the same pattern. There is, in fact,

a strong sense of uniformity running throughout the entire period, with many artists, especially the preference shown for sixteenth- and seventeenth-century Italian, occurring in both seventeenth- and early eighteenth-century collections. The Pond and Knapton *Facsimile of Old Master Drawings in English Collections*, published in 1733, confirms this impression, with particular emphasis given to drawings by Parmigianino, Correggio, Raphael, Polidoro, Guercino and Agostino and Annibale Carracci. Obviously there are slight changes and developments, as, for example, the greater interest in Claude and Rembrandt drawings in the early eighteenth century than previously, (viz., Devonshire's 1728 purchase of Claude's *Liber Veritatis* and the large number of Rembrandt drawings in Richardson's collection), but on the whole there is a marked continuity.

To a certain extent, this continuity is inevitable as a real and actual link exists between many of these collections: if not all, then most collections at this period, can be traced back to Lely's. Many of Richardson's and Devonshire's drawings, if not bought personally as young men at Lely's sales, were subsequently acquired through Prosper Henry Lankrink and the miniaturist William Gibson, who were both sizeable buyers at Lely's two sales, and, especially Gibson, active as dealers in the 1690s. Further 'Lely' drawings were acquired by Devonshire in his 1723 purchase of Flinck's collection, as Flinck had himself earlier acquired them, indirectly, through the Dutch collector, Signor Bergestein (who in turn had probably acquired them through Frederick Sonnius, a member of Lely's studio). There were also strong personal links between many of the collectors themselves. As a young man, Richardson had frequented the circle of Gibson, Sonnius and the Keeper of the King's pictures, Parry Walton, who are emerging, although still rather hazily, as key figures in an important dealing and auctioneering circle in late seventeenth-century London.[20] As an older collector, Richardson was closely involved with a number of other early eighteenth-century collectors, such as the 2nd Duke of Devonshire and also, the Lord Chancellor, John Somers, who employed both Richardson and his son, to remount and edge with gold borders, sixteen volumes of drawings (almost all entirely fifteenth- and sixteenth-century Italian) he had acquired, through John Talman, from Padre Resta in Rome.

However, it is clear that the availability or non-availability of particular drawings would have ultimately determined the nature of many of these collections and established a certain canon of taste. For example, the fact that a large proportion of Michelangelo drawings remained in the Buonarroti family until the French invasion of Florence in 1796, can perhaps explain the relatively small numbers in English collections before that date. Similarly, as there were quite a large proportion of German prints in late seventeenth- early eighteenth-century English collections, yet few (although some) German drawings, suggests there were in fact fewer German drawings available in England at that time, not that there was no interest in them. Conversely, to judge from the Parmigianino drawings in the collections of the Earl of Arundel (etched by van der Borcht and Lucas Vosterman) and Nicholas Laniere, there were clearly large numbers of his drawings in England in the early seventeenth century and as very few of Lely's Parmigianinos have the two earlier provenances, a further source must have become available by the middle of the century. (Although North's 'multiplication' should not be discounted.) By the beginning of the eighteenth century, far more Italian drawings were in English collections, since, according to Richardson, 'The Riches of England, Holland and France and other countries of Europe may well be supposed to have drawn away by much the greatest number of what curiosities could be had'.[21] A

[20] At present, I am researching this particular aspect of late seventeenth-century English collecting.
[21] J. Richardson, *An Essay on the Art of Criticism* (London, 1719), p. 182.

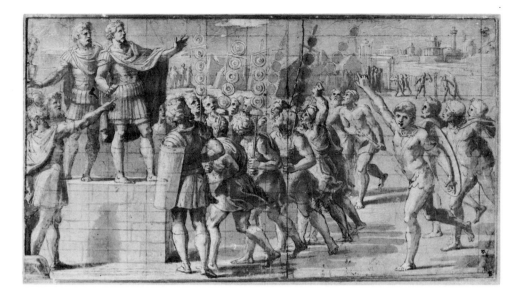

FIG. 8. School of RAPHAEL (Giovanni Francesco Penni?), Devonshire Collection, Chatsworth, reproduced by permission of the Chatsworth Settlement Trustees. *Constantine addressing his troops, startled by the Vision of the Cross in the sky.* Pen and brown wash over black chalk, with bodycolour, partly squared for enlargement, 23.2 × 41.5 cm. *Photo: Courtauld Institute of Art.*

number of late seventeenth-century drawing collections were described in their sale catalogues as having been formed 'by a Gentleman on his Travels' and this became more widespread as the Grand Tour itself did, with many early eighteenth-century collections, such as those formed by Richard Topham, Hugh Howard, Thomas Coke and George Knapton, evolving from purchases made while travelling abroad.

Some collectors, unable or choosing not to travel, used (as in the case of Lord Somers and John Talman), the growing number of dealers and *marchand-amateurs* to buy on their behalf. And to judge from the steady increase in the numbers of London drawings' sales during this period, it seems likely that many foreign purchases were made with the express intention of immediate re-sale on the London art market.

Perhaps though, what was thought to be available is the key issue here, as 'the great numbers of drawings' mentioned by Richardson, sounds a note of caution, which Richardson himself clearly shared, claiming 'I believe that there are few Collections without Instances of these mis-named Works, some that I have seen are notorious for it'[22] and urging

> Great Care must be taken as to the Genuineness of the Works on which we form our Ideas of the Masters, for abundance of things are attributed to Them, chiefly to Those which are most Famous, which They never saw.[23]

Of these 'most famous' Raphael received more spurious attributions than any other artist, inevitably perhaps given the high regard — 'the great Model of Perfection'[24] — collectors held for him and the resulting eagerness to own examples of his work. Virtually every collection had its Raphael (more often than not by one of his followers) for which, as in the case of this drawing (Fig. 8) of *Constantine addressing his troops*, sold at Lely's 1688 sale, collectors were prepared to pay prices enormously high by the standards of their day.

> ... it was rallied at first, some said 6d knowing what it would come to, but then £10, £30, £50 and my quarrelsome lord bid £70 and Sonnius £100 and had it.[25]

Raphael is the most extreme case of this tendency but there are other examples. Drawings now identified as 'followers of', 'school of', were clearly believed to be by the artist himself and copies made by, for example, Rubens after earlier Italian artists, were possibly bought as originals.

Richardson, on the other hand, achieves quite a high level of accuracy with his attributions: clearly one of his main reasons for writing the *Art of*

[22] Ibid., p. 141.
[23] Ibid., p. 140.
[24] J. Richardson, *An Essay on the Theory of Painting* (London, 1715), p. 162.
[25] North, op. cit., p. 200.

Criticism — to help distinguish originals from copies — had proved effective, although as he himself admits, he *was* fallible

> Nor do I pretend that my Own has not Some few on which I would not have the least dependence in forming an Idea of the Masters whose Names they bear. They are as I found them and maybe Rightly Christened for ought I know; I leave the Matter as Doubtful in Hopes of Future Discoveries; But a Name I know or Believe to be Wrong, I never suffer to remain, I either expunge it and leave the Work without Any, Or give it such as I am Assured or have Probable Arguments to Believe Right.[26]

In this paper I have chosen to concentrate on old master collections, but other types of drawings' collections, which concentrated on a much more specific area (for example the collections of architectural drawings of John Talman and the Earl of Burlington), were formed at this time. Even within those collections, now regarded essentially as 'old master', there are items — totally out of keeping with the rest — which reflect personal or idiosyncratic interests. For example, the large number of botanical and anatomical studies in the collection of Dr Richard Mead and over sixty drawings by Simon Dubois, a great favourite of Lord Somers, in the latter's otherwise predominantly fifteenth- and sixteenth-century Italian collection.

I have also concentrated on 'first division' collectors, noted today and by their contemporaries, for the quality of their drawings, yet there were others collecting below that level. Those who before the late seventeenth century could only have afforded to collect prints but who now are including drawings; who would have regarded themselves as old master collectors but whose collections consisted primarily of topographical material, later copies of sixteenth-century Italians or drawings by relatively minor contemporary English artists. In the case of some artist-collectors (for example John Riley and Sir James Thornhill whose collections were sold in 1694 and 1734 respectively) their own work accounts for by far the largest part.

With a few and notable exceptions, this period is sometimes regarded as a rather dull filling sandwiched between two more interesting and important collecting periods; a temporary break in the collecting chain of Charles I and Arundel and Reynolds, Lawrence and George III. But, while obviously benefiting from the earlier collections and contributing much to subsequent ones, it clearly had a quality and momentum of its own.

Attitudes and preferences remain, for the most part, markedly consistent, particularly considering the differing intentions of many collectors. Lely's as we have suggested, had probable didactic purposes; whereas William Gibson seems to have regarded his collection essentially as the basis for future dealing transactions. Some aristocratic collectors, such as the Earls of Leicester and Pembroke, probably even Devonshire and Somers, undoubtedly formed their collections because it was fashionable to appear as men of taste and letters. In contrast, Richardson's collection, although containing working and preparatory studies of potential value to his own work, had no didactic relevance, but appears to have been formed on the principles of scholarship and connoisseurship discussed in his writings.

To talk of a collector's 'intentions' presupposes a degree of choice and, while agreeing that many drawings were obviously bought *en masse*, there are signs from a careful reading of Constantijn Huygens *Journal*, that certain collectors, although by no means all, could and were more selective than has previously been realized. The direction of Lely's collection was clearly not coincidental. According to Buckeridge

> he set about to industrily [ie in forming his collection] that at length he obtained what he sought after and may well be said to have had the best chosen Collection of any of his time.[27]

[26] J. Richardson, *An Essay on the Art of Criticism* (London, 1719), pp. 141–42.
[27] R. de Piles, op. cit.

It is difficult to prove Buckeridge's claim as the exact origins of Lely's collection are obscure. (The only certainties are those drawings bearing the Charles I and Lanier provenance which suggest they were bought at these collectors' sales.) Yet Evelyn's comment, after visiting one of Arundel's heirs, his nephew the 5th Earl of Norfolk, that 'Lilly had gotten some of the best'[28] of Arundel's Raphaels, implies Lely had negotiated with Norfolk for a selection. And if the suggestion that Lely also dealt in drawings, possibly even supplying Charles II, is correct,[29] he clearly was in an advantageous position to exercise considerable choice in adding to his own collection.

Perhaps Lely is an exception, yet Huygens suggests that other late seventeenth-century collectors could exercise that choice also by buying from dealers such as Gibson, Walton and Michael Rosse who sold drawings individually after careful scrutiny. There is no reason to assume that this did not continue in the eighteenth century when purchases made abroad and more London drawings' auctions gave the potential buyer greater choice. If we accept that opportunities for greater choice did exist, the eighteenth-century collector, guided by the advice given by such writers as Richardson and Shaftesbury, was better equipped than his seventeenth-century counterpart to implement that choice; better equipped, as Richardson urged in *The Science of a Connoisseur*, to become part of a nation of connoisseurs. It is this developing connoisseurship which differentiates what is otherwise a remarkably homogeneous collecting period.

[28] *Diary and Correspondence of John Evelyn.* Edited by W. Bray, 4 vols (London, 1850–52).
[29] E. Schilling, *The German Drawings in the Collection of Her Majesty the Queen at Windsor Castle* (London, 1971).

60984 81800